BENEATH IT ALL
A CENTURY OF FRENCH LINGERIE

FARID CHENOUNE

RIZZOLI
NEW YORK

*My God, I want to speak of noble
things and here I am telling stories
about bras.*

ALBERT COHEN, *Belle du Seigneur*, 1968

This page:
In 1951, Warner's Cinch-
Bra: cinch-belt–bra–bustier
with garters, to be worn
under an evening dress.
It unfastens in a single
movement.
Following page:
Model in the dressing
room preparing herself
for a fashion show in
the Stedelijk Museum,
Amsterdam, in the 1950s.
Page 6:
Valisère bra-slip, 1994,
for *Le Jardin des modes.*

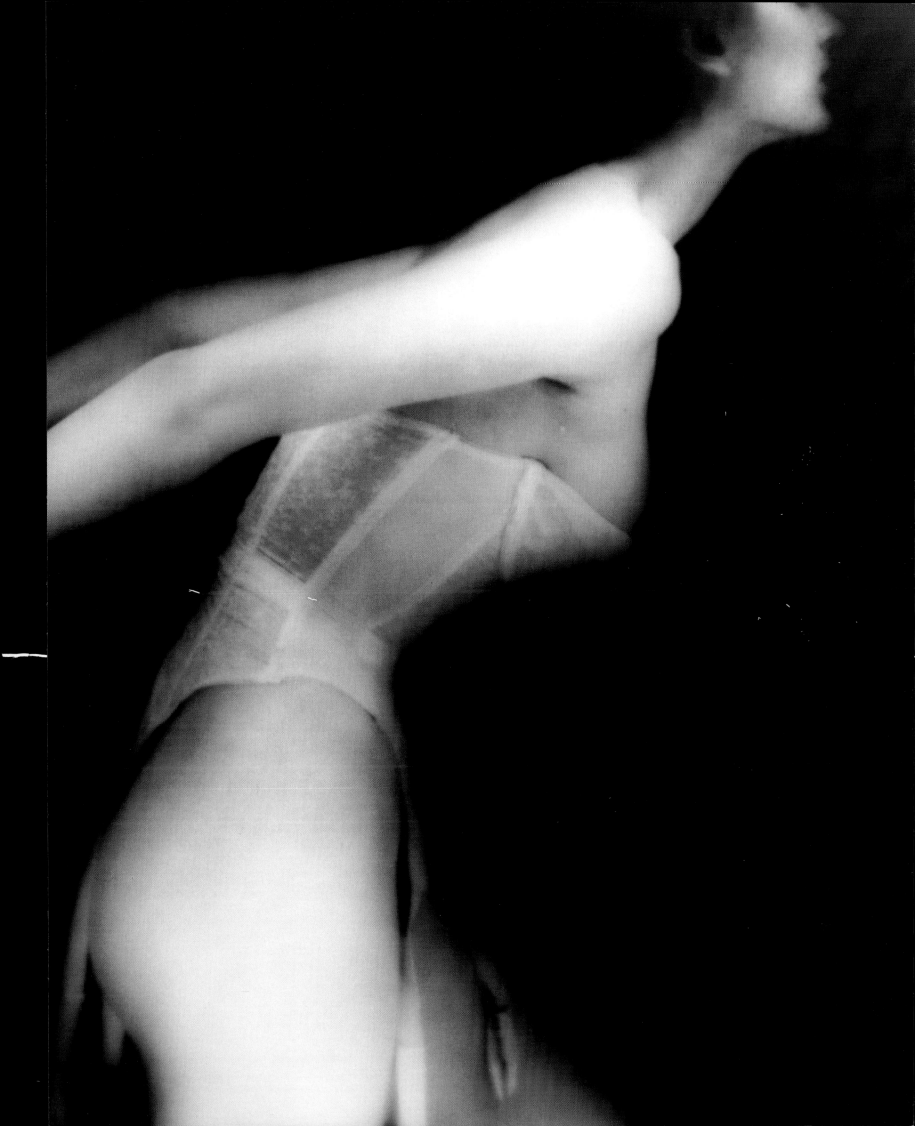

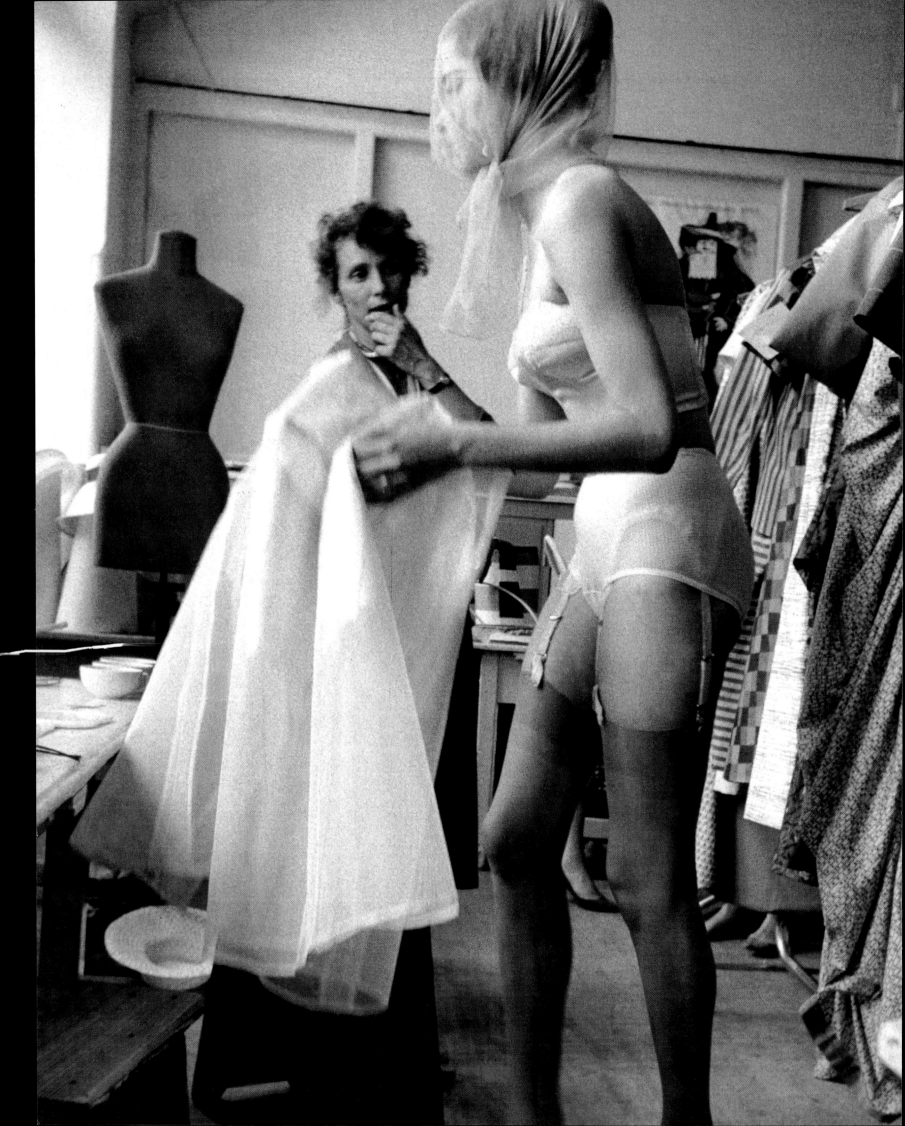

CONTENTS

PROLOGUE: THREE LINES OF INQUIRY – 9

Female Underclothes as Erotic Proposition – 9

The Role of Lingerie in the Trousseau – 10

Corsetry and Fashion – 13

1) TROUSSEAU AND UNDERWEAR: INVENTORY AND INVENTION – 14

A Brief History of Women's Drawers – 17

Intimacy Ablaze – 22

2) THE HEALTHY BODY VERSUS THE CORSET – 28

Modeling and Enhancing the Female Figure – 28

Liberating the Bust – 38

3) THE FLAPPER IN THE AGE OF DEMOCRATIC LINGERIE – 44

The Boyish Look – 44

The Look of Flesh-Toned Silk – 49

4) PENELOPE 1930s: NOSTALGIA FOR THE FEMININE – 58

Needlework and Eternal Womanhood – 74

5) 1947–1957: COLD YEARS—HOT UNDIES – 82

Corsetry of the "New Look" – 84

Slipping into Something More Comfortable – 102

6) LITTLE GIRLS AND LIBERATED WOMEN: PANTIES, BIKINI BRIEFS, AND TIGHTS – 114

Reign of the Child-Woman 114

Women Lose Their Bras—and the Trousseau Loses Its Illusions – 124

7) TEMPTATIONS FOR A NEW EVE – 134

Influence of the Peep Show and Sex Shop – 134

Pandora's Chest of Drawers – 146

8) SLIM BACK, BIG BREASTS: THE 1990s – 150

Undies on Top: Fashion Drains Undergarments of Erotic Charge – 156

New Fibers for Femininity: Transparency Skin-Deep – 166

APPENDIXES – 177

Timeline – 178

Notes – 183

Bibliography – 191

For Christine

The Chest of Drawers

It was a rustic Louis Quinze chest of drawers I'd got from an antique shop in the sixth arrondissement—I must have been between thirty-five and forty-five at the time, and I probably bought it with the money I got for The Sea Wall. *I'd had it for about ten years or so when one night I was tidying my things at night, as lots of women do, and for some reason I don't remember now I took the middle drawer out and put it on the floor. And a piece of material that had been caught between the drawer and the back of the commode fell out of the shadows. It was a slightly yellowish white, but bright, crumpled like a screwed-up piece of paper, and flecked with pale pink stains. It was a caraco [camisole], a woman's loose under-blouse, gathered at the neck and with a narrow lace trimming around the edges. It was made of lawn. No one had ever taken the drawers out even when moving house. "1720," I said aloud. The pink of the marks was the colour blood leaves on the cloth after it has been rinsed. The caraco itself had taken on the smell of polished wood. The drawer must have been too full, and the under-blouse, on top, must have got caught and dragged by the drawer above until it disappeared down the back of the commode. And there it had stayed for two hundred years. It was covered with months and years of darns— with darns which had been darned themselves, as beautiful as embroidery. The first thing you think when you realize what it is, is: "She must have hunted for it all over the place." For days and days. She couldn't think where it had got to.*

MARGUERITE DURAS. *Practicalities,* [1987], 1990.

PROLOGUE:
THREE LINES OF INQUIRY

*Three key moments of the Western world: under the Old Regime, private
life lived as a ceremony; in the nineteenth century, as a confidential novel;
in the twentieth century, private life acted out in public…*



OCTAVIO PAZ, *Alternative Current*, 1967



W omen wear lingerie. Men simply put on underwear.[1] This remark by psychoanalyst Eugénie Lemoine-Luccioni captures with almost disarming concision that obvious yet unbridgeable difference the world knows as the gender divide: of all of a woman's finery, it is perhaps *lingerie* that embroiders most fully on her legendary mystery.

Undergarments converse in silence with the women who wear them; women confide in them, hidden, invisible beneath their clothes, as if in some guardian angel of their femininity. The *scream* of a piece of silk, the light crack of a corset, the static rustle of a pair of stockings under a slip or dress, a petticoat's *frou-frou*—all provide faint echoes of those once-private conversations that have now become almost the very sounds of cliché.

This book seeks to lend an ear to these undertones, endeavoring to look beneath—and beyond—to unearth what is underneath, as it were. It treats of material history, social history, the history of symbols, and, finally, as woman moves from her chest of drawers to her mirror in a search for identity, the history of an imaginary world where the fabric of femininity is first unpicked and rewoven. The weft and warp of this fabric are formed from many different strands like so many Ariadne threads that must be unraveled before the whole pattern can be grasped.

FEMALE UNDERCLOTHES AS EROTIC PROPOSITION

The erotic purpose of female underclothes has been emphasized on countless occasions. They hint at what is hidden; they conceal, but only the better to excite desire. The subtle or touchingly artless exercises in this rhetoric of seduction vary from era to era and from class to class. Tracing the shifts and ploys of this little game was indeed one of the more diverting tasks in writing this study and the first thread to be unraveled. One analysis of the game is proposed by the philosopher and author Georges Bataille, writing on the subject

of woman's "evasion" from masculine desire and the role of personal adornment. Published in the 1950s, it coincides with a vogue for pinups that enflamed the erotic imagination during a period otherwise deep in the grip of prudishness: "By the care she lavishes on her toilet, by the concern she has for her beauty set off by her adornment, a woman regards herself as an object always trying to attract men's attention [...] more often than not the object inciting male pursuit eludes it," Bataille writes in *Eroticism* (1957). "That means not that the suggestion has not been made, but that the necessary conditions have not been fulfilled. Even if they are, that first refusal which seems to deny an offer already made, only enhances its value.... Putting herself forward is the fundamental feminine attitude, but the first movement is followed by a second, a feigned denial. Only prostitution—a proposal *not* followed by its feigned negation—has made it possible for adornment to stress the erotic value of the object. Such adornment really runs counter to the second movement, when a woman evades the attack. What happens is that the use of adornment implies that the wearer is a prostitute: or a pretence of evasion that sharpens desire."[2]

THE ROLE OF LINGERIE IN THE TROUSSEAU

Another line of inquiry unravels from the opposite pole. For underclothes have quite another purpose, a purpose that one might think of as primary, even archaic: hygiene. As an article of skin care, undergarments protect outer clothes from the secretions the body constantly exudes. More profoundly, however, they have a hygienic purpose connected to woman's reproductive functions—to her menstrual blood and periods. This is underclothes in the most intimate meaning of the term: underlinen. In this sense, the origin of female undergarments lies in the sanitary napkin.

We are here concerned with a taboo subject linked to the role of virginity and to the social organization of procreation in traditional societies; it is here that the roots of the symbolic role of underclothing run deep. Traditionally, promotion to the underclothing of an adult woman was timed to coincide with changes in the young girl's physiology and physique, and accompanied her apprenticeship into womanhood with its attendant rites of passage. In the young lady's trousseau, underclothing was invested with a more domestic and ceremonial meaning. In ground-breaking and evocative pages, Yvonne Verdier (with the pen of a Colette writing an ethnology textbook) has described the rites that accompanied assembling a trousseau in a Burgundy peasant village. She has shown how a girl who had begun menstruating (who was *en fleurs*—"in flower"—as nineteenth-century French had it) would *mark* her undergarments with her initials or with a monogram sewn with a special embroidery stitch that belonged to her and to her alone—her *point de marque*. For the other items of needlework in her trousseau (embroidery, lace, and haberdashery), a girl might enlist the help of her mother, sister, or seamstress; but she had to sew her personal *point de marque* on her garments unaided. "Thus," writes Yvonne Verdier, "if embroidery can be seen as a way of making time pass, an art of waiting

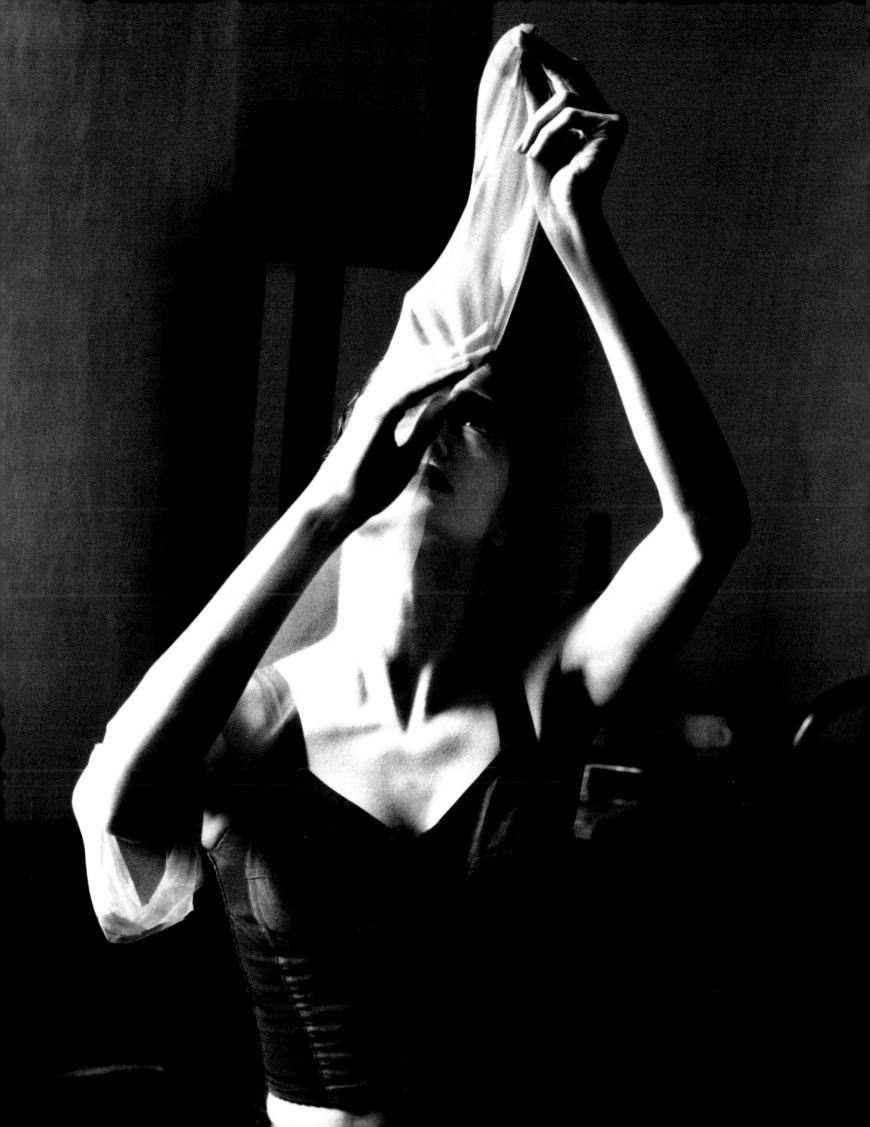

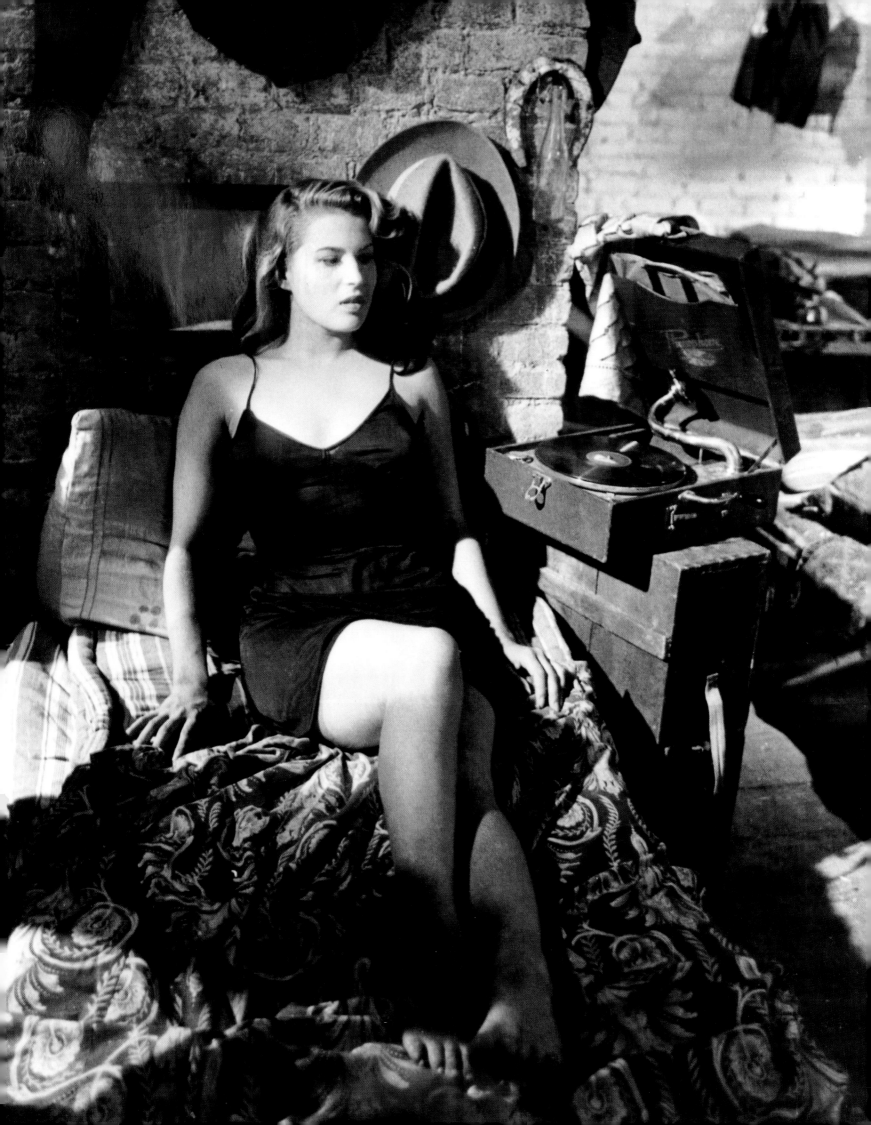

(embodied in the tragic figure of the village spinster who, madly plying her needle, waits forever, embroidering expectantly for a wedding that will never come), so the mark permits no such dallying. Sewing it was a duty that had to be performed without delay. As a stitch of pride, as well as concrete evidence of the organic link between a girl and her trousseau, it seemed to say, "If this girl sews her mark well, then she must be a 'well-made' girl."[3]

At once the logbook and engagement diary of an apprenticeship to womanhood, the trousseau codified the relationship between women and their own femininity. The present study is played out against the backcloth of the trousseau's gradual decline in the twentieth century. Behind its demise lurks a long string of questions centering on how femininity was transmitted, inscribed, and *marked* in underclothing itself, and on the ways it was worn during our own century. What then is left of the notion of the trousseau? Does something of its unalienable mark still survive; or has all vanished with the arrival of profit-seeking *trademarks* that are forever clamoring their uniqueness—though in fact nothing is more replaceable?

CORSETRY AND FASHION

The third thread, the third line of inquiry, is corsetry: stays, corsets, wasp-waisted cinchers, girdles, brassieres, or, with increasingly tenuous connections to lingerie, sculpting bodies and bodysuits, and control tights. Corsetry that offers women *support* has both an aesthetic and a technical purpose: when a corset is worn, the dress lies on its invisible guardian, held up by its framework and foundation. Corsetry is a behind-the-scenes trainer as well, shaping the body as it is manufactured by fashion, creating new lines for each successive style. Corsetry provides an "intermediate body" that hovers midway between the physical, anatomical body—with its flesh and bony superstructure—and the walking utopia that is the "fashion body."[4] Thus a comprehensive history of female undergarments provides at once a course on human morphology and a lesson in social mores.

The three processes in the history of female underwear we have referred to—erotic proposition, the trousseau's role in symbolizing the internal workings of the female organism, and lingerie as an "intermediate body" serving transitory aesthetic canons—are by no means totally distinct; they necessarily overlap and intermingle, at times inextricably. Vocabulary itself is often the most sensitive indicator of these subtle shifts. With these three facets permanently in mind, we can now start to track our subject and seek to understand it in a new light. The following account attempts neither to resolve every inherent contradiction nor illuminate every corner of the mystery. That indeed is the whole charm and challenge of addressing such a subject.

Facing page: Silvana Mangano wearing a combination in *Bitter Rice*, a film by Giuseppe De Santis, in 1949.
Page 8: String bikini brief and full slip, 1994.
Page 11: Bra-corselet, Italian *Vogue*, 1988.

TROUSSEAU AND UNDERWEAR: INVENTORY AND INVENTION

"He told me he liked fine underwear," she said. "So I bought some. There!
Six pairs of drawers at twenty-five francs a throw. Just look at that lace—and
the ribbon! And do you know what, the dirty dog didn't even look at them!"

JULES RENARD, *Journal*, November 17, 1901

At the end of the nineteenth century, women began to wear tailored undergarments beneath their dresses—to wear underclothes, or *dessous* (a noun derived from the French for "beneath"). Until that time they had only worn underlinen and corsets. Does this represent a semantic shift or a real change in behavior? Perhaps the best hypothesis is that there was a transformation in both, though the discrepancies and lack of correlation between the collective imagination and the daily routine of any one individual were naturally legion. Documents of a private nature that might throw light on the situation are sparse, too. It is probable that *dessous* cropped up in a few places before that time: it dates back to the sixteenth century with the meaning, "a piece of clothing that is worn beneath another." The great nineteenth-century lexicographers Pierre Larousse and Émile Littré make no mention of it. Perhaps they departed this world a fraction too soon (the former in 1875, the latter in 1881), at the very moment when the word began to be bandied about, with its sulfurous reputation that the French words *lingerie* and *corseterie*—and still less *sous-vêtement* (undergarment), which didn't appear in dictionaries until 1907—never acquire.

With assonances of *frou-frou, trous-trous* (slits for ribbon), of *falbalas* (ruffles) and *tralalas* (trumpery), with the dual shiver of the illicit and of temptation, the success of the new term *dessous* betrays the extraordinary euphoria that gripped the world of women's underclothing at the time: a euphoria—as we will see—of words and pictures that affected men and women alike. The expression *linge du corps* (underlinen) is purely descriptive; like *linge de maison* (household linen) and *linge de table* (table linen) it forms part of the vocabulary of a woman's wedding-day, motherly and homespun, as part of those traditional mainstays of matrimonial agreement—the trousseau and its inventory. *Dessous* (with all the

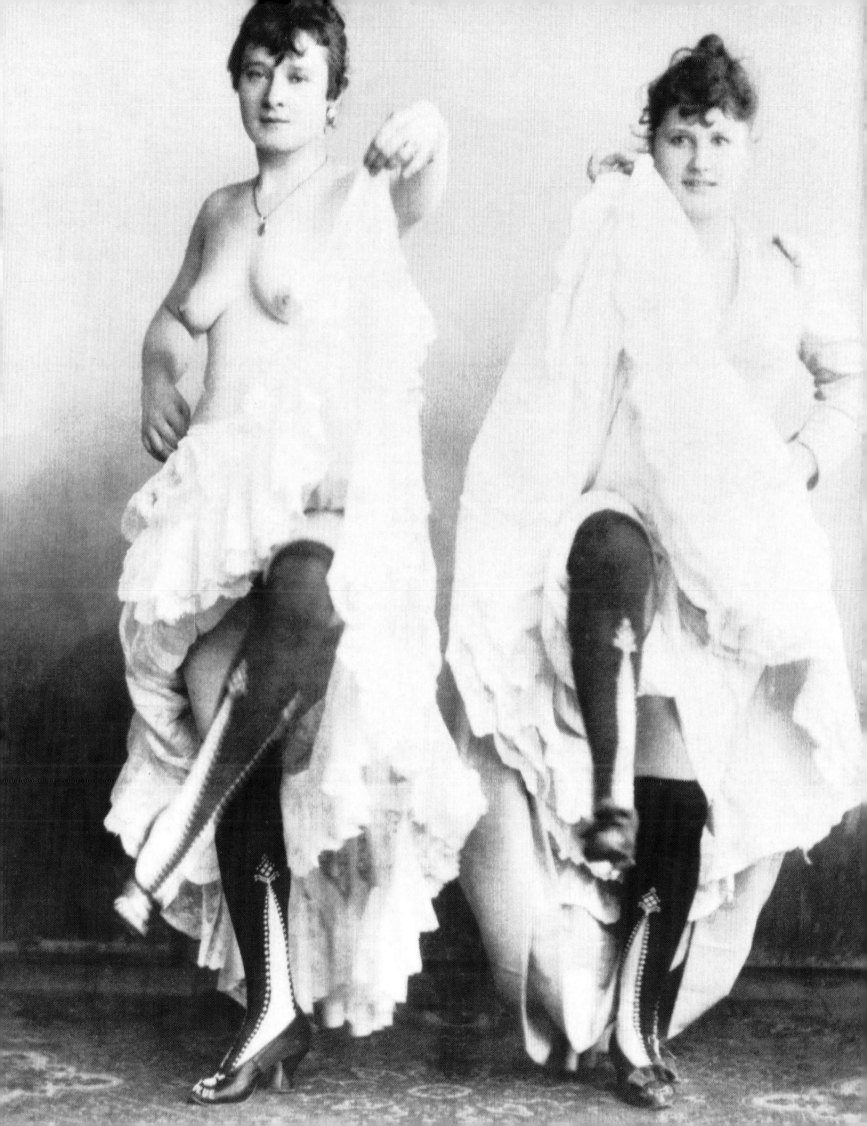

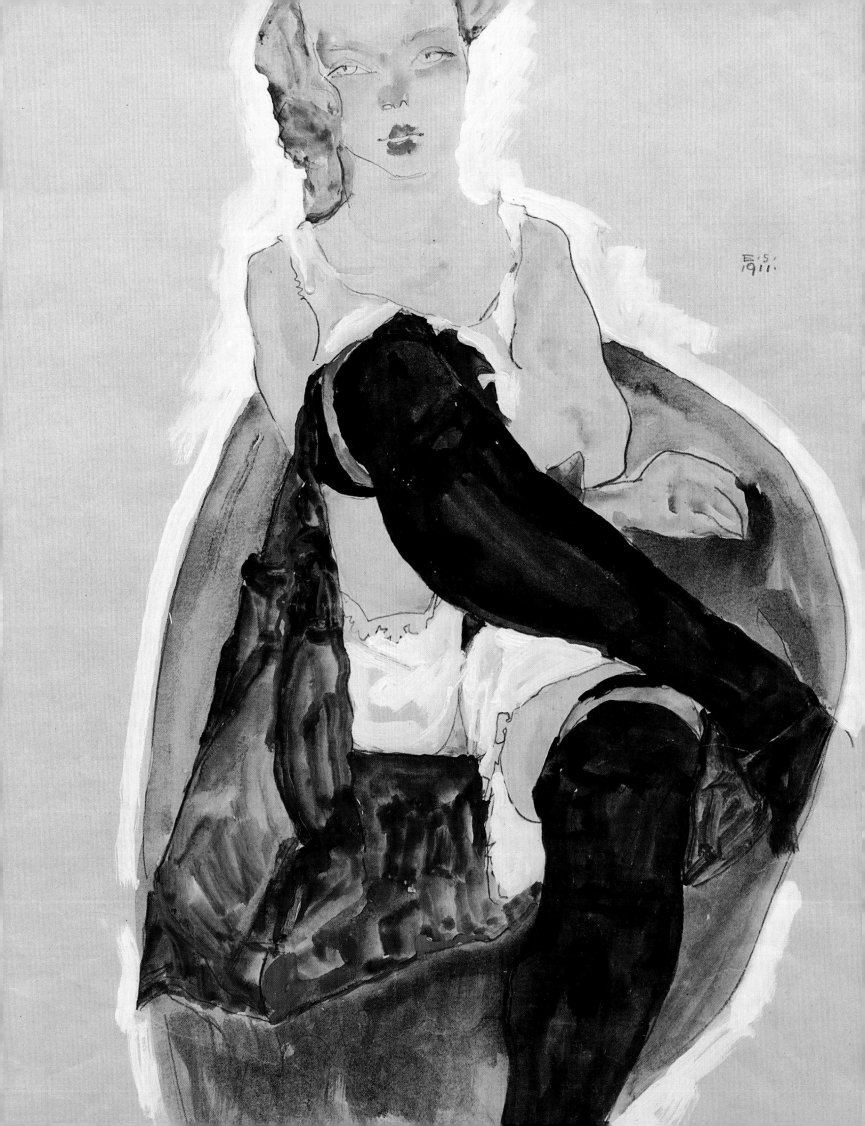

connotations of "beneath"), on the other hand, is suggestive, a sensual invitation to a mystery, to a secret, to some hidden truth, an encouragement to be inquisitive, to go and see, to have a look. It belongs rather to that *galant*, loose femininity that the shows, the photos, the fashion trade, and the press of the late nineteenth century were transforming into an industry fit for the erotic imagination. After the invention of *dessous*, lingerie was to attain the status of a fetishistic object for the giddy Belle Époque, with its liking for pleasure, for rubbing shoulders with the hoi-polloi, and, as the then-new expression of 1883 put it, *se rincer l'oeil*—for "ogling." If the trousseau prepares the ground for weddings and wives, then *dessous* goes with the fin-de-siècle *noce* (bash) and its partygoers. One is the precious casket of virginity, the other the shelter of prostitution.

A BRIEF HISTORY OF WOMEN'S DRAWERS

Ladies not wearing trousers are requested to
lift their legs no higher than the waist.
Poster for a Solferino ball in *Le Journal amusant*, August 11, 1866

Although underwear as such freed itself resoundingly from mere underlinen, its popularity was achieved only due to an enduring vogue for white goods in general, to the quiet but decisive victories of that "great century of linen," the nineteenth century.[1] In a hothouse atmosphere and in the wake of the textile revolution, a new aura of feminine intimacy dawned. As the dutiful servant of social policy and matrimonial machinations, lingerie was further promoted and became more popular by the twin nineteenth-century obsessions with cleanliness and prudery. By the middle of the century, amid all the lace frills and linen goods, the favorite stitch of all "young persons" for the intimacy of their undergarments[2] was for the application of hand- or machine-sewn Valenciennes lace. The preference is evidence of the dual yet ambivalent role nineteenth-century women had to play: a woman of leisure resembled a window dressing for her menfolk, forced simultaneously to observe decorum and vaunt her beauty and so unite modesty with adornment. Although condemned to a life sentence of frivolity and fashion, women nonetheless commanded a distinct sphere of knowledge and concealed a secret to which the trousseau itself testified. The growing importance of intimate and invisible apparel corresponds to a growing concern with the privacy of the feminine sphere. The nineteenth century is not only the great century of the intimate journal—the diary of the soul—but also of the trousseau—the diary of the body. It is the great century of fabric, of lace, embroidery, close stitch and openwork, of plying the needle and laying out the *whites*, of those ceremonies that made becoming a woman a ritualized yet individual experience.[3] Embroidering her initials on her immaculate linen (often using red-dyed thread), the young girl about to start her periods inscribes—as if on an unsullied sheet of paper—a crucial event in her life.[4]

The trousseau was an object of pride that redounded to its owner's prestige. Until around the 1870s or 1880s, it remained the custom for the bride-to-be to exhibit it shortly

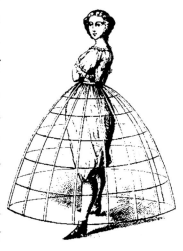

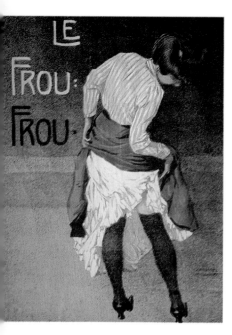

before the wedding together with the basket of presents from her fiancé. By the later years of the century, such a show of linen would be deemed shockingly indecent to good manners. By 1890, in a celebrated guide to etiquette, *Usages du monde*, Baronness Staffe wrote of her joy in having seen the end of the practice: "Such exhibitions of intimate linen were painful to behold for the husband-to-be and the modesty of more than one fiancée found them grossly offensive."[5] As the trousseau was gradually transformed into a secret garden devoted to the modesty of womanly privacy, underwear was increasingly being reworked into a forum for an exhibitionist and fantasist femininity.

The adoption of pantaloons, or drawers, marked the high point of the triumph of underlinen. For a long time, women had worn nothing at all beneath their petticoats or underskirts. Indeed, in the countryside, peasant women for a time continued to leave their genitals and buttocks unclad, a practice that in some regions endured into the mid-twentieth century. In the sixteenth century, Catherine de' Medici, following a lead from the courtesans of Venice, had launched a short-lived vogue for band-tied drawers. After a couple of centuries of obscurity, they appear to have resurfaced around 1730, not in the intimacy of some aristocratic or middle-class wardrobe, but as part of the costume of the dancers at the Paris Opera. Reports noted that the new garments had been deemed necessary by the receding hems of the girls' dance petticoats and skirts (ancestors both of the tutu), eventually being enforced as stage wear by order of the police. As the attribute of these notoriously loose females, women's drawers, before they could be taken up by the middle-classes, had first to shake off the curse of their scabrous beginnings. The Church put the situation in a nutshell: it is the man who wears the trousers, not the woman.

In late eighteenth-century France, pantaloons were initially worn beneath their Grecian-style transparent robes by the Directory's eccentric aesthetes, the *merveilleuses*. The nineteenth century saw them taken up by younger girls following the example of English schooling that prescribed plenty of exercise and games in the fresh air. On the swing and at the skipping rope, these almost ankle-length pantaloons soon became part and parcel of a little girl's wardrobe, emphasizing the distinction in dress between them and adult ladies. As women took up travel, horse riding, and ice skating, these undergarments gradually moved up the age scale, finally making an appearance in the trousseau of certain *comme il faut* young ladies,[6] and by the latter half of the century they were being worn by the majority of middle- and upper-class women. Fashion was now going in for crinolines, huge bell-shaped dresses with cages that left women at the mercy of the biting wind and open to the indiscretion of a draft or a fall, incidents that provided the press of the time with a rich vein for satirical sketches. Between the crinoline and women's drawers, middle-class prudery erected a barrier of primness defended by euphemism. If the term "drawers"—or in France *culottes*—seemed rather low, even racy, so the reign of Louis-Philippe saw *tuyaux de modestie* (modesty tubes), the British wore "smallclothes" and "divided skirts," and the Second Empire had *indispensables* and even *inexpressibles*—exact parallels for the Victorian "unmentionables" and "indescribables."

A long *chemise* (as shifts were increasingly called) was stuffed into these drawers; then

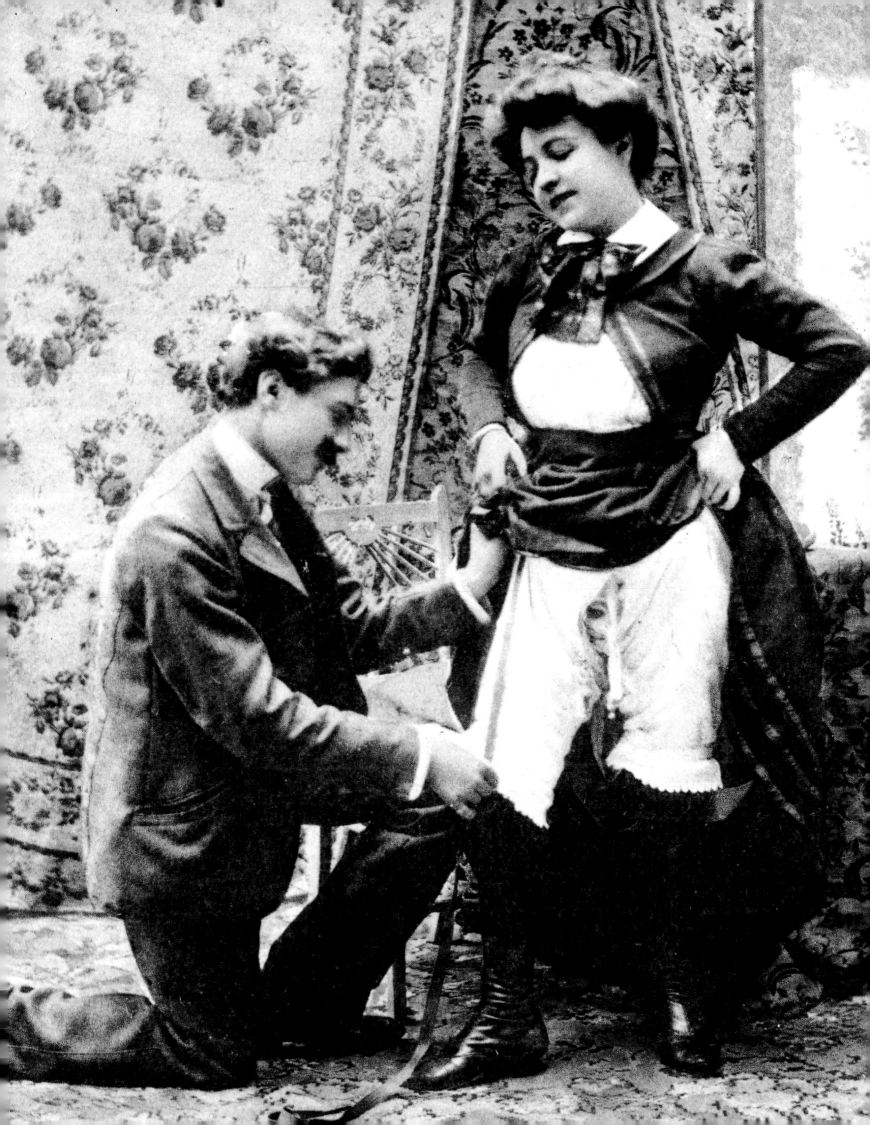

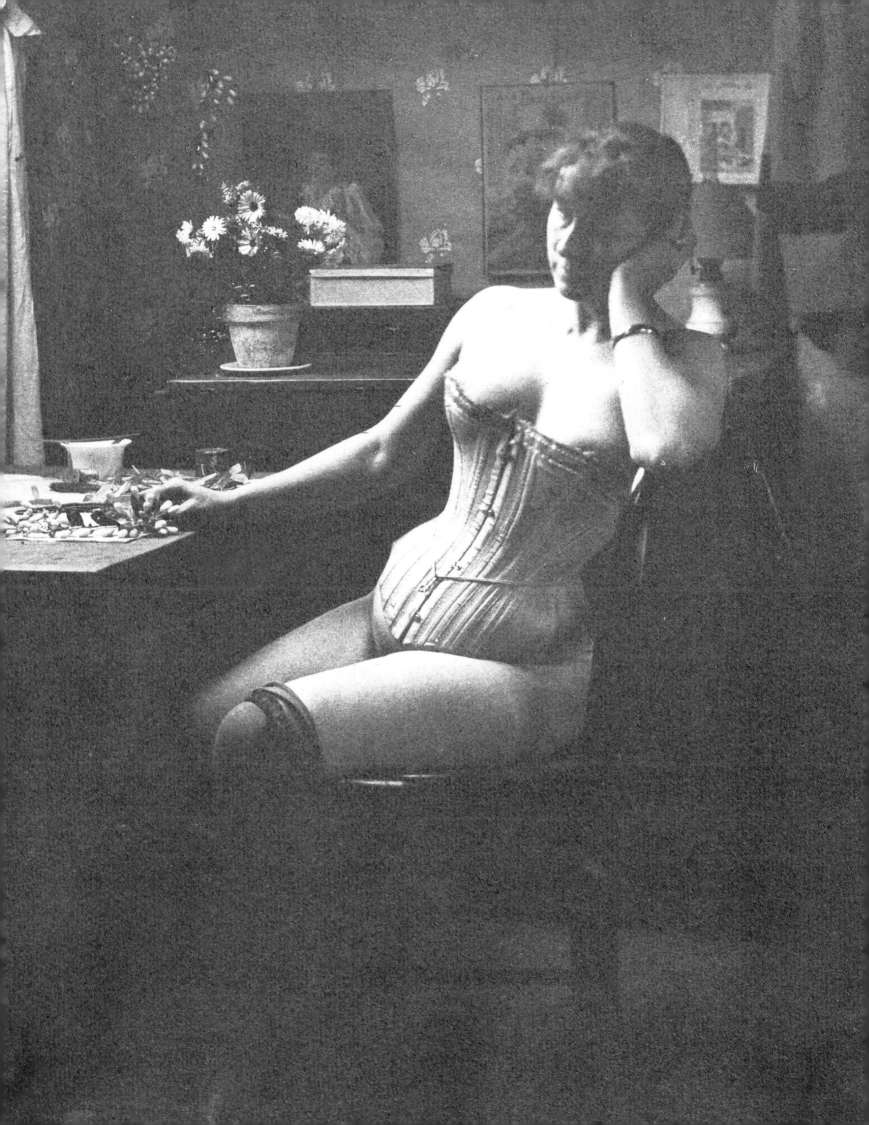

came a corset, one or even two underskirts, a corset cover (or camisole), and stockings held up just above the knee by band garters (and later by suspender garters). Such, around 1880, were the garments providing the never-to-be-seen armor of a woman—a protective ring of whalebone, lawn, madapolam cotton (a soft, bleached muslin), lace, and occasionally silk. In the midst of this labyrinth nestled the focus of fin-de-siècle male fantasies—the crotch vent. The classic difference in form between the clothes of the sexes ensures that female garments remain open and male closed: the drawers of the period initially conformed to this difference in gender and were not sewn at the crotch but left open, the slit often wide enough to let the flapping front of the shift peep through. As the female body concealed itself, fleeing and almost disappearing beneath these new-found modest wrappings, so the thorny subject had to be grasped: *should* women's drawers be open or closed?

INTIMACY ABLAZE

The culmination of her day is not the moment
when she gets dressed to go into society, but when she undresses for a man.
Marcel Proust, *Du côté de chez Swann*, 1913

The burning question of whether drawers should be open or closed reached boiling point when it concerned the high-kicking legs of the sensual or obscene line dancers of the *chahut*, the *can-can*, and the almost naked *quadrille naturaliste*. Along the dance circuit near the old Paris tollgates, from the Élysée-Montmartre to the Moulin-Rouge, show girls were all raising their legs and expertly doing the splits—"right up to their honor," as the Goncourt brothers put it in a 1864 diary entry.[7] In the wake of the dancing show girls, the turn-of-the-century's pornographic obsessions and visually attuned literature became fixated with the opening in women's drawers. A zealous advocate of Montmartre's buzzing nightlife, a satirical weekly

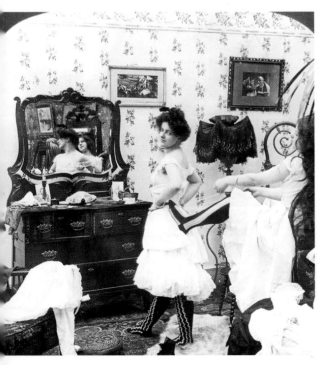

Below:
An oft-repeated theme in early portrayals of underwear, especially in eighteenth- and nineteenth-century caricature: lacing the corset.
Facing page:
Édouard Manet's *Nana*, 1877. The diminutive Venuses appearing in the scurrilous pictures cluttering the stalls of traders in smutty material were, nonetheless, distant cousins of the dancers, washerwomen, and laundresses portrayed in the work of Degas and Manet.

called *Le Courrier français*, describes the male audience as it gazed entranced at La Goulue's flying petticoats with "thieving eyes ever on the lookout for the crack in her embroidered drawers, longed for, yet always out of reach. Depending on the figure of the quadrille she dances, she sticks out her belly or swings her hips seductively: thrown nimbly into the air, the ruffles expose a pair of spread-eagled legs through a froth of pleats and undergarments—in a sudden tumble of Valenciennes lace—and a tiny corner of real, naked flesh protrudes just above the garter. And, from this piece of vermilion flesh, there gushes over the breathless audience a red-hot torrent of molten steel. Then, in a mock gesture of delight, the smutty bacchante of the gutter hoists her skirts up to her belly and offers to the delectation of the group that shuffles forward a sight of her curves—curves so inadequately clad by a see-through gore of lace that at one moment a dark patch reveals her most intimate bud."[8]

Open or closed drawers? "For unmarried ladies" closed; "for married ladies" open, Armand Silvestre assures us, much amused by this "dispute"

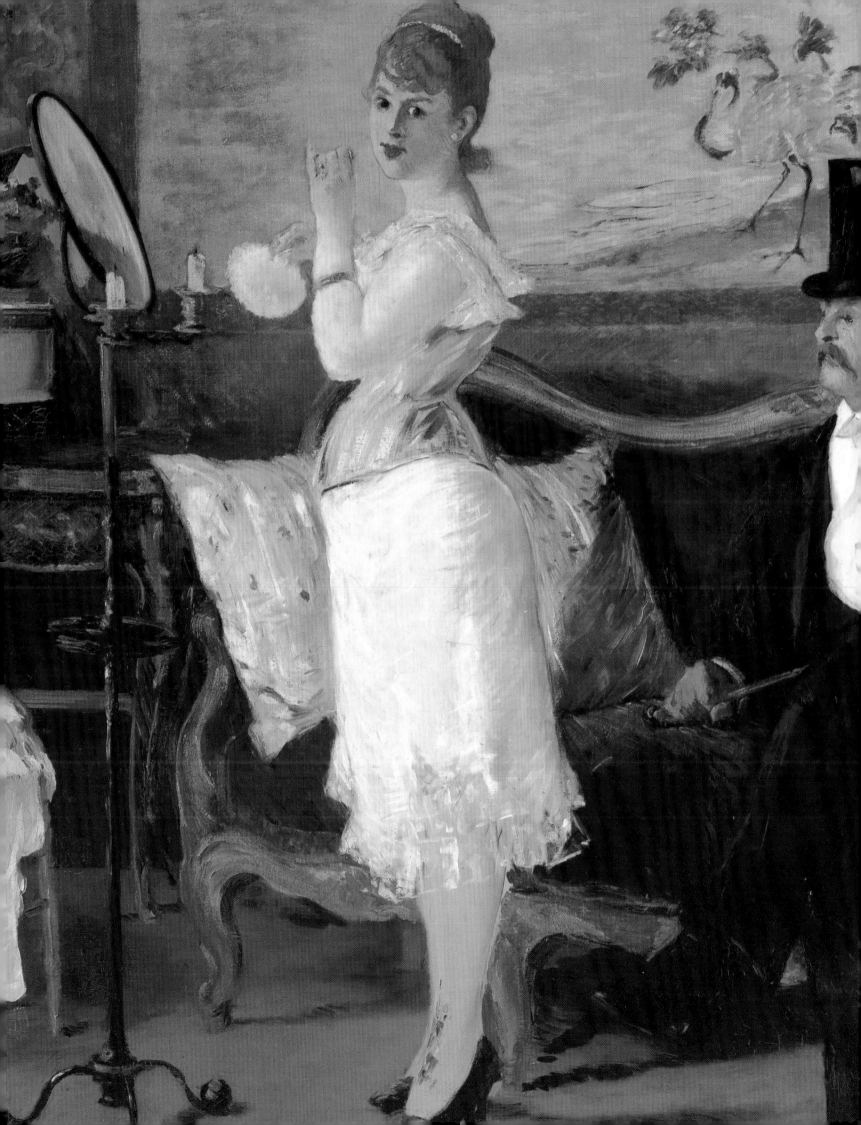

5299.

Volant pour jupon, fond tulle grec noir ou ivoire, rubans noirs, ivoires ou nuances claires, double volant.

Largeur 2m, hauteur 0m,37.

Occasion exceptionnelle.

Prix

2.10

Volant pour jupon, tulle grec fond noir ou ivoire, rubans noirs, ivoires ou nuances claires, double volant. Largeur 2m, hauteur 0m,40.

5210.

Prix **3.75**

Volant pour jupon, tissu lavable, fond blanc, rayures en noir, rouge, marine, ciel, rose, mauve. Largeur 2m, hauteur 0m,36.

5243.

Prix **2.75**

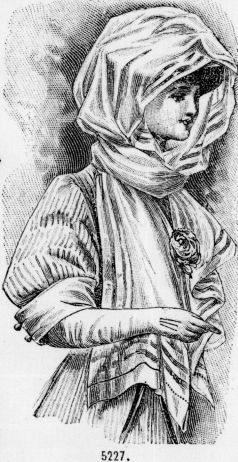

5211.

Volant pour jupon, taffetas belle qualité, plis piqués et gansés. Largeur 2m, hauteur 0m,40.

Noir **7.90**

Nuances claires **8.75**

5220.

Volant pour jupon, moire pékin, noir et blanc, plis piqués et gansés. Largeur 2m, hauteur 0m,40.

Prix **4.50**

5227.

Voile-Écharpe

pour voyage et auto, mousseline soie belle qualité, 3 rayures satin, grand choix de nuances.

Longueur 2m,40, largeur 0m,60.

6.50

enjoined by the "learned doctors of love," and "which sees no sign of abating."[9] In a treatise on pregnancy, a Dr. Olivier advises against open-legged drawers as they "let in the air and the numerous microbes it harbors."[10] By the outbreak of the First World War, this raging debate, which a complex network of fantasy, morality, fashion, hygiene, and medical knowledge had conspired to render inextricable, finally awarded the palm to closed drawers.[11]

The fate of split and sewn pantaloons is a metaphor for the accessibility or inaccessibilty of female genitalia. Around the shameful split, women's undergarments were emblazoned in countless new ways. The haberdashery trimmings that adorned them, making them sparkle or bloom, became ever more plentiful; their very profusion transformed the private space of woman into a teeming, pulsating, humming froth of flounces, frills, baby ribbon, gores, piqué rosebuds, and silk binding threaded in and out of its slots. In 1902, Pierre Dufay summarized the logic behind this proliferation of all things frilly: today's drawers, he wrote, "are a gaping hole trimmed with lace."[12] To a certain extent this logic could be said to mirror that of lace itself, since lace making is an art based on openings, on patterns sewn round a void. Openwork, stitches, pillow lace, embroidery, Chantilly and Valenciennes lace are all brought into play to excite desire, to defer pleasure. Lace even invaded outer garments, and a vast catalog of techniques and decorative patternwork was born from which outerwear could usefully draw inspiration.[13] The press, the fledging science of advertising, and the huge displays in the new department stores reflected and exacerbated this new vogue. New developments seemed to urge women to introduce into the dutiful intimacy of the conjugal bedroom the titillating wiles of the kept woman or dancing girl. "Nothing is as opulently seductive as female underwear [*dessous*]," wrote Baronness d'Orchamps in *Tous les secrets de la femme*. "We [women] can turn to our own account the giddiness into which the male brain is unfailingly thrown when faced with these ever-inventive vaporous and fluffy veils; they increase the mysterious power of temptation exercised by delights yearned for all the more as [we] feign to protect and withdraw them."[14]

If exhibiting the bride-to-be's trousseau had become indecent, the gap was being quickly filled by those temples to modern consumerism the department stores, which now opened underwear counters in an eager quest for new customers. This switch in focus from a private to a public arena is in keeping with developments in the popular imagination. In the poetical language of his novel *Au Bonheur des dames* (*Ladies' Delight*, 1883), Émile Zola penned an eulogy to the century's *textile neurosis*: "Every variety of women's linen, all white things which are hidden underneath, was displayed in a succession of rooms divided into different departments. A scene of wanton undress garments… on one side fine linen goods…. On the other were camisoles, little bodices…. And the clothes underneath were appearing, being shed one after the other; there were white petticoats… knickers of cambric… chemises…. The display in the trousseau department was lavish and indiscreet, it was woman—from the lower-middle-class woman in plain

Below:
Purchasing the household linen, about 1890. Initially confined to keeping just city women provided with ready-made unerlinen and household linen, industry and trade were increasingly able to supply their sisters in the country, too. They thus fostered a steady decline in the practice of the trousseau (initiation, apprenticeship, the handing down of traditions, needle embroidery, and so on) that gathered pace in the twentieth century.
Facing page:
Page from a *Printemps* catalog, 1900.

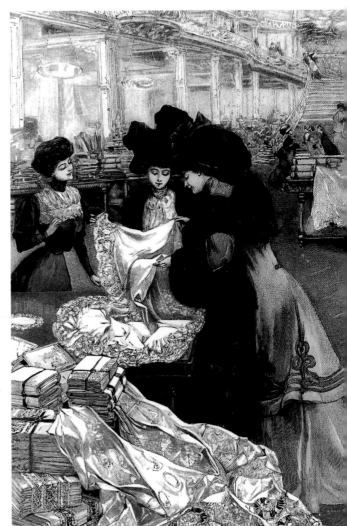

linen to the rich lady smothered in lace—turned inside out and seen from below, a bedchamber exposed to public view, and its hidden luxury, its tucks and embroideries and Valenciennes lace became more… a sensual debauch."[15]

"Velvet of the hips," "fine silk of the thighs," "shining satin of the breasts," Zola continues in the same vein.[16] As the cult of undergarments was whipped into a paroxysm, turning skin into a material and cloth into skin, an erotic shudder rippled beneath the surface of all displays of fin-de-siècle textiles. It is this that quickened the hands of the handkerchief "collector," of the lover of white goods (great displays of linen were all the rage in the department stores of the time), of even the shoplifter at work over at the underwear counter. Police records report that the number of fetishistic delinquents was on the rise, while the fledging science of sexology began to classify them by type of sexual perversion. In his *Psychopathia Sexualis* of 1886, Krafft-Ebing cites the example of K., a cobbler of forty-five, at whose house were found "three hundred items of female attire, including chemises, pantaloons, women's nightcaps, garters, and even a doll."[17] In 1908, Dr. Gaëtan Gatian de Clérambault published a treatise on the eroticized desire for fabrics among his female patients. Among the case studies was that of a woman arrested in 1902 for stealing two silk bodices from a display in a department store. She describes the "pleasure" she experienced touching the fabric as it "rustled." "It excites you, you feel wet.… But the climax is stronger when I've stolen.… Silk attracts me, in ribbons, in skirts, in bodices. When I hear a silk dress rustle, I feel a tingling under my fingernails, and then it's useless to resist—I just have to have it."[18]

All at once, women's underwear was being promoted into material suitable for trade publications, literary descriptions, tongue-in-cheek or erudite studies, and learned medical treatises. The enthusiasm it elicited in the written word was not, however, the end of the matter: the new inventiveness also resulted from visual pleasure, and male voyeurism becoming more diverse, more intense, more mechanical. At dance halls, young men "don't dance any more, they watch. The youth, from actor on the stage, has become spectator," a journalist noted in *Le Figaro illustré* in 1894.[19] This was the year in which Blanche Cavelli presented at the "Concert Lisbonne" a pantomime called *Yvette Goes to Bed*, heralded in the annals of risqué stage shows as a forerunner of the modern striptease.[20] Following Cavelli's lead, shows with titles like *The Parisian Lady's Toilette*, *The Bride Retires*, and *A Little Seamstress Disrobes* appeared on the Paris stage. Theaters such as Les Folies-Bergères, Le Bataclan, and Les Folies-Pigalle were awash with titillating performances in this scantily clad genre, each with similar plot lines and licentious scenes, like so many 'Stations' of passionate desire."[21]

In 1906, for example, one could have subscribed to a biweekly journal called *Le Déshabillé au stéréoscope*, and received hermetically sealed bundles of nine color-tinted views of bare-breasted women posing in chemises and pink stockings. These are the "professionals of the photosensitive plate and the picture-postcard."[22] The breviary of this frolicsome Belle Époque underworld comprises hundreds of hackneyed scenes showing some capricious *élégante* in her boudoir with a dewy-eyed lover, a professional beauty *en déshabillé* at her dressing table, or a come-hither workinggirl in corset and drawers bouncing on the leg of some good-time Charley.

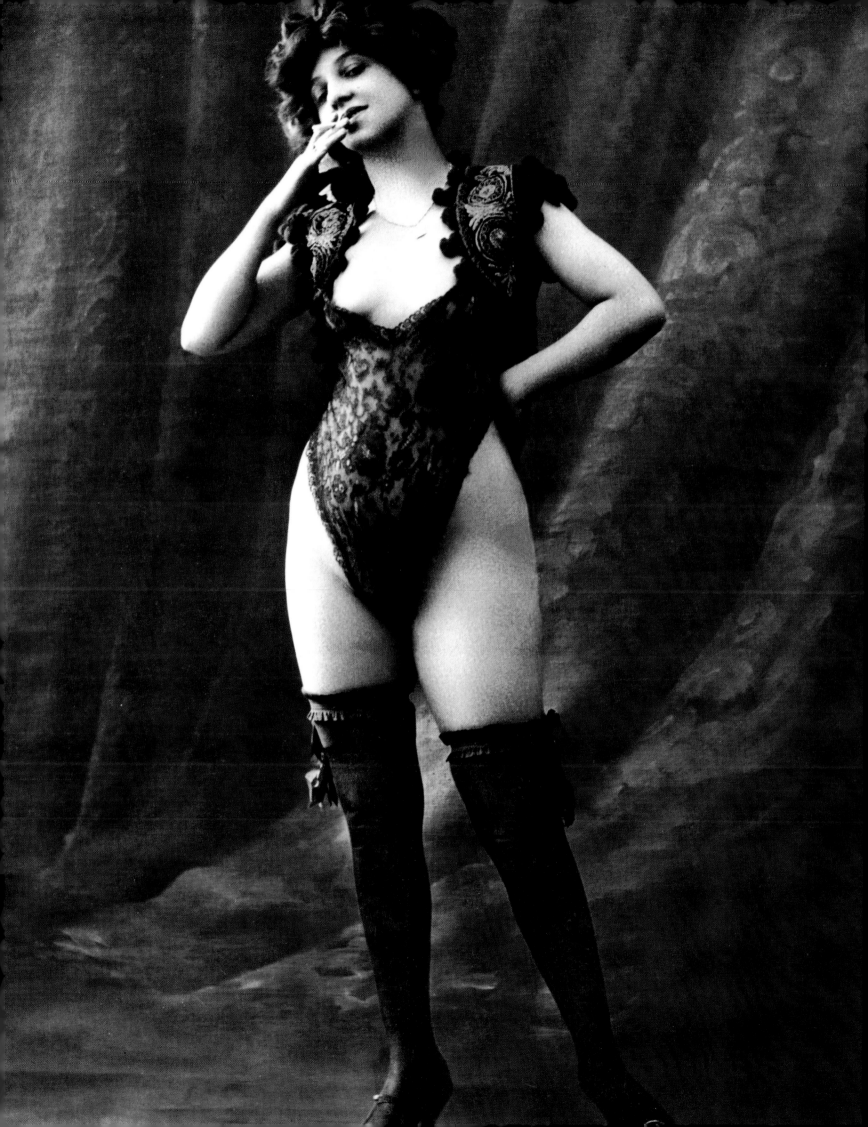

THE HEALTHY BODY VERSUS THE CORSET

The corsets and bustles occupied one counter: there were stitched corsets,
long-waisted corsets, armor-like corsets, and above all white silk corsets,
with colored fan-stitching on them, of which a special display had been arranged that day;
there was an army of dummies without heads or legs, nothing but torsos lined up,
their dolls breasts flattened beneath the silk, having the disconcerting lewdness of the disabled.

ÉMILE ZOLA, *Ladies' Delight*, 1883

"Armor, shields, chokers, girdles, beribboned flounces, stays, shoulder pieces, greaves, gauntlets, corsets, lengths of pearl, escutcheons of plume, satin, velvet and gemstone cross-sashes, chain mail...." So Jean Cocteau recalled two of the most famous *demi-mondaines* of the 1900s, Otero and Cavalieri, leaving the Bois de Boulogne. Thus clad, these "riders bristling with tulle, with sunbursts and eyelashes, these sacred scarabs armed with asparagus tongs, these mink and ermine *samurai*, cuirassiers of pleasure"[1] were only the most extreme armor-plated Belle Époque specimens of desirable womanhood. At the heart of this siege mentality stood the *corset*, for the years of frenzy for underclothes were also years during which the arts of corsetry reigned supreme.

MODELING AND ENHANCING THE FEMALE FIGURE

From about 1810, after the disappearance of classical-style robes of the Directory with their below-the-bust waistlines, the corset gradually recovered its lost ground, returning with laces and whalebone, as well as the wood or iron busk sewn into a gusset to stiffen the front and provide support to the wearer. By this time, however, its function had shifted. In the eighteenth century, corsetieres had designed a conical sheath, an instrument for instilling deportment and maintaining the posture, body trainer and tutor all in one. In the following century, that corrective mission was taken up instead by medical staymakers. Compared with the period before the Revolution, fewer and fewer children were expected to wear a corset. The new stays were no longer required primarily to support or straighten, but to model and enhance the female figure (waist, bust, and rump) in accordance with the aesthetic and erotic canons of

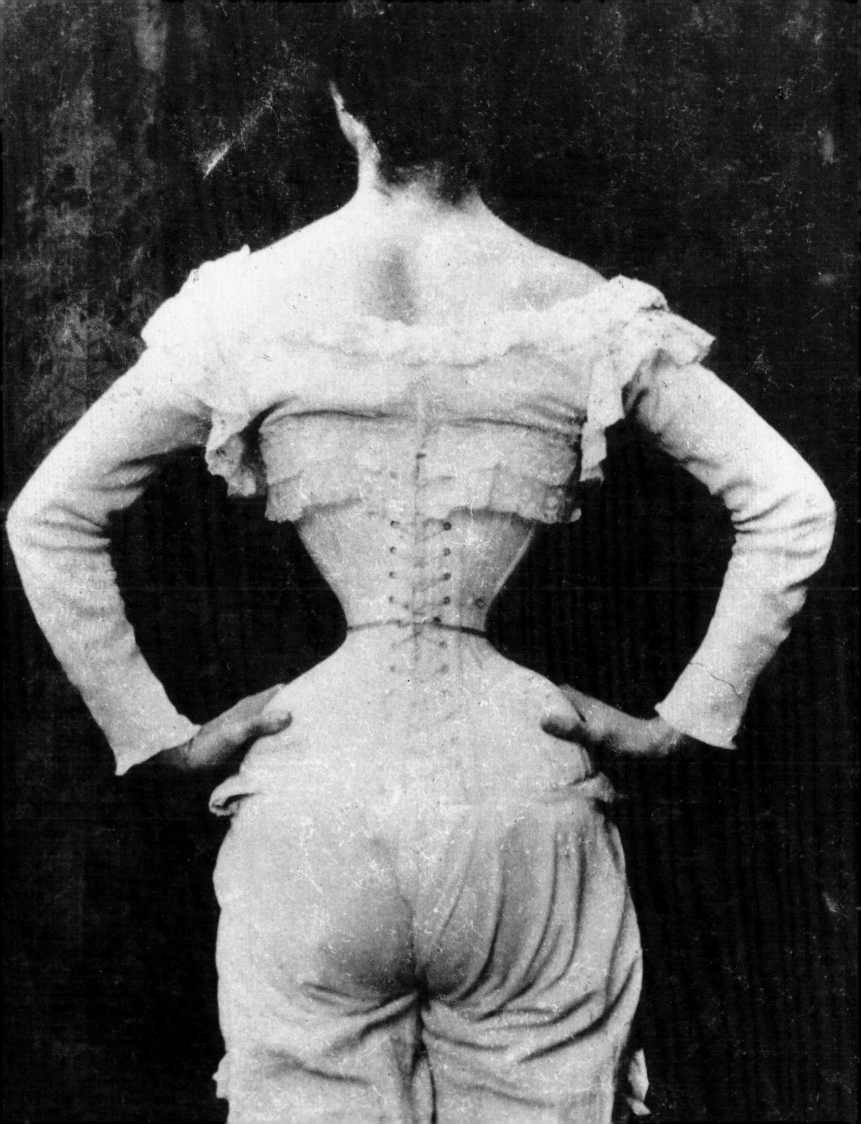

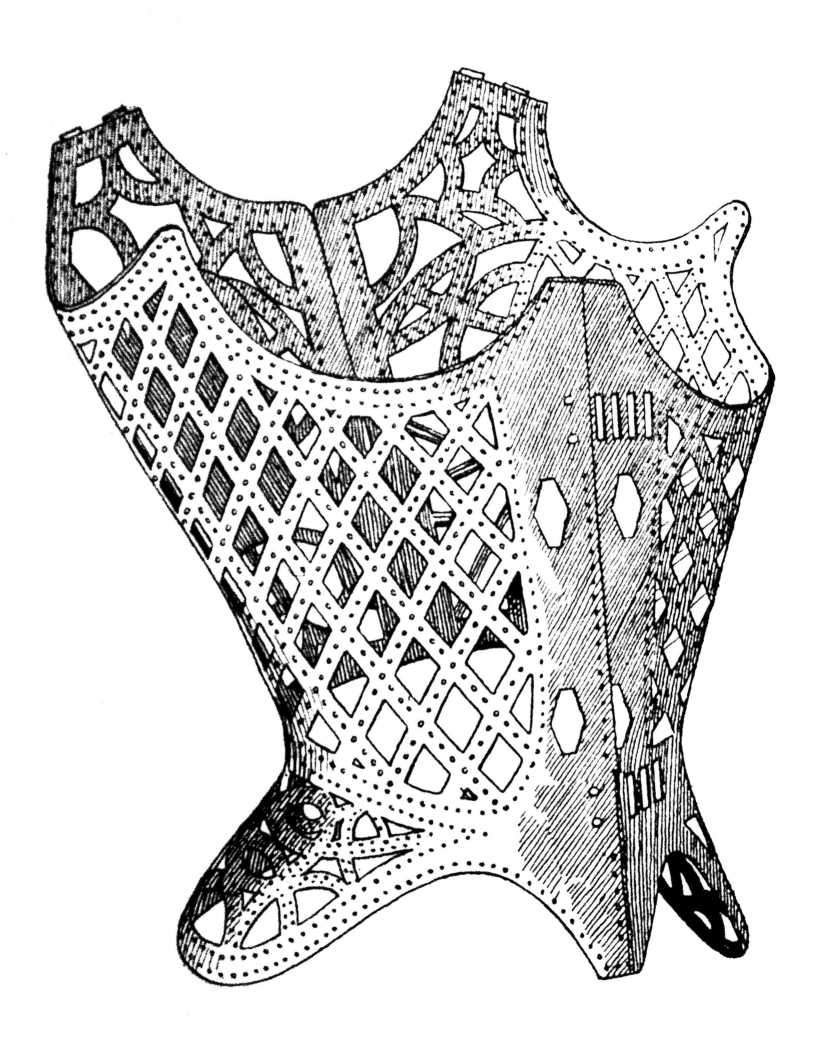

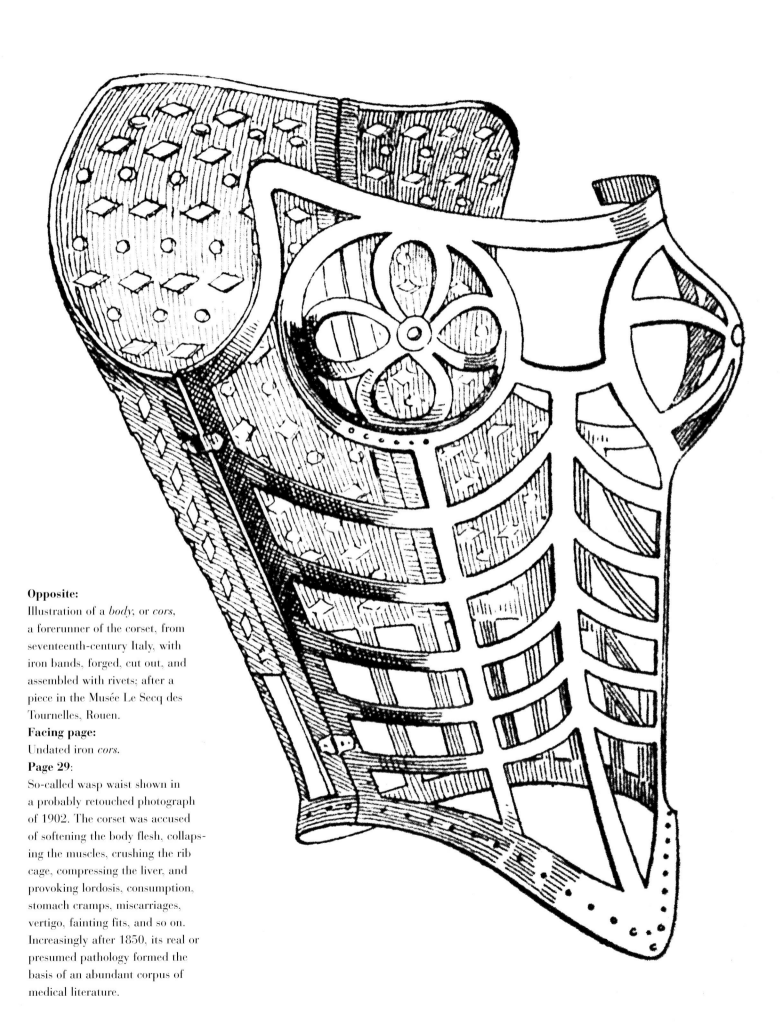

Opposite:
Illustration of a *body*, or *cors*, a forerunner of the corset, from seventeenth-century Italy, with iron bands, forged, cut out, and assembled with rivets; after a piece in the Musée Le Secq des Tournelles, Rouen.
Facing page:
Undated iron *cors*.
Page 29:
So-called wasp waist shown in a probably retouched photograph of 1902. The corset was accused of softening the body flesh, collapsing the muscles, crushing the rib cage, compressing the liver, and provoking lordosis, consumption, stomach cramps, miscarriages, vertigo, fainting fits, and so on. Increasingly after 1850, its real or presumed pathology formed the basis of an abundant corpus of medical literature.

the time.[2] A tireless servant of fashion, the corset formed a framework for the female silhouette and its ever-changing contours: from the hourglass corset of Second Empire crinolines to the cuirass bodice for the lithe beauties of the late 1870s (all long waist and hips); from corsets for the "swan women" of 1885 complete with hollow back and *strapotin* bustle (a "dress improver" named after the tip-up opera seats they resembled), to the more sinuous "S-shaped" 1900s styles and the 1910 "tube" for elegant women inspired by the Empire line.

Such corsets form part of a make-believe orthopedics of fashion, a kind of *orthogyny* (literally, correction of woman) to the glory of a wholly artificial female, cultivated like some hothouse plant for a century of bachelors (such as Balzac, Flaubert, and Baudelaire) who could only glare at natural womanhood in disgust. By modeling her silhouette or by giving her a wasp waist, the corset also boosted a young girl's chances on the marriage market. In a 1852 drawing by Frédéric Bouchot, a mother is seen instructing her daughter's seamstress to "pull as tight as possible," for, she explains, "we have our eye at present on a new prospective husband who... prefers the slimmest of figures."[3] "Poor children!" exclaimed Dr. Debay in 1857. "And your benighted mothers torture you like this just to render you more attractive...."[4] Use of the corset became increasingly routine, with the tailoring industry offering to the woman of the lower orders and to the farmer's wife coarse cotton twill versions of what had previously epitomized the gilded idleness of the *aristocrate* and *bourgeoise*. Increasing numbers of models could now be ordered by catalog: wedding corsets; traveling, morning, night, riding, dancing, and summer corsets; or special designs in which a lady might bathe or perform in a song of an evening. On department-store shelves, the constricting instrument had become a fashion accessory that excited customers' covetousness.

The voluntary torture of women of the era provided ample ammunition for satirists and caricaturists alike. They had great play at the expense of the shapeless *coquette*, emerging of a morning as a mere sack of bones in her nightdress, who, by evening, appears as a full-buttocked and great-breasted beauty thanks to the inflationary powers of a corset and a *cul de Paris* (literally, "Parisian backside," resembling the bumroll of old), or even, in 1867, *poitrines adhérentes* (adhesive breasts), ancestors of the "falsies" to come.[5]

Another pet target for caricature was the ceremony of unlacing the corset: the bemused efforts of the dull husband who found himself in the evening undoing a bow in his wife's stays when he was *sure* he had tied a knot that very morning or else a prostitute scoffing at the clumsy struggles of an inexperienced customer all fingers and thumbs, as in a drawing by Gavarni (about 1845–50): "'So, love, do you like oysters?' 'Oh yes, but I prefer women.' 'But do you know how to open them?!!!'"[6] From the 1830s, when the busk was split into two halves that fastened with hooks and eyes, then, from the 1840s, with the introduction of an easy-lacing corset *à la paresseuse*, it became possible for a woman to put on or take off a corset unaided. The sexual symbolism of a man unlacing a woman's stays—a metaphor for her deflowering—was such that it conserved much of its erotic potency even when it had been replaced by the less highly charged act of unfastening. "Like some great lover, I would

Nr. 38 und 39.
Korfett in
moderner,
bequemer
Form. Schnitt: Schnittmuster-
bogen Nr. XIV, Fig. 89—94.
Bezugsquelle: G. Neumann,
Berlin, nur Leipziger-
strasse 84, keine Filialen.

Above:
German advertisement
for a ribbed corset,
1910.
Facing page:
Window display in a
store dealing in corsets,
Boulevard de Strasbourg,
Paris, about 1900.
Page 35:
The ceremony of unlacing
the stays. Illustration by F.
V. Reznicok, 1980.

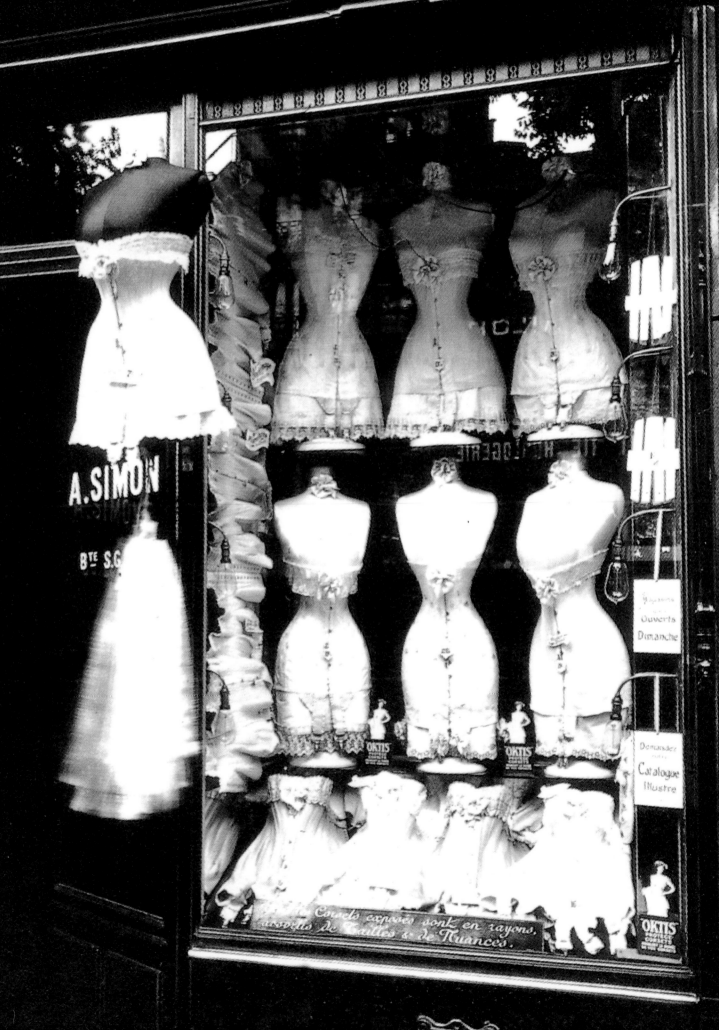

The sexual symbolism of a man unlacing a woman's corset—a metaphor for her deflowering—was such that it kept much of its erotic potency even when it had been replaced by the less highly charged act of unfastening.

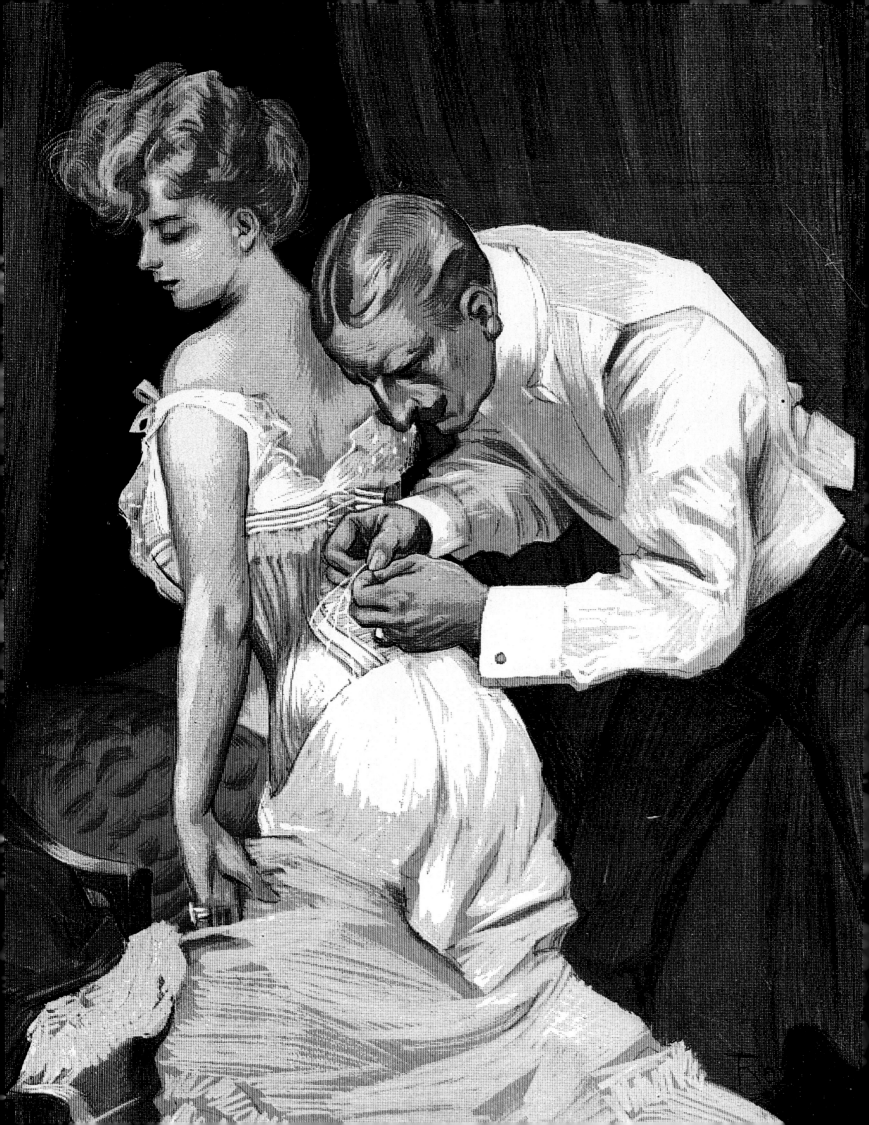

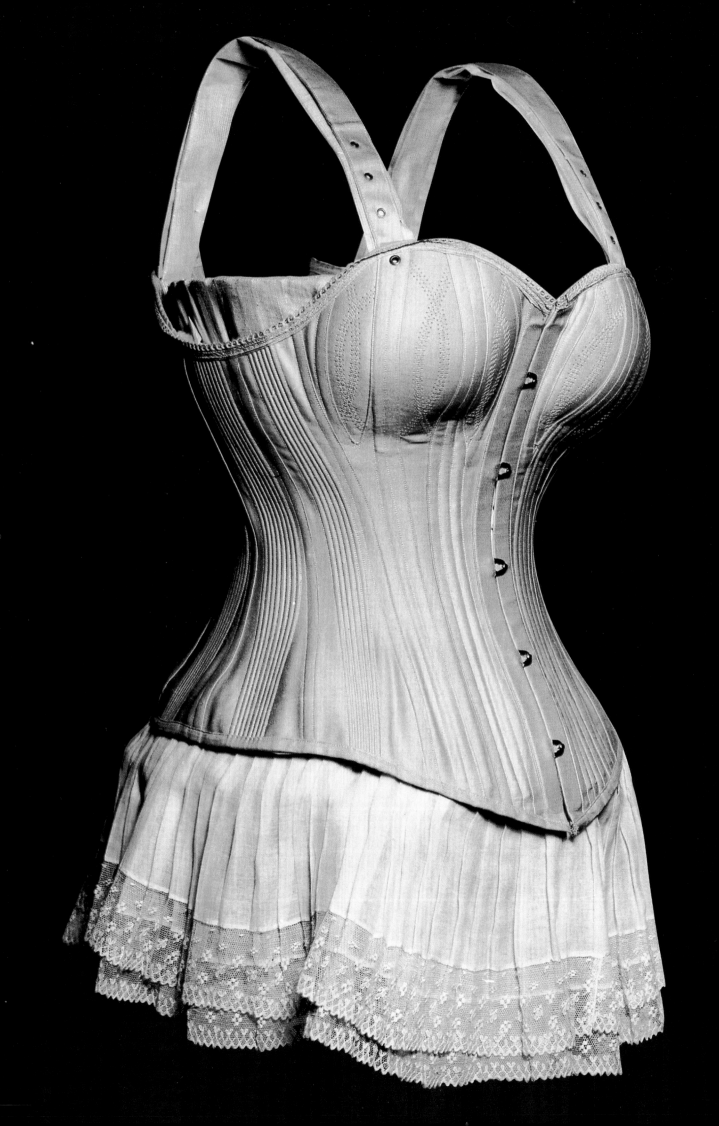

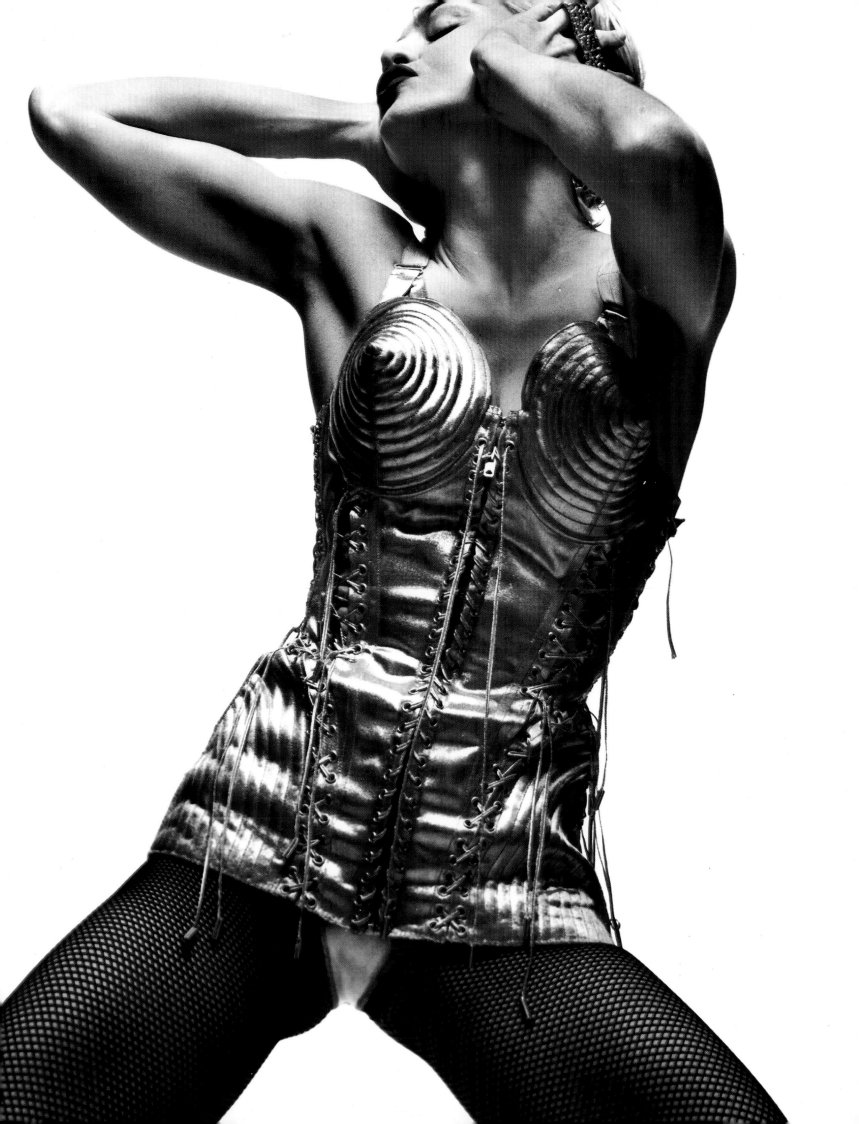

have liked to tear through the buttonholes and rip off her underclothes, but, fearing she might make some untoward remark, I controlled myself," the hero of a novel by Emmanuel Bove confessed in 1924. "Soon she was in her corset. The busks were twisted. It laced across the back. Her breasts touched. I unfastened the corset, trembling."[7]

LIBERATING THE BUST

And then there's how they dress—too comfortable, too short, too light-colored.
I long wondered what it was that threw me the most: then I noticed that they dressed
without a corset so that everything they wear looks as though it's coming loose.
And with that, come cycling, masculine ways, and a nose in the air.

HENRI ALAIN-FOURNIER, Letter to Jacques Rivière, July 1905


Below:
The four corsets for *bourgeois* living in 1840. "Splendid! I took four sizes, corresponding to the women in my life. Fifine, number one! Then Cocotte—that tart Cocotte! Then big Mimi, and my wife, up there in the corner." Daumier, *Chez Bauger, Rue du Croissant, 16.*
Facing page:
Page from a catalog for the department store Grands Magasins de la Samaritaine, around 1905.
Preceding pages:
Left, medical corset, 1890. *Right*, Madonna wearing a corset created by Jean-Paul Gaultier for her Blonde Ambition World Tour, in 1990.


The boyish "flapper" of the Roaring Twenties, hemline high and hair cut short, was to be a corsetless woman. The role of the First World War in transforming the female figure and thereby symbolizing a shift in collective attitude and conditions is a theme that has been rehearsed before. Leaving the home to do the men's work that soldiers at the front line had had to abandon, the story goes, women were to loosen the shackles of feminine apparel and not return to them even after hostilities had ceased. It is now understood that a slow metamorphosis was already well under way before August 1914. Around 1904 or 1905, the feminine line was beginning to lengthen, becoming slimmer and breaking away from the requirements for clearly separated body volumes in an aesthetic climate that fostered more elastic forms. The high priestesses of this movement were modernist dancers such as Loïe Fuller, with her vast, undulating, winglike veils; Ruth St. Denis, whose feminist mother had taught her to throw off the corset, and even Isadora Duncan, long-time disciple of the libertarian Rousseau and reader of his *Émile*.[8]

"Everything that hinders and constrains nature is in bad taste. This is as true of the adornments of the body as it is of the ornaments of the mind. Life, health, reason, and well-being ought to go ahead of everything."[9] In 1762, following a famous passage in his treatise on education that condemns the swaddling of children, Rousseau goes on to lambast "the use of these whalebone corsets" by which women "counterfeit their waists rather than display them." "It is not attractive to see a woman cut in half like a wasp," he continues. "That is shocking to the sight, and it makes the imagination suffer. The narrowness of the waist has, like everything else, its proportions, its limit, beyond which it is certainly defect. This defect would even be an assault on the eye when seen naked. Why should it be a beautiful thing under clothing? I dare not pursue the

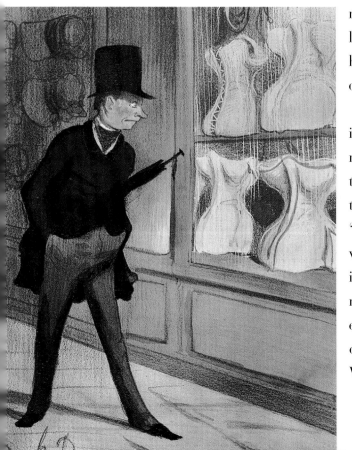

CORSETS LINGERIE FINE

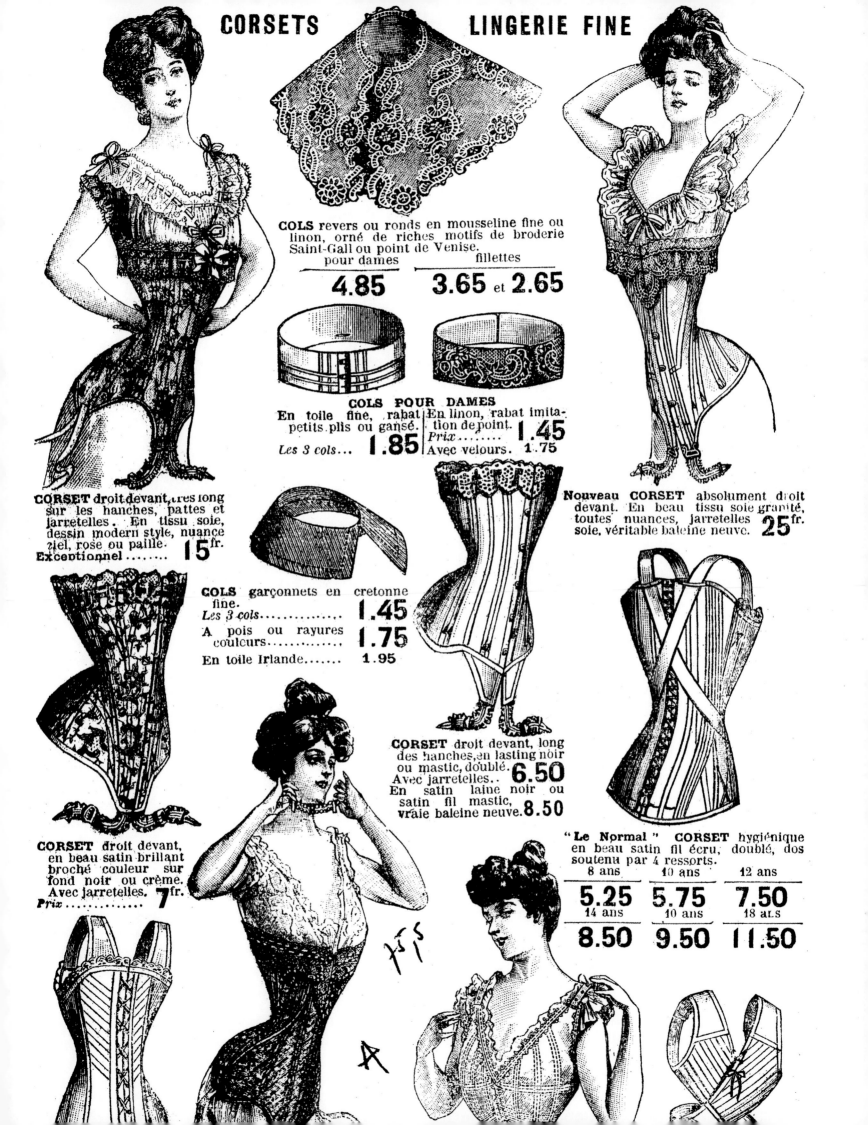

COLS revers ou ronds en mousseline fine ou linon, orné de riches motifs de broderie Saint-Gall ou point de Venise.

pour dames	fillettes
4.85	**3.65** et **2.65**

COLS POUR DAMES

En toile fine, rabat petits plis ou gansé.
Les 3 cols... **1.85**

En linon, rabat imitation de point.
Prix........ **1.45**
Avec velours. **1.75**

COLS garçonnets en cretonne fine.
Les 3 cols............. **1.45**
A pois ou rayures couleurs............. **1.75**
En toile Irlande....... **1.95**

CORSET droit devant, tres long sur les hanches, pattes et jarretelles. En tissu soie, dessin modern style, nuance ciel, rose ou paille. Exceptionnel........ **15**fr.

CORSET droit devant, long des hanches, en lasting noir ou mastic, doublé. Avec jarretelles.. **6.50**
En satin laine noir ou satin fil mastic, vraie baleine neuve. **8.50**

Nouveau **CORSET** absolument droit devant. En beau tissu soie granité, toutes nuances, jarretelles soie, véritable baleine neuve. **25**fr.

CORSET droit devant, en beau satin brillant broché couleur sur fond noir ou crème. Avec jarretelles. **7**fr.
Prix.............

"Le Normal" CORSET hygiénique en beau satin fil écru, doublé, dos soutenu par 4 ressorts.

8 ans	10 ans	12 ans
5.25	**5.75**	**7.50**
14 ans	16 ans	18 ans
8.50	**9.50**	**11.50**

reasons why women are obstinate about thus putting themselves in armor: a drooping bosom, a fat stomach, etc. This is most displeasing, I agree, in a twenty-year-old, but it is no longer shocking at thirty."[10]

By the end of the nineteenth century, various currents of thought and reforming movements (from Rousseau's heritage to the rising tide of feminism and the advent of hygienics) were conspiring to make the corset a thing of the past. The voices of medical men (such as Debay in his *Hygiène vestimentaire* of 1857), of militants (the Rational Dress Movement was launched in 1881 in Britain), and of artists (from the Pre-Raphaelites around William Morris to Oscar Wilde) were all raised as one.[11] In the early twentieth century, thanks to such movements combining with an increase in the practice of sport and the triumph of physical training and nudism, a natural-looking, pared-down, athletically slim beauty gradually became the paragon. With exercise and "slimming pills," a generation rid itself of the fleshiness and plumpness that had endowed the opulent belles of the past with their indolent sensuality.[12] "Physical culture, physical culture! How they do go for it!" exclaimed Colette in 1913 faced by hoards of women dreaming of "athletics, and personal bests... all the while chatting of hygiene, gymnastics and of a 'rational' existence...." "Rational!" she adds, "I wonder what earthly meaning they can give to the

word.... I think that for them it means 'naked,' or something of the kind...."[13] In 1910, Colette's corsetiere assured her that she had to exercise her considerable powers of imagination to satisfy "these women who want to slim" but keep on finding that they have "too much skin on the stomach," or else those like Mme. P——, who demand miracles: "Madame Adèle,... I don't want hips any more! Do the necessary!"[14]

Some haute-couture designers were already sketching out the lines of the new, corsetless womanhood (Madeleine Vionnet, for example, at that time at Callot Soeurs),[15] but it was Paul Poiret who stepped forward as the real abolitionist hero. "I waged war upon it [the corset]... it was equally in the name of Liberty that I proclaimed the downfall of the corset and the adoption of the brassiere, which, since then, has won the day."[16] In 1907, Poiret was incontrovertibly an innovator when he hitched his Directory-inspired, raised-waist gowns up onto a high belt, a grosgrain tape, lightly boned, that held the gown in position and dispensed with the need for a corset, the freed bust being covered if necessary by a little brassiere or bust supporter.[17] Some of his models even dispensed with the grosgrain tape. "Lola Montès," for example, a 1906 afternoon dress-gown hundreds of copies of which were reproduced, falls straight from that part of the body from which modern garments are still suspended: not the waist, as in the past, but the shoulders.[18] The reality

Above:
Colette in 1906, at the time when, starring in a mime drama called *Le Pan* by Charles van Lerberghe, she appeared "outrageously naked beneath her wild animal skins" (*Paris Lumière*, December 5, 1906).

Following page:
Theda Bara, cinema's first *vamp*, in the First World War period.

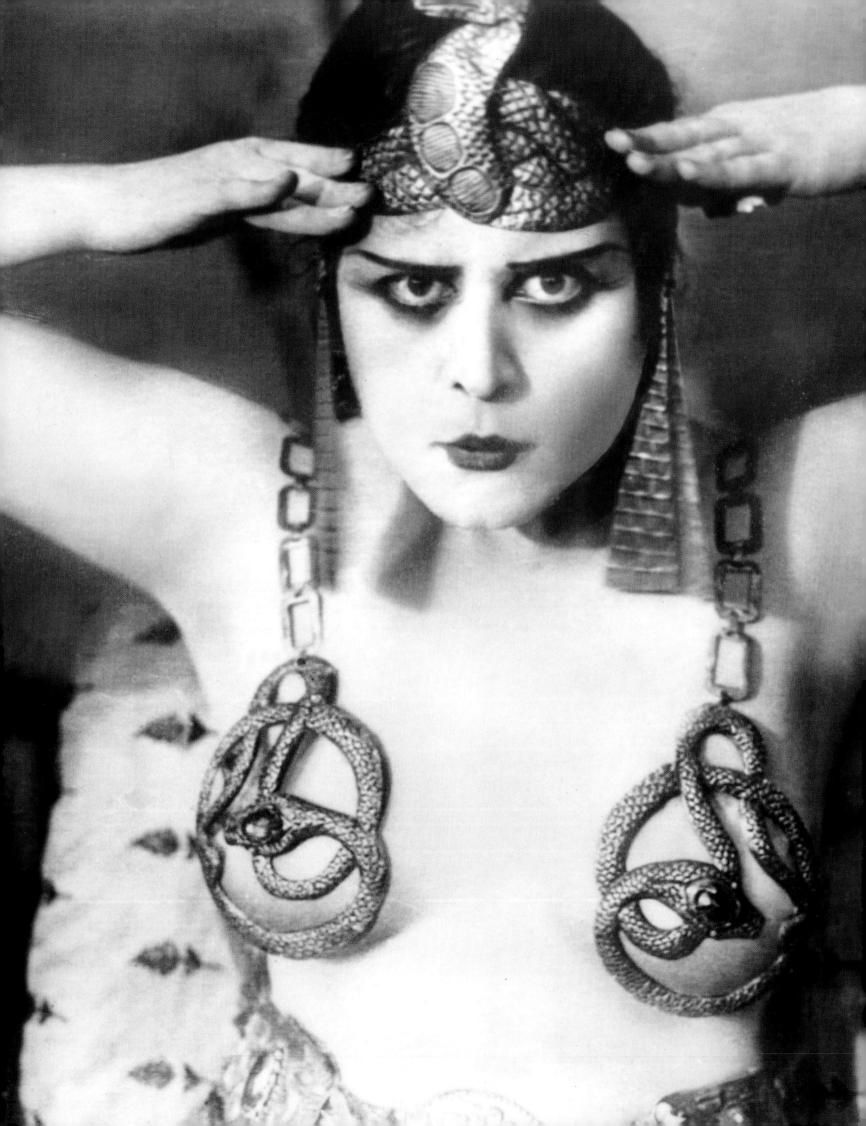

of the situation is more involved and subtle, however. Recall for a moment Poiret's hobble skirts inspired by the Orientalist costumes of the Ballets Russes production *Sheherazade* (1910) that had just met with riotous success: they indeed left the bust unhampered, but they shackled the legs (it was this aspect that first struck Poiret's contemporaries) and thereby reflected the contradictory tensions of an era traumatized by the new-found freedoms (be they electoral demands or closet Sapphic tendencies) that women were winning.

The long-line look prevalent around 1910 tended to leave the bust free while it lowered what was now a flexible corset almost to mid-thigh, whalebone being gradually replaced by rubberized or celluloid-covered metal springs. The corset was slowly becoming a girdle. In French the word for girdle, *gaine*, first appears in 1909, while Poiret himself commented in the November 1, 1913, issue of *Vogue*, "The girdle has no other purpose than to underscore the swell of the bust and the curve of the elegant line that starts beneath the arms and falls to below the ankle. It seems to me that its customary place is just below the bust, so that, whatever the pose or movements executed, none of the sculptural qualities of the body be hampered by the gown."[19]

The bust thus liberated, the breasts could now be held up either by a small corset cover–brassiere, sometimes slightly boned, by the ever-present chemise (kept under tension beneath the corset), by a special underbodice, by a bust supporter, or even by what women in Anglo-Saxon countries were beginning to call a "brassiere." The French equivalent, *soutien-gorge*, first appeared in the *Grand Larousse* dictionary in 1904. The garment was the result of considerable research and trial and error on the part of physicians (often women themselves, like the Dr. Gaches-Sarraute so pilloried by Poiret in his attack on the corset) and corsetieres (such as the inventor of the *corselet-gorge*, Herminie Cadolle)[20] who, in patent after patent, strove to come up with a hygienic corset that would bring relief to the abdomen. By holding up the cups, shoulder straps (that at this time sometimes had to be knotted in place) now allowed the dual function of cinching the waist and supporting the bust, hitherto combined integrally in the corset, to be separated. However, in the 1910s, fashion had abandoned the voluptuous figure, and the lightly padded brassiere had none of the underwiring with which it would be equipped in the 1930s. In 1910, just when the princess dress and flattened sheath dress had finally dethroned the bosom, the rather extempore use that Colette's corsetiere made of the brassiere—both the word (*soutien-gorge)* and the thing—encapsulates the situation perfectly: "Don't be frightened! I'll explain everything with this length of material.... You just grab a breast, like this, see, and you fold it back, pushing it down as far as possible on to the ribs. On top, you put on a little brassiere: my 14b, a darling! It is not exactly a brassiere but rather a tiny piece of elasticated cloth that maintains the breasts in position. And, over it all, you put my corset, my 327—superb, a marvel of the age. And there you have it, a divine figure, no more hip, stomach, or posterior than a bottle of Riesling, and above all the bust of Ganymede! The bust of Ganymede, that's the crucial thing!"[21]

THE FLAPPER IN THE AGE OF
DEMOCRATIC LINGERIE

Ah! Those fine taffeta petticoats whose rustling alerted men to the approach of a woman,
just as the hunter is alerted to a rattlesnake moving in the jungle.

Princess Bibesco, *Noblesse de robe,* 1928

omen's rejection of titillating undergarments came to a head in the 1920s, exacerbated by their wartime experiences. In France in 1914, the *gosselines*, who with their hair cropped in the manner of "flappers" danced without corset with their flashy boyfriends, had started a trend.[1] Prewar tangos, foxtrots, cakewalks, one-steps, and shimmies were ousted by the Black Bottoms and Charlestons of the jazz age. All the jumping and shaking the dance craze involved ousted the corset from the "bright young things'" wardrobe once and for all.

THE BOYISH LOOK

The straight-lined, unfitted dresses of the period were made for a flat, androgynous body, with no curves, no buttocks, no waist, and no breasts to speak of (some women, in fact, underwent breast reduction operations): where the average waistline had been 22 inches in 1889, by 1922, it had risen to 28 inches.[2] To obtain her "little boobies," the average woman had to squeeze into a "flattener brassiere" or "bandeau" instead of a bust supporter. She swapped her prewar pantaloons for a pair of drawers, like those made by the up-and-coming French label Le Petit Bateau,[3] in jersey or else, for sheer elegance, in triple voile. If she had thrown off her corset, she might still wear a rubberized knitwear girdle (or "belt," as it was known) next to the skin, and no chemise. Chemises, corset covers,

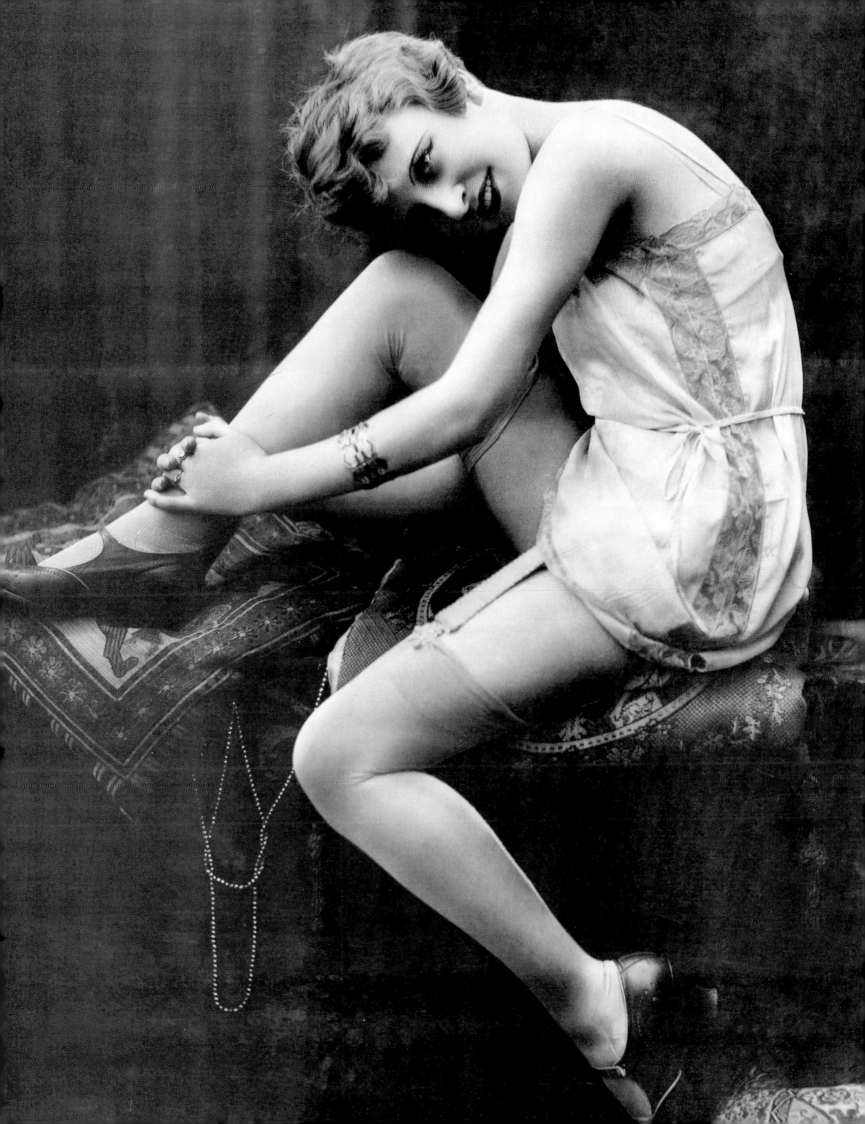

petticoats—all were cast to the winds as the closet was ransacked. A pillar of Belle Époque society, the painter and caricaturist Alfred Willette (1857–1926), was outraged: "They have done away with feminine underlinen, the vandals! Why, even the butcher knows that a leg of mutton has to be done up with a paper frill!"[4]

Ever the attentive observer, Colette in 1924 reported the recriminations of an elderly disgruntled shop assistant working in a couture house. Women having jettisoned the depository of the perspiration, secretions, and, well, secrets that their underclothing provided, the old lady found herself discommoded by odors of the most intimate origin. "What can you expect, Madame? Once a woman used to wear underwear, fine linen underwear that cleansed her skin; now, when she takes off her dress, turning it inside-out like skinning a rabbit, what do you see? A long-distance runner, Madame, in a little pair of trunks…. No chemise, no linen drawers, no petticoat, no combination, a brassiere sometimes yes, often a brassiere…. Before coming for a fitting, these ladies have walked, danced, eaten, perspired…. I'll say no more…. A long time all in all from their morning bath! And their dress, worn next to the skin, what does it smell of, their dress that cost two thousand smackers? Of a boxing match, Madame, a fencing championship! '*Round Two*, the unholy odors'…. Oh, Lord!"[5]

Away from the cosmopolitan dance halls and Parisian design houses, a similar, if attenuated, tendency emerges from the graying hush of popular catalogs, magazines, and ten-cent beauty–body care manuals. "Jersey drawers held tight to the leg with elastic" were soon taken on as all-purpose drawers recommended to be worn "under any garment whatsoever"[6] due to the "extremely short hemlines."[7] Be that as it may, the *Mon Trousseau* manual explains, whether we are dealing with "fancy drawers" or, for all those who have not yet abandoned them, "lawn pantaloons, it is crucial that they take up the least room possible under the frock."[8]

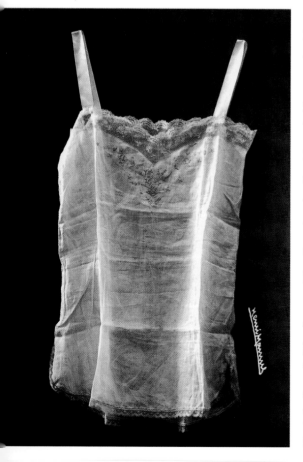

Chemise and pantaloons, as separate items, were fast disappearing. It was now in the form of the so-called *combinations*, dating from before the First World War, that they held their ground. Attendant on this dual-function garment came a posse of problems in the between-the-legs area: uncomfortably short or poorly fastening crotch tabs, errant buttons, and so on. The fabrics used were so sheer that women were advised to line the bottom half, especially if there was a crotch piece.[9] In tandem with combinations between drawers and chemise, the *cami-petticoat* appeared on the scene early. Each of these forms possessed a series of satellites: for one there were *cami-bockers* and *cami-knickers* (or better known as *cami-knicks*); and for the other, *camisole–half-slip*, *cami-slips*, and even a combination of corset cover and half-slip. *La Lingerie chez soi* proposed patterns for its readers of more modest means, reminding them that "one can always find enough pieces among the material left over from making a dress to agreeably trim an undergarment."[10] The author of this work, Paul Louis de Giafferri, was also careful to extol the calming and diverting effects of the patient exercise a lady's needlework demands: "Whenever a woman feels

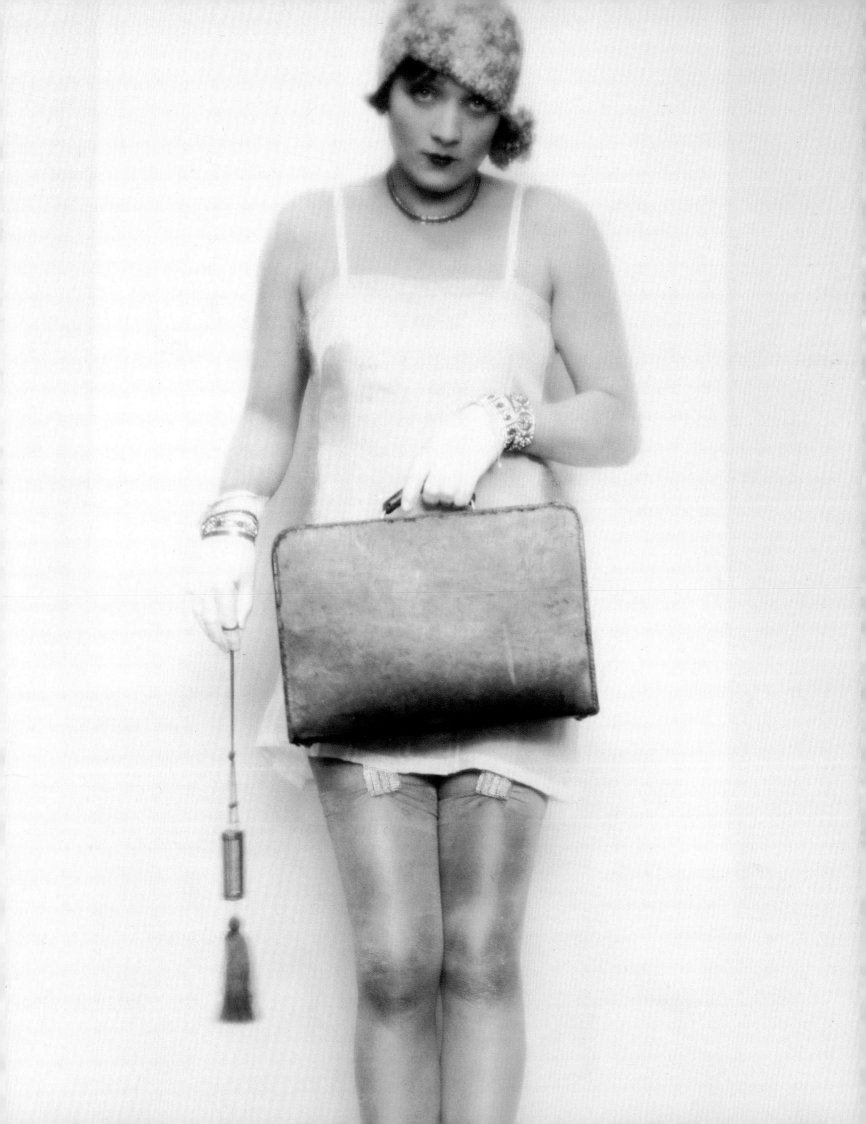

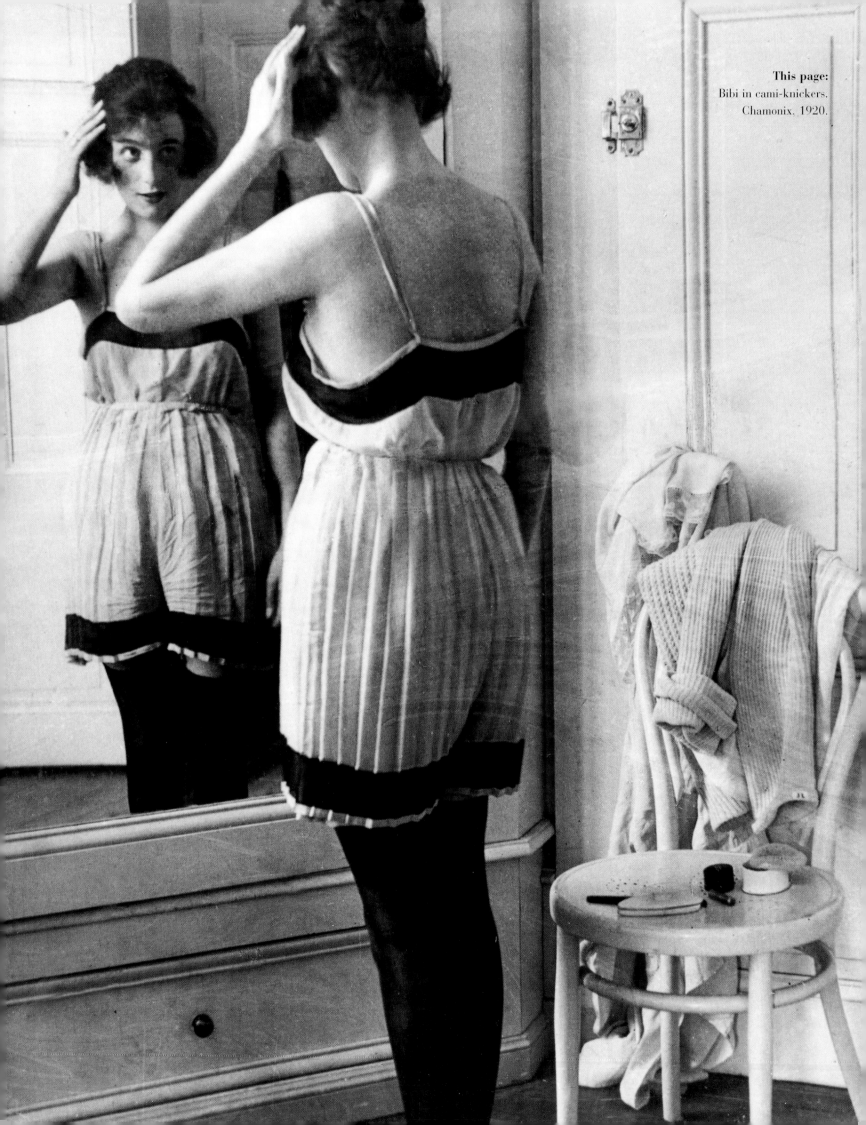

This page:
Bibi in cami-knickers.
Chamonix. 1920.

concerned or worried, nothing beats returning to a familiar piece of needlework or running up some spruce little novelty. Work is the best palliative to affliction."[11]

Nevertheless, the period was not one for patience. The crop-haired *garçonne* was no maiden to be making up a trousseau. She wanted everything and she wanted it now, sensitized by the dazzling, opulent, and magnetically attractive pictures of women she could see at the movie house—from the dangerous vamp and beguiling coquette to the brazen flapper and bathing beauty. Everything conspired to incite her: industrialized mass-production, department stores, catalogs, a great variety of prices. In 1924, the Bon Marché store in Paris was offering cami-petticoats in cotton crepon for 9.75 francs, in brushed white finette (a cotton serge) for 18.50, in pure-wool jersey for 31, in crepe de chine for 49 and, the finest of the finest, in "openwork and eyelet lace, piece-dyed blue, pink, and black" at 79 francs. People were entering, as Louis-Ferdinand Céline put it, "a new period of democratically available fine underwear."[12] In fashion journals, the number of pages devoted to making up undergarments and to needlework in general was on the wane to be replaced by ever more advertising or purchase advice and hints on upkeep. The traditions of the trousseau thus continued on their downward spiral, victims of a form of cultural alienation, of the loss of the necessary skills, and of an inherited tradition crumbling before growing commercial and industrial standardization. The trousseau also suffered from the waning interest shown by women themselves in a form of ritualization of their biological existence and of femininity to which they felt increasingly foreign.[13]

THE LURE OF FLESH-TONED SILK

Madam,
a pair
of silk stockings
is not
a leap into space.

ANDRÉ BRETON, *First Surrealist Manifesto*, 1924

The two most spectacular conquests of this new *democratic* lingerie were color and silk, one by offering a change from white, the other an alternative to pure linen. White and linen being the rule, color and silk had always been tainted by a time-honored symbolism, an amalgam of luxury and lust. Their general availability, in putting what had been the preserve of the rich and morally reprehensible within the reach of all and sundry, reflects the very essence of the Années Folles. Such democratization had its detractors in the 1920s, of course. The author of *La Lingerie chez soi* castigated women who thought it safe to wear "brightly colored" slips with the excuse that "it hardly matters... as they remain unseen."[14] As well as gaudy colors (the oranges, reds, and blacks that had to be periodically refreshed with "balls of commercially available household dye"),[15] subtle and soft pastel shades (bright and flesh pink, cream, ivory, peach) were also in vogue, turning

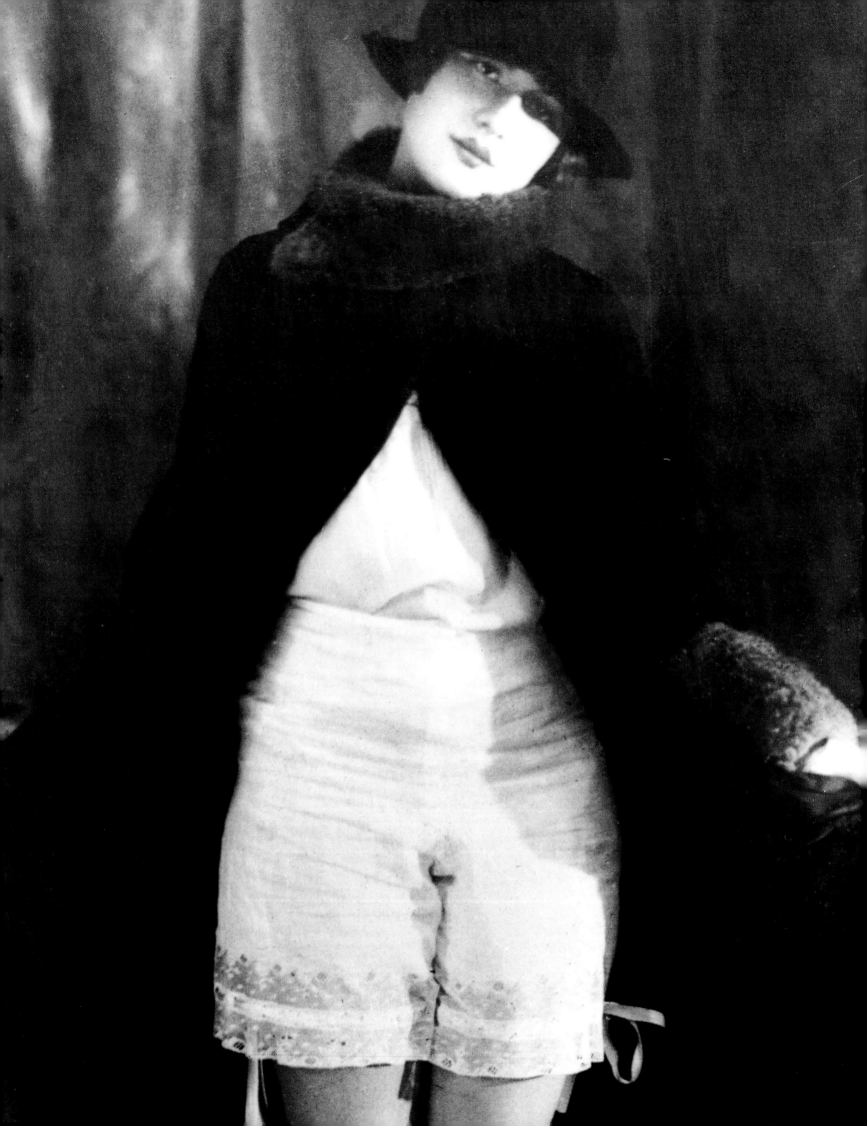

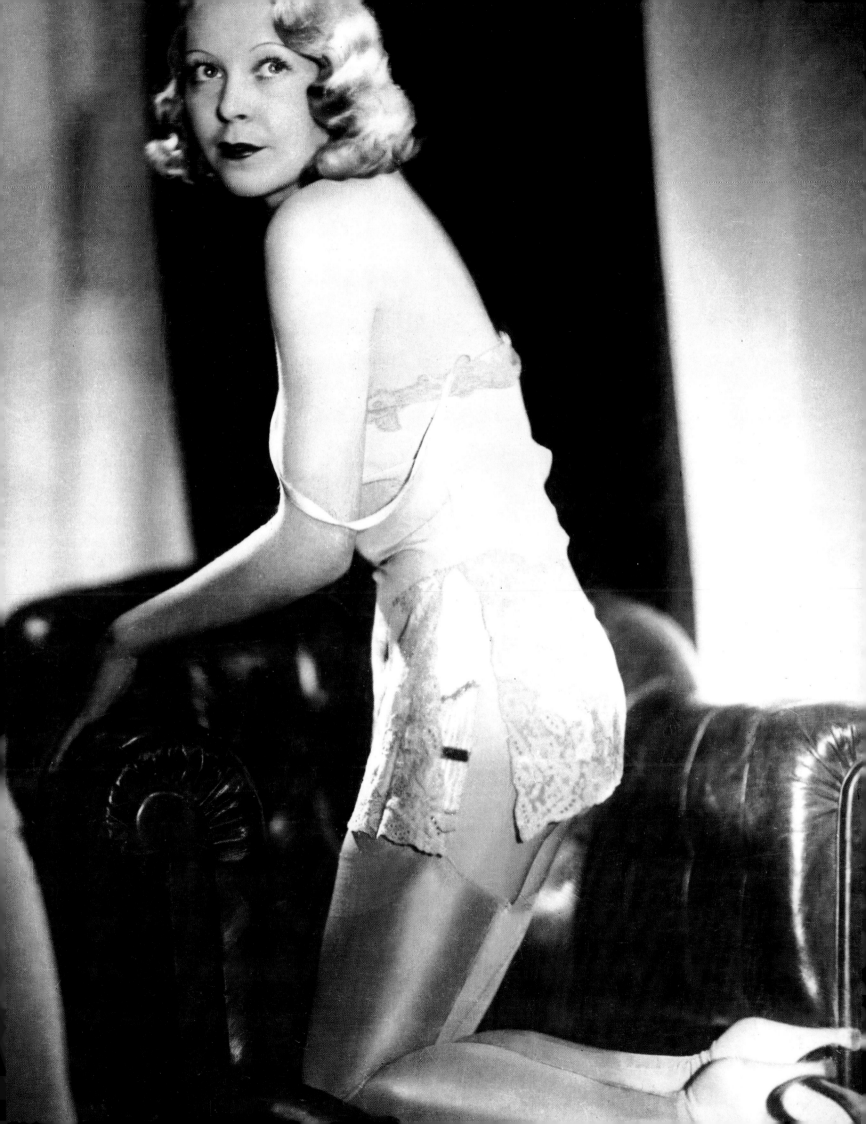

up in catalogs with infinitely greater frequency and gradually accepted as a more decent alternative to the virginal white that had been de rigueur. Color-dyed underclothes only filtered down to southwest France by the mid-1930s, in the somewhat reticent guise of pale blue or pink nightdresses with demure self-color embroidery.[16]

The softness of silk has a whiff of luxury and lust, too. "I'd like to sleep in silk, but it's not my style," Widow B—— confided to Gaëtan Gatian de Clérambault at the beginning of the century, "that's only for women who show themselves off in bed."[17] By the 1920s, to possess an ensemble or even just a slip made of silk in a trousseau was no longer an out-and-out privilege nor cause for criticism. *Mon Trousseau* reminded its readers that "a dress cannot glide smoothly on cotton since the slip might roll up, forming ungainly folds beneath the clothes." With silk, such mishaps are a thing of the past.[18] As regards such a material, the most commonly employed weaves were "crepe de chine, triple voile, satin crepe, pongee, crepe georgette," and, above all, "plain weave silk."[19] But the period's great textile event is the advent of *artificial silk*, particularly American *rayon*, so aptly christened by its inventors in 1924. These less costly "silks" illuminated a woman's body like on the silver screen of a movie house, making the illusion of luxury universally available. Artificial materials like rayon were now coming of age. Soon millions of pairs of female legs were to be sheathed in their radiance, to the eternal chagrin of those disillusioned with contemporary femininity such as the Parisian poet Léon-Paul Fargue, for whom "the development of sexual equality through the vogue for sport, through women stripping naked in music halls, through the ever more widespread use of face powder, massage, and silk stockings has done away with the mystery indispensable to female allure and Parisian panache alike."[20]

Since the scandal at the Longchamp racetrack occasioned by three Poiret models in "Hellenic robes" revealing their stocking-clad ankles and calves as they walked, dresses and skirts had become ever shorter.[21] By 1925, hemlines had risen to the knee; by 1926, they attained their highpoint, 16 inches above the ground, an altitude from which they could only descend. This show of leg was a "valley of sighs for many an unfortunate creature," as the popular novelist Lucie Delarue-Mardrus put it in her book of beauty hints, *Embellissez-vous!* ("Become more beautiful!"). Topics covered included heavy ankles (henceforth a "terrible misfortune"), varicose veins ("monsters lurking beneath the stocking"), or even bow legs like "jacket sleeves" (a thoroughgoing "rectification program" guarantees ridding oneself of such a "defect" but only if one perseveres).[22]

To clothe publicly visible legs, Parisian hosiery firms such as Marny came up with woolen, cotton, and silk stockings in 1925. In a publication devoted to "Stockings through the Ages" and

Below:
Models (complete with explanations as to tailoring) for cami-knickers, cami-bockers, and other pantaloon or petticoat combinations offered to the readers of *La Lingerie chez soi.* around 1927.
Facing and preceding pages:
Lingerie in the 1920s. If the corset was no longer worn, the girdle, or the shorter rubberized (or still newer "elasticized") wool waist-cinching "belt," were being taken up instead. In 1922, Warner brought out the Wraparound girdle for this new "tube" line.

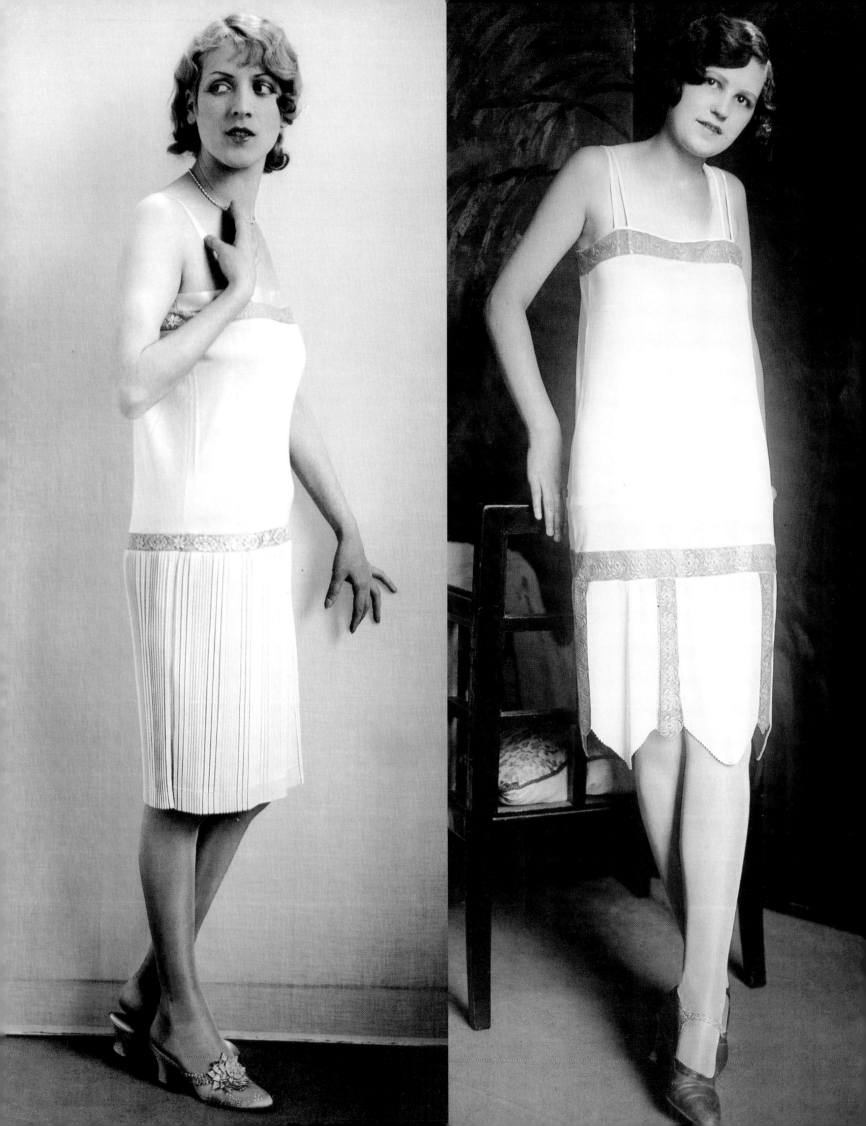

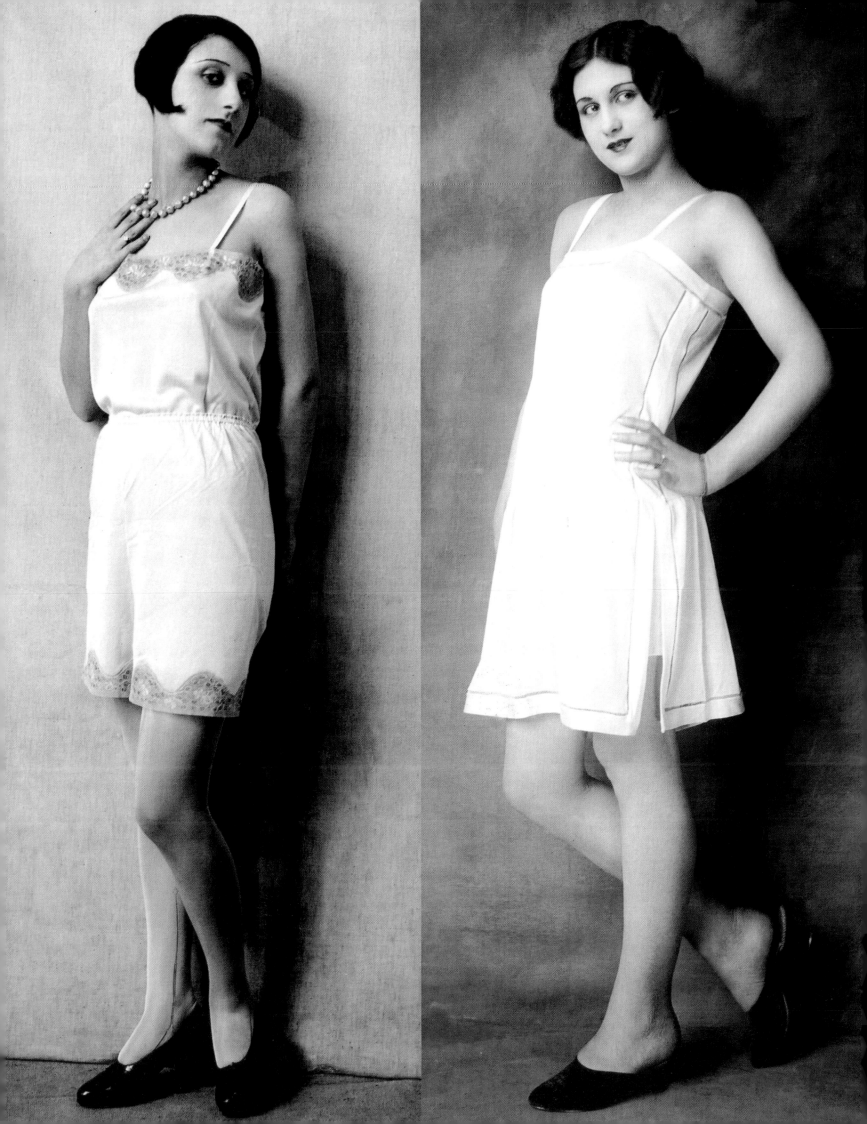

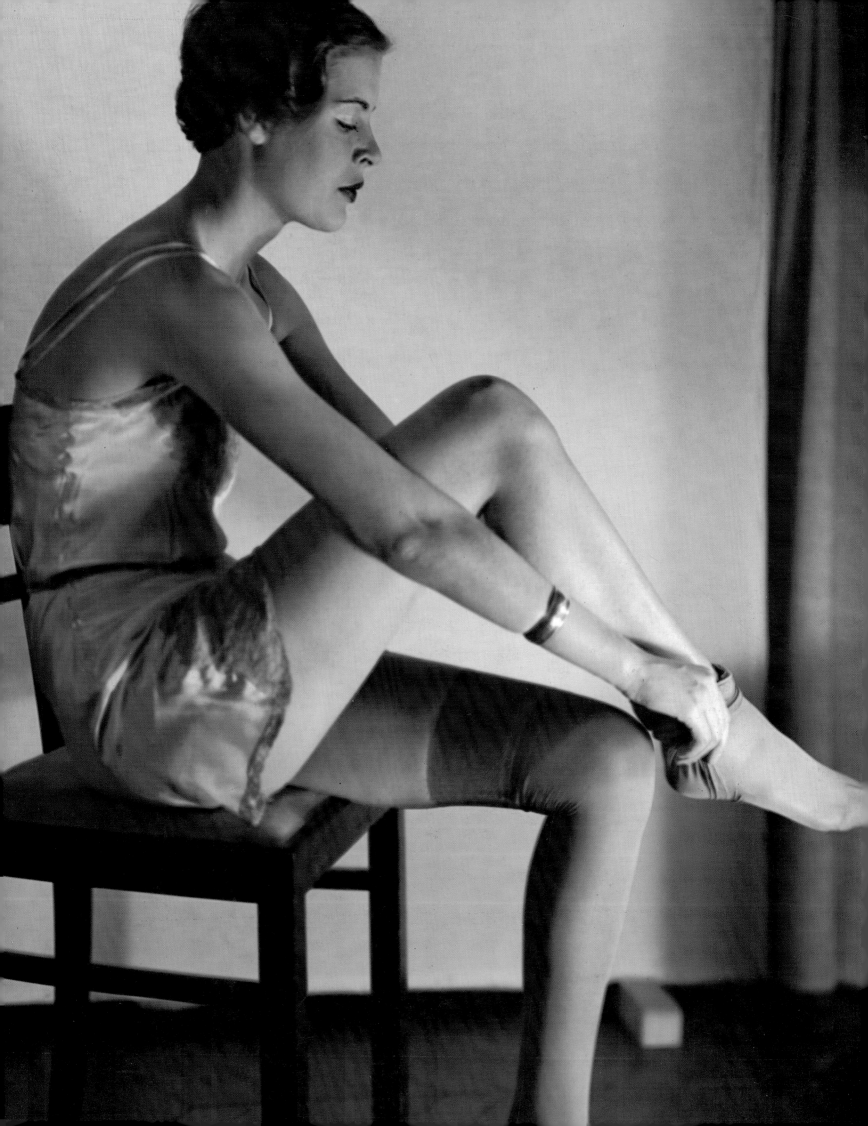

"What Is a Good Color to Buy," the company details the range. The first line—"for skiing, golf, skating, motoring, shooting, tennis, and the French Riviera"—was ideal as "understockings" for cold and "nasty" weather. Angora flesh-colored understockings were marvelously successful, remaining invisible "however fine the weave of the stocking worn beneath might be." Mercerized lisle stockings were "excellent for trotting about in," while those in "supertransparent" dry-spun folded yarn voile give the "flawless impression of silk stockings."[23]

"Pink stockings are but a thinly veiled nakedness," Lucie Delarue-Mardrus deplored, doing her utmost to remind her "sisters" of the 1920s who were tempted to follow the boyish look that "mystery is a necessary attribute of femininity."[24] On the borderline between fabric and flesh, new enticements, new evasions were to surface on these female legs wrapped in flesh-colored silk under short dresses.

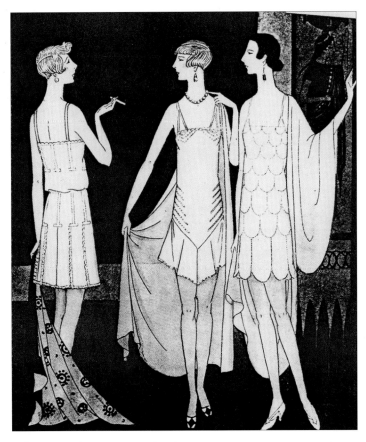

A new generation of erotic and pornographic images was born and—as is always the case when the frontiers between what can be seen and what remains hidden are modified—its mystery acquired a different focus. In the satirical drawings of the time, the elegant creatures of Art Deco would be shown sitting with their legs crossed to reveal two cheeky little suspender garters. These "wicked" women are of a piece with those who showed their stockings to the narrator of Céline's *Death on Credit*: "sometimes they'd put their feet upon a stool just to give you a view of their ass."[25] Or—in less prosaic mood—like the unmoving woman André Breton contemplated for a time at the Paris waxworks, the Musée Grévin. "The adorable lure of a woman fastening her garter in the shadows," the leader of surrealism writes in *Nadja*, "and it was the only statue I know of with eyes, the very eyes of provocation."[26]

In the accessories store that kept this little "theater" supplied, one could still find, lying next to the suspender garters, a pair of band garters for holding up the stockings and keeping them taut that women wore by rolling them at mid-thigh. Since the former are sewn straight onto the corset or girdle and garter belts as such remained uncommon, the band garters that had been so popular in the Belle Époque were given a new lease of life in the 1920s thanks to simpler styles in women's underwear. In their wake came a whole host of fantasies and daydreams: "I left her in her stockings because in my opinion they're prettier like that. Anyway, the women you see undressing in the magazines all wear stockings," says the hero of *Mes amis*, Emmanuel Bove's 1924 novel from which we have already quoted, adding that "her thighs overflowed her garters."[27] In his 1929 novel *La Petite Infante de Castille*, Henri de Montherlant noted for his part, "I like to see, pink on their naked legs, the mark left by their garters."[28]

Above:
Modeling a range of fine lingerie by Madeleine Vionnet, 1926.
Facing page:
Stockings and garters, 1927.
Preceding pages:
Four lingerie lines by the firm of Neyret, 1928.

PENELOPE 1930s STYLE:
NOSTALGIA FOR THE FEMININE

Women no longer understand what it is becoming to show and
what it is better to keep hidden.... They say, they read, that they have to
get fat again, and they let the couturiers bring out the bust, but as soon as the
scales show that they've put on a single pound, they all start dieting like mad!

EMMANUEL BERL, "La Mode 1932," *Les Nouvelles littéraires,* April 16, 1932

We lost great chunks of crowd to each of them.
I picked a movie house with posters of women in slips,
and what legs! Boy, oh, boy!

LOUIS-FERDINAND CÉLINE, *Journey to the End of Night,* 1932

"It's working. All these women are squirming on their chairs, tugging their short skirts down. They already feel quite out of fashion."[1] At Jean Patou's haute-couture house in 1929, the mood is buoyant: falling hemlines, the focus of the most recent collection by the couturier, are a hit. A fresh page is about to be turned, one that marks the end of short skirts and, in consequence, of the boyish look. Fashion, like dreams, takes delight in distilling gradual transformations into breathtakingly unpredictable events, brief but ground-breaking snapshots, extravagant gestures that can ring in a new era. Patou's victory salute is a particularly satisfying example of this tendency. In fact, his triumph was simply the confirmation and crystallization—as it percolated down through the fashion houses—of a development that had been tangible since 1926. The woman *engarçonnée*, the shapeless flapper, had had her day, and a new femininity, hailed at the time as a return to more natural forms, was making its presence felt. The novel line surfaced initially in evening gowns, but daywear was soon to follow: these frocks proclaimed falling hemlines (in front just under the knee, but lower still behind), waistlines that rose to their rightful place ("the waistline at the waist"),[2] and, finally, whereas the boyish line had shied away from the feminine form, the new dresses were body clinging.

The return to a more traditional mold of womanhood in the 1930s took place against the backdrop of two new trends that shot through elite and mass culture alike: an appeal to the classical lines of Greco-Roman antiquity and romantic nostalgia. The decade's taste for the Greek or even the Roman and Egyptian past appears as much in the pomp and circumstance of monumental Fascist architecture, with its columns, pediments, and

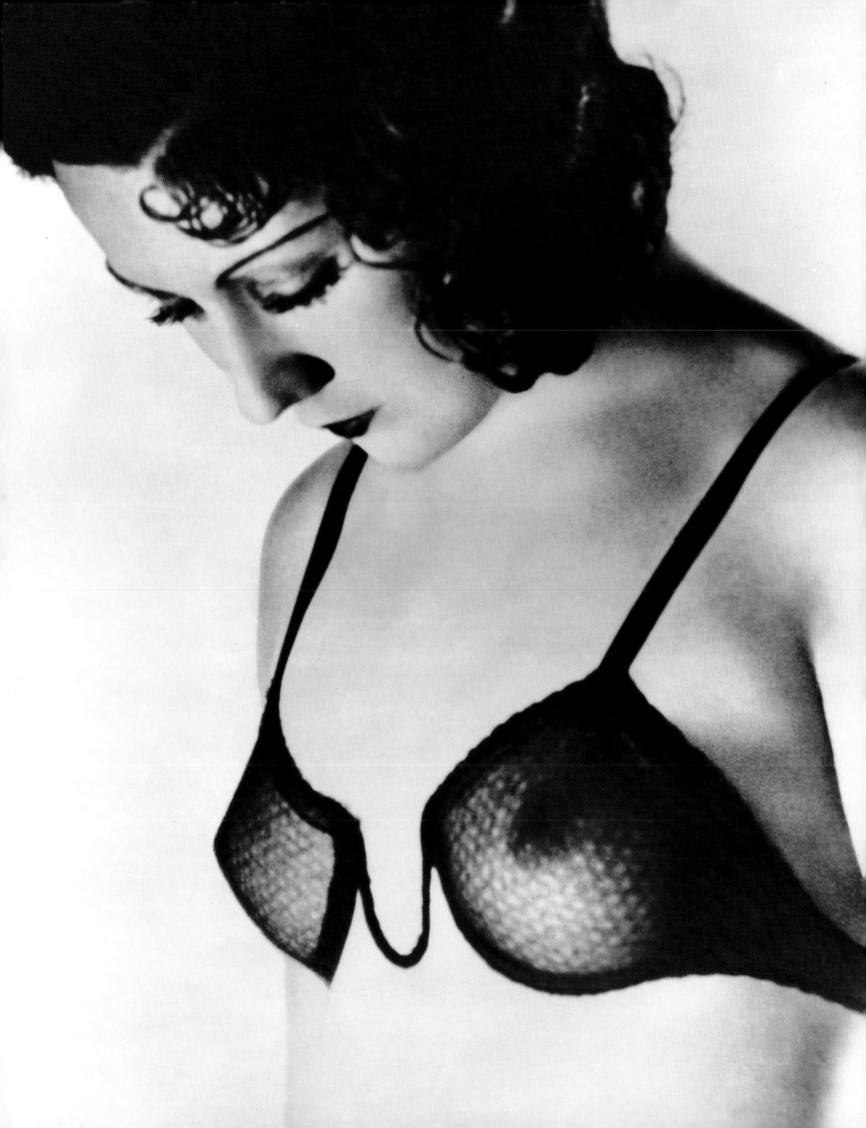

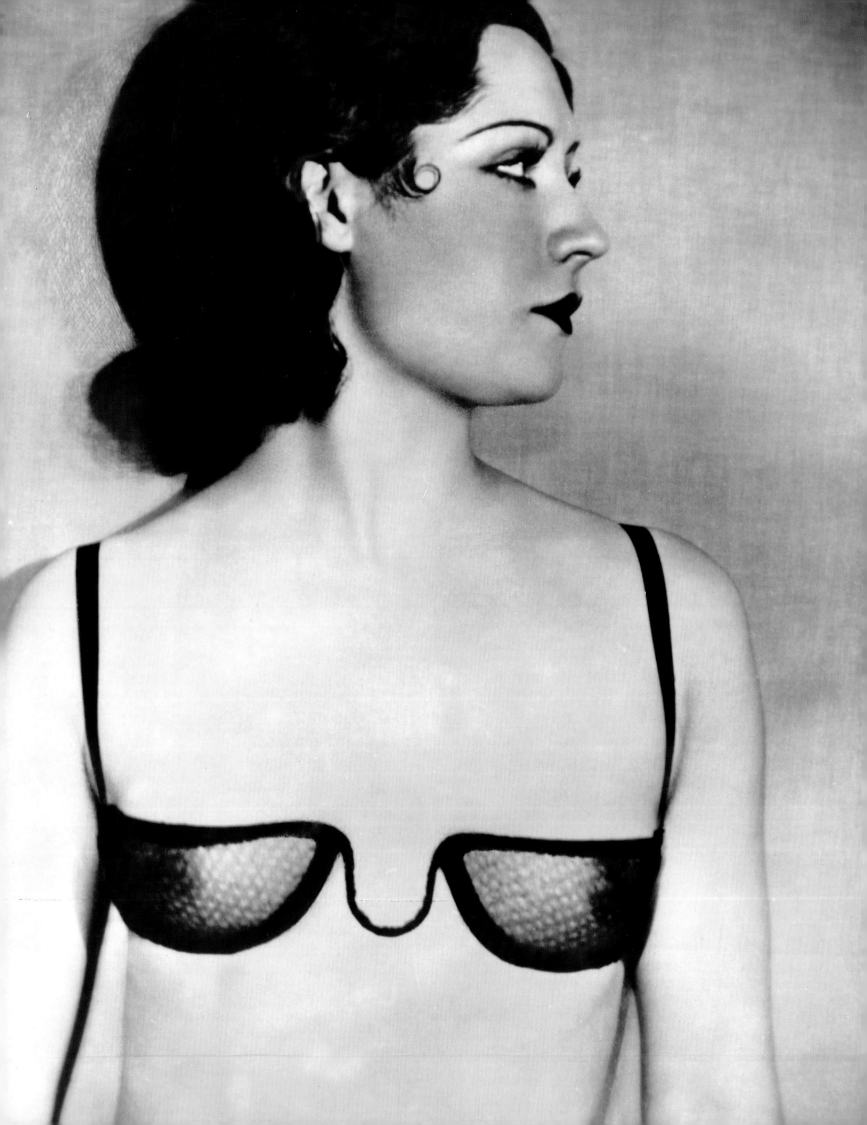

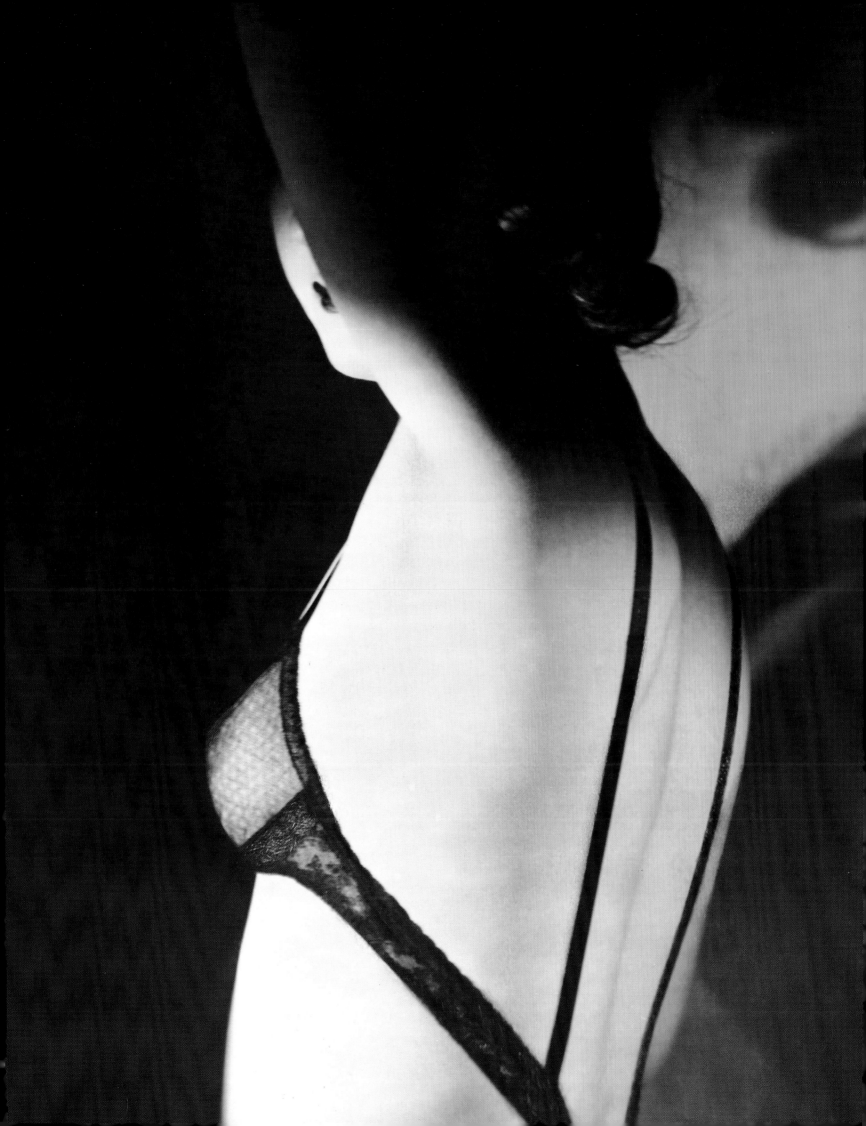

entrance stairways, as in the subtle fairyland, the shimmering yet grave lightness of Jean Giraudoux's mythological theater—in such plays as *Amphytrion 38* (1929), *La guerre de Troie n'aura pas lieu* (*Tiger at the Gates*, 1935), and *Electra* (1937). The Egypt of the pharaohs—as revisited by the Hollywood production machine—plays the starring role in Cecil B. deMille's 1934 *Cleopatra*. Like a lamé serpent of the Nile, Claudette Colbert could be seen parading her body across the silver screen in the vast "dream palaces" or "pleasure domes" we now know as movie houses.[3]

In the world of high fashion, the remodeling of the female form according to neoclassical canons attained its zenith in two phenomena: the *fixed drapery* of the majestic flowing silk jersey robes by Alix (costume designer for *La guerre de Troie n'aura pas lieu*), and later Madame Grès inspired by the antique *peplos;* and Madeleine Vionnet's evening gowns, whose *bias cut* magically hugged the body, the seemingly living material paying homage to a woman's natural curves. Reporting on this renaissance of the fuller form after the reign of the "Anglo-Saxon silhouette," a 1929 number of the journal *Le Corset en France et la lingerie* speaks—in the xenophobic language typical of the Far Right of the time—of the "revenge" wrought by Parisian designers on behalf of "deep-backed women of Latin race."[4]

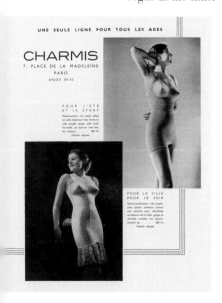

Far removed from the angular geometry of so-called cubist fashion, models inspired by romanticism also flowered in the second half of the 1930s, and ruches and flounces, tulle and lace, bouquets and embroidery accompanied the new line as soon as it appeared like bashful bridesmaids. In a West deep in the throes of economic depression and a hardening of ideological and political positions, the fad for frills and ruffles offered women a feminine side that was "romantic," in the least historical and most novelistic sense of the word. In France, femininity became doe-eyed sentimentality, swaying gently to a Viennese waltz or reading the Cartlandesque stories of Delly and the wishy-washy verse of Paul Géraldy. On a deeper level, however, the vogue also brought with it the ardent womanliness of idealistic young girls in the mold of the heroic Scarlet O'Hara (*Gone with the Wind* was an instant success on publication in 1936), captured on screen in the pretty features and wasp waist of Vivien Leigh in 1939. If the preferred thematic period in the United States was that of the Civil War and in Britain the Gay Nineties, in France a similar role was filled by the Belle Époque. These distant times were refurbished with the nostalgic charm of a paradise lost, of a happy, carefree era infused with the kind of twinkly-eyed innocence and naïve sentimentality that oozed from the turn-of-the-century picture postcards that were now becoming collectable.

Corsetry and lingerie pandered assiduously to the needs of those women—first long and undulating, then curvier and serpentine—arising out of that renaissance of femininity. Both forms reverted to their original purpose in providing foundation garments to the dress. Before visiting her couturier, an elegant woman of the time would start out for her corsetiere: "No real chic is possible, even with a dress tailored by a master dress designer, if your line is not prepared first," an advertisement for Charmis (a firm on the Place de

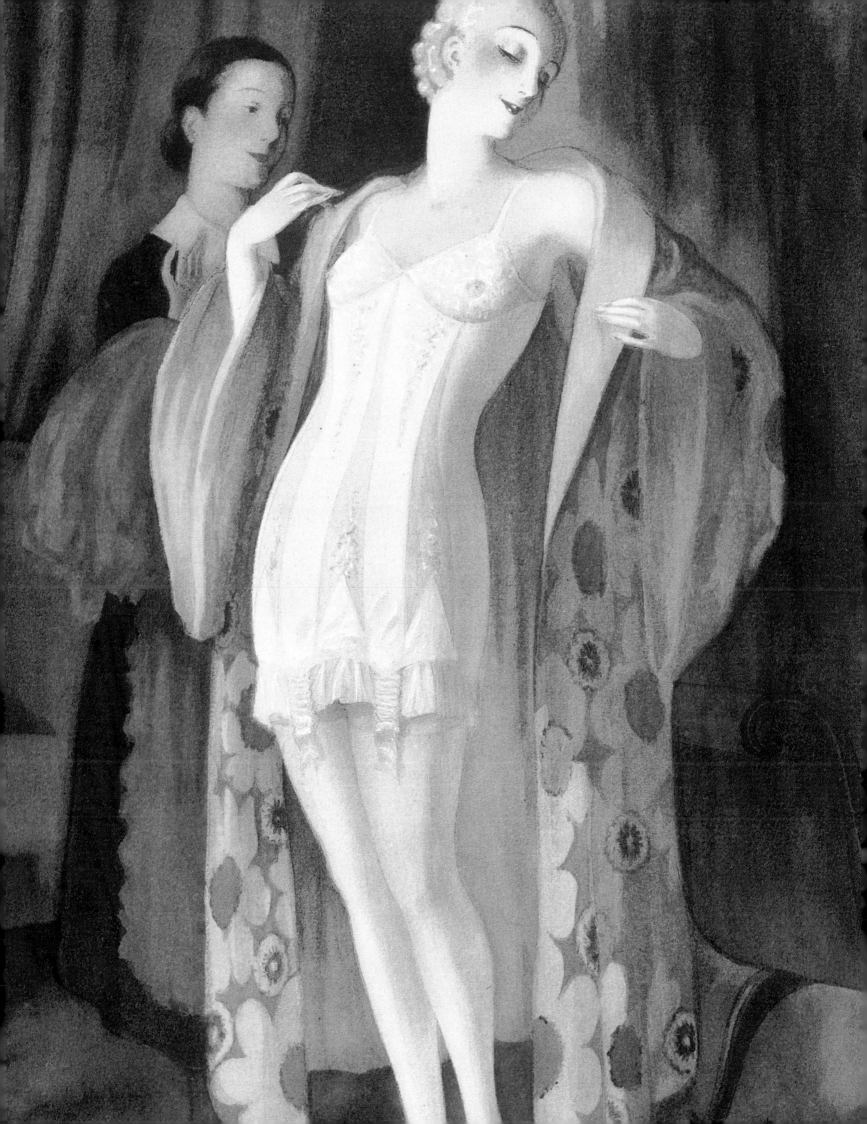

la Madeleine in Paris) reminded her in 1937. The rebirth of the curve, however, was not to be engineered by corsetry as it had been understood in the past. At once cause and effect of the decline in the old style, a new dynamic marrying body to envelope was developing; its logical conclusion would be attained in the 1960s metaphor of the "second skin." In the 1930s, its first technical manifestation was the *bias cut*. The practice had long been employed in tailoring collars, sleeves, gores, borders, and, notably, undergarments. As early as the 1910s, Madeleine Vionnet promoted cutting diagonally across the fabric grain from this unassuming role and extended its use into the art of dressmaking. Firmly of the opinion that the dress designer is not an orthopedic surgeon but can only "doctor the line," Vionnet insisted that her customers "respect their own body and practice the exercise and rigorous hygiene that would get them to throw off forever those artificial suits of armor that so deform their bodies."[5] In the 1930s background of neoclassical aesthetics, the bias cut was to establish its ascendancy in the hands of Madeleine Vionnet

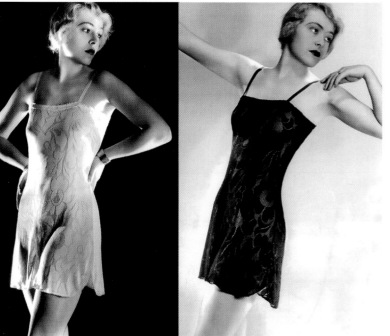

Above:
Two short-hemline combinations, 1930.
Facing page:
Model by the Neyret firm, 1928–29. Toward the end of the 1920s, such precious combinations and nightgowns—invisible, intimate envelopes for a new type of woman—began to conform to the voguish "princess line."

herself. With a new-found suppleness and flexibility that is impossible to attain cutting on the straight, the material hugged the undulations of the female frame, bringing out every curve and fluid line. The gown itself, meanwhile, thanks to the almost spiraling effect of the bias cut, started to dream that it might one day be its own foundation.

The bias cut was much in demand behind the footlights. By the end of the 1920s, following the lead of Madame Jenny (proprietress of the firm of the same name), the demand was for girdles and cinch belts that "hold the body well, able to mold it, and even, as it were, to style it."[6] To achieve this aim, cutting diagonally became simply unavoidable. In 1937, Charmis trumpeted the "slim-look bias cut" of "Favorite," its "belt for city wear, in fine batiste and hand-sewn elastic" (made-to-order for 400 francs). The majority of girdles were, in fact, hybrids: bias-cut for the side panels, straight-cut for the center-front and back. The rarer crisscross girdles were the preserve of women aiming for total perfection.

In addition to the bias cut—gripped by the dream that a flawless woman might wear a foundationless dress—another technical leap forward contributed to the predominance of the hip line during the 1930s: the latex and elastomeric yarn revolution that allowed for the development of fabric elastic in warp and weft alike, providing support both width- and lengthwise. Credit for the invention goes, it would seem, to the American company Warner in 1931. The yarn was initially christened "Lastex" and the fabric "Youthlastic," while the girdle itself was known as "LeGant," and thus enhanced with an aura—all-important in the lingerie market—of "Frenchiness." The new girdle was soon taken up by a whole generation of young women who had never known the heavy boned corsets of old and who were supposedly devotees of physical exercise. Like their supple fair-haired sister in the advertisements of the period, even in heels, stockings, garter belt and bra, the new woman could bend over and

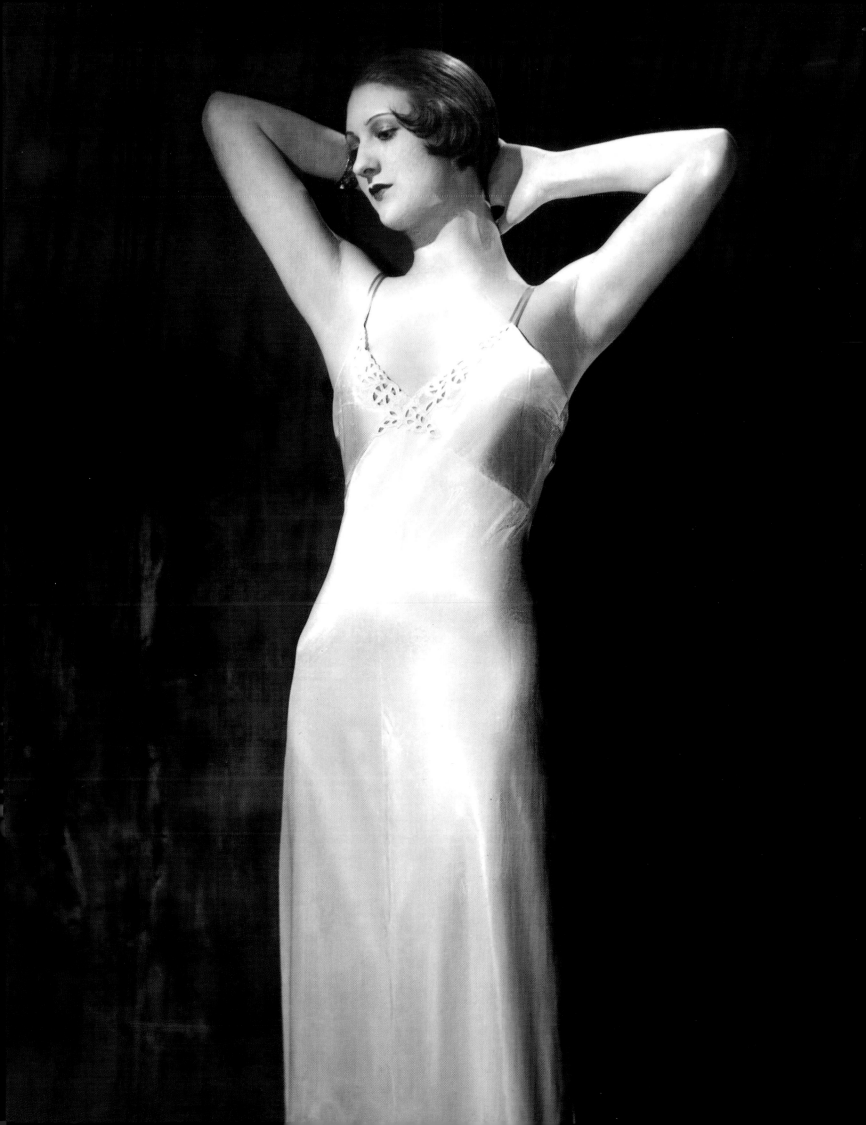

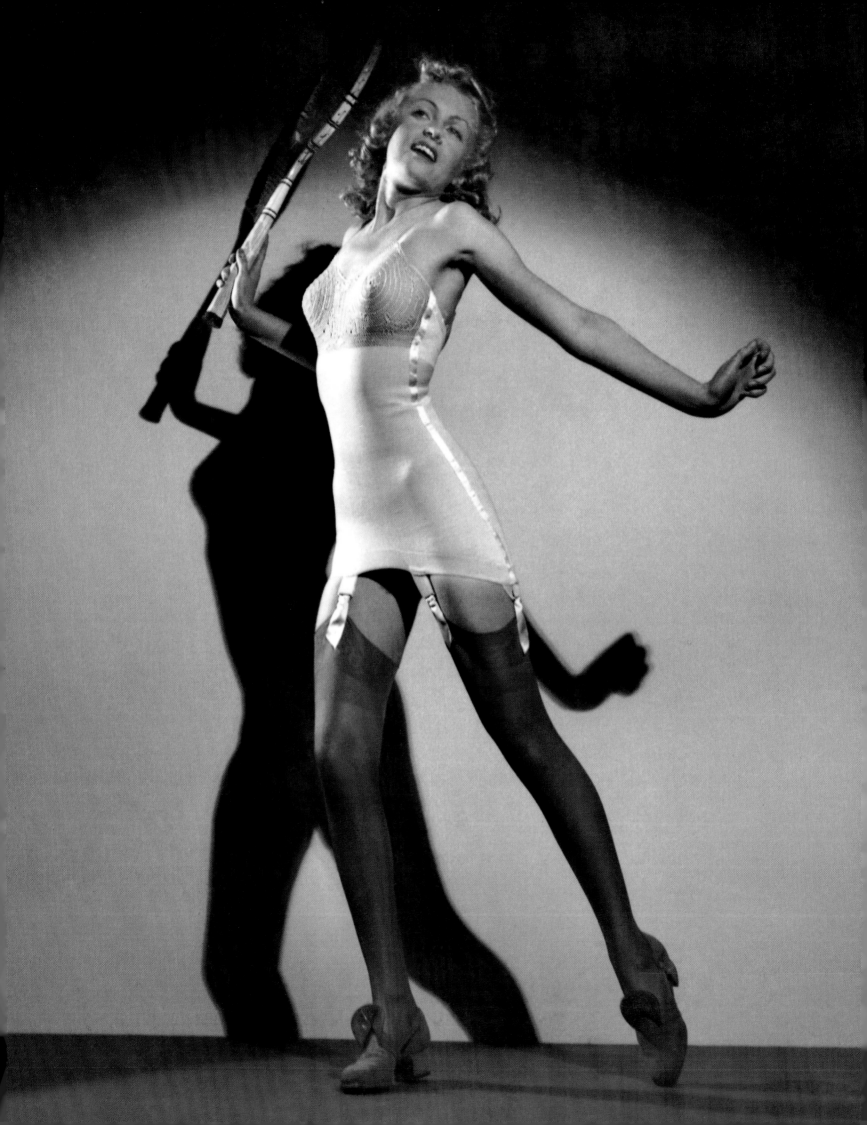

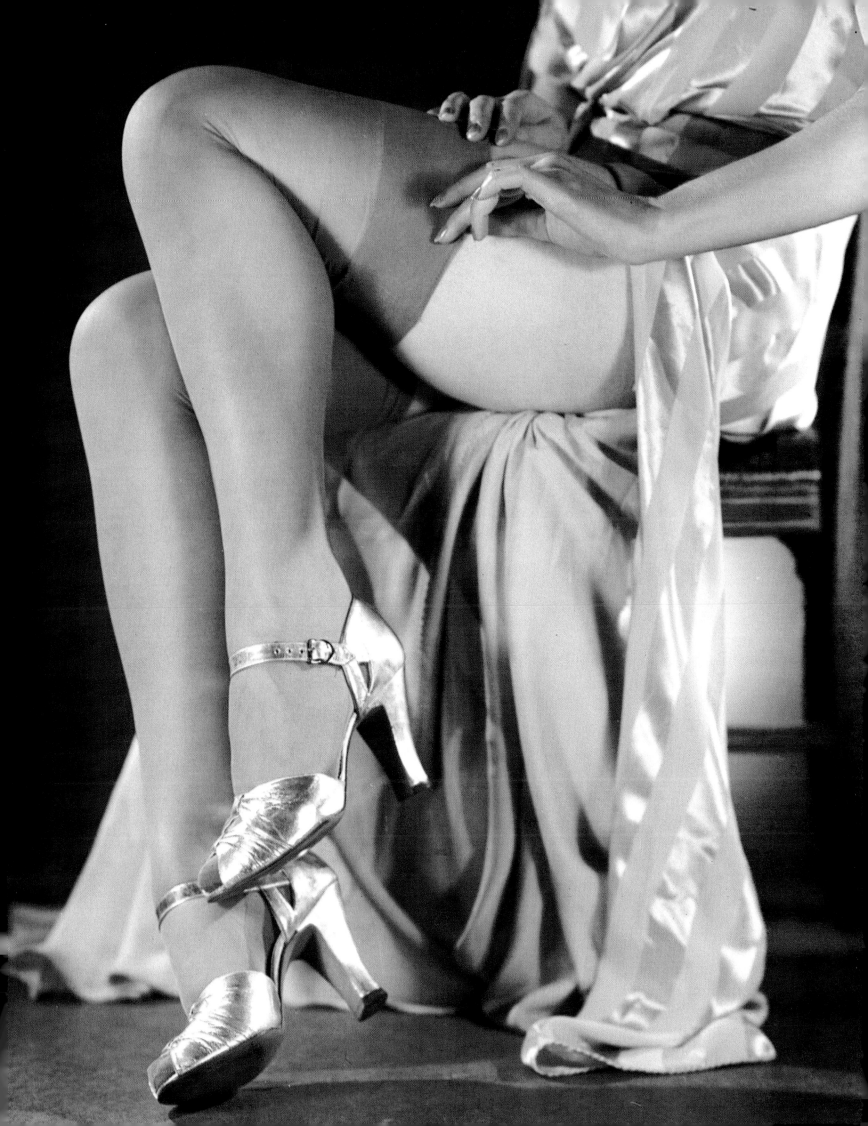

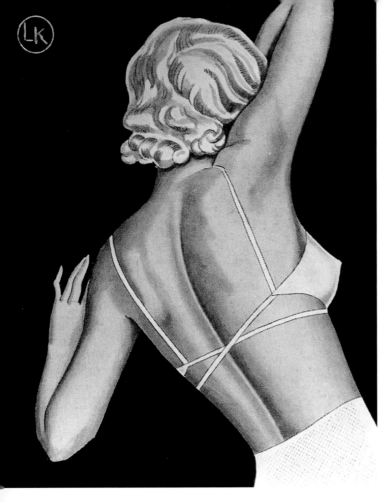

graze her toes with her fingertips, an exploit hitherto beyond the realm of possibility.[7]

Girdles, waist belts, corset belts, corselets: as the terms gained in nuance, through details in design and differences in materials, the elasticized sheaths that succeeded the stockinette (rubberized tricot) generation all sought the bewitching appeal of the "glove fit." Elastic they may have been, but they were still made of rubber, and the results were far from meeting expectations. In 1933, Marlene Dietrich, who had already grudgingly adopted the garter belt, was putting on a little weight and, in an effort to fight the flab, ordered dozens of the latest, flesh-colored girdle models. The experiment was to last fully two weeks. "My mother, who hated even her garter-belts, loathed these rubbery things, especially the line they made beneath her narrow skirts. The garter-belt at least allowed the line from thigh to crotch to show unhampered while moving, but this thing cut the line and created its own—right across mid-thigh.... 'They make you look as though you have short legs and an old behind, all flat,' she said."[8]

Above:
Brassiere with narrow shoulder-straps, 1939.
Facing page:
Catalog of the department store Au Bon Marché, 1939. Colorful lingerie was becoming more popular. "She wore a mauve combination with great bands of ochre lace that cut across her bust and legs. That woman has no taste at all, Philippe thought to himself. He only liked women in simple underwear, or else the extravagant wiles of the hookers at the Madeleine Theater or the Opera House." Paul Nizan, *La Conspiration*, 1938.
Preceding pages:
Left, the modern all-elastic corselet (1930s). From this time, the majority of girdles had slide fastenings. *Right*, stockings (end of the 1930s).

A smartly dressed woman owned at least three types of girdle: one for shopping, one for sport, and one for gowns and evening wear. If she was of slender form—and if her girdle was styled to order—perhaps she might avoid another, almost inherent pitfall of the girdle and a constant bane to the feminine self-image of the time: the "spare tire." This fold, "occasionally of considerable size," that "rides up over the stomach and the hips and even under the shoulder blades at the back" lay unseen beneath the over-the-head dresses of the 1920s. It was soon to become "intolerable with the close-fitting dresses" of the following decade.[9] To counteract it, the corsetiere fitted the girdle with gussets or, in a more radical alternative, would suggest that her dissatisfied customer move up to the all-in-one, which, by melding girdle to brassiere, had the advantage of melting away the offending bulge.[10]

As this rebirth of natural body curves became ever more pronounced, so the brassiere gained in acceptance. No longer the strip of material or bandeau to which it was confined in the 1920s, it acquired its modern form, structured around two sections of material—whether cups, triangles, shapers, cones, or so on. The variants in construction and terminology reflect one and the same purpose with regard to the breasts: separate and support. This new generation of the brassiere was embodied by the triangular-shaped models of the American brand Kestos, created at the beginning of the 1930s. Another minor revolution was in the offing: in an effort to classify the female form and so standardize production, manufacturers were adopting a universal size system. In 1928, after a pioneering anthropometric study on five thousand women, the Australian Berlei company defined the five major types of bust.[11] In 1935, Warner launched the first

Lingerie de couleur

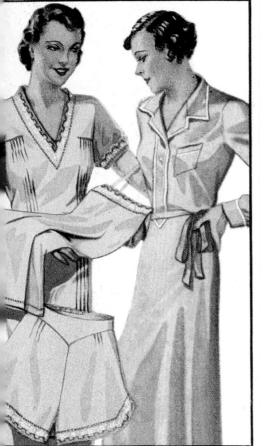

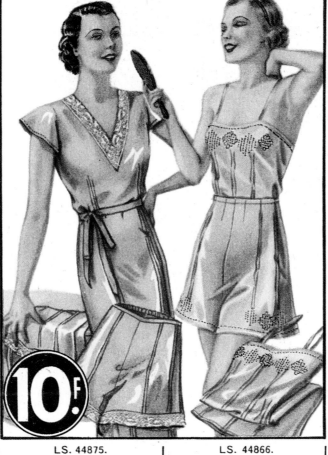

LS. 44870.	**LS. 44853.**	**LS. 44875.**	**LS. 44866.**	**LS. 44814.**	**LS. 44851.**

...URE nansouk rose, ...citron, rehaussée d'une ...rie sur tulle ton assorti.

...emise de ...u la culotte. **8.50**
...mbinai-...pon ... **13.50**
...emise ...t **19.50**

CHEMISIER en pico-tine rose, citron ou parme, orné liséré blanc, blanc orné liséré rouge.

16.50

Occasion. PARURE crêpe de Chine artificiel rose, ciel, blanc, ornée d'une dentelle bourdonnée.

La chemise de jour ou la culotte. **10.**
La combinaison-jupon ... **15.**
La chemise de nuit............ **20.**

Sensationnel. Cette **PARURE**, entièrement faite à la main, est ornée de jolis motifs de jours grilles exécutés sur une toile de **soie natu-relle** rose, ciel ou blanche.

La chemise de jour ou la culotte. **29.**
La combinaison-jupon **39.**

Cette **PARURE** est en nansouk rose, ciel, citron, de belle qua-lité. Les bordés et les pois main sont de teinte nattier et en font une opposition agréable.

La chemise de jour ou la culotte. **15.**
En taille exceptionnelle **17.**
La chemise de nuit ... **29.**
En taille exceptionnelle **33.**
La combinaison-jupon. **20.**

CHEMISIER en p... cale filetée rose ... citron, col et pa... ments blancs, poche... brodée.

12.75
Taille exceptionnel...
15.75

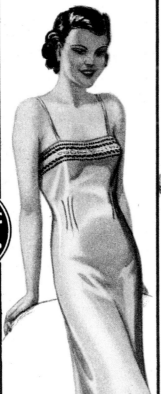

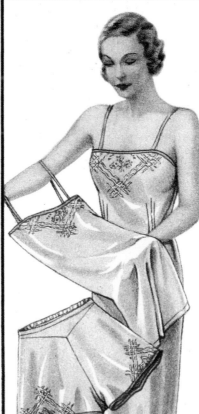

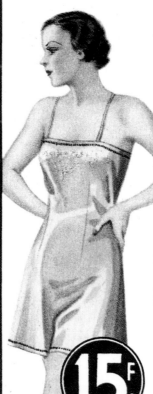

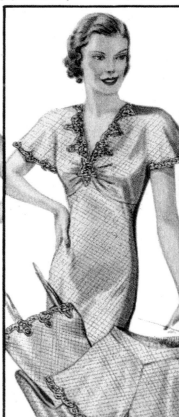

MARLENE DIETRICH
AND HER BRASSIERES

Dietrich, young or old alike, had terrible breasts—they hung, drooped, and sagged. Brassieres and, finally, her secret "foundation" were the most important items of clothing in all our lives, for she expected those of her inner circle to suffer this affliction with her.

Dietrich bought every make and model of every brassiere ever designed. If she thought she might have found the perfect one, dozens were immediately ordered, only to end up in storage boxes when they didn't work out after all. The first things we did on arriving in a new town or country was to look for lingerie shops. Maybe this time we might find the magic cut that could transform her, as she called them, "ugly" breasts into the pert, upstanding young glands she so desired. She agonized over each fitting. Each blouse, dress and sweater had its own style or bra—never interchanged, always carried with us in marked envelopes, "for Fittings." For some low-cut dresses, when nothing would do the uplifting effect correctly, wide strips of adhesive would pull and fold the flesh into the aesthetic shape of a young and perfect woman.

Maria Riva, *Marlene Dietrich by Her Daughter*, 1992

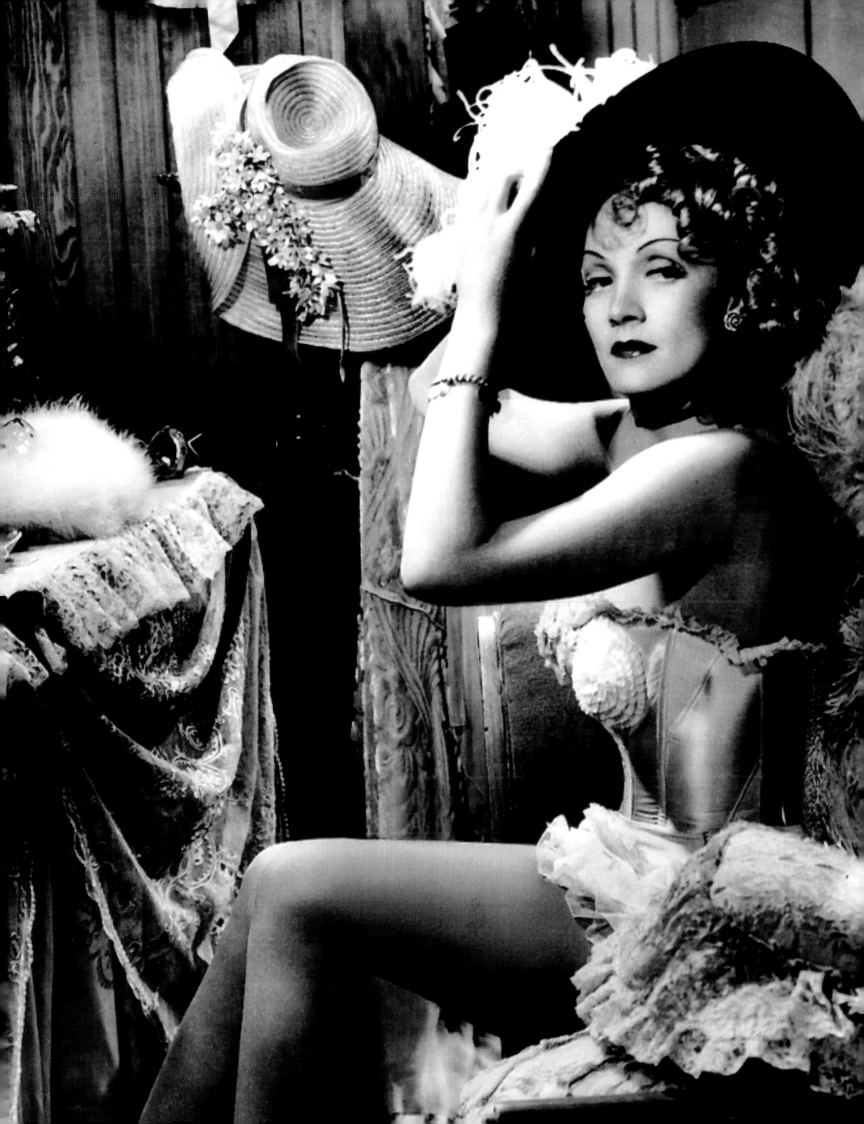

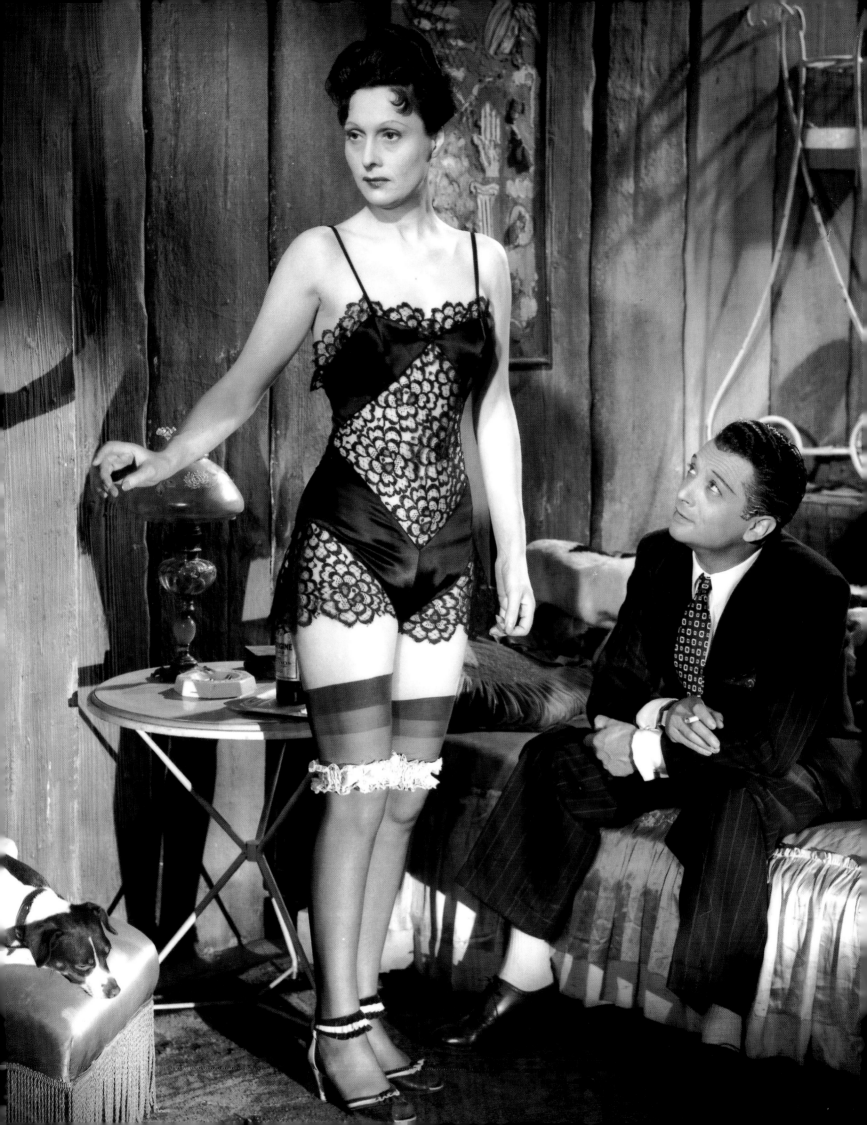

alphabetical classification of the bosom: from size A to size D, from the most modest (Small Bust) to the most imposing (Very Heavy Bust).[12] The transformation of the brassiere at this time is a prime example of fashion, taste, technology, and vocabulary, of body culture, and of erotic uneasiness converging to produce a single effect. A piece of corsetry in the strictest meaning of the term, the brassiere was now to become the "hotel"—if not the "altar"—of the bosom. In this sense, the bra was now ready to form part of the sensual liturgy of women's lingerie. Almost entirely absent from both advertising and pornography during the Années Folles, it surfaces in 1930s publicity material, where it is vaunted for its capacity to provide support and firmness for the breasts. Little by little its image gained in erotic charge. After the Second World War, above all in the 1950s, it entered a golden age and in turn became an object of fetishistic obsession.

NEEDLEWORK AND ETERNAL WOMANHOOD

Once in their room, she started very slowly to undress while he watched her, holding the lamp in his hand. At last she was ready, standing there in her nightgown, feeling more than ever defenceless with nothing but the thin fabric between him and her nakedness.

MAXENCE VAN DER MEERSCH, *Hath Not the Potter*, 1937

Seconding the new fortresses of corsetry such as the girdle and the brassiere, the day slip and the nightdress now came forward to serve as godmothers to nascent 1930s femininity. The decade witnessed the last gasp of the "cami" family—of the cami-knickers and cami-drawers—that had floated around the *garçonne*'s immodest forms. According to the summer 1935 number of *La Belle Lingerie*, either "little chemises" with drawers separates or else "slips falling onto drawers" (or onto the new briefs, or, *slip*) were now to be preferred. Another borrowing from the show girls of 1920s Paris music halls, briefs in 1929 were still being considered in some quarters as "the most anti-aesthetic and ridiculous thing one could hope to see clothing a human body,"[13] but by 1938 they had become "indispensable."[14]

A distant descendant of the corset cover and the petticoat that had between times developed into the bra-slip, the modern one-piece full slip is no longer a "cami" combination of drawers and chemise, but a unique and inseparable sister to the dress that runs down from the shoulders over the bosom to slide decorously along the curve of the thighs. Ordinarily in cotton, it acquired a sophisticated sheen through the use of materials such as satin crepe, crepe de chine, yarn crepe, watered crepe mousseline, satin georgette, and other washable fabrics. By 1938, it had matured into an invisible "underdress" worn beneath the gown, hugging the bust but not the stomach or thigh. In its taffeta variant, "whose gentle rustle brings back the

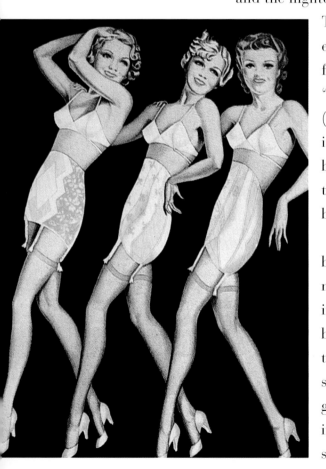

Below:
Assorted girdles and brassieres by Kestos, 1939. "Bust too large, bust too flat, bust too low": on February 3, 1939, in reaction to the 1930s renewed interest in the bosom, the magazine *Marie Claire* devoted six pages to the "bust problem," presenting a range of brassieres supplied by corsetieres.
Facing page:
A young woman in the 1930s, in cotton-knit underwear perhaps by the French firm Petit Bateau, "pour Dames": "yielding, elegant, and practical" (*Modes et Travaux*, April 15, 1939).

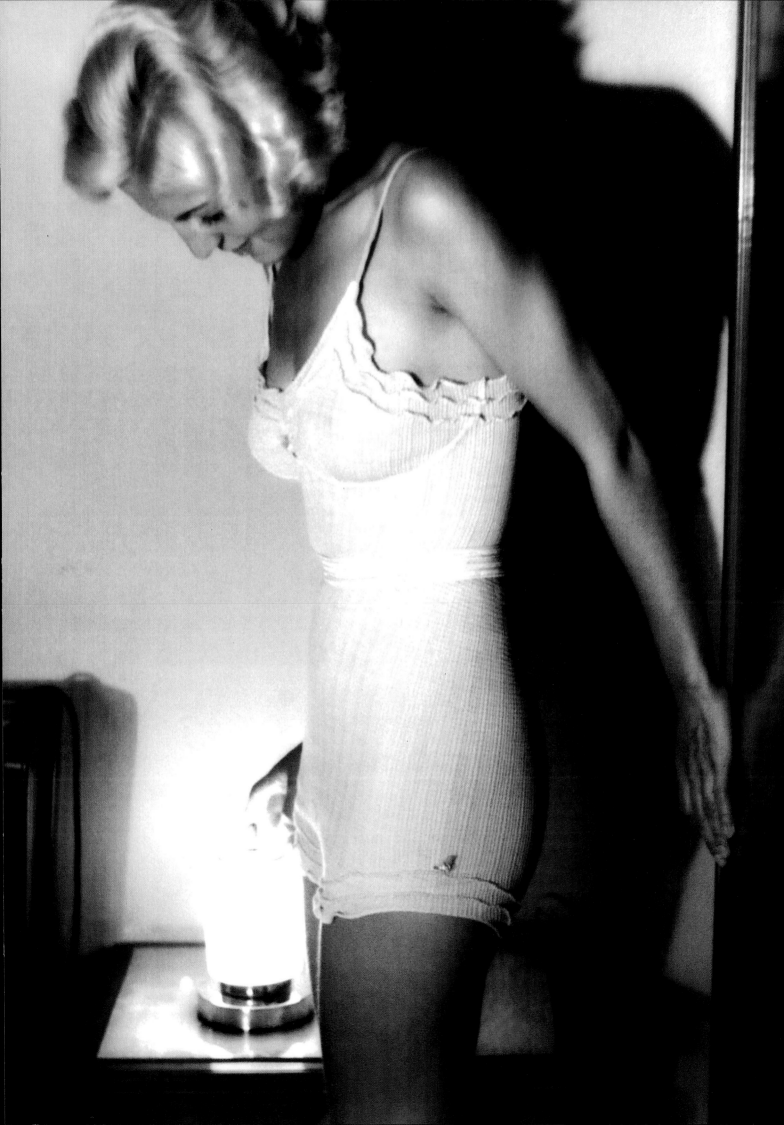

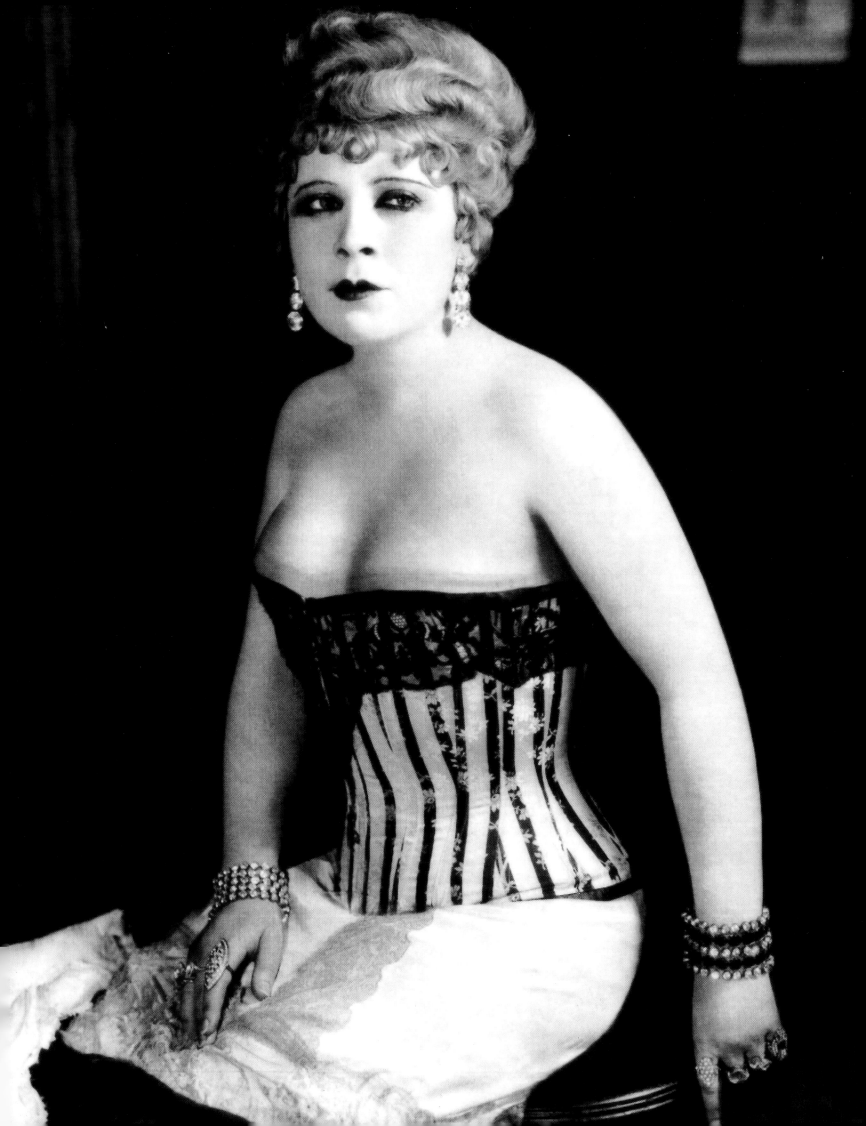

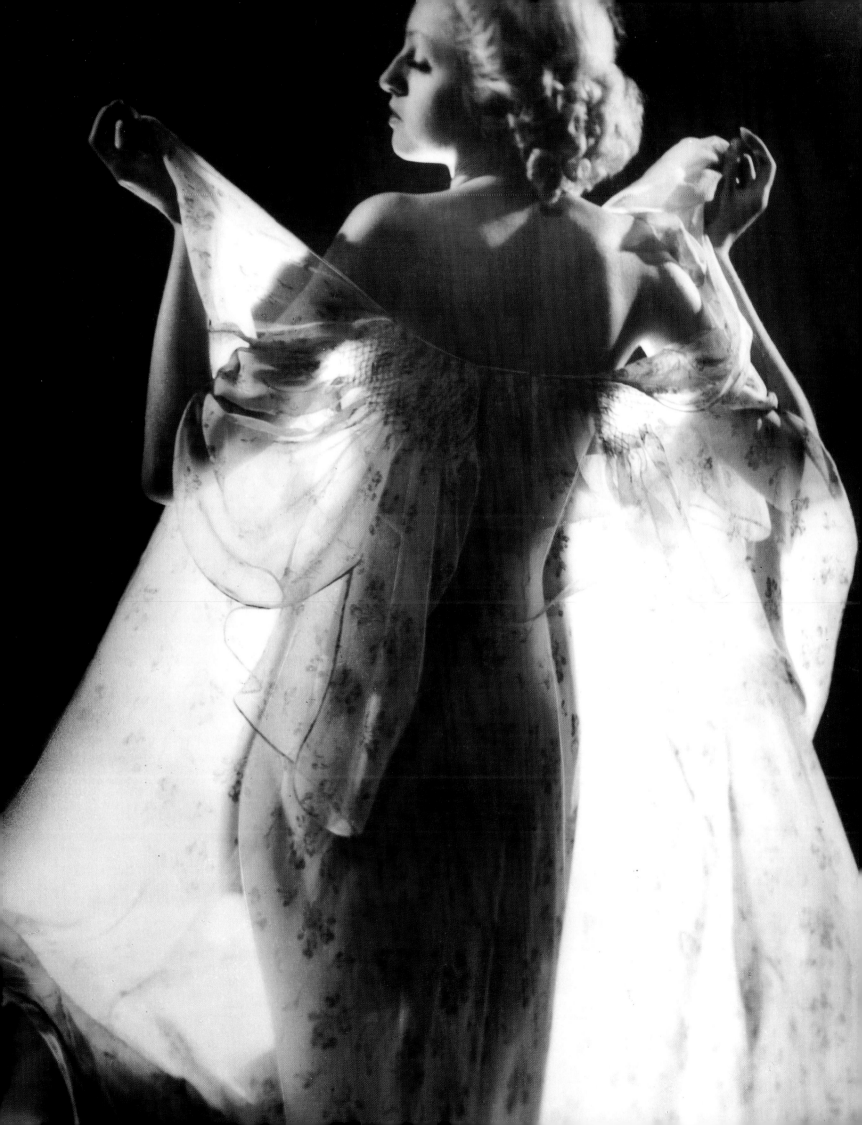

Right:
On the left and at right, nightgowns, and, in the center, a deluxe dressing gown or *matinée* (morning dress), all three made by Cadolle at the beginning of the 1940s. As the 1930s progressed, nightwear became increasingly sophisticated under the influence of the Hollywood studios that draped its heroines in gorgeous but decorous negligees rather than leave their movies open to attack from the board of censors. The elevated term "nightgown" was used to describe nightdresses, and the new refinement proved detrimental to pyjamas: "Save for travel wear, the negligee is competing strongly with pyjamas," one could read in a 1935 number of *La Belle Lingerie*. "A downward line for the silhouette is back, a truly feminine shape, now derived from fashions in evening wear."

Preceding pages:
Left, in the climate of censorship created by the Hayes Code in an America deep in the slump of the Great Depression, Mae West scored a hit with a bosom that exploded from beneath dresses that she always wore with a corset. When Marlene Dietrich lamented that producers (with the audience in chorus) were always clamoring for her "legs," West was heard to express the opinion that, if Dietrich would only give the punters a "bottom," she'd give them a "top" (quoted in Maria Riva, *Marlene Dietrich by Her Daughter*, New York: Knopf, 1992). Here, Mae West at the theater in *Diamond Lil* in 1928. *Right*, a diaphanous negligee from *Harper's Bazaar*, 1937.

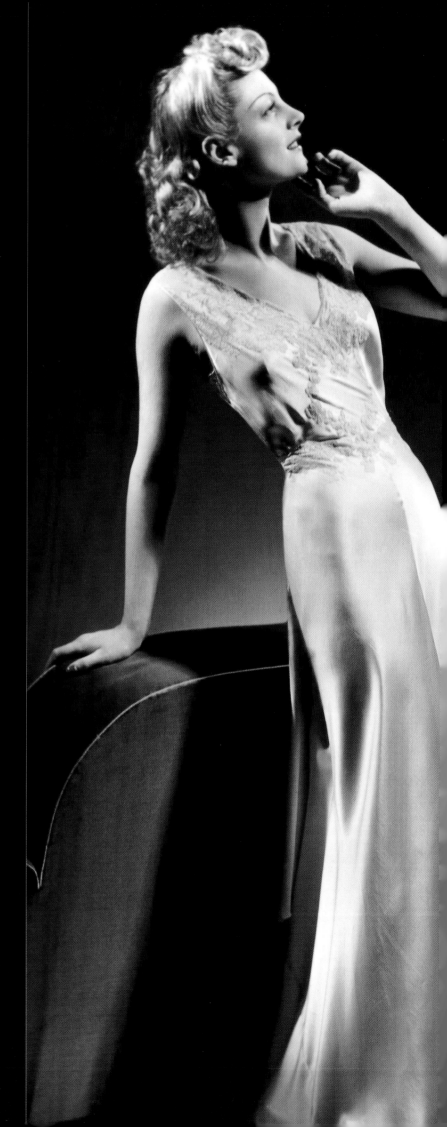

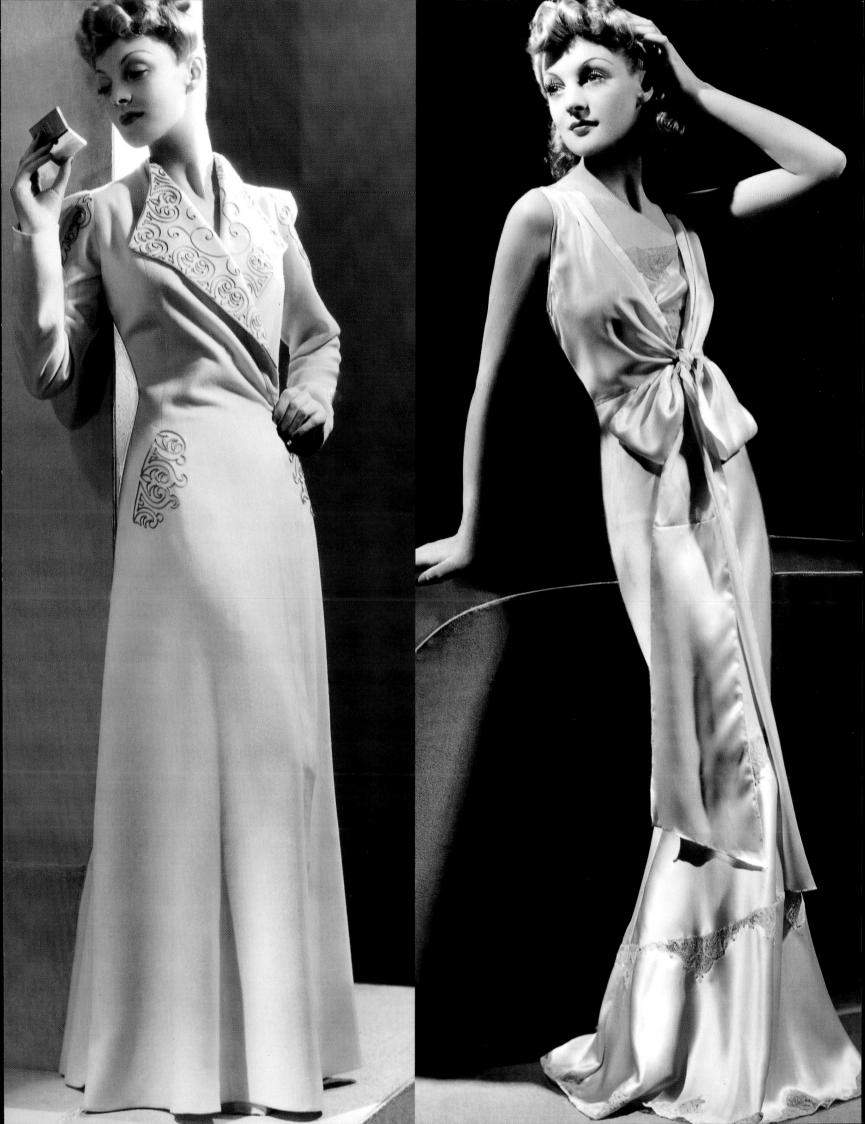

sound of some delectable waltz,"[15] it produced, within the intimate arena of the under-
skirt, a muffled echo from the fashionable kind of romantic "Viennese" blockbusters that
Hollywood was now turning out. With the advent of the talkies, dresses no longer remained
silent as they flitted across the movie screen. Rustling, crackling, and swishing, an audible
train would follow the gown, confiding its secrets in hushed tones. By carefully selecting
fabrics and installing microphones that captured and amplified the faintest murmur,
Hollywood dress designers could concoct a voluptuous soundtrack.

The new, prettified nightdresses and negligees, and even, in the most gorgeous of
trousseaus, bed jackets, mantels, night shawls, boleros, and nightshirts, reflected a senti-
mental return to the intimate privacy of home life. "Men are tired of their sexual free-
doms—women even more so," wrote Emmanuel Berl in 1932.[16] After the orgies of the

1920s (be they real or imaginary) the
decade deserted easy-come easy-go
affairs and, echoing more than one popular song, began once again to dream
of hearing "sweet nothings" whispered in its ear. Fashion's hesitant thrill in its
treatment of the nightgown is one of the telltale signs of a new mystery, of a
fresh innocence and decorum to which the period now aspired.

Like slips, nightdresses were soon to embrace the princess line already so
much in vogue in the late 1920s. As much decorative fervor could be fostered
on a nightdress (with silky materials, fresh colors, and pretty lace trim) as on
any evening gown, to the point that, in 1929, nightgowns had become "verita-
ble, even elegant, little dresses."[17] "Nightdresses have almost liberated them-
selves entirely from the notion of being 'undergarments.' They have become
independent," *La Belle Lingerie* said in summer 1935.[18] During the winter of
1938, the journal was even asking itself whether, generally speaking, it could
call the season's underwear mere "day linen" since it offered such delightful
variants in trim, including "flowers and leaves, dragonflies, birds, and butter-
flies, tulle and lace, taffetas and satin, in both insertion and appliqué."

Above:
Advertisement for
Flexees girdles. *Harper's
Bazaar*, 1939.
Facing page:
Junie Astor in a
combination (1930s).

There ensued a comeback of fine white goods and a resurrection of lace: as
the decade progressed, fashion embroidered still more—and the press commented still
more—on the intimate secret domain that women cultivated like a walled garden for their
regained femininity. In the "flat ruffle borders, pulled-thread work, pleated 'beehives,'
raised patterns, and gossamer inserts in lace and tulle,"[19] they could espy a renewal in
handicraft, a sure sign that painstaking Penelope was once more at her work. The praise
heaped on needlework was a foretaste of the celebration of "eternal womanhood" under
the Occupation, when Vichy leader Marshal Pétain—whose watchwords were the "spirit
of sacrifice" as against the "spirit of pleasure" exemplified by the Roaring Twenties—
strove to chase Frenchwomen back into the kitchen and guide them to the gentle joys of
domestic toil.[20]

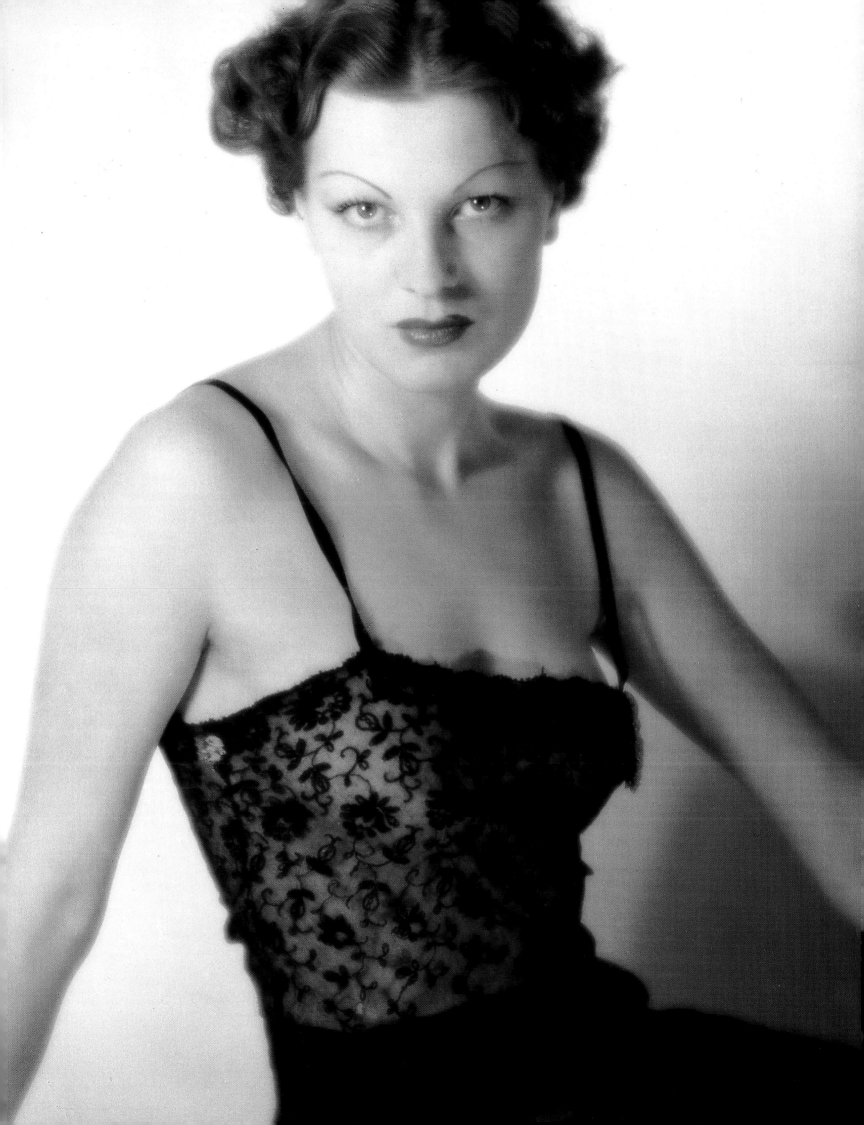

1947–1957: COLD YEARS—HOT UNDIES

There were only six mannequins ... on one occasion one of them, an extremely pretty blonde
English girl, fainted and fell into my arms. I thought I was clutching her securely, but she continued
to slide to the floor while I found myself holding only ... her bust! I had completely forgotten
that in my desire to give prominence to this most feminine attribute, I had asked those whom
nature had neglected to equip themselves with "falsies."

CHRISTIAN DIOR, *Christian Dior et moi*, 1956

Choupette had put her bra back on, probably just to enjoy undressing again.
"Touch of the slut there!" thought Bernard. "They're all the same!"

RENÉ FALLET, *Banlieue sud-est*, 1947

A pretty Parisian cycles across the Place de l'Opéra, her feet clad in bobby socks and clogs; another, more coquettish, coats her legs with walnut stain or a brown dye like Filpas lotion to make it look as though she is wearing silk stockings: charming pictures like these from the years of the Second World War and the Occupation seen from the fashion angle are hardly scarce.[1] Lighthearted snapshots of rationing and of "going without" in difficult everyday conditions, they also illustrate that gift for recycling things, for "making do," and for the ingenious use of needle and scissors typical of the period.[2]

Not only did the outerwear wardrobe have to come to terms with the new situation; the chest of drawers containing the women's linens had to as well. As raw materials became scarcer, what remained hidden was sure to come last in a woman's list of priorities as the war imposed changes in habit. An elegant cyclist in divided skirts would not wear a slip underneath at all, and back in her freezing apartment (coal was in short supply), she laid aside her prewar tea gowns and her lace and mousseline negligees to take up warmer and comfier wraps.[3] Shortages persisted until well after the Liberation while, for some French families, the use of ration books dragged on until the end of the 1940s. As deprivation lingered, so did the habit of scrimping and saving and the knack for repairing and salvaging clothes. Such shortcuts fed into a vast body of knowledge of the "be your own seamstress" genre that long outlived the war years: slips that have seen

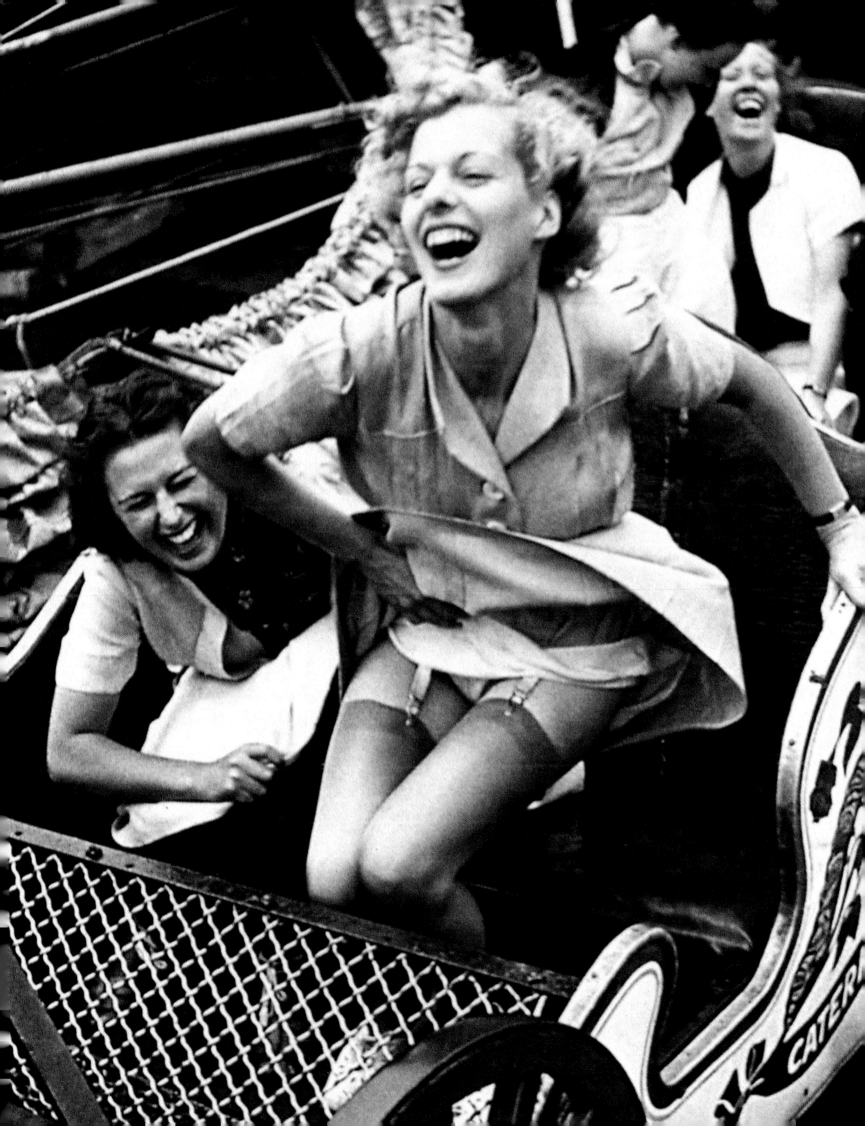

better days must be repaired in a special way and not "simply by sewing a patch over the threadbare areas"; lace trim has to be unpicked from a "worn-out piece of underwear" before being carefully washed and twisted around a bottle to be dried;[4] an old pair of silk stockings is to be hauled off to the hosier for an umpteenth restitching.

"Just between the two of us, nothing will ever take the place of pure cotton for underwear": so said a shop assistant in the Printemps store to Pimprenelle, the newlywed heroine of the famous novel-guide of the same name who is tempted by a "pretty ... very neat, very distinguished" nightdress made of *Albène*, a type of dull acetate yarn that felt chilly on the skin.[5] During the war, silk and cotton having more or less disappeared, manufacturers fell back on artificial fibers, in particular on two cellulose-based substitutes, rayon and spun viscose. A promotional exhibition in Paris had been devoted to these materials as early as July 1941, and Anny Blatt, as well as other designers, presented a collection of nonrun lingerie manufactured in these stopgap fabrics.[6] Such substitutes were, however, of poor quality, and, lacking body, quickly lost their shape. After the Liberation, luxury and haute couture lingerie alike soon abandoned them and returned to their prewar fondness for nobler fabrics. All the same, the common run of underwear continued to pander to the mediocre, much to the distress of a trade journal like *Les Dessous élégants*, which, in 1952, wondered whether postwar lingerie had not entered an "age of mass-produced defamation," and whether women had not lost all taste for and understanding of fine linen.[7]

CORSETRY OF THE "NEW LOOK"

It was against this background that Christian Dior presented his first collection on February 12, 1947. On seeing his full-busted flower-women and his "Corolle" line dress, the American journalist Carmen Snow, in terms which have since become historic, exclaimed: "Dear Christian, your dresses have such a *new look!*" A fresh figure for the ideal woman was being drawn: possessing bust, waist, and hips, its curvaceous lines were to be accentuated as the 1950s wore on. As we have noted, in the wake of the prewar reaction against the boyish look a revival of more womanly forms was already under way. In the United States, in autumn 1939, *Vogue* proclaimed the advent of the "hourglass" figure and recommended the use of a whole new generation of corsets capable of giving women a slim waist without any of the pain entailed by whalebone stays.[8]

The war had stifled this trend and muffled its effects; yet the backlash was now endowed with a symbolic charge on which the "New Look" was quick to capitalize after the Liberation. In the New Look, a deliberately backward-looking femininity exacts revenge on the remaining military females built as sturdily as boxers who "still looked like Amazons."[9] Dior

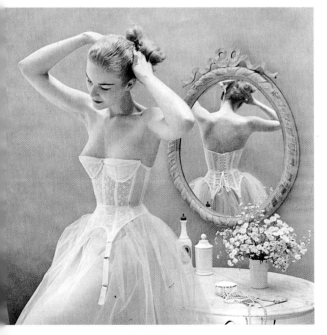

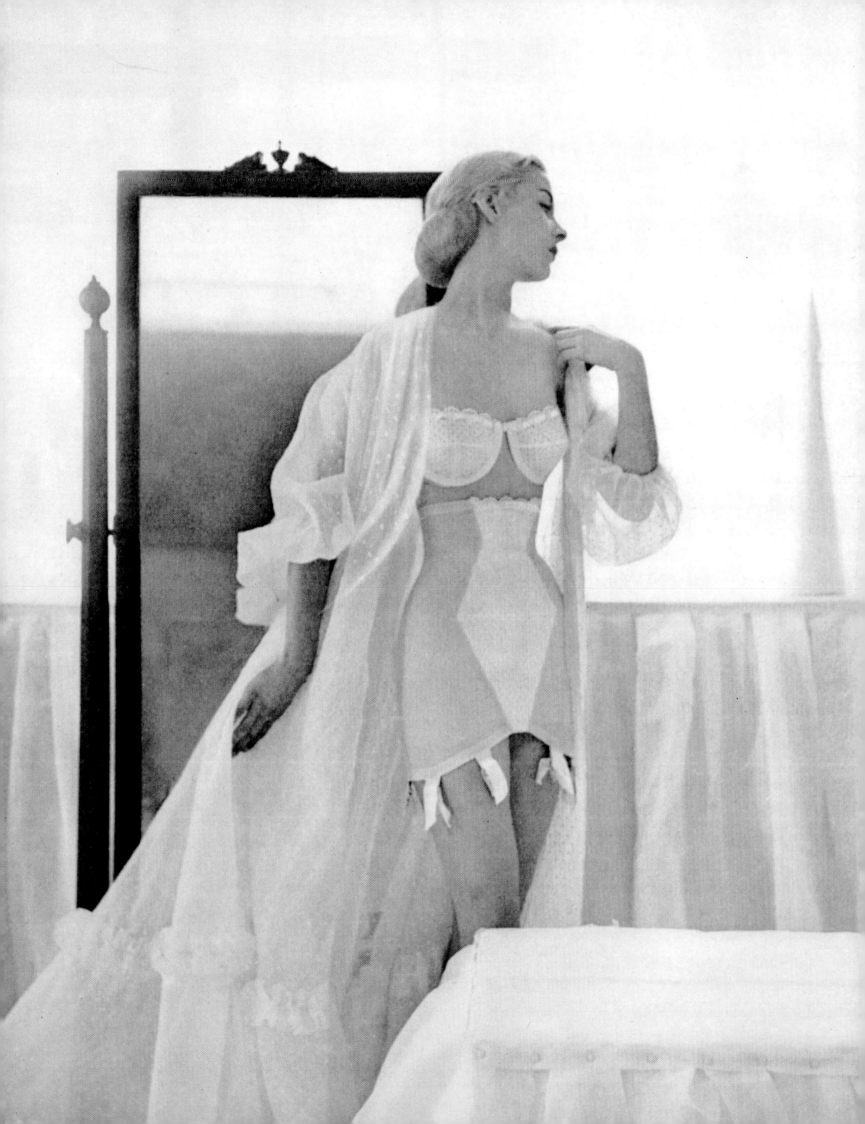

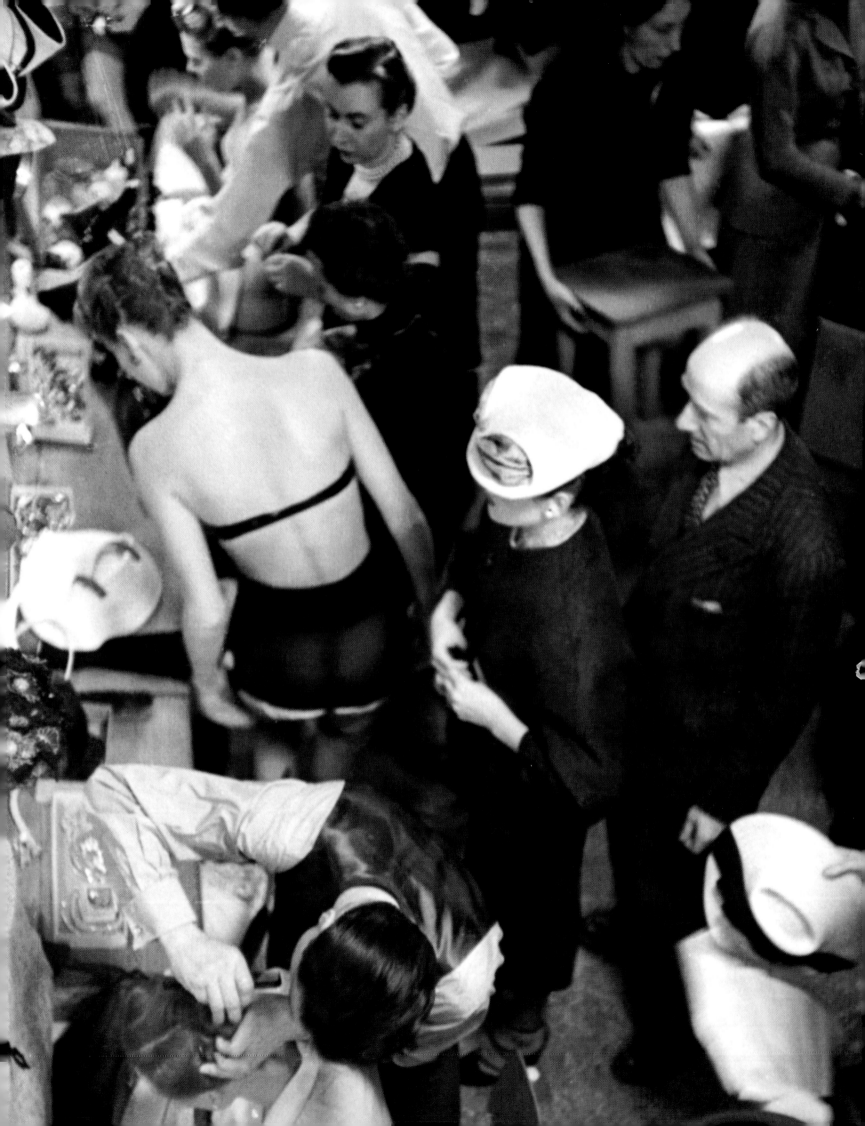

was to hark back to the Belle Époque or the Second Empire, to "clothes that were well made," with "pretty styles which were *becoming* to women for the first time in years," and from which they had been ironically debarred, "by a woman"—though in his memoirs he did not name the real target of this barb, Coco Chanel.[10] Generous with fabric, flounces, and ruffles, the New Look acted as a focus for many postwar aspirations. It amounted to a manifesto that pleaded for more pleasurably feminine clothes after years (many years for some) of shortages and pedestrian fabrics. By the same token, women, who had been such active participants in the recent conflict, were now placed back on a pedestal and invited to revert to their former status as pretty but frivolous creatures— though now at least they had the right to vote (in France since 1944). "'Down with the New Look!' 'Burn Monsieur Dior!', 'Christian Dior, go home!'" Such were the words of welcome (as he reported himself) meted out to the couturier on his arrival in Chicago by the "suffragette housewives brandishing placards on sticks" who cast such a shadow over his American tour.[11]

"Rounded shoulders, full feminine breasts, and hand-span waists."[12] The bywords that Dior used to describe his style encapsulate a whole generation that, for nearly ten years— as a devastated Europe struggled back to its feet and the Cold War hardened an already puritanical worldview—dreamed of voluptuously bosomed females. If Dior and his frocks were winning over well-dressed American women, so the unambiguous poses and suggestive lingerie of transatlantic pinup girls (new-style Venuses draped meekly over the page and dropping out of B-29 holds and GI truck cabins)[13] had become the stuff of which male dreams in the Old World, too, were being made. In 1943, the deep-cut dress struggling with Jane Russell's unabashed bosom as she frolicked amid the hay bales had netted more than one lawsuit for Howard Hughes' film *The Outlaw* while the poster was banned for immorality in many U.S. cities.[14] Some years later, she and other putative daughters of Mae West (Gina Lollobrigida and Sophia Loren, Marilyn Monroe and Rita Hayworth, Ava Gardner and Elizabeth Taylor) had not only invaded movie screens, but were plastered over hand-painted cinema billboards and, protected behind glass like untouchable icons, adorned the stills hanging in the theater foyer.

If one ignores for a moment yawning chasms in taste, distinction, and class, the haute couture *élégante* with her sublimated eroticism and the blatantly *sexy pinup* (both terms were gaining ground even in France at the time) were part of one and the same imaginary female: while the latter exaggerated her volumes and curves, the former refined her silhouette or—to use the high-fashion buzzword of the time—her *line*.[15] Between these two extremes, the resurrection of the anatomical trinity uniting bust, waist, and hips brought with it an expression that was to meet with great success: *vital statistics*. In 1954, armed with her measuring tape (and Larousse's *Guide de l'élégance*), every Frenchwoman could compare (and perhaps contrast)

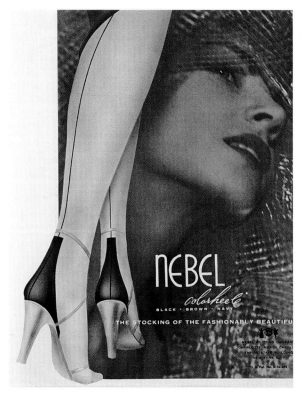

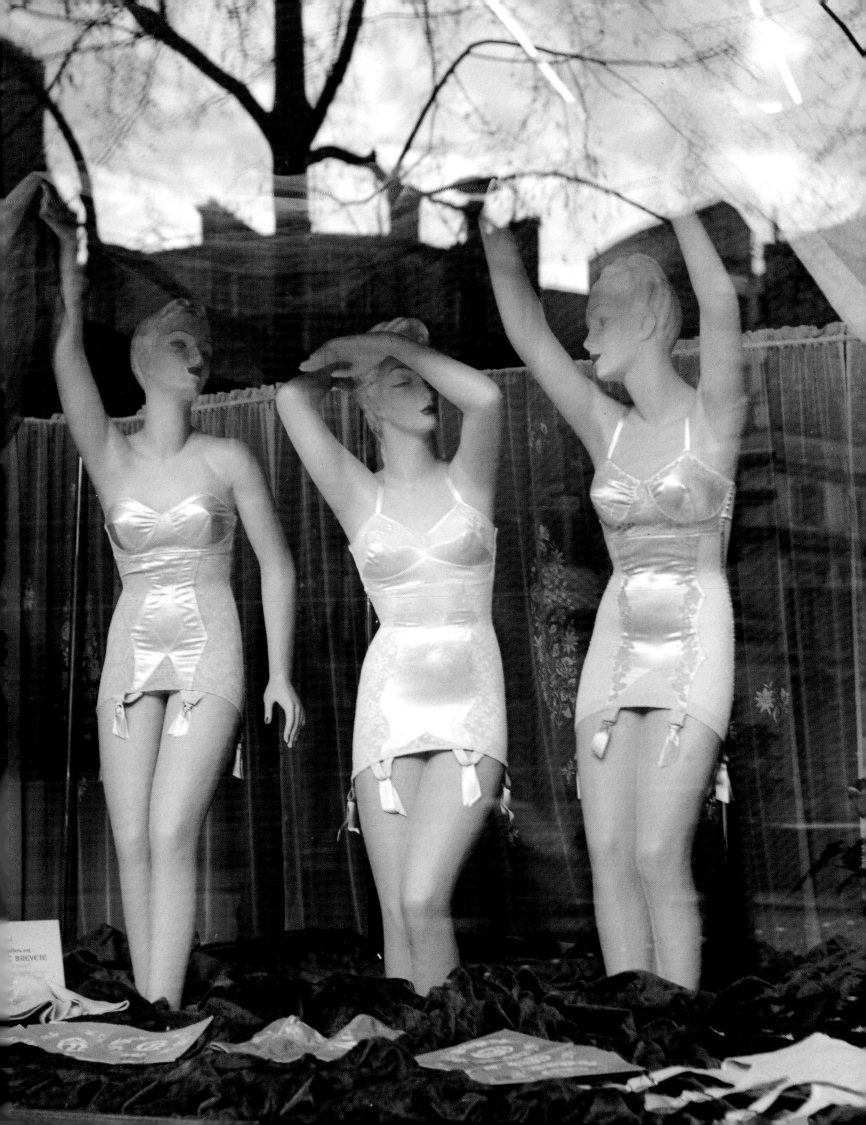

This page:
One of five photographs
from a June 1949 *Harper's
Bazaar* article entitled
"Nylon, a Natural Traveler."
The model, shot in a railway
compartment, is wearing
pink zip-fastening panties
by Paris Maid ($5.98).

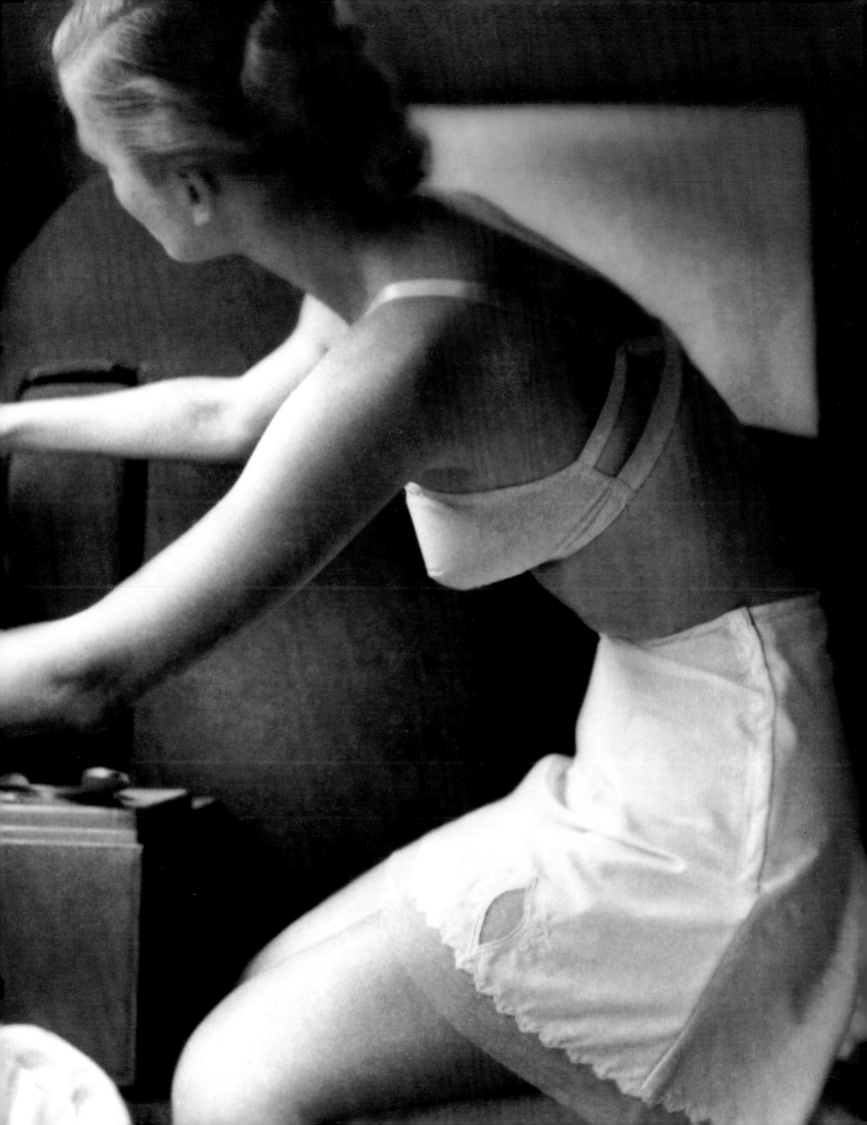

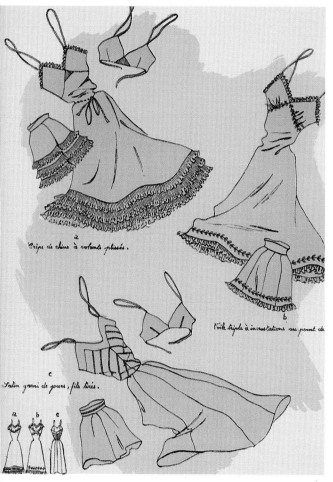

Preseason inspirations
for bras, bra-slips, half-
slips, 1948.
Facing page:
For afternoon wear, "Valse
petticoat in nylon pekined
poplin," by Nicole Bernard,
1954. At the end of the
1940s and during the
1950s, the fashion for pet-
ticoats and funnel-shaped
dresses even drifted
through the pages of litera-
ture. "Afternoons, he'd go
for a walk along a road
leading into the mountains.
He would be constantly
overtaken by girls on bicy-
cles, their light dresses bil-
lowing up in the wind. One
of them said with a laugh:
'Ah! this wind, he's such a
one!'" Henri Calet,
Poussières de la route.

her own statistics with those of the era's fashion runway stars: Fabienne (5' 5", 108 lb., bust 34", waist 17", hips 35"); Bettina (5'4", 110 lb., 34-21-33); or Capucine (5'6 1/2", 127 lb., 36-22-37).[16] Such "model" figures gave a fillip to corsetry: the "balconette revolution" in 1947, as vindicated by Madame Carven (her corsetiere being Marie-Rose Lebigot); the strapless "push-up" variant that Jacques Heim claimed to have "launched";[17] or else the fleeting success of the French neologism *corsouple* (supple-body), to replace the old-fashioned *corset*, forged and imme-diately adopted during an interview by Christian Dior, who then demanded to be acknowledged as its "godfather."[18] It was in fact the corselet (girdle and bra in one), with the occasional addition of a flounce running round the hem in the guise of a slip, that stepped into the new role, especially under evening gowns. In the United States in 1951, the Warner company, taking inspiration from a film starring Lana Turner based on Franz Lehar's *Merry Widow*, launched an all-in-one of the same name, available in black or white, with attached garters and optional straps. For a number of years, the bare shoulders of wealthy American heiresses ensconced in the hourglass "merry widow" burst out of their bustier dresses like full-blown flowers.[19] Back in France, Dior, who had since abandoned his godfatherly responsibilities, released a *Combiné-Dior* in elastomeric fiber. Every stylish corsetiere was now proposing her own made-to-order model, from Marie-Rose Lebigot (whose creations had bestowed such a majestic allure on Simone Signoret in the 1952 film *Casque d'or*) to Cadolle and Madeleine Riccy, whose advertisement in the February 1949 issue of *Vogue* sang the praises of an "unwired evening [model] in nylon" with a delicately frilled border.

B y the end of the 1940s, the majority of these models made good use of what is thought to be the world's first wholly synthetic fiber. Following their cousins in the United States, European women were only now beginning to familiarize themselves with a name that heralded the first generation of hosiery to benefit from its textile qualities: *nylon*. Tensile, lightweight, flexible, and easy to care for, patented by Du Pont de Nemours in 1938, nylon was *the* dream fabric for the female leg in the postwar period, although initially it came over to France as a relative luxury being still scarcer and dearer than rayon.[20] The *Age of Nylon* (so ran the title of a novel saga by Elsa Triolet) was, however, only in its infancy. Luxury corsetry found in the technically advanced fiber a source of renewal from which commercial lingerie would reap the benefit only at a later date. Among all the "inventions" destined to satisfy the dictates of the postwar narrow-waisted look—stretch girdles, longline girdles, waist cinchers, corselets, hip confiners, wired garter belts, and so on—it was the *guêpiére* (literally, wasp-waister), known to Americans as a French cinch, that was to reign queenlike over lingerie of a saucier cast in its later

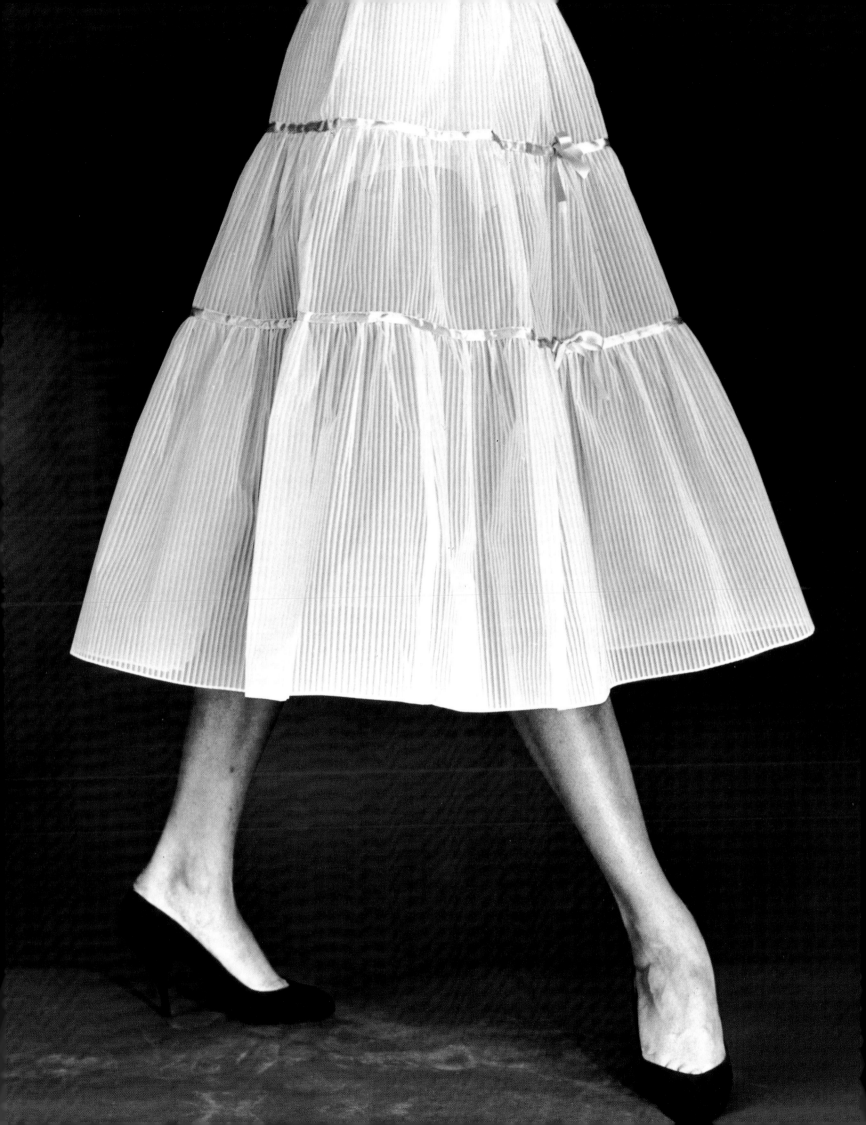

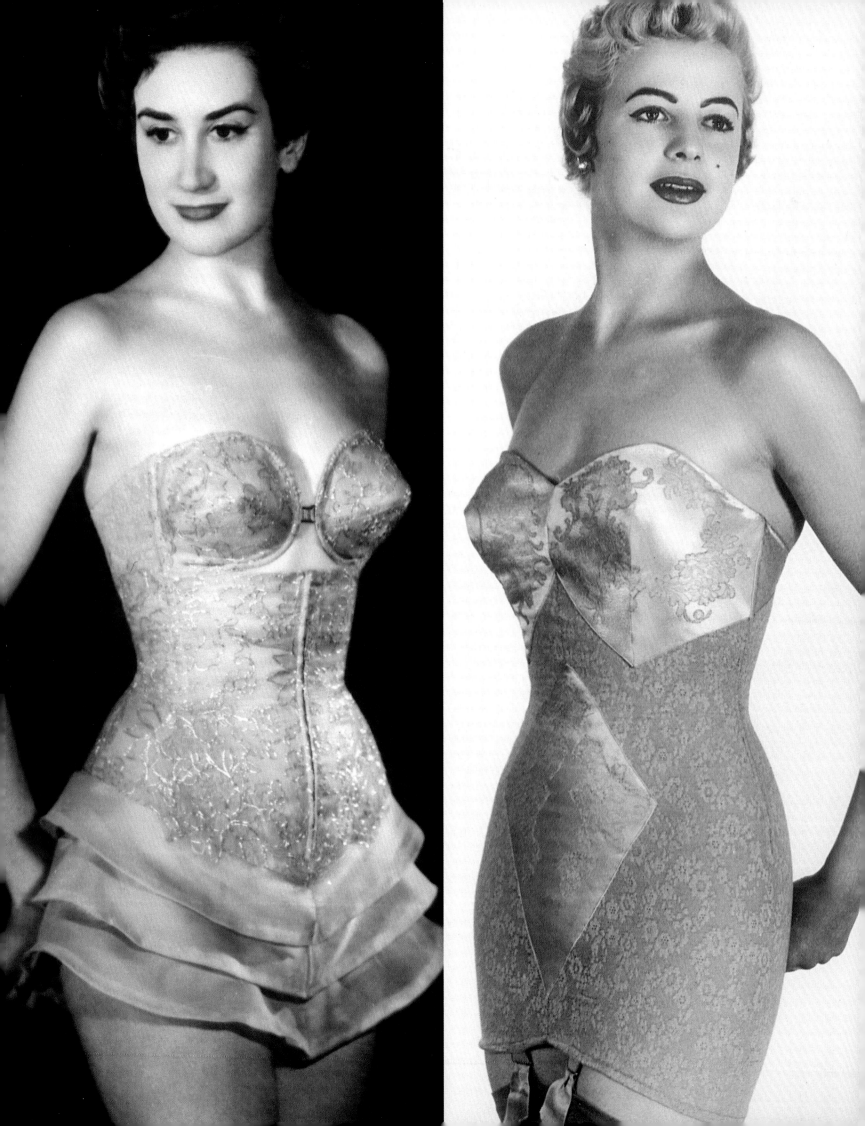

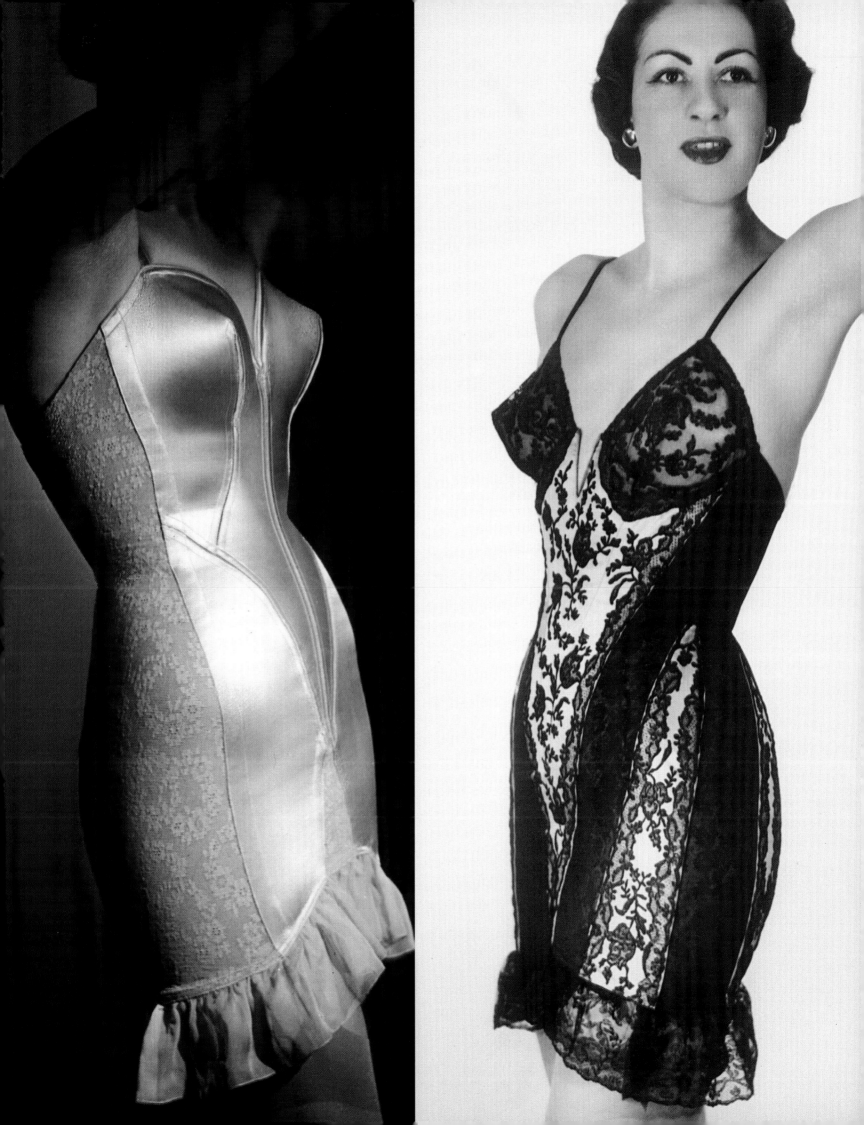

PINUPS AND STARLETS, THRILLERS AND DIRTY MAGAZINES: TEEN MEMORIES OF FIFTIES LINGERIE

At age fifteen we'd masturbate over *Paris-Hollywood* and *V Magazine*. The latter's pages swelled with pneumatic pinups with explosive knockers, Russellesque bazookas, and Hayworthian undulations; the former publication, following an unvarying script, would show chicks in wishy-washy colors (apricot and spinach) and in various states of undress: (1) top; (2) skirt; (3) bra; (4) stockings; (5) garter belt; (6) briefs (with either a quick flip to the backside or a clever angle to avoid showing any reprehensible pubes). Such were our boarding-school Madonnas. The eroticism our grandfathers had preferred, all ankle boots and whalebones, left us cold—as would today's (if it exists) in jeans and tights. The same went for the page with prewar *femmes fatales* (coal-black eye makeup, silk drawers with lace inserts, satiny stockings, stage-girl or shower-room breasts). Even Suzy Delair's* frippery did not turn our heads: too many old-fashioned frilly bits. The war had hardly fostered fetishistic excitement: the hideous wedgies, the viscose or rayon drawers, the darned cotton stockings, the chicory dye with which clever girls painted seams on their legs. Our generation lived to see the reign of synthetic fabrics and of King Nylon. Good-bye corsets of suburbia, farewell darning girls, sitting in booths on the arcades or behind a haberdasher's shop front, eyes down on their repairs.... With prosperity came a vast immoderation of wedding white, Chesterfield's "perfect legs encased in a spiderweb of nylon," "tiny pert panties," the "Scandale" girdle in sketches by Brenot, push-up cleavage, "featherlight" garters and other clichéd trappings of modernity with which Peter Cheney and his disciples kept us amply supplied. The slip hung around for a time in neorealist films, but it was soon chased out by Brigitte Bardot's frothy underskirts.

JEAN-CHARLES GATEAU,
"Et la quatrième créa,"
in *Chroniques des années froides
(1947–1956), Silex,* 20, 1981

* Actress Suzy Delair, star of *Quai des Orfèvres* (1947) and *Lady Paname* "Lady Paris," (1949).

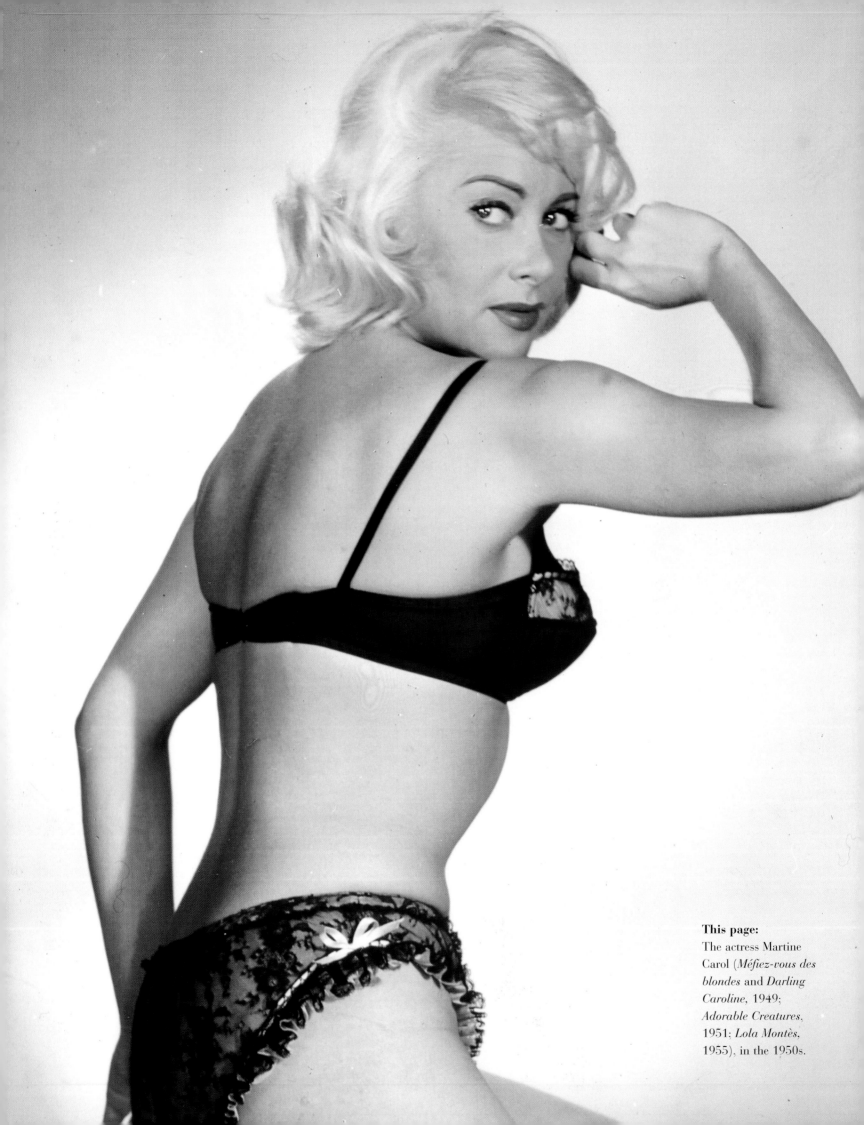

This page:
The actress Martine
Carol (*Méfiez-vous des
blondes* and *Darling
Caroline*, 1949;
Adorable Creatures,
1951; *Lola Montès*,
1955), in the 1950s.

Cécile Aubry,
end of the 1940s

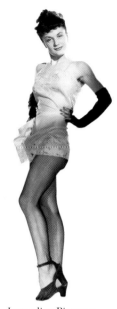

Jacqueline Pierreux,
about 1947

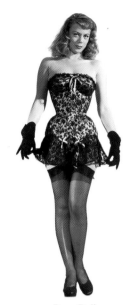

Dora Doll,
early 1950s

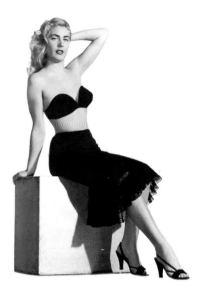

Geneviève Kothinoff,
end of the 1940s

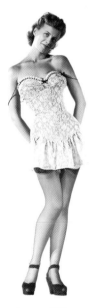

Jeanne Miller,
beginning of the 1950s

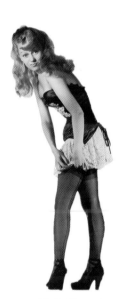

Gisèle François,
early 1950s

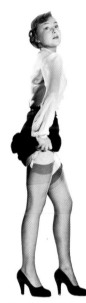

Dominique Wilms,
beginning of the 1950s

Sophia Loren, 1950s

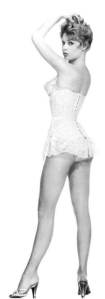

Brigitte Bardot, 1956

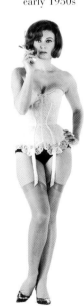

Nicole Gaillard, 1959

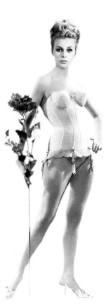

Advertisement for Vertige,
late 1950s

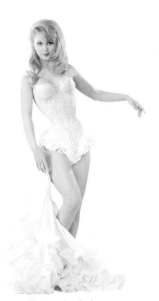

France Anglade,
early 1960s

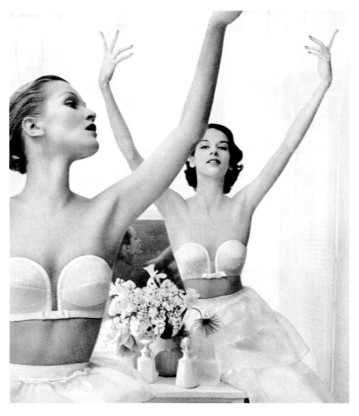

Above:
Advertisement for a
strapless brassiere worn
with an evening gown.
Harper's Bazaar, end of
the 1940s.
Facing page:
Diana Dors, the celebrated
1950s English actress who
arrived on the movie scene
after winning a beauty
contest—a famously
curvaceous tease from
many British films of the
1950s. *National Police
Gazette*, 1957.

transmagnifications. A little shorter and with more wiring than a girdle, its name—which describes its effect—was a strong argument in its favor.

Launched by Marcel Rochas in 1945, the wasp-waister was in the same vein as the bustier-dress with which the couturier had made such a splash in September 1942 and the outfits he had devised for Mae West before the war.[21] In black lace, often fitted with garters and even sometimes with an abbreviated slip, it soon became obligatory photo-shoot apparel, almost official dress for the sex-appeal starlets of the 1950s, from Rita Hayworth to Ava Gardner and from Jane Russell to Marilyn Monroe or Brigitte Bardot. By 1954, its erotic aura was such that Pauline Réage (the pseudonym under which Dominique Aury wrote the pornographic *Story of O*) cast it as one of the book's fetishistic liveries. There was a white model and a "tight-fitting corset of black nylon taffeta, reinforced and sustained by wide, close-set stays which curved in at the lower belly and above the hips" with which the heroine O was laced, constricting her waist and stomach but leaving her "rear completely free."[22]

Quite apart from such choice specimens, it was the girdle and the brassiere that were to become the alpha and omega of the 1950s line. Worn with suspender garters, the ideal girdle would hold in the tummy so as to obtain the famous "hollow look" of which couturiers were so fond while molding and giving sweep to the hips.[23] "Ample" women would go for a girdle in satin, étamine (lightweight open-weave fabric of coarse tightly twisted yarns), broché (fabric decorated with a swivel or lappet weave pattern) or in "resistant elasticated lace"; "medium" women might prefer taffeta, satin, nylon or "two-way stretch lace giving horizontally in some parts and vertically in others," making for the "ease of movement" that was also recommended for those whose abdominal muscles had suffered from the aftereffects of childbirth.[24]

Despite all this bodywork, considered at the time as indispensable even in the more common, shorter models, the step-in girdle was simply going out in a blaze of glory. Already on the wane during the Occupation, the modern young things of Saint-Germain-des-Prés and the girls who danced at Le Tabou nightclub had long since jettisoned it entirely. For trainee actress Suzanne Marchellier, born in 1922 and who had come to the capital shortly prior to the Liberation, the corset reminded her of her grandmother and the "Paris of the 1900s." The girdle belonged rather to her mother's prewar period and neither she nor her college student sister four years her senior was ever to wear one.[25] Simplification in underwear was the work of a generation who no longer observed the precepts of elegance and haute couture and who heralded the "fringe" street and youth fashions that were to gain such a foothold in the future. The repercussions were already broached in an editorial in a 1953 number of *Les Dessous élégants* that fulminated against the "lamentable nonchalance" of

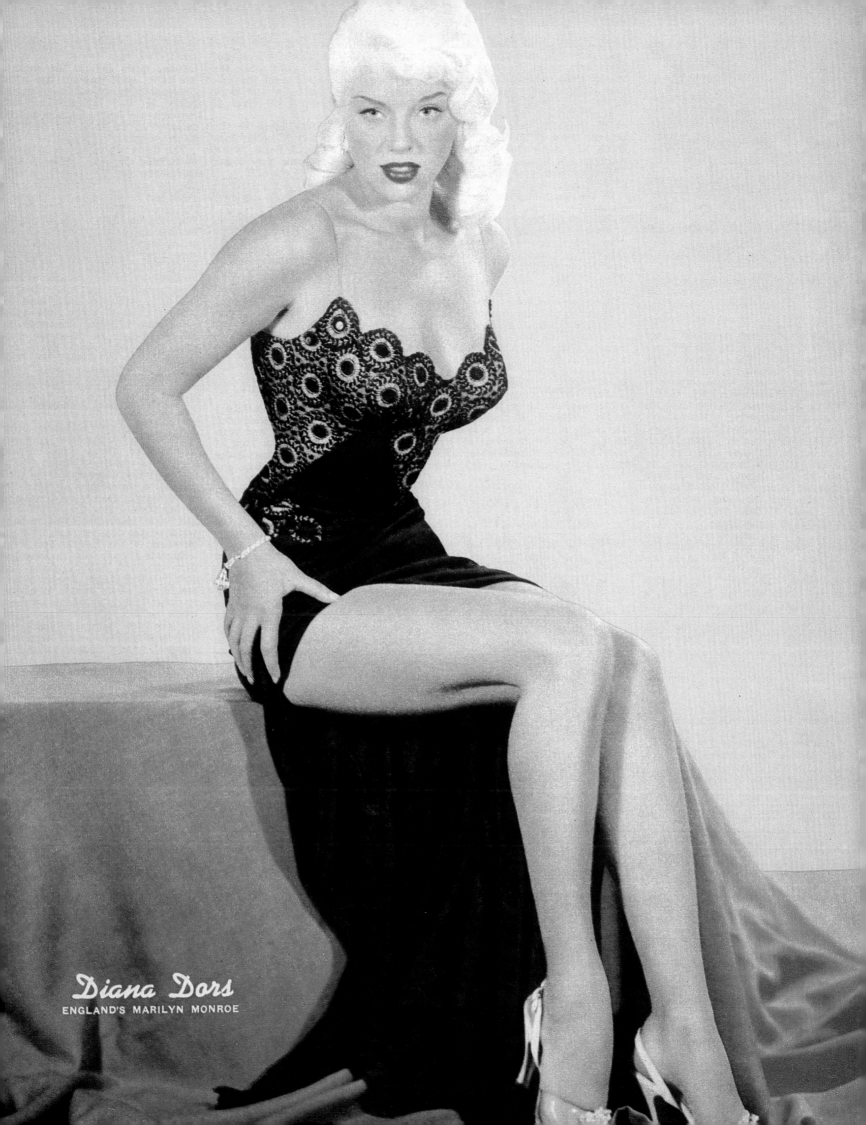

Diana Dors
ENGLAND'S MARILYN MONROE

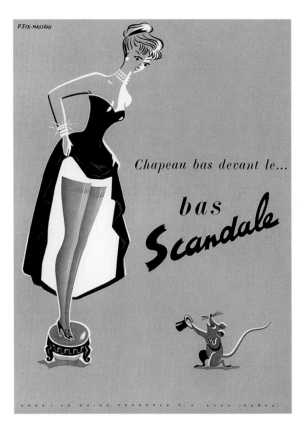

P.FIX-MASSEAU

Chapeau bas devant le...

*bas
Scandale*

those women who are content with nothing more than a mere "slip of the basest kind, whose lines are quite visible under the dress," although this flew in the face of hygiene, comfort, and taste.[26]

Push-up half bra, push-up, décolleté, conical cup, long-line, strapless: the very range of bras available in the 1950s bears witness to the period's fascination with the bosom. Like the movies, the detective novel tailed the subject closely. In his 1953 gumshoe novel *Touchez pas au grisbi!* ("Mits off the dough!"), for example, Albert Simonin lingers over the *"roberts roses"* that endow one of his creatures.[27] Simonin's usage enshrines the growing popularity of a word that designated the breast in the slang of Parisian "tough guys." It had its origin in the surname of the inventor of the first mass-produced rubber-nippled baby feeder which had become famous through an advertising campaign: the "Robert baby bottle."[28] Urged on by the mammary fixation of the period, aided and abetted by a number of fashion designers, wild-haired brassiere professors came up with a host of short-lived technical brainstorms. In the early years of the 1950s, Scandale launched "Very Secret," a nylon brassiere "with infill cups lined with an extremely lightweight plastic pad that can be inflated as desired." Once the bra was on, it was simply a question of blowing into the bags with a pipette "until the required volume was attained" and closing the valve.

SLIPPING INTO SOMETHING MORE COMFORTABLE

– It's horribly hot, Geneviève murmured, wiping droplets of sweat from her brow.
– How I envy the way men can make themselves comfortable.
We women hardly have the chance....
– But who's stopping you?
– Well, you, of course. Normally I wear hardly a scrap in summer.
Though I don't know why I'm telling you all this, I must say.

RUDY GAIRLAINE, *Opération pinup*, c. 1947

L ike the girdle, the slip, too, was starting out on its slower, more convoluted path to oblivion. Disaffection was felt strongest in the summer months. "Too many women," *Les Dessous élégants* deplored, "think they can do without a slip in summer."[29] Its detractors countered that it coarsened the figure and even "flattened the bust."[30] The 1954 *Guide de l'élégance* advised them that, "if you prefer not to have a double thickness of material over the bust, wear a slip fitted at the waist with a length of lastex."[31] The slip remained an option, however, primarily thanks to advantages in hygiene, stylishness, and economy. It protected blouses and dresses from the adverse effects of perspiration, accen-

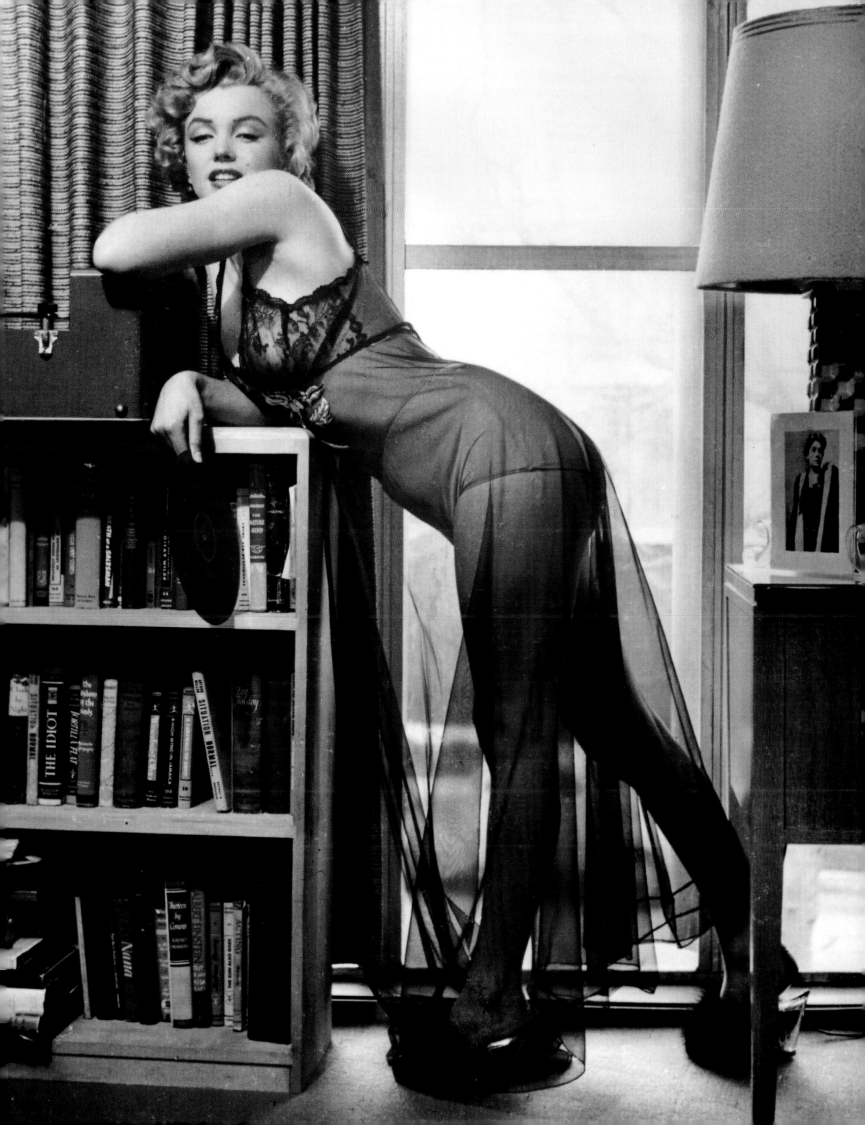

In 1954, armed with her measuring tape, every Frenchwoman could compare her statistics with those of the era's catwalk stars: Bettina (5'4", 110 lb., 34–21–33); or Capucine (5'6 1/2", 127 lb., 36–22–37)

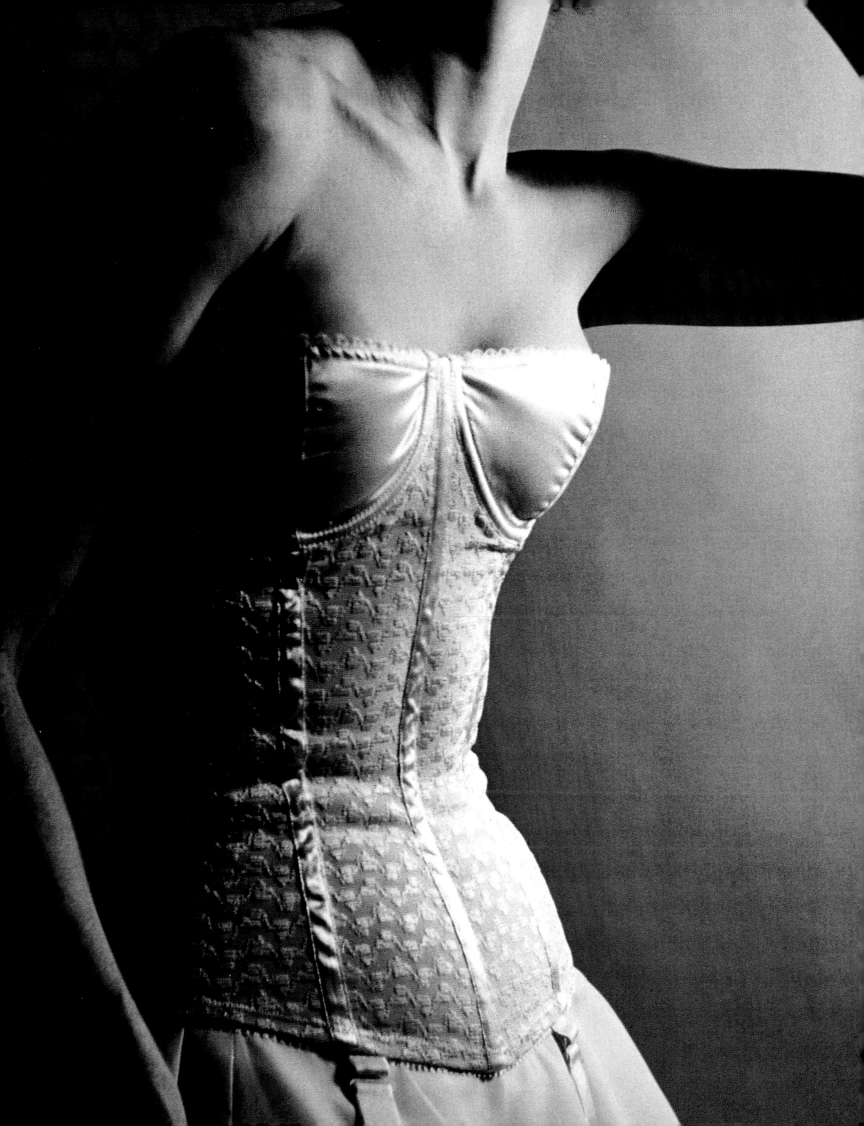

tuated perhaps at the time by a limited observance of the requirements of personal hygiene, the fruit as much of an entrenched distrust of water as of a dearth of domestic sanitation. In many cases equipment in the home was limited to a basin, the kitchen sink, a fixed or fold-away bidet, or even, when the faucet was out on the landing, a washing bowl and jug.

None of these were valid reasons, the *Précis des nouveaux usages* pontificated in 1948: "Only unclean people make loud clamor for a bathroom to wash in since not having one supposedly excuses their negligence. Whatever the means employed—bath, shower, tub or bowl—the human body *must* be washed from head to toe every day, God ordains."[32] If such a thorough going-over was in general reserved for the Sabbath, at least by washing or regularly changing her slip a woman might keep her dresses in good condition longer and save on dry-cleaning bills, too.

A slip could also protect the body against coming into contact with certain fabrics (especially woolens) that could be uncomfortable even when lined. And last, but by no means least, a slip "allows the dress to *fall* and does not hamper the stride."[33] At a time when elegant and high-quality garments were costly (although cheap mass-produced garments existed, fashionable prêt-à-porter did not), when women, so as to avoid having to change their dresses every season, would rather repair and alter them (or have them altered) as fashions and hemlines came and went, such plus points enabled slips to bask in an Indian summer that lasted into the 1960s. In silk, satin, crepe de chine, and wool jersey, for the most part cut on the bias as fashion demanded, its seamed panels would mold the bust and form into a brassiere, while the ribbing would sometimes aid in softening the figure and tucking in the waist. Less stylish were combinations made of nylon and especially rayon or spun viscose, wartime ersatz fabrics that remained much in evidence in the wardrobe. Finally, the slip was transformed into a *foundation* (dress form or foundation dress), which, as its name suggests serves as a kind of backing or lining for a dress, making it fall correctly and assuring smooth wearing, without, however, the full slip's sophistication.

Changes in the erotic imagination had their part to play in the demise of the slip: the very coyness of this little sister to the dress no longer had charms for men now serenaded by seminaked sirens. By 1953, the world of lingerie was indulging a bout of heartsearching over the "suppression of the slip." Marthe Rosemont saw in it a consequence of the "mistaken notion that many women have of the male psyche." To guide women back onto the path to a man's heart, she paints a bizarre picture of the looming threat of repulsion and rejection: "Often, a man who can see against the light that a woman is not wearing a slip or petticoat under a flimsy dress experiences a

Below:
Illustration by Gruau for the "terrific lines" of Lejaby lingerie. *Paris-Match*, 1957.
Facing page:
Michèle Morgan in Yves Allegret's *The Proud and the Beautiful*, 1953.
Preceding page:
The "hollow-look" stomach, fashionable in the early 1950s.

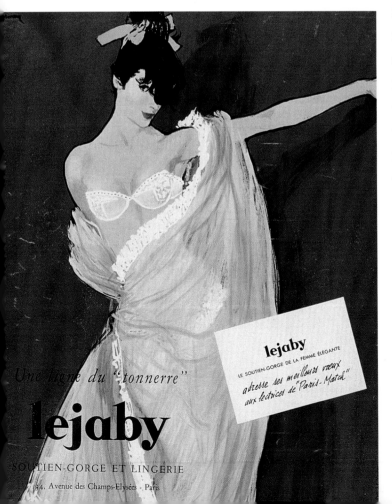

Une ligne du "tonnerre"

lejaby

SOUTIEN-GORGE ET LINGERIE
34, Avenue des Champs-Elysées - Paris

lejaby
LE SOUTIEN-GORGE DE LA FEMME ÉLÉGANTE
adresse ses meilleurs vœux
aux lectrices de "Paris-Match"

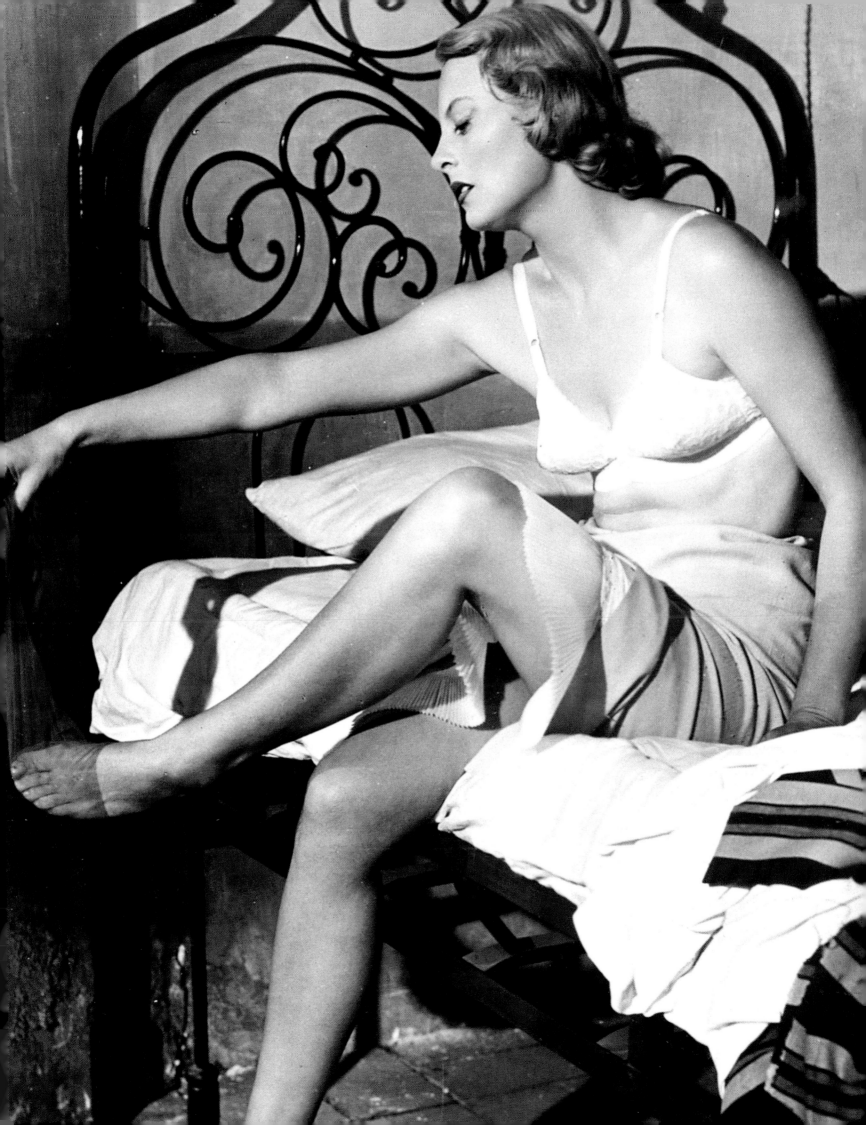

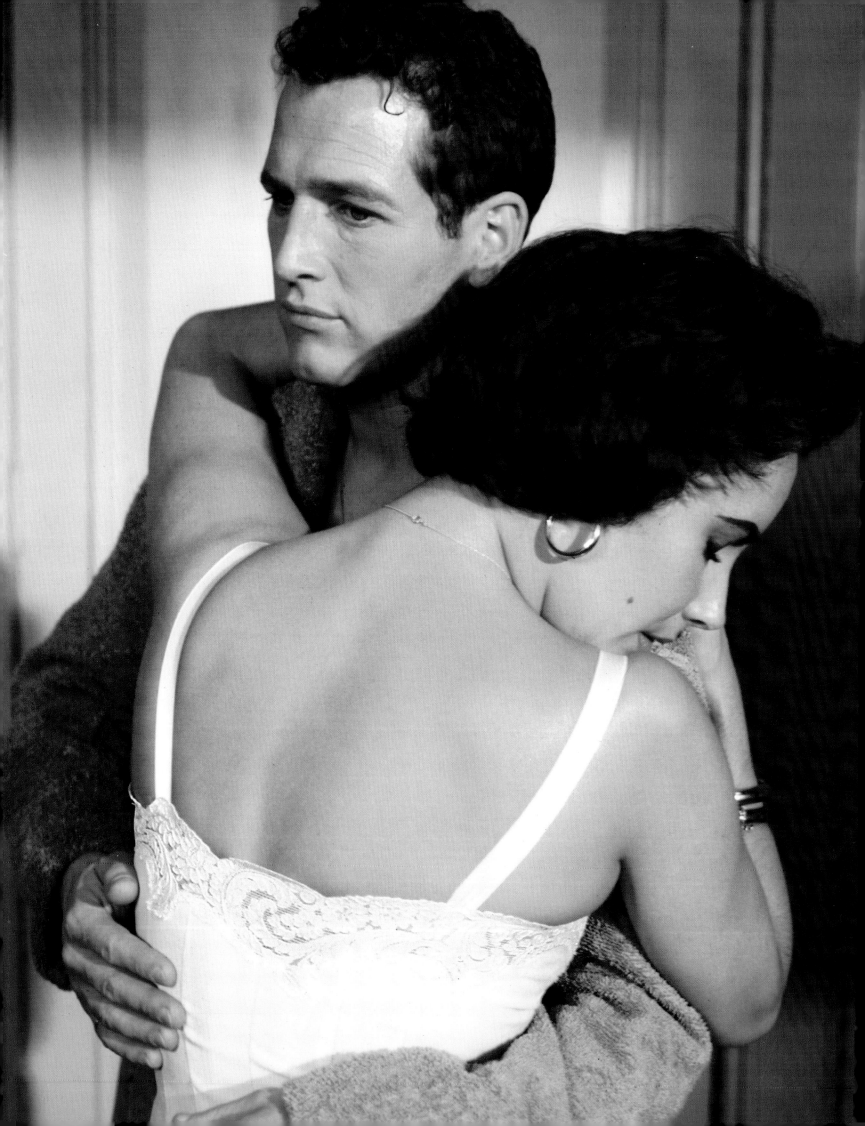

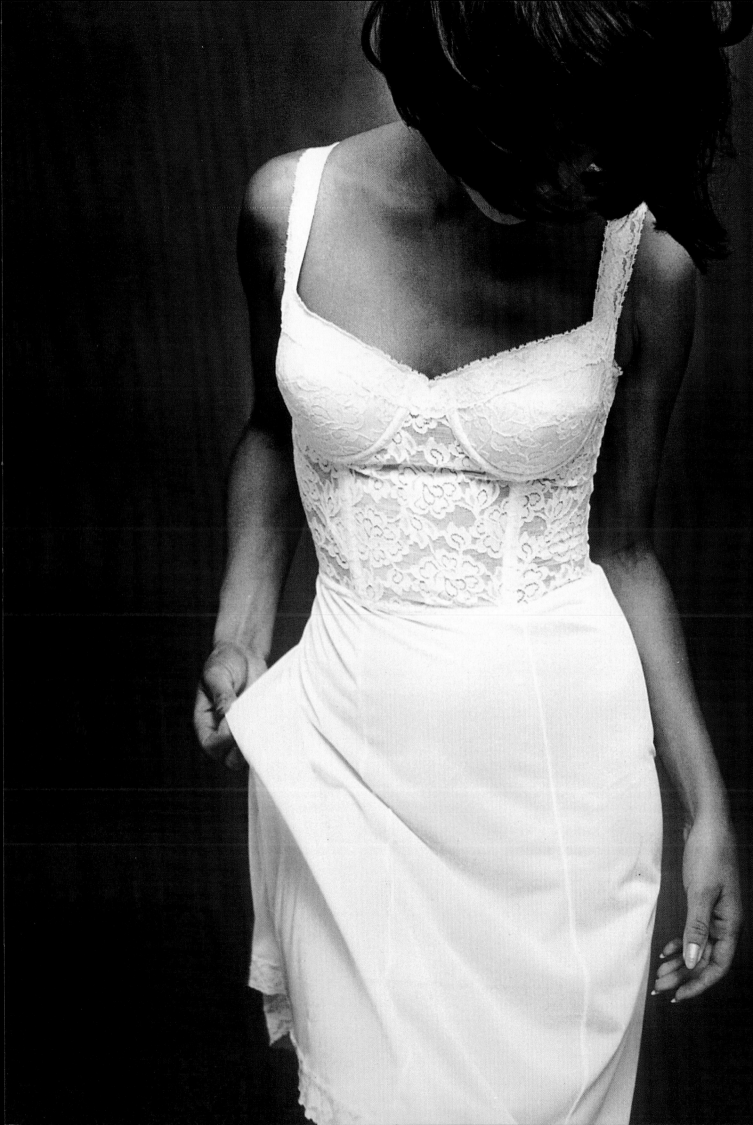

feeling of unease," she writes, adding: "a recent Gallup poll indicates that there can be no room for doubt on the subject."[34] But there would be no going back. Under the watchful eye of the censor, a rearguard action by the cinema did endow the slip with a sensual if fading glow as an optional wile in the game of love, and its aura still appeared dependable to proper housewives and well-brought up young ladies throughout the 1950s. For women of the following generation, however, the slip would seem little more than an out-of-date, out-moded piece of underwear, associated in the memory with homespun and prosaically apple-pie images: a mother splashing some water over her face in the morning or removing her makeup at night; auntie at home, half-dressed in the summer heat.

The true guardian angel of 1950s femininity was the nightgown. Modesty's last ring of defense was pitched in the privacy of the bedroom, and reflected a long-held tradition that forbade wives from appearing naked in their spouse's presence and urged them to disrobe out of sight in their bathroom or behind a screen in the bedroom. Others might undress in the conjugal bedroom but only let the husband enter once robed in a night-gown and safely under the sheets with the lights out. For a woman to expose herself naked in front of a man seemed typical of the prostitute or loose woman. As recently as the late 1930s, stores were still selling nightgowns incorporating a hole especially for the practice of conjugal intercourse.[35]

Since the eighteenth century, middle-class male values had marked a sharp divide between unfeeling and unpleasurable sexual activity with the wife-mother and the seductive, knowing eroticism of the prostitute. From the end of the nineteenth century, however, this frontier was becoming blurred, as public images of professional sexuality modified desires, expectations, and behavior back in the matrimonial bedroom. In the private life of a modern couple, seduction was now being added to the list of wifely duties and the night-gown became one of the most important articles in her armory.[36] In 1902, an author explained (to his woman readers?) the art of using the so-called "conjugal nightgown." "Wives will not start to wear it immediately," he advised, "but after a little time they'll understand the value of the Oriental silk and the batiste fitted with broad lace insertions, all a-quiver with Valenciennes flounces round the hem."[37] From being a decorous covering for the spouse and occasional symbol of her fragility and vulnerability, the nightgown grad-ually turned into an erotically charged object that pressed into service all the wiles of fit and length, of see-through fabric and plunging neckline. This evolution culminated in the sen-sation made by a cropped nightdress worn by Caroll Baker in the 1956 film *Baby Doll* that gave its name to a brand-new piece of nightwear indicative of a brand-new moral outlook.

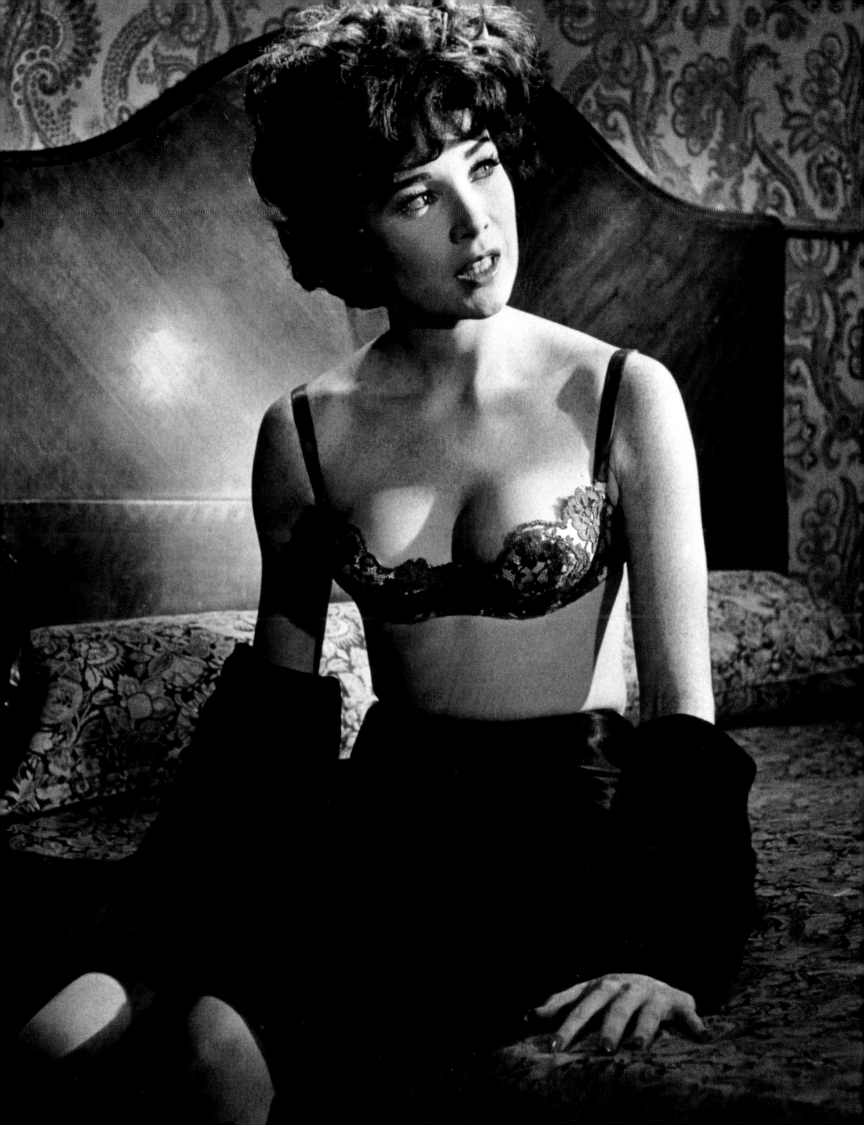

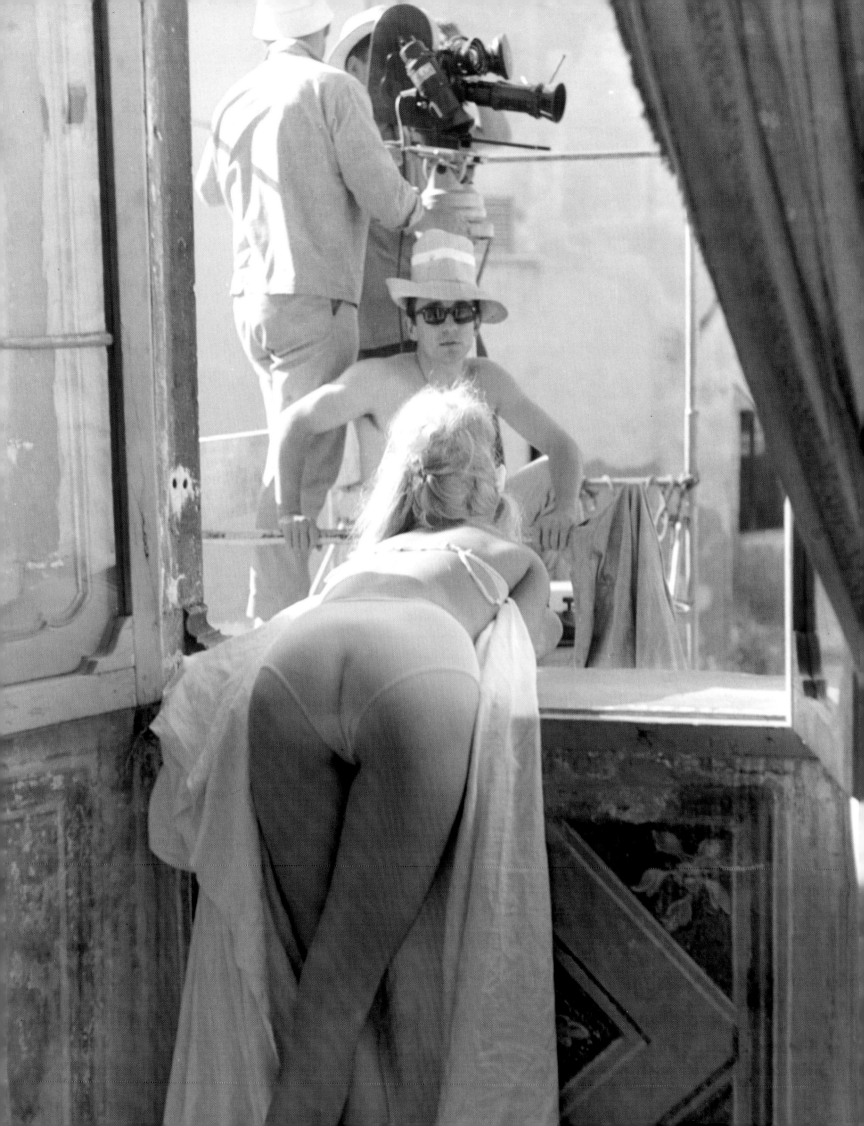

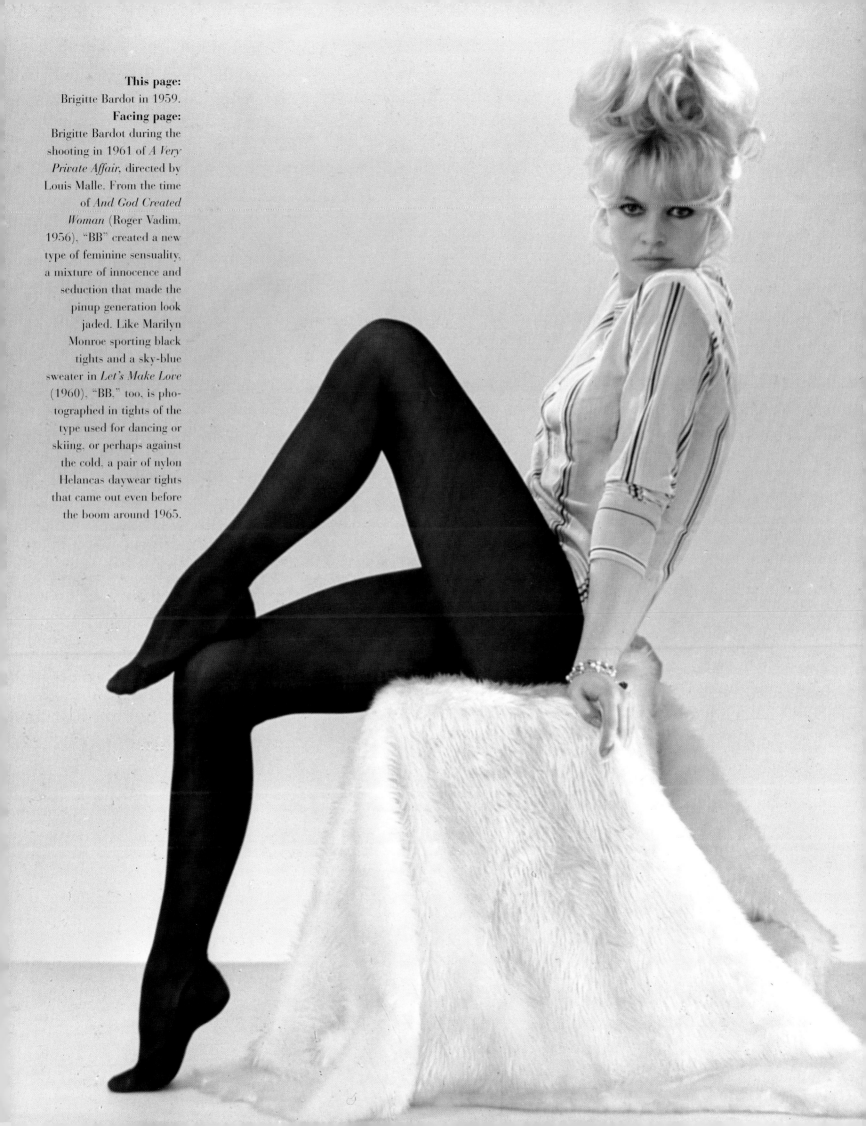

This page:
Brigitte Bardot in 1959.
Facing page:
Brigitte Bardot during the
shooting in 1961 of *A Very
Private Affair*, directed by
Louis Malle. From the time
of *And God Created
Woman* (Roger Vadim.
1956). "BB" created a new
type of feminine sensuality.
a mixture of innocence and
seduction that made the
pinup generation look
jaded. Like Marilyn
Monroe sporting black
tights and a sky-blue
sweater in *Let's Make Love*
(1960). "BB," too, is pho-
tographed in tights of the
type used for dancing or
skiing. or perhaps against
the cold, a pair of nylon
Helancas daywear tights
that came out even before
the boom around 1965.

LITTLE GIRLS
AND LIBERATED WOMEN:
PANTIES, BIKINI BRIEFS, AND TIGHTS

Those refined English girls, their ever so white skin dusted with pink.

Jean-Jacques Schuhl, *Rose poussière*, 1972

*There's only Creezy now. Creezy with her golden profile, Creezy saying "Cheese,"
Creezy with her wide green eyes, Creezy my painted icon, Creezy in her long, slim,
white pants, Creezy walks toward me with her model's walk,
placing her heels firmly, looking straight ahead.*

Félicien Marceau, *Creezy*, 1969

Five-foot five, eighty-eight pounds. Around 1966, in the "Swinging London" of the Beatles, the Rolling Stones, the Animals, and the Who, the woman who embodied contemporary femininity in the hip *boutiques* on King's Road and Carnaby Street was not an actress but a model nicknamed Twiggy. Half-child, half-woman, slightly knock-kneed (though her legs were insured for £400,000 with Lloyds)[1] an androgynous female almost bereft of *bust* (though the word itself was following *bosom* onto the lexical scrap heap), this flat little English girl born in 1949 is a prime illustration of the economic and symbolic role being played by youth, now the most important figure in the fashion world and its principal consumer. "At one time, fashion existed solely for the rich. Today, fashion exists for teenagers," explained the journalist sent to do a program on Polly, the model in William Klein's 1966 film *Who Are You, Polly Magoo?* "Fashion for little girls, tiny dresses, without waists, without busts, without hips, just knees, socks, flat-soled shoes, ankle-boots, and all the rest.... It's a fashion for sexless Little Red Riding Hoods in miniskirts."

REIGN OF THE CHILD-WOMAN

Like Polly, Twiggy, and the models used by Mary Quant (who, around 1966, was engaged in competing with Courrèges for the miniskirt monopoly), like the "slim girls, taciturn, and bow-shaped"[2] who danced the Monkey or the Shake at Castel's Club Princesse in

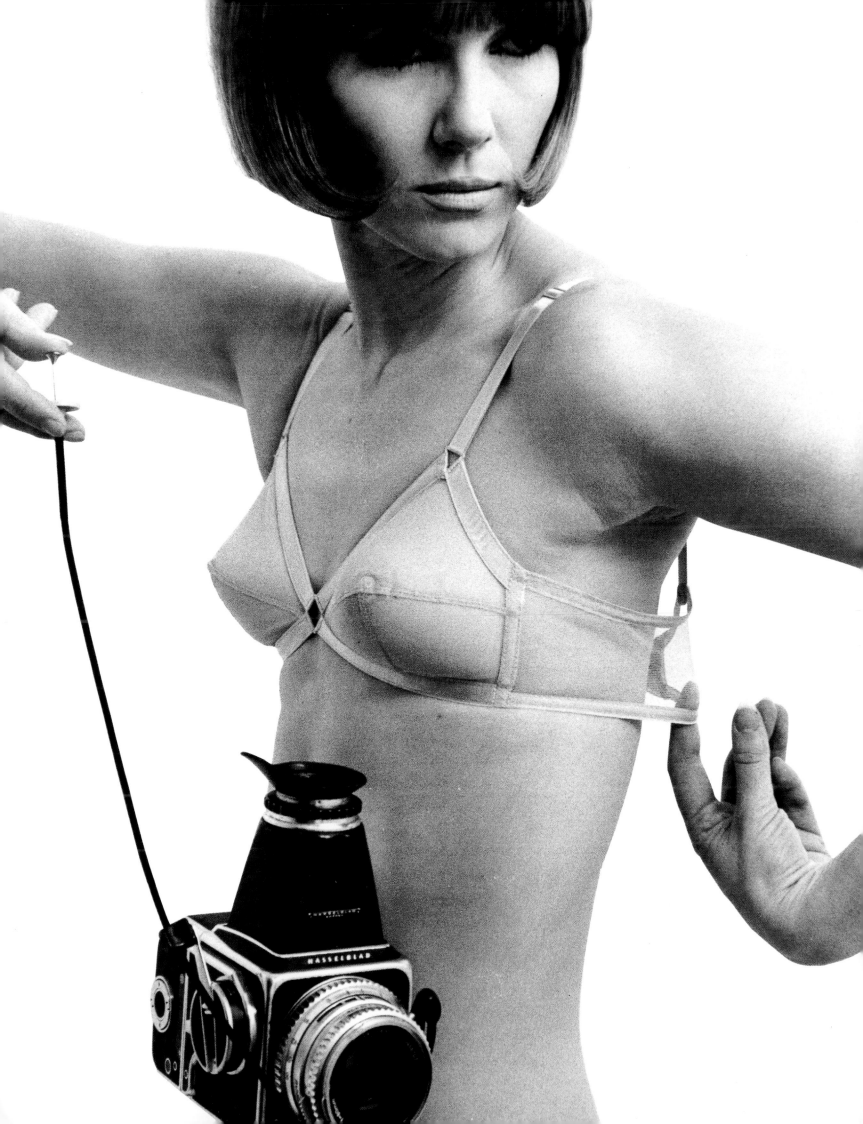

Paris in the autumn of the same year, teenagers and young women of style pursued the same dream of pared-down volumes as the previous generation. The body is reduced to a surface: sharp, sleek, perfectly smooth—a female physiology without depth, an organism without memory. "Spots, pus, rashes, cold sores, scars" burst forth on Twiggy's face. On the surface, "her cheeks are plastered with powder, her eyelids made up, her lipstick red: the face is buried beneath it all."[3] Polly's stiff, raven wig juts out over long, black, false eyelashes and over huge, blindly staring eyes ringed with liner. The spindly girls at the Club Princesse—replicas of the long-limbed French pop star Françoise Hardy, another much-vaunted anorexic of the period—wear "pinkish white, pinkish beige, Lido pink," or again, "pale blue" stockings, "bandages that swaddle them like mummies with thin, gold belts."[4]

Below: Naked woman with rose. This celebrated photograph was used in the first advertisement not to show its product. Rosy (1962).
Facing page: Coordinates by Peter Pan, 1967. *Left*, "preformed bra and Lycra tulle panties in sky blue or pink checks." *Center*, "stretch-bra without underwiring," and crisscross girdle. *Right*, push-up bra and French panties, in white, straw yellow, and sky blue.
Preceding page: Bra. *Elle*, March 20, 1965.

The obsession with clear lines, cleanliness, and surface sheen in both makeup and accessories is motivated by one and the same aesthetic utopia, the same never-never land of beauty. As cosmetics became big business, as beauty became a career, so a new and voguish profession was born, which, like becoming a model, crystallized the dreams of many a working-class girl: beautician. Antiquated Europe herself was beginning to discover the brave new world of consumer durables and a throwaway life-style with the light-headed enthusiasm of the recently converted. This cosmetic utopia arose not only with the craze for "body care," but also with the home's new role as a *status symbol* (full of shiny domestic appliances and gleaming interiors) and with the growing fetish for the automobile (for bodywork design, for souped-up cars). On the French literary scene, the clinical descriptions of the Nouveau Roman ("Around us... things are *there*. Their surfaces clear, smooth, intact," as one of its chief exponents Alain Robbe-Grillet put it) form part and parcel of the same phenomenon.[5] In 1951, *Elle* magazine had whipped up a furor with a survey into personal hygiene among Frenchwomen which had revealed that, on average, a woman in France washed her garter belt once every *two years*.[6] Fifteen years later, more than 85 percent of French households benefited from running water (against only 39 percent in 1946). Above and beyond such incremental improvements in physical cleanliness, everywhere, on the wireless, on billboards, in magazines, and in boutiques, ideals of hygiene and body freshness were being loudly trumpeted. Pouring out of the radio in the soundtrack for Jean-Luc Godard's *Pierrot le fou* (1969) came the news that if "it's easy to *get* fresh, to *stay* fresh you need 'Printil.' Its soap cleanses, its eau de Cologne freshens, and its scent perfumes. To prevent body odor, I use Printil after washing and have complete confidence for the rest of the day. Printil comes as a spray, vapor stick, or roll-on."

In this aesthetic that shares affinities with both Op and Pop Art, the *trompe-l'oeil* bodies of the child-woman models employed by Mary Quant, Courrèges, and Pierre Cardin are without a history and inhabited

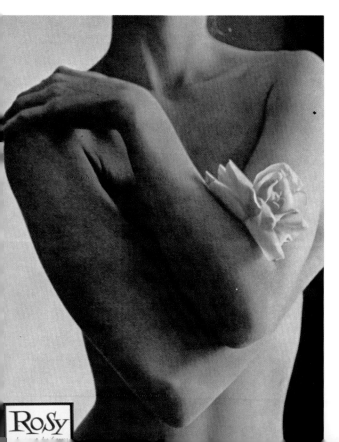

ROSY

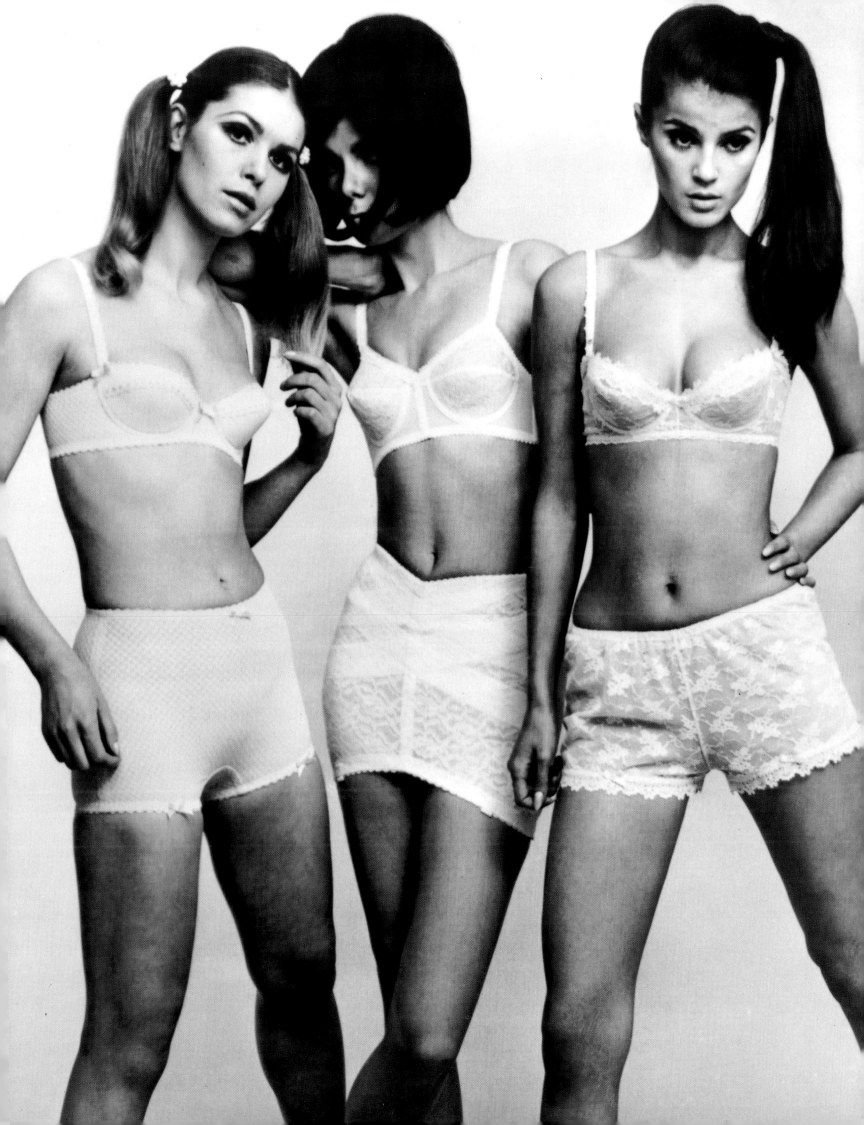

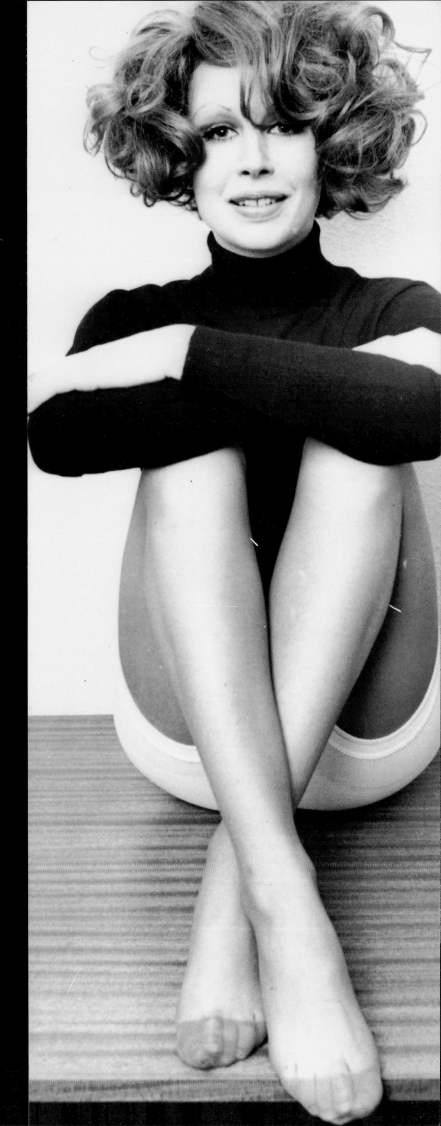

This page:
Model Anne Pucie in 1968. "If men and a certain type of women—slightly older ones and those of more refined taste—have conserved a decided preference for great wraps of tulle with hints of the *frou-frou*, the young, boys and girls alike, as well as today's women—working women who want to feel comfortable, who have no staff and who therefore need a non-iron synthetic fiber that is easy to wash and preferably color dyed so it's less delicate—these women have a, let us say, *sportier* outlook than before on the female body. The much-vaunted mystery is no longer to be found nestling behind a strip of lace. Katia D. Kaupp, *Elle*, March 10, 1966 (on the occasion of the Second Salon of Corsetry and Lingerie for Women).

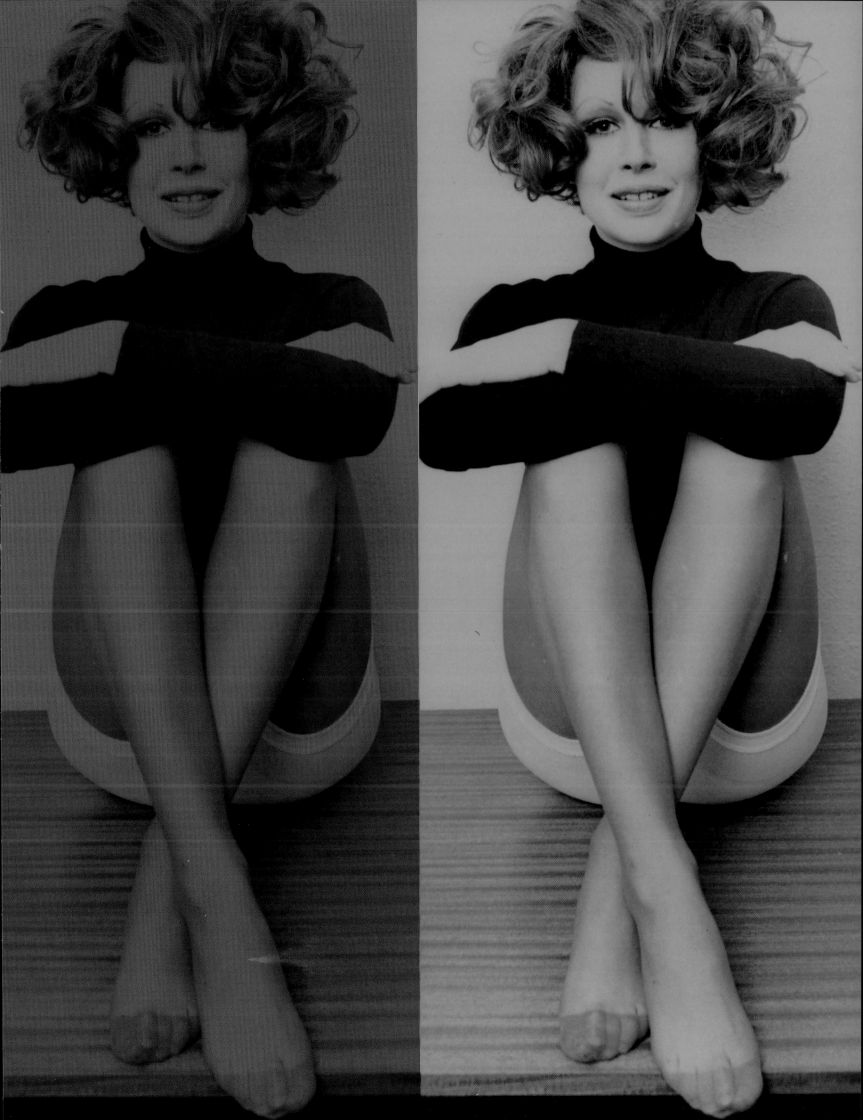

by little girls who have stalled on the threshold of their femininity, never to undergo the transformations brought about by breasts that swell or periods that soil. By focusing on adolescent girls, 1960s fashion addressed the *"question* of their sexuality" (as people began to express it) and proceeded to obscure the subject beneath a stream of dubious comment. In an open letter to her parents published in 1971 with the first number of *Le Torchon brûle* ("The Rag Afire," the emblematic journal of the post-1968 Women's Liberation Movement in France), an unnamed young woman recalled the silence in which these "uncomfortable questions" were shrouded in the middle-class, Catholic milieu of her adolescence, and how shameful it seemed to have periods in the 1960s. "This is the reason I didn't come to see you straightaway, mom, when I started my periods," she wrote. "I preferred to discuss them with one of my sisters who suffered from feeling dirty just like me, from the idea that she might be ostracized once a month from the family just because she had a tiny lump or else a little blood stain on her skirt bottom, and who, morning and evening, would lock herself away in the bathroom to change and wash the horrid cloths, those towels, cheaper and more hygienic than disposable sanitary napkins (and I say sanitary napkins because Tampax were completely unknown to us—do you mind!? stuffing *that* up your vagina! It might have given us some funny ideas!) Then there was hanging them out to dry when we had to hide them because (and I quote) 'they excited the boys'!"

So a 1960s child-woman had no periods. She also had no breasts, and her bras, made of revolutionary Lycra, a supple fabric that had recently entered the lingerie market, made no effort to emphasize the bust in the way of the classic full-cup and push-up brassieres of the preceding decade. The year 1964 even saw the launch of the *stretchbra*, a brassiere with elasticated straps specifically designed for "the smaller bust that does not intend to put itself forward."[7] It would cost, for example, 59 francs from Warner or 38 francs (Lycra with lace) from Peter Pan, an apt name for a company catering to a type of femininity that could not face growing up.[8]

Like Peter Pan, the child-woman wore *tights*. Tights, like those that snugly wrapped the legs and thighs of ballerinas and gymnasts, achieved their ascendancy around the middle of the decade, aided and abetted by the craze for the miniskirt. Their advent quickly put an end to traditional underwear even in updated styles. One such was the panty (or panties, the name deriving from the voluminous *pantaloons* of the nineteenth century), an all-in-one girdle and panty that served to shape the tummy. In April 1964, the French news journal *L'Express* had loudly trumpeted its success. "*Panties* are in fact like a redesigned pair of shorts with add-on garters," explained the modern weekly popular with the sort of youngish, middle-class couple that Georges Perec portrayed in *Things*. "Less strict than a girdle proper, more alluring under a fitted skirt than a mere pair of briefs, it comes in every elastic material."[9] On certain longer panty types, like Vanity Fair's, "the garters button up high on the thigh and remain hidden even under tension." This little number hardly came cheap, however: 83

Below:
Long-legged panty-girdle and bra. Advertisement for Aubade, early 1970s.
Bottom:
Rosy "College" coordinates in printed cotton, edged with scalloped braid, 1965: lightly preformed bra, garter belt, briefs, and half-slip. Modern lingerie throws off flesh pink and goes in for floral patterns and colors.
Facing page:
Polyamide nylon coordinates in multicolored stripes from *La Redoute*. Left, bra and a culotte-style pantslip; right, dress form.

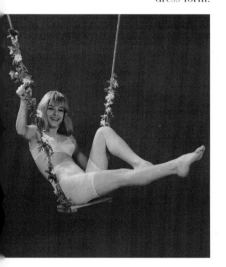

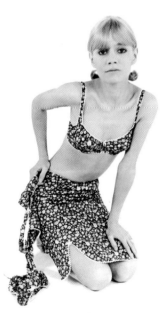

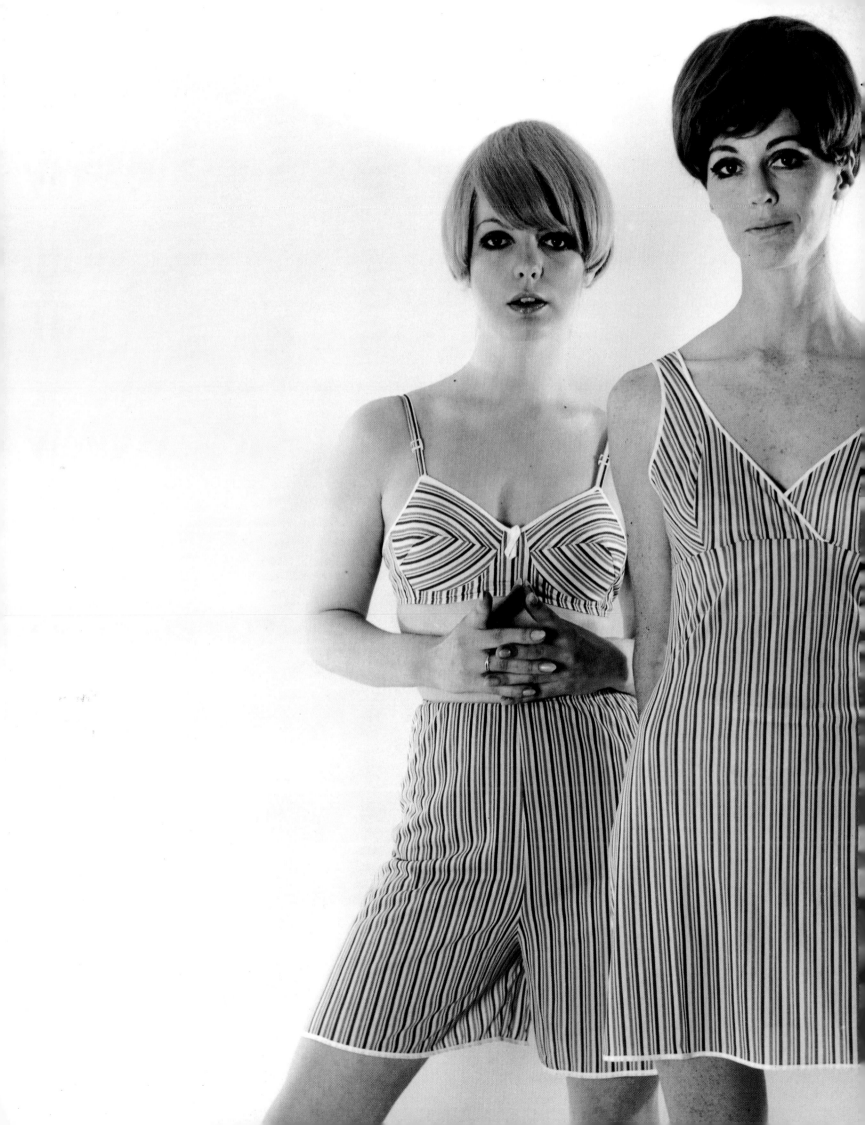

The only problem we have to face is \ How to separate into two portions 120 pounds of pink flesh \ And half an ounce of nylon." So sang Claude Nougaro in "Les Don Juan" in 1962. It was true that by the 1960s, women's underwear was becoming lighter and lighter, leaving off the complications of the preceding generation, and evolving into the bikini briefs that were soon to lead the field under tight-fitting trousers and sweaters. **This page:** See-through bras and hipster briefs. *Elle*, 1966.

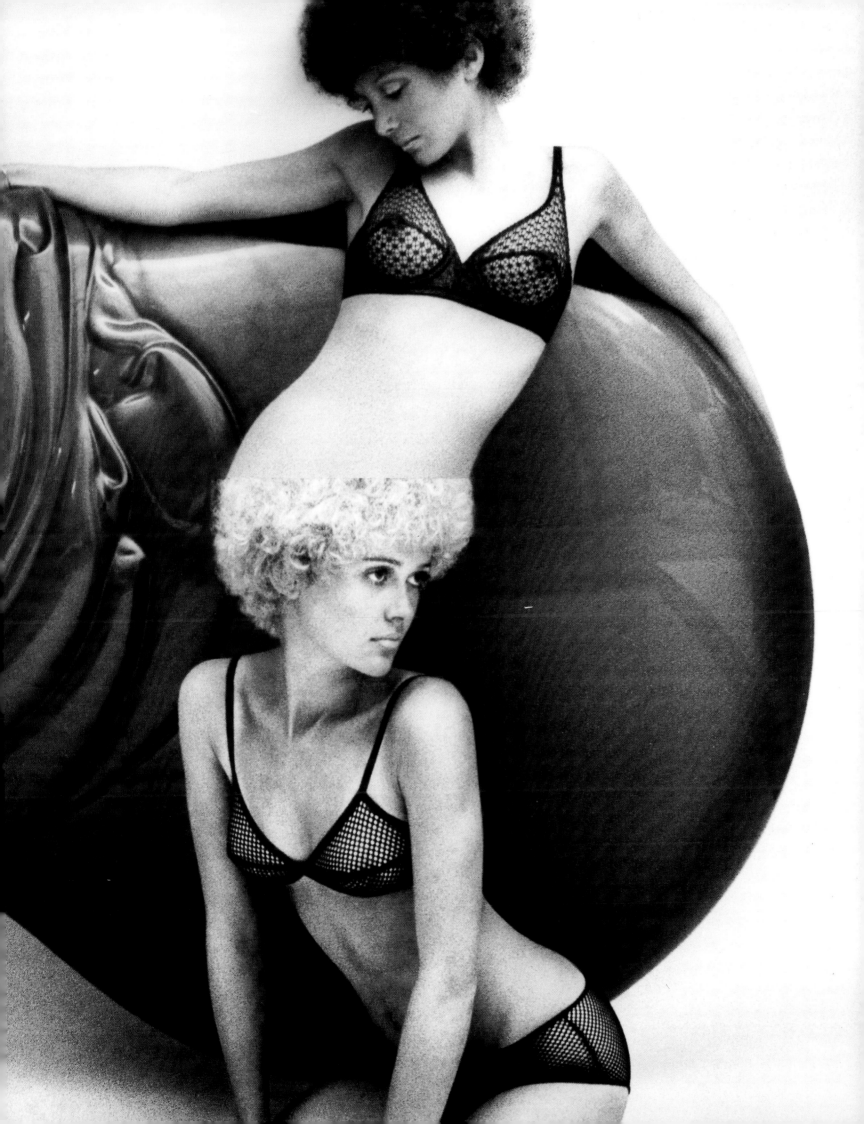

francs in white, sky blue, or orange Lycra, as against 15 francs for the simple blue-and-white pin-striped Lycra panties sold in price-cutting Prisunic supermarkets.[10] Clarisse, the trendy young girl in *Il était deux fois* ("Twice Upon a Time"), a novel in diary form published in 1968 by Benoîte and Flora Groult, would leave a pair of "little pink nylon panties in the bathroom, in full view, like an open invitation."[11] The panty could be trimmed with a little lacework around the leg holes, such frills being particularly appreciated by younger girls of the time like Christine Martin, twelve in 1969. Her panty "descended right to the hem of a short, trapeze-line, sleeveless dress, in turquoise with a little floral motif brought out with wide fuschia-colored bias-cut panels, its appeal being that one could catch a glimpse of it when the dress moved even a little."[12]

The market success of tights that came in the wake of the "mini" in 1965 did indeed seem like a sea change—so much so that, by 1969, the manufacturer Dim, which had made a name for itself selling stockings in batches (ten for 10 francs) and through its "Tel Quel" range (sold, not folded flat, but simply "as they came," rolled up in a cube pack), decided to restructure itself around the production of tights. From 1971 onward, Dim's movie advertisements would fill intermission screens in the cinema with bevies of euphoric girls, their long legs clad in tights of every conceivable hue, dancing with wanton disregard for geometry to a chorus line from the soundtrack for *Night of the Fox*. Soon, almost an entire generation would be able to hum along to *pa-pa-pa-pa-pa....*[13]

Quite a different aspect of the craze for legs transpires in the breezy but essentially serious axiom uttered in *The Man Who Loved Women* (1977) by Bertrand Morane, a character created by a director who remained forever true to his heroines' nylons and garters, François Truffaut. "Women's legs are the compasses that bestride the earth in every direction, endowing it with harmony and balance."

WOMEN LOSE THEIR BRAS—AND THE TROUSSEAU LOSES ITS ILLUSIONS

We are not dolls!
Banner at a women's lib rally, April 14, 1971, Paris

I wondered what she was going on about. I was in the process of
sliding her skirt up over her hips and had just noticed that she was wearing
tights but no knickers. I found it hard to think of anything else.
PHILIPPE DJIAN, *Betty Blue*, 1985

Dim was not the only company to offer a wide range of colored tights, being preceded in Great Britain, for example, by Mary Quant. In fact, the women's underwear scene was swamped by the kaleidoscopic joviality that—from *The Umbrellas of Cherbourg* (1963) to the cheap-and-cheerful "Prisu" style (sold at the Prisunic chain) from the Paris Drugstore's interior to the little Shetland pullovers that the miniskirt set flaunted—made up "Sixties style." Next to classic models in pink and white, stores were now offering a

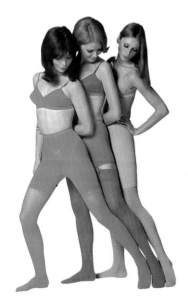

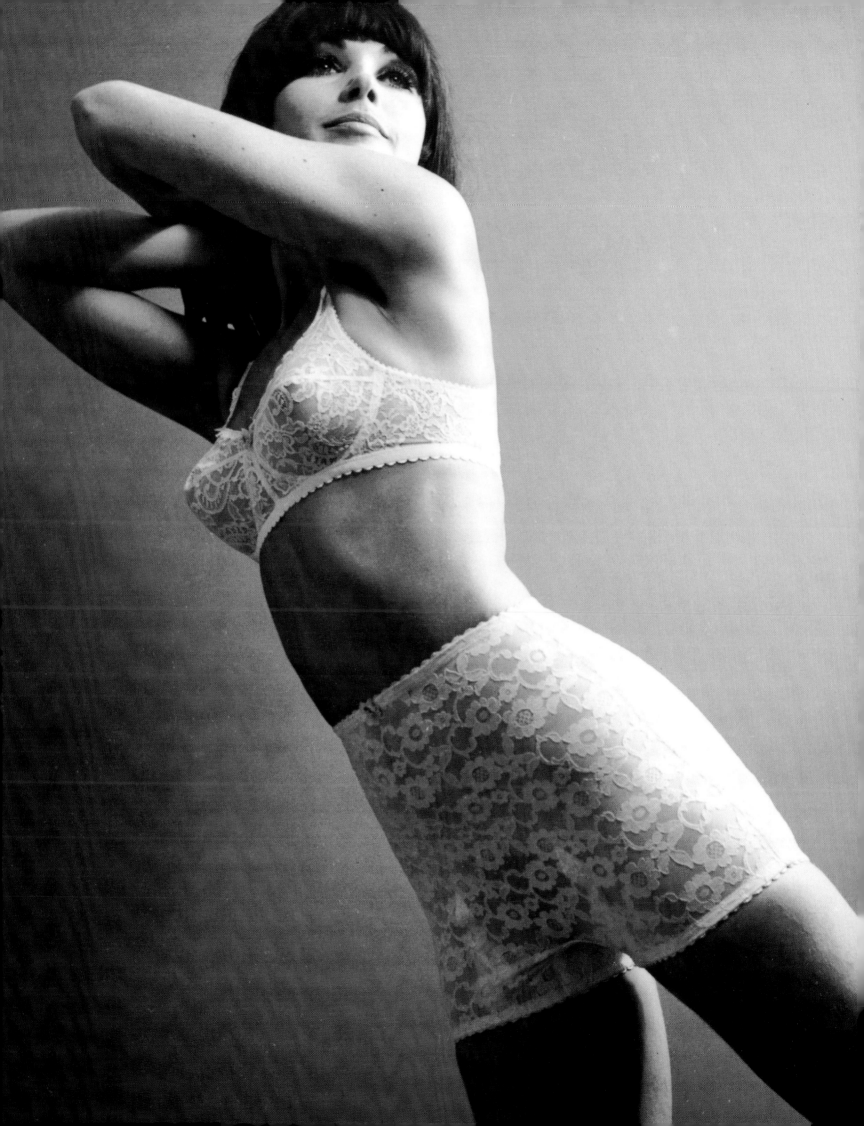

range of *fancy* styles to their adolescent clientele (and to those adult women anxious to parrot their fashions): striped panties, polka-dot or checkered bras, bra-and-panty coordinates, bra-and-shorts sets and, above all—with the craze for miniskirts and the widespread donning of trousers—the bikini brief with bra, which the shopgirls would tell them should be always worn as a set. By introducing a tart glare of sherbet tones into the world of women's lingerie, this "color revolution" put an end to "seductive" lingerie lines whose appeal had been built on a fondness for the pastel tints of flesh, champagne, cream, and baby pink, or else for the sulfurous whiff of black and red.

Tights were at once a response and an incitement to the provocation Jean Baudrillard discerned behind the vogue for the miniskirt, which he stated had substituted "simulated rape" for the "apparent prohibition" of yesteryear's fashions.[14] Others were to consider them a contributing factor to the "de-eroticization" of female undergarments. Not only have tights done away with stockings and garters, the argument went; but also, by encasing a woman's private parts as if within an elasticated chastity belt (since briefs, too, were soon jettisoned), they undermine the subtlely fluctuating frontiers on which lingerie's

erotic charge was founded and blur the boundaries between female flesh and its precious container, between the open and closed, between the body and its subterfuges, and finally between desire and the obstacles to desire. The mass abandonment of "undies" that marked the post-1968 period and on through the 1970s was primarily a rejection of obsolescent types of ritual seduction. The statistics are unambiguous: in 1968, 1,418,915 half-slips were manufactured in France, but only 549,395 by 1971; 397,854 garter belts in 1969 and only 32,521 by 1971; as for panties, their production attained a peak of 3,681,855 units in 1969 before nosediving.[15] In November 1970, reviewing a "motivation study" conducted by the Havas Conseil market-research team, the trade journal *Créations lingerie* noted that "traditional lingerie has lost its capacity to be feminine, to be alluring and erotic," and "it is closely associated with ways of behaving which people feel to be totally outdated." If the magazine is to be believed then "men themselves often suffer from embarrassment and nervousness when faced by a partner in fancy lingerie and may exert a form of censorship over them (particularly unforgiving among younger men) in expressing a preference for 'natural' underwear that 'doesn't cheat.'" In *The Web of Lace* (the novel by Pascal Lainé that won the prestigious French literary prize the Prix Goncourt in 1974), a son of good family studying at the library science college the École des Chartes gives lessons in how to dress in hip style to the dowdy working-class girl with whom he lives, persuading her "to give up wearing a bra under her short-sleeved shirt" just like the fashionable young things of Saint-Germain in their Cacherel blouses.[16]

The world that "doesn't cheat" is a *unisex* world.[17] Unisex was one of fashion's reactions to changes in the *female condition*, and to the growing market share held by

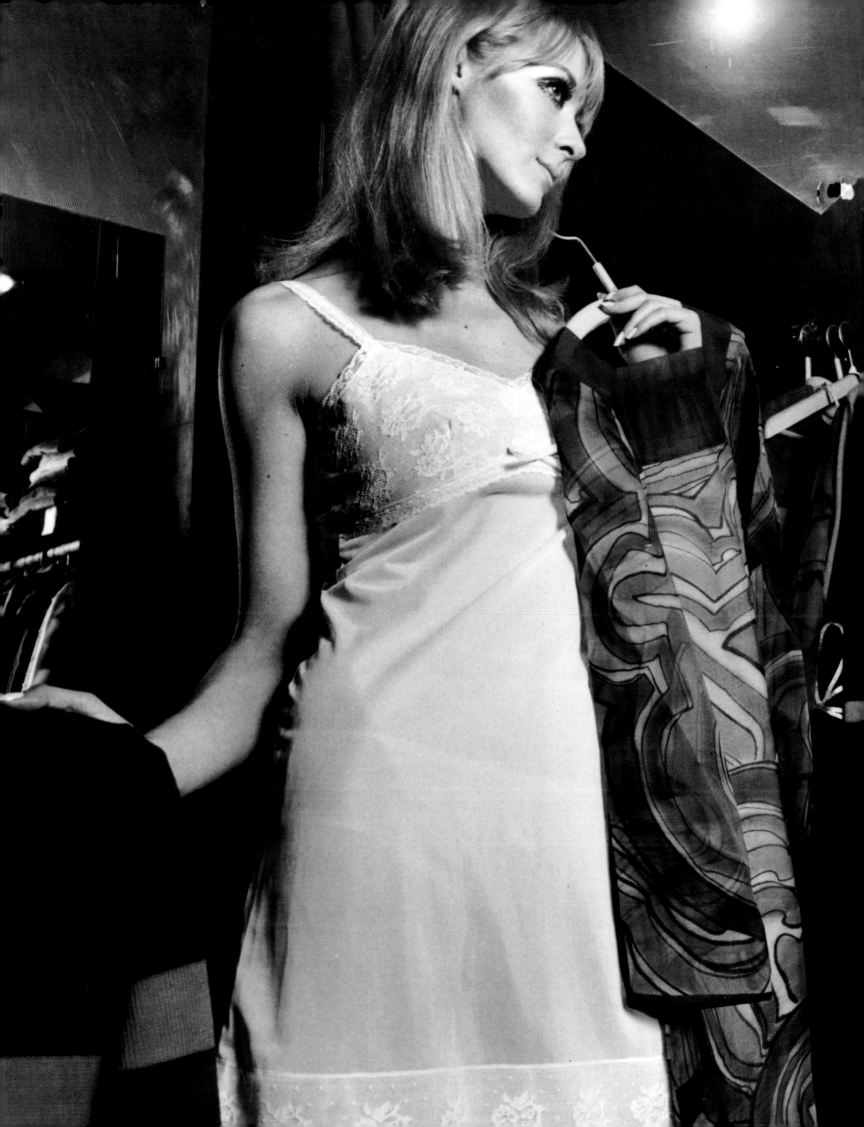

Above:
Left, nylon taffeta hipster brief and bra set; *right*, bra and panty in lace and Lycra "for stars and starlets." Rosy, 1966.
Facing page:
Bikini briefs and bra in Dacron and Lycra. Maidenform, *Marie Claire*, May 1971.

teenagers. By 1965, the percentage of girls in secondary education in France equaled that of boys; the number of women employed was on the up (38 percent of the active population by 1973), and there were demands for women to be paid the same wages as men for the same job. In addition came the struggle for abortion to be legalized and free (culminating in France with the Loi Veil of 1975) and, in the media and vocabulary at any rate, sexual liberation and popularization of the Pill (legalized in 1965, though still used by only 8 percent of French women by 1973).[18] "Our bodies belong to us!" *féministes* proclaimed in 1971 as their *sisters* in the United States were burning their bras under the windows of the White House. Those women who did not go bare-breasted beneath the skintight pullovers of the time uttered a silent prayer to all nonwired bras, such as those marketed by "Huit" in a plastic shell packaging. It was a style that left them free to shake their fists and wave banners without the horror of the cups riding up, a circumstance bra-wearing females had long feared but from which they were at last becoming immune. In fact, despite all the clamoring for freedom, bras (though often in no more than voile) continued to be worn. Production maintained its levels: 20,785,036 units manufactured in France in 1969 rising to 26,401,666 in 1971.[19] Nothing encapsulated this little contradiction more perfectly than the astute name chosen in 1969 for one of the transparent brassieres of the epoch: the "No-Bra Bra."[20]

A pair of briefs, a pair of tights (or socks under trousers), a bra (or not): by the mid-1970s, women's lingerie had been reduced to "nonunderwear."[21] The underclothes worn (or rather taken off) by the actress Miou-Miou in Bertrand Blier's 1974 film *Going Places* (*Les Valseuses*) were a glaring example. The trousseau, meanwhile, as the repository of an organic, maternal, and domesticated femininity, was almost an extinct species, a victim of a neglect that only gained momentum as the century progressed. With the advent of the Pill lessening the threat of an unwanted pregnancy, with the taboos surrounding menstruation undermined from advertising campaigns vaunting the advantages of modern tampons and sanitary napkins, with the ideal of the "housewife" henceforth supplanted by that of the "active woman," the very idea of the trousseau had fallen by the wayside. As the thing itself disappeared over the event horizon of womanhood, the culture of the trousseau became an object of nostalgia, retro fashion, and scholarship. It was at this time that Yvonne Verdier undertook protracted research on the life of peasant women in the village of Minot in Burgundy, her surveys culminating in the enlightening pages (especially concerning the culture of dressmaking) of *Façons de dire, façons de faire*, published in 1979.

In those years, a sort of ecological romantic fashion—embodied in Laura Ashley's floral cotton frocks—was born from a cross between hippie "commune" utopia and retro

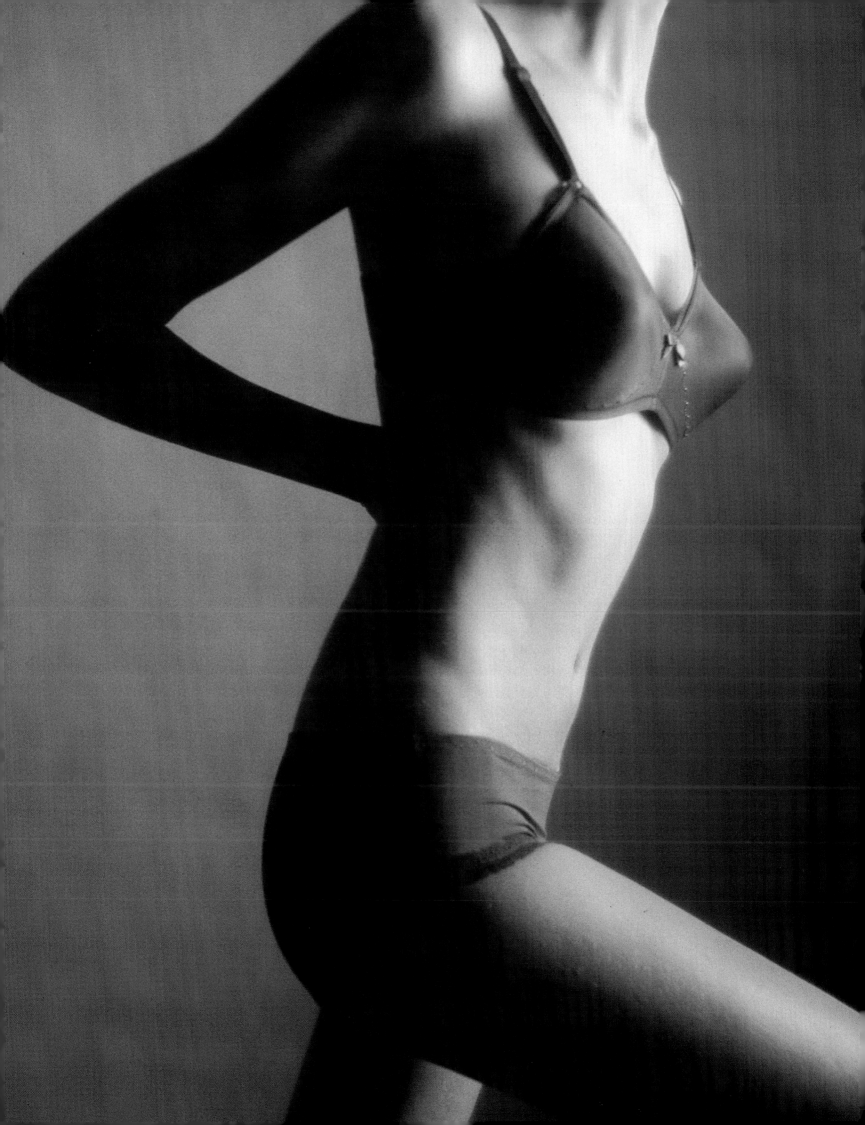

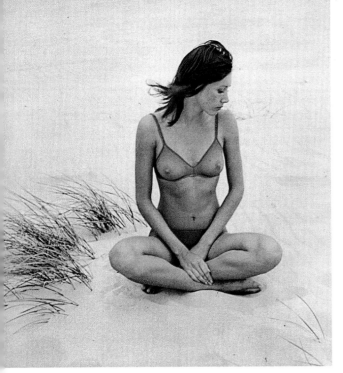

nostalgia for a preindustrial golden age (cotton and linen versus nylon). In its wake, wave upon wave of embroidered shirtfronts, guipure lace camisoles, lace-frill petticoats, and other undergarments worthy of grandma or great-grandma tumbled out of modern women's wardrobes. They were worn *on top*, as outer garments, for three or four summers running. Certain articles of modern lingerie were "converted" by similar methods. Thus, for instance, the so-called nightgowns by Madame Albert, manager of the Cleo Boutique at Courtrai (Belgium), which her customers wore as summer dresses. "And I'm sure," the storekeeper assured *Créations Lingerie* magazine in February 1976, "that they knowingly bought them to wear in the street." To Laura Ashley's dresses and Yvonne Verdier's analyses might be added the elegiac outpourings that the trousseau, embroidery, lace, and women's underlinen generally inspired in Chantal Chawaf's novel *Le Soleil et la Terre* ("Sun and Earth") like a faint lyrical echo from Zola's *Ladies' Delight* of the previous century. A writer from the stable of the feminist imprint Éditions des Femmes, Chantal Chawaf sang of linens that watched over a physiological, archaic, nursemaidenly femininity: flesh breathes, blood circulates, menses flow, skin quivers, milk swells the breast. But her paeans are now bestowed on a trousseau that has lost its illusions. Her eulogies of lingerie are the fruit of nostalgia, infused with a sense that neither this type of femininity nor the trousseau it succored have any place in modern society, as if the feminine body, reduced—to adopt the language of Giorgio Agamben—to the rank of a "commodity" by the "unbending laws of mass standardization and exchange value," was being deprived of its "biological destiny," of its "personal biography."[22]

 lace insert on a piece of ivory satin, the sun-ray pleats of a mousseline dressing gown: of what use today were these "crumply, yielding things?" asked Chantal Chawaf. "Our femininity can only leave us with inanimate adornments, emptied of life and drained of breath because the body, because sensation, because woman herself has been withdrawn from them, because from all these luxury articles— these pinks, creams, and whites heaped up in the department stores through which my daughter and I wander about feelingly—there subsists nothing, just a portrait without a face.... Through ruched taffetas, bob-faced white aprons, dresses with folded gathers, gingham working smocks, body-hugging see-throughs, lace tulle décolletés,... foundations with openwork and serried pleats, ... on we roamed through all the guileless and frivolous ways of getting the best out of a body and out of the light, among these tangible traces of the intangible, these cruel reminders of yet another loss, of yet another deprivation.... For, even if we were to take all these costly articles, all this lingerie, lacework, and fascination home with us, even when we'd done all we had to do, we'd still be left asking each other, 'What's the use, what *is* the use?'"[23]

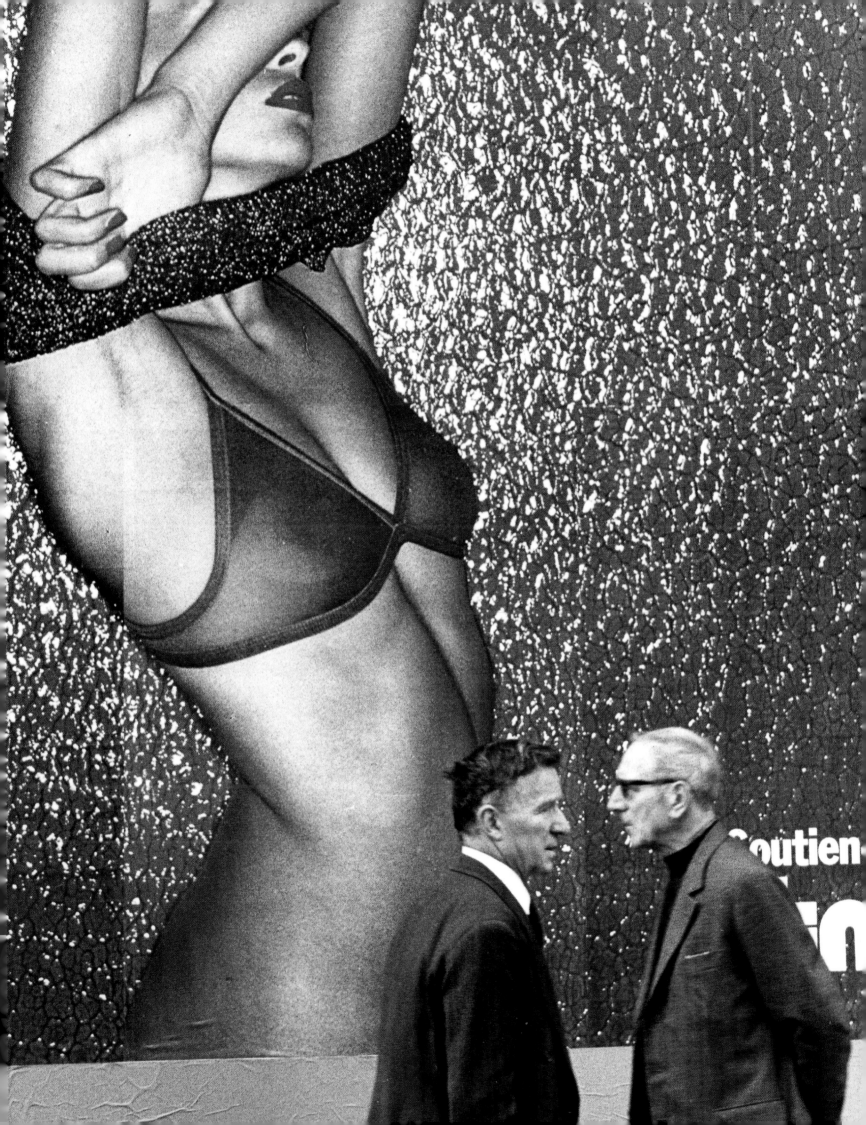

TEMPTATIONS
FOR A NEW EVE

CHANTAL THOMASS: *Some people say this is*
underwear for whores. That's not true at all.
GÉRARD DEPARDIEU: *Oh! Who said that?*
La Mode en peinture, winter 1982–83

Passive, she is pensive
In her evening negligee.
CAROLINE LOEB, from the song "C'est la ouate," 1986

By the mid-1970s, the erotic—its vestiges or imitations at any rate—had been driven out from a now insipid trousseau and had found refuge elsewhere: in David Hamilton's photograph posters with their romantic and vaseline-lensed Lolitas, in soft-porn girlie magazines, draped with nymphettes stark naked under a man's shirt gaping open to the navel, or in surprising box-office successes such as Just Jaeklin's *Emmanuelle* (1973), with Sylvia Kristel as the first porno star to enjoy public notoriety.[1]

INFLUENCE OF THE PEEP SHOW AND SEX SHOP

Over the suggestive undertones of eroticism, the wind was now favoring pornography in the most hyperrealist detail: in voyeuristic *peep shows* and *beaver-shot* magazines of increasing prevalence, an obscene course on intimate feminine anatomy was under way that reflected, as in a fairground mirror, a distorted image of the feminist debate on clitoral and vaginal orgasms.[2] *Penthouse* magazine owed its success to being more *hot* (the word borrowed from English, was becoming popular) or hard core than its elder competitor *Playboy*. Censorship and regulations record the changing trend. In the United States, the voluminous report demanded by Congress from the Commission on Obscenity and Pornography presented in 1970 to President Richard Nixon came out in paperback.[3] In France, meanwhile, a 1975 law defined a new film classification: "X-rated." In Paris, only the *sex shops* (another recent

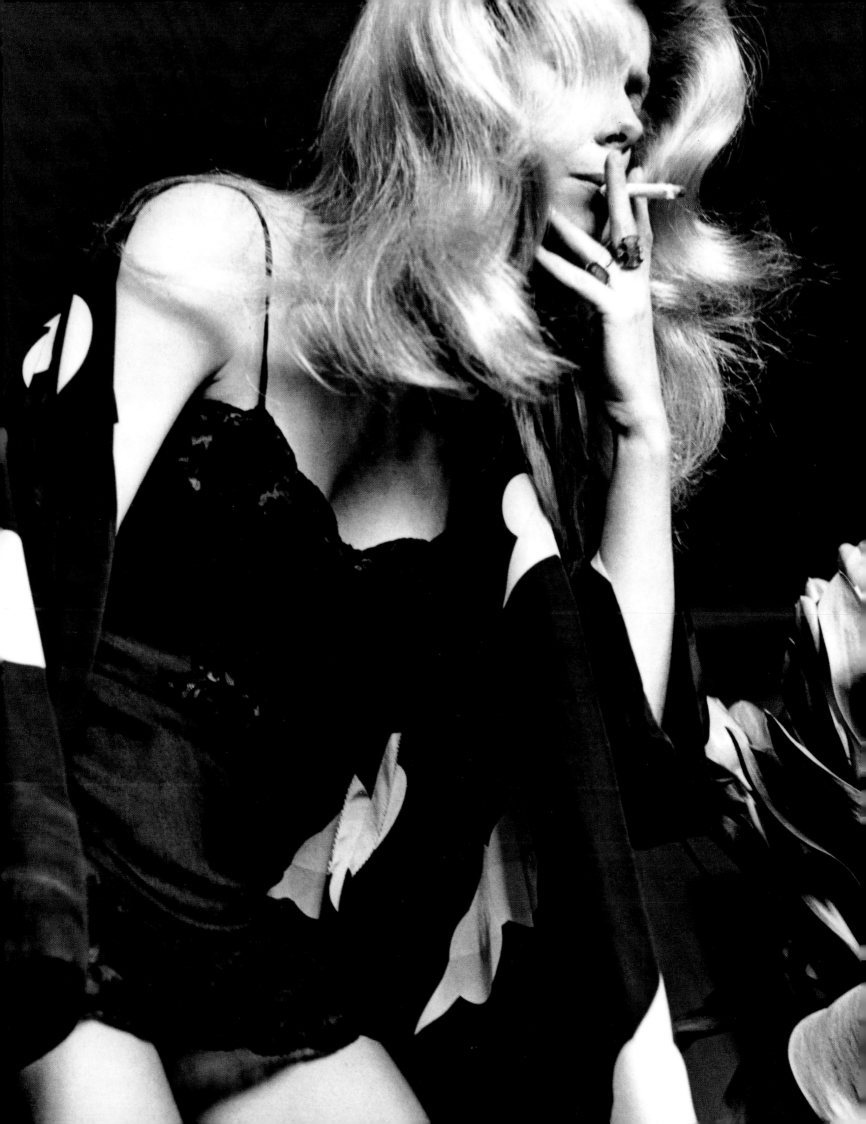

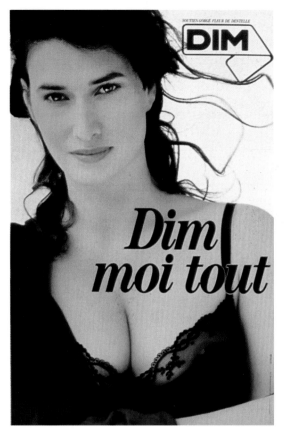

DIM

SOUTIEN-GORGE FLEUR DE DENTELLE

Dim moi tout

borrowed term from English) on Rue Saint-Denis and the specialized bou-
tiques in Pigalle were still dealing in titillating undies (red, black, Parma
violet), which, like some ceremonial garb donned for the occasion, had
brightened up the sexual awakening of many a twenty-year-old male
between the end of the Second World War and the early 1950s. "The
women's undies that charm you in your youth mark you forever,"
Alphonse Boudard confessed. "The pink and black frilly bits... the pillow
lace... in spite of yourself you've become attached to them... they become
a fixation.... That's the reason for the very real difficulty men of my gen-
eration have getting used to jeans and tights... to these outfits with no
decoration... in thick cotton... frankly masculine."[4]

Influenced in part by the sex shops, sanctuaries of pornography and
sadomasochistic paraphernalia (with which decadent glamrock groups
like The New York Dolls and The Stooges were flirting), ornate undies
began to make a comeback on the lingerie market. In London, punk-
rock dressing revolved around Sex, a boutique opened in 1974 by
Vivienne Westwood and the Sex Pistols' manager Malcolm McLaren that
delved deep into the reserves of the capital's red-light district: torn fish-
net stockings (the same that Madonna was to revamp during her 1985 Like a Virgin
tour), garter belts, tulle petticoats, black leather or Leatherette miniskirts, stiletto heels,
even lacey fingerless gloves. In 1976 Paris, Chantal Thomass picked up her "funny, sexy,
dirt-cheap things you just can't find anywhere else" from the shady Pigalle quarter. Back
in her new boutique on Rue Madame, Thomass, who was to derive her inspiration as
much from the impudent side of 1900s lingerie as from 1940s Hollywood glamour, con-
ferred on them the "legitimacy" they lacked by running them up in "pretty materials."[5]

As an antidote to functional "nonlingerie,"[6] the more courtesan
styles of undies—what might be called their fantasy sluttish-
ness—gradually, by dint of the derisory and despairing influence
of punk, gained a rebellious and provocative foothold in the work
of the French stylist. Chantal Thomass found herself taken up by
a new type of fringy, off-the-wall, fun-loving Parisian socialite
who had her own night haunts (the brasserie La Coupole, the 7
Club on Rue Sainte-Anne, a Montreuil disco called La Main
bleue, and so on) and her own celebrities that the general public had not even heard of
(Thierry Mugler, Claude Montana, Jean-Paul Gaultier, Adeline André, Paquita, Djemila,
Edwige Grüss, and a columnist with *Façade* and *Libération*, Alain Pacadis). Le Palace, a
night spot that, in 1978, smack in the middle of the disco craze, opened in an old, galleried
music hall, set itself up as a headquarters for this fun-loving in-crowd. They showed an
insatiable appetite for partying, for fashion and fancy dress, for playing games with dis-
guise and appearance, ironically hijacking or appropriating men's and women's clothing,
as outside the feminist banner lowered and the *gay* cause took to the streets.[7]

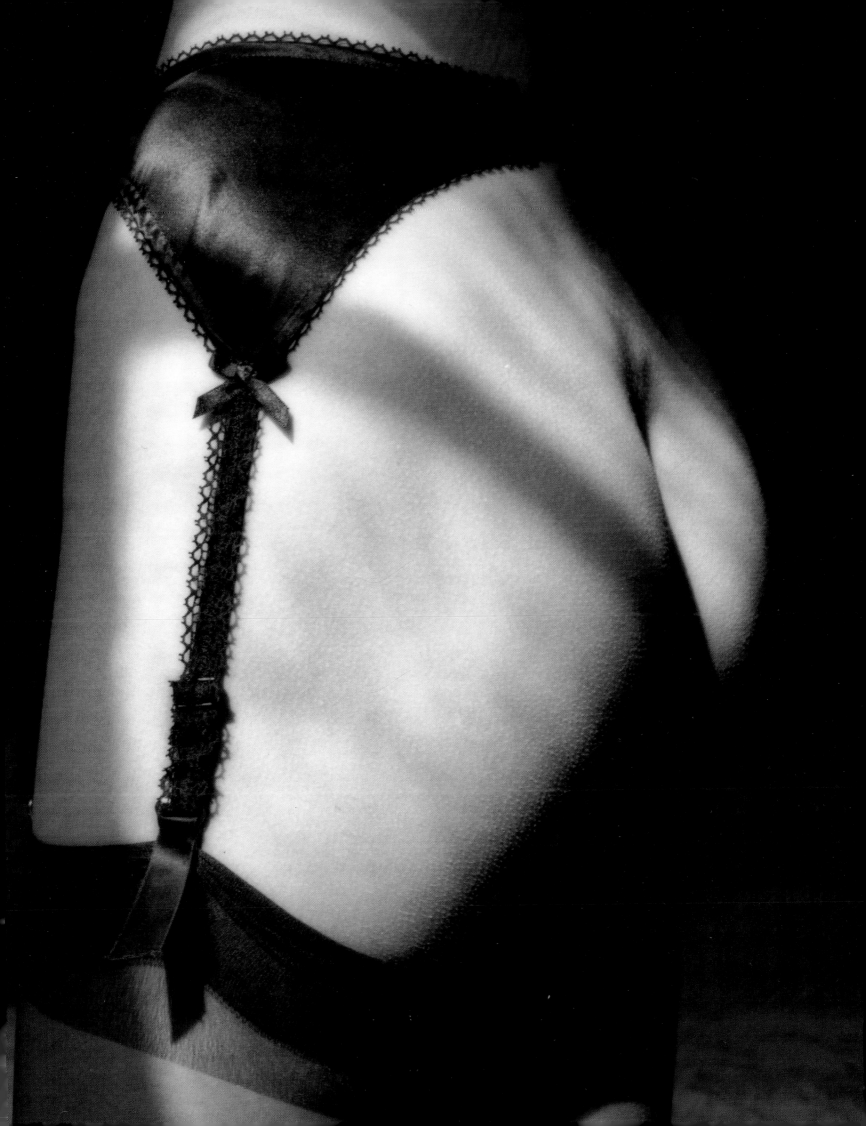

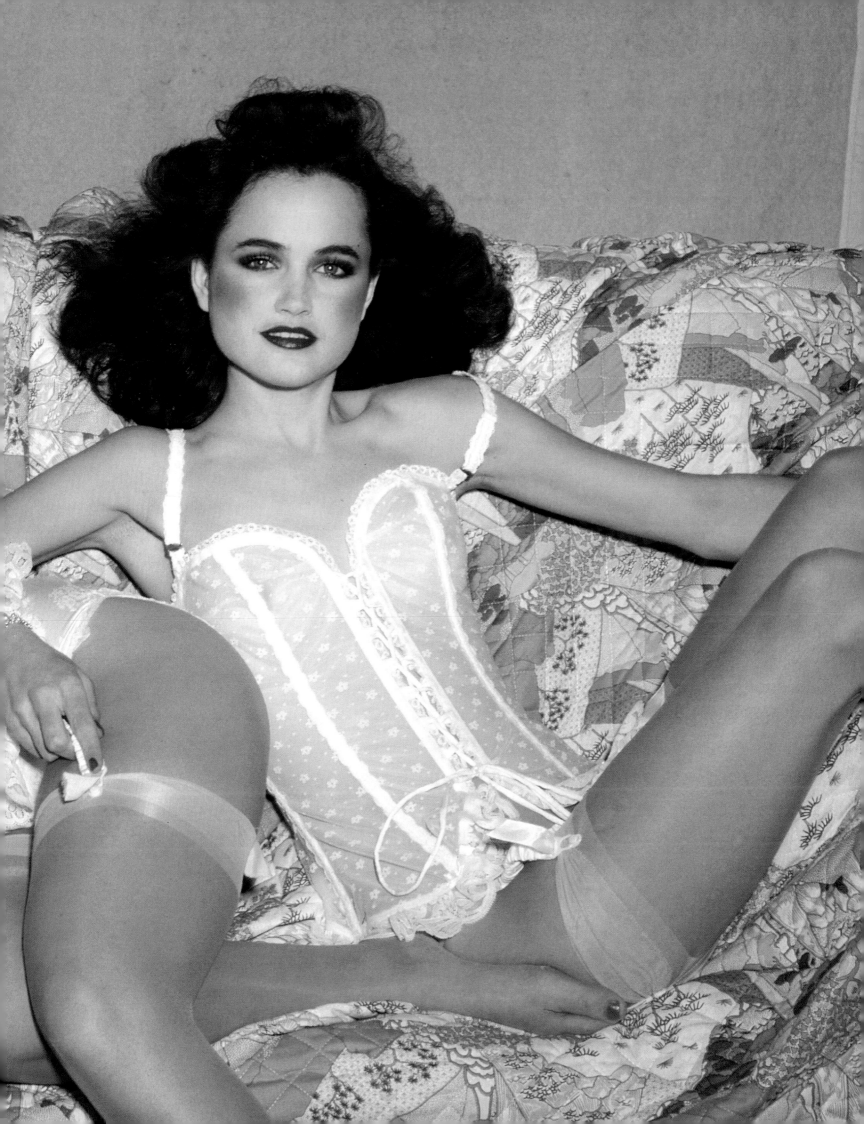

Chantal Thomass's bustiers, garter belts, and lacey stockings carried with them a whiff of provocation that the period believed was inseparable from seduction. "Chui's the kinda star I like," Evane Hanska confessed in a bout of unabashed postfeminism. "Hush-hush, go for it doll, garters and sexy dance-hall undies. What I would have best liked to play in the movies, apart from nurse and nun, is some broad in a saloon done up in a wasp-waister and black nylons...."[8]

Beneath their leather skirts, under their skintight two-piece set (sometimes signed Mugler, more often from the flea market or one of the used-clothing dealers around the Les Halles market), fashionable young girls (in a hip, double-think pose typical of the time) were also fond of sporting precisely the sort of woman-as-sex-object lingerie so decried in recent years. Were they, through their ironic manipulations and provocative parodies, through what some commentators called the "lingerie spectacle,"[9] simply returning to the traditional games of adornment, desire, and flight (or feigned flight) that Georges Bataille had analyzed? Some thought it doubtful. Jean Baudrillard saw this "erotic look" as simply "playing with simulacra" from which all ritual has been drained, as a mere "irruption of the erotic into outwardness, the erotic as a 'special effect' brought into the fashion arena," totally at variance (he contended) with the last, genuine "event in the history of social behavior" viewed from this angle: the miniskirt.[10]

More down to earth, women's magazines voiced their concern over another aspect of this reversal—the wholesale panic that might grip contemporary man encountering yet

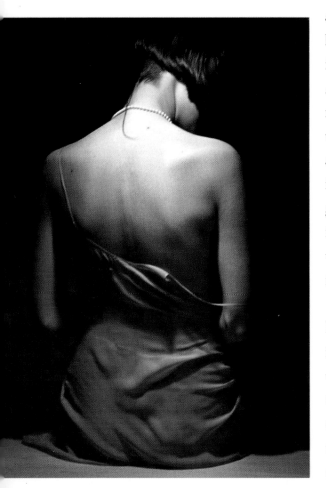

another feminine model being advanced by the media: the *superwoman*, beautiful, intelligent, and go-getting, power-dressing her way into the fortresses of male dominion in her shoulder-padded suit (by, for example, Anne-Marie Beretta or Junko Shimada). *F. Magazine* presented a picture of men as "incapable of maintaining a position of strength" with modern-day women, "lacking decisiveness, their sexuality diminished, on the brink of androgyny." If a woman wanted (or wanted to keep) a man who was "up to it," it was time once again to "lay out her full hand": black stockings, bustier, garters, the lot. *Marie Claire* gave up columns to a reader (a prostitute by profession) whose recommendations to married women among the readership were undeniably straightforward: ladies, if you don't satisfy your husband's fantasies, he will go "elsewhere" in search of pleasure.[11]

This climate explains at once the 1982 advertising campaign for Aubade lingerie (with its no-nonsense byline "Aubade—for a man") as well as the irate response it provoked from the minister with special responsibility for women's rights in the ruling Socialist government of the time, Yvette Roudy. One of the shots in the campaign showed a virile hand, and only the hand, of a man in dark suit and white shirt with cufflinks: it had come to rest on the slightly raised thigh of a young woman, the upper portion of whose face and whose lower leg had been cropped for the photo. Half prone, leaning on

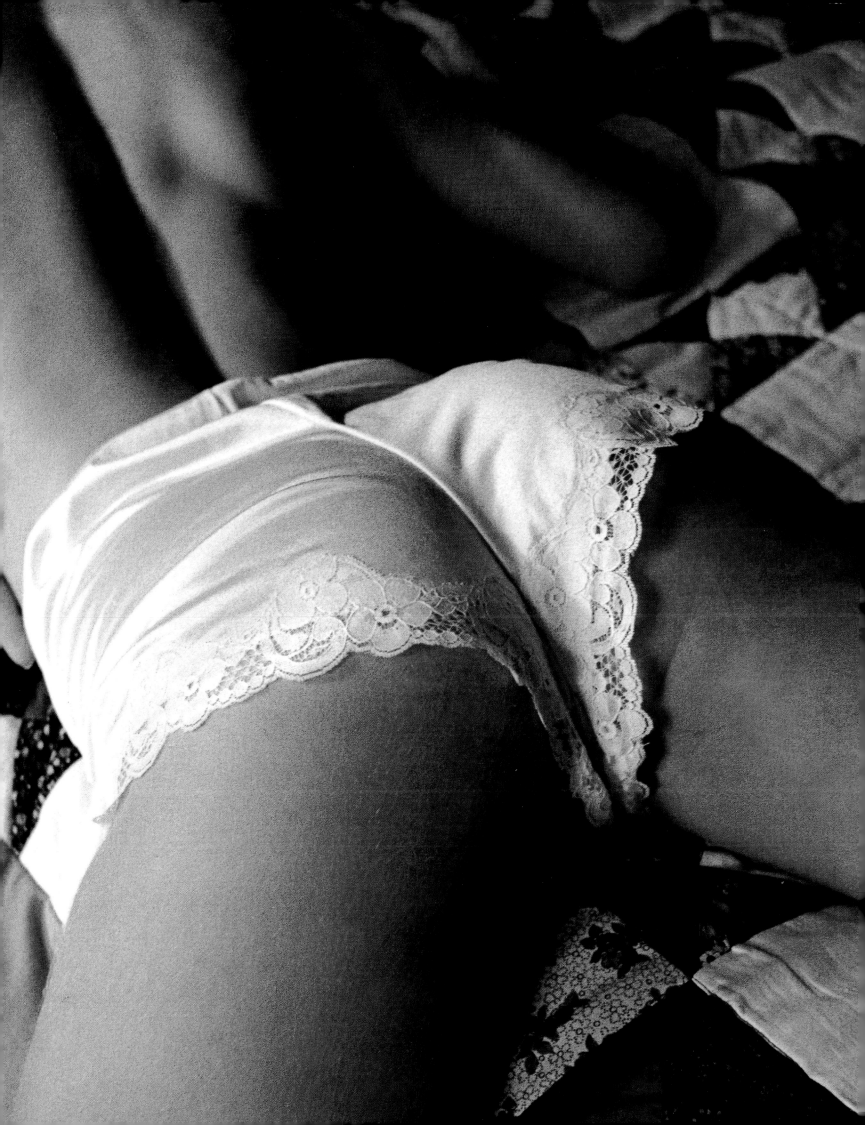

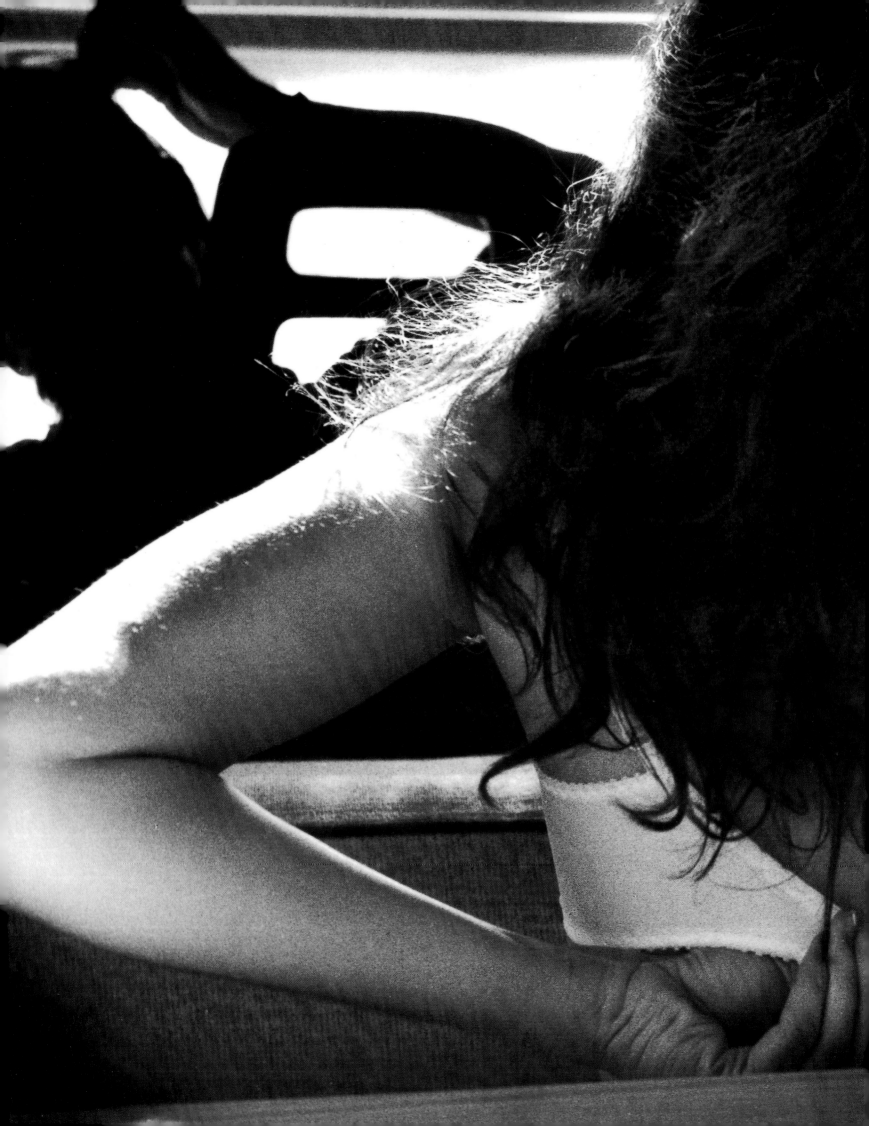

Above and facing page:
Lace and Lycra, tights and bra (*above*), and body garment (*right*) 1985. In her early lingerie, Chantal Thomass used silk weft and weave. In 1979, her tights were made of raschel lace, at the time the only elasticized lace available but they went baggy at the knees. In the 1980s, thanks to Lycra, a whole range of effects could be safely achieved: fishnet, ribbing, lace, brocade, embroidery, crochet, smocking, stripes, and real or simulated clocking.
Preceding pages:
Spanish edition of *Marie Claire*, 1989.

an elbow, her torso bent back, she was adorned as if for some sexual ceremonial: in wedding-white bra, stockings, and string bikini garter belt, elegantly draped in accessories (pendant, pearl bracelet), her lips and nails painted, seemingly in red. She had placed her hand on that of her conqueror and appeared to be pressing it as if urging him on, giving her consent. Infuriated by advertising's continued exploitation of two classic feminine figures, Yvette Roudy's complaint amounted to "Mom or whore—we've had enough!"[12] On the other side of the Atlantic, in an 1991 overview of the foregoing decade, the journalist Susan Faludi saw in the resurgence of bustiers, nipped-in waists, and décolleté half-cups a return to the bad old days of sexism, an antifeminist "backlash." Like Dior's "Corolle" line dresses that rehabilitated an essentially reactionary image of post war womanhood, the frills and ruffles of Christian Lacroix's creations, beneath all the talk of "high femininity," amounted to command liberated women's attention with a counterattack," "a fashion war," in order to regain control of liberated women's bodies and turn them once more into dolls. The upswing in lingerie (illustrated by the success of the Victoria's Secret chain in the United States) was simply this "revenge" being carried over into the bedroom.[13]

In France, where, thanks to the influence of the courtly tradition, social and group relationships between men and women are regulated (among the elite at least) by less conflict-ridden and more subtle codes, such an antagonistic point of view generally had little relevance. The new and suggestive lingerie, nonetheless, lay at the heart of a network of tensions whose two poles are indeed male and female. While in the background both genders were undergoing their separate crises, 1980s fashion combined the roles of the girl playing with an explosive chemistry set and of her mom selling her for sex: in the stylistic exercises of Jean-Paul Gaultier (who equipped both male and female models with sizable velvet breast cones), fashion adulterated and doctored, purloined and swapped the style clichés of *both* sexes, and as such made a point quite different from 1970s *unisex*, which had simply shielded its eyes from the enigmatic difference between them.

The slang of the time chimed in well with such speculations. In 1970s French, *nana* (chick) had invaded both mind and street. The 1980s went back instead to *fille* (girl) and *garçon* (boy) as if to reinvest "sexual difference" with the incontrovertibility of a birth certificate. It was as if they were calling to each other, each gender in its own corner, and soon thirty- and forty-somethings on the trail of some long-lost paradise were calling themselves "boys" and "girls." Apart from *fille*, most of the old favorites of barroom lingo knew their brief moment of glory, each intended so that women might return to their distinctive, separate status. Thus the French went through not only the slang of *gazelle*, *caille* (literally, quail), *loute*, and *lady*; but also the more vulgar *pouf*, *pouffiasse*, *pétasse*, and even *gonzesse*, *souris* (mouse), *poulette* (chick), *sauterelle* (grasshopper), references to the detective novels and *films noirs* of the 1950s.[14] At the same time in the hotspots of Pigalle, for their "theme" nights,"switched on," "plugged in" nocturnal revelers were recolonizing the chocolate-box décor of a 1950s club with a name that spoke volumes: La Nouvelle Eve. This was precisely the "New Eve" that fashion was to clad in *chic* yet *shocking* undies—key words once more from the 1980s.

PANDORA'S CHEST OF DRAWERS

The chicest undies
Are to reveal nothing at all
When you've had to tell yourself
It's no good at all.

The chicest undies
Are garters going snap
In your head like
A face given a slap.

The chicest undies
Are a contract cancelled for fun
Like an old pair of fishnets
That's just started to run.

The chicest undies
Are a delicate feeling
Made up to the nines
In red like you're bleeding.

The chicest undies
Are to guard yourself deep inside
Like a piece of silk
So fragile you gotta hide.

The chicest undies
Are bitter ribbons and lace
Thrown over the door
—A downer of a place!
(Chorus)

The chicest undies
Are those stilletto heels
That stab a girl to the heart
—That's how she feels.

Les dessous chic
C'est ne rien dévoiler du tout
Se dire que lorsqu'on est à bout
C'est tabou.

Les dessous chic
C'est une jarretelle qui claque
Dans la tête comme une paire de claques.

Les dessous chic
Ce sont des contrats résiliés
Qui comme des bas résillés
Ont filé.

Les dessous chic
C'est la pudeur des sentiments
Maquillée outrageusement
Rouge sang.

Les dessous chic
C'est se garder au fond de soi
Fragile comme un peu de soie

Les dessous chic
C'est des dentelles et des rubans
D'amerture sur un paravent.
Désolant.
(Chorus)

Les dessous chic
Ce serait comme un talon aiguille
Qui transperceait le coeur des filles.

SERGE GAINSBOURG, *Les dessous chic*, 1983

DIAM'S
L'habit de lumière

Gainsbourg's song, interpreted by Jane Birkin, hit its target in seeking to depict the mood swings of the young and rather well-off women consumers who beat a path to boutiques selling the sort of lingerie and novelties their elders had abandoned. If Chantal Thomass was the French First Lady of sexy undies, other names and other boudoirs-stores gave their blessing to the return of the somewhat "naughty" women who would shiver (or pretend to shiver) at the mere touch of silk and satin, lace and fishnet: Les Folies d'Élodie, which opened in 1974, Sabbia Rosa on Rue des Saints-Pères in 1976 (just opposite the feminist publishers Éditions des Femmes, as was often

remarked), Pascale Madonna, Capucine Puerari, L'Indiscrète, and so on. From these 1970s outposts, lingerie's renewed adventure took on the look of a victory march.

If the bustier and the garter belt set the tone, they nonetheless remained singularly luxurious "impulse buys." The garter belt was to see its fledgling comeback brutally cut short, moreover, by thigh-high stay-up hose (such as the pioneering "Dim Ups") that burst on the scene in 1986. Quite apart from the aforementioned ancient contraptions, new ones, christened with new names, bestowed on lingerie and its vocabulary a stamp of excitement they had long lost. Launched in 1980 by Triumph, the tireless Sloggi brief in core-spun cotton with Lycra earned almost universal plaudits (a princess from Qatar was to order three hundred pairs a year),[15] but it had none of the sex appeal of a little battalion of high-cut briefs that were to bring the thigh into prominence and become useful accessories for the buttocks and rump: the *tanga* (thong), the Brazilian brief, and, somewhat older, the string bikini.

The string bikini, an escapee from mid-1970s revue bars and cabarets such as the Crazy Horse Saloon in Paris, was ideally invisible under figure-hugging outerwear (such as the trousers or the skin-tight acetate mesh dresses by Azzedine Alaïa), and was to experience a surge in popularity in inverse proportion to its minute dimensions. Its triumph was very soon sufficiently assured to earn the honor of literary allusion. In his 1979 novel *Bloody Mary*, Jean Vautrin described (in language that sounds lifted straight from a catalog or label) the "lagoon green, skin-soft, very low-cut, absorbent, perforated" model that awaited its fate in the chest of drawers belonging to Victoire, a blonde hairdressing apprentice from the socially-deprived area of Sarcelles, next to a "Angel-Skin bra, 15 percent spandex entirely free from underwiring" and "superlook styles with adjustable gate-backs," as the period demanded.[16]

Round about the same time there appeared what *Marie Claire* in France called *combines*: sets composed of a short bodice stopping at the hip, and loose-fitting drawers—cousin of boxer shorts for men—in silk, in Lycra, in figured material, trimmed with lace and rolled hems for the more luxurious variants, available in black, white, pearl, ivory, or pink. Christened "cami-tops" by some, *camisoles* enjoyed a solo career as an underblouse and became known in French high fashion as *caracos*. The word came from the term for an eighteenth-century narrow-sleeved fitted jacket, a "morning or evening garment, worn when taking the air or appearing in public when it is too early to go about in formal day or evening wear."[17] If the lexicographer Littré is to be believed, the word made it through the nineteenth century in the guise of a *caraco corsage* "of varying fit and length." Hiding—or perhaps forgotten—since then, it resurfaced as an undergarment as the decade opened, bringing with it distant echoes of libertine imagery of the eighteenth century: the audibly charming and enigmatic tones of the word *caraco*, its light, caressing sensuality with only a hint of the frivolous was tailor-made to designate the silk number with narrow shoulder straps that, by the 1980s, it had become.

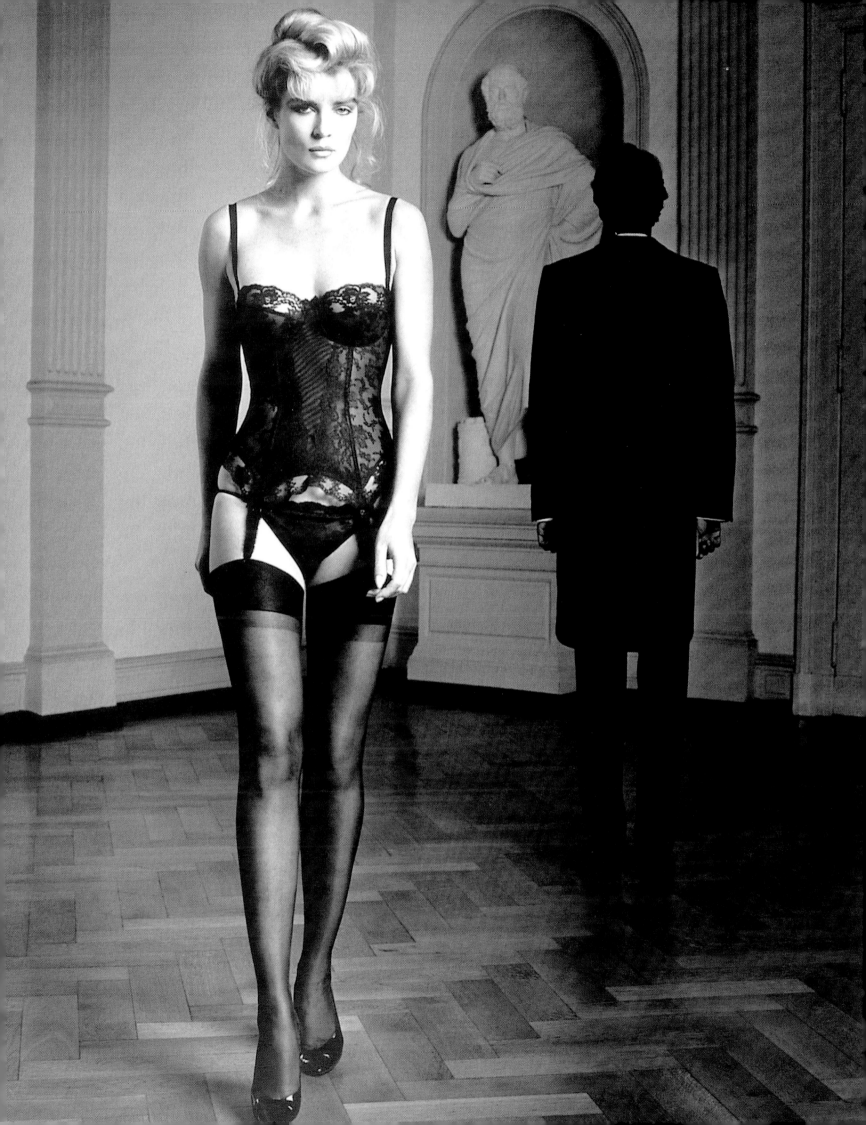

SLIM BACK, BIG BREASTS—THE 1990s

Atten——tion! Up and at'em, girls!

Mademoiselle, April 1988

I'm a Barbie girl
In a Barbie world

AQUA, *Barbie Girl*, pop song, 1997

Platform sneakers that make her legs look endless, wide-legged trousers (or sometimes a miniskirt) hugging the buttocks, a little fleece bomber jacket with a hood opening onto a short waist that parades with pride a high bosom under a T-shirt or a skintight cropped top that leaves the navel bare: such is the 1990s Betty Boop, the *bad babe*, the *fly girl* who has filled a decade of male daydreams. She could be a creature from a Japanese *manga*, like the PlayStation heroine Lara Kroft. She might be a Spice Girl, one of the five or so young English popsters who, for a couple of years, set hearts racing in the school yards and vied with "boys' bands" for the affections of preteen girls scarcely weaned of a devotion to Barbie dolls. Her disciples were taken from out-of-town housing projects, from the ghettoes where rap groups make for outraged headlines, her most dedicated followers in France being second-generation adolescents living in the city outskirts.[1]

In the age of the pinup and of the democratization of the car, the men of the 1950s had increasingly used metaphors borrowed from garage parlance to refer to women, and talked in France of a "classy chassis," and big "headlights." A flouncy summer dress, billowing in the wind like Marilyn Monroe's over the subway vent in the *Seven Year Itch* of 1955, gave fresh impetus to this vein of mechanical language. In France, for example, the cry, "Put the hood down, we can see the engine!" might have been heard.[2] In 1963, Alphonse Boudard spoke of the bra as

"bumpers."[3] Thirty years later, with more security-conscious car design, a "babe's" breasts are gauged by their resemblance to the volume, form, and texture of automobile airbags.[4]

Below:
Floral bra and panty set by Princesse Tam-Tam, 1997. Founded in 1985, this make derived its name from a Josephine Baker film. As in the 1970s, 1980s lingerie took on dyes and prints, in particular for the teenage market, even though white remained the biggest seller.
Facing page:
Lines by the American manufacturer Victoria's Secret (1998), created in the 1980s, today with two hundred stores.
Preceding page:
Underwired padded décolleté bra, 1991. This line, an illustration of a return to fashion for the bosom, ushered in the era of the "Wonderbra," the flagship of the uplift bras that reigned supreme in the heart of the decade.

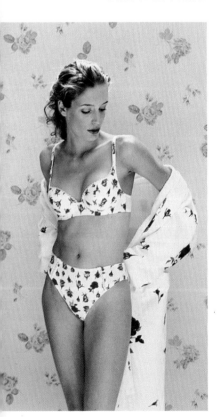

This upsurge in the bust's paragon virtues, this revival in eloquence was mirrored by a new and emblematic mark of lingerie: the *Wonderbra*. The Wonderbra had been initially designed (and none too successfully distributed) by Canadelle in the early 1970s. Once relaunched by Playtex around twenty years later, its name, its uplift characteristics, its push-up potential for elevating the breasts at the bust line, were a boon. A single year after its arrival in France in summer 1993, around 8,000 a day were being sold (at 242 francs in lace and 199 francs in cotton) when forecasts had only run to no more than 2,500. In 1994, a total of 1,600,000 units were sold.[5] During the 1980s, it was the underwired bra, with its eye-catching undercups and alluring strapless look, that had lorded it over the well-nigh invisible, underwireless, molded-cup models that had survived through 1968. With the Wonderbra it was the amplified bust generation—sometimes known as the Up Generation—of bras that made their mark, and thrust out breasts confident of their attractions and determined to play the seducer. "Look me in the eyes and say you love me," the supermodel Eva Herzigova requested in a Wonderbra advertisement, presenting living proof of the virtues of the garment. "It's astonishing that...five years after women burned their bras to show how liberated they were, they've reverted to the status of a nicely put together cover girl," the French daily *Libération* noted the same year, "the only difference being that they have done so without compulsion. Yesterday's bra bonfires had given them the option of wearing comfortable cotton underwear—or nothing underneath at all. Today, women have the choice: one day to be a pinup drawing by Aslan [star graphic artist of the racy *Lui* magazine], and the next to wear guileless Petit Bateau ensembles. They can dress like a boy—and wear something devastatingly sexpot so the slow ones at the back catch on. Quite prepared to go bang! in a man's face—just for the hell of it."[6]

As the decade broke, Karl Lagerfeld replaced the long lines of Inès de la Fressange with the well-upholstered Claudia Schiffer as *femme Chanel*, thus giving the institutionalized fashion world's stamp of approval to this change in proportions. It was, in truth, that studio glove maker of the female body Azzedine Alaïa—constantly polishing, loosening, and eroticizing womanly curves—who came up with its sexiest, most sophisticated guise. The renaissance of the cleavage and its support even surfaced in the outlines chosen for the cola bottle launched by Virgin in 1994, inspired by the ever-popular anatomy of *Baywatch* star Pamela Anderson. Some trotted out a well-known sociological law to account for this transformation, which states that female curves evolve contrariwise to those of the economy. So, flat chests in periods of wealth (the 1920s and the 1960s–70s) are followed by more prosperous bosoms in times of

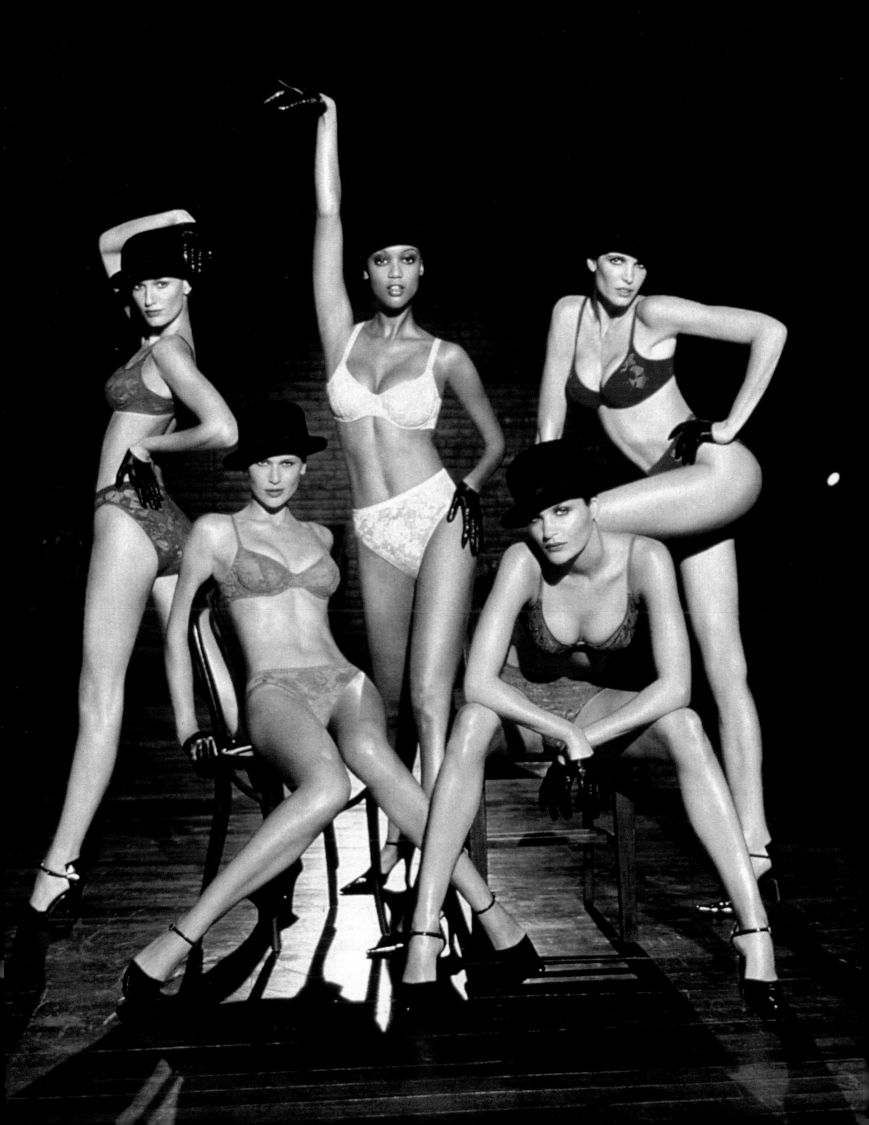

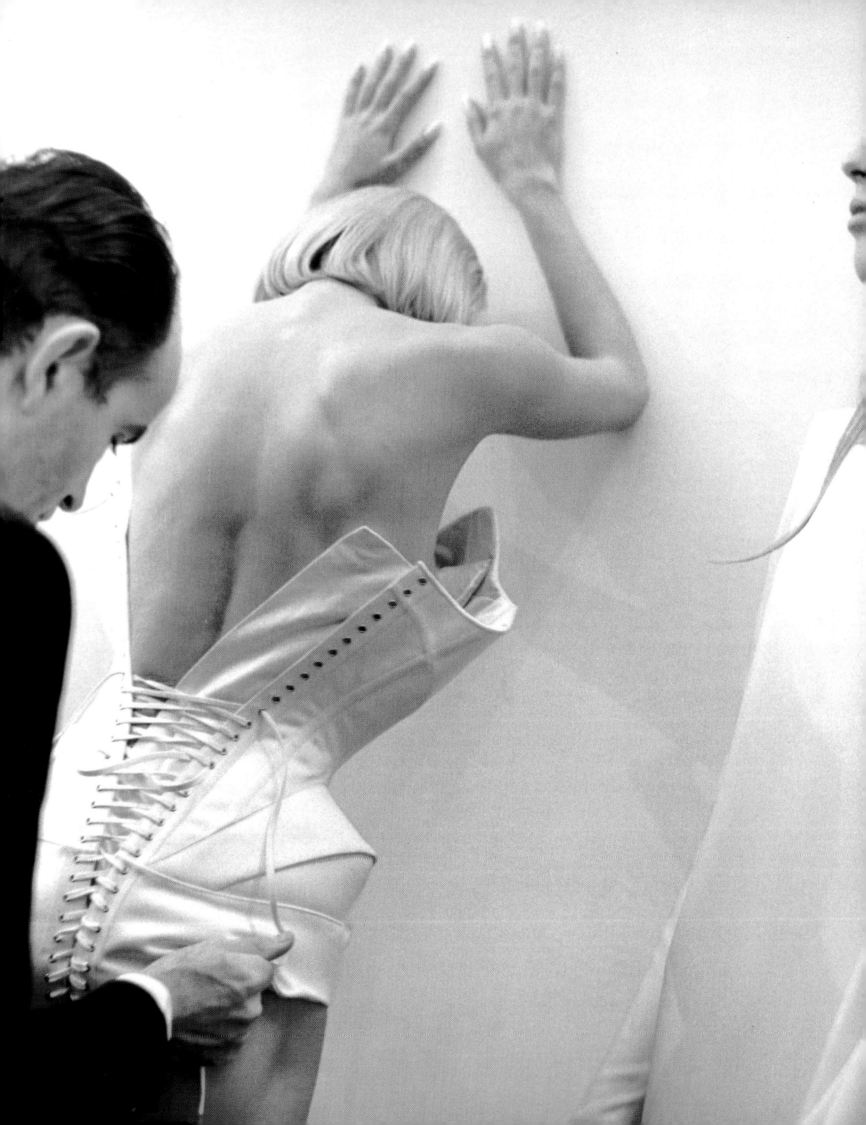

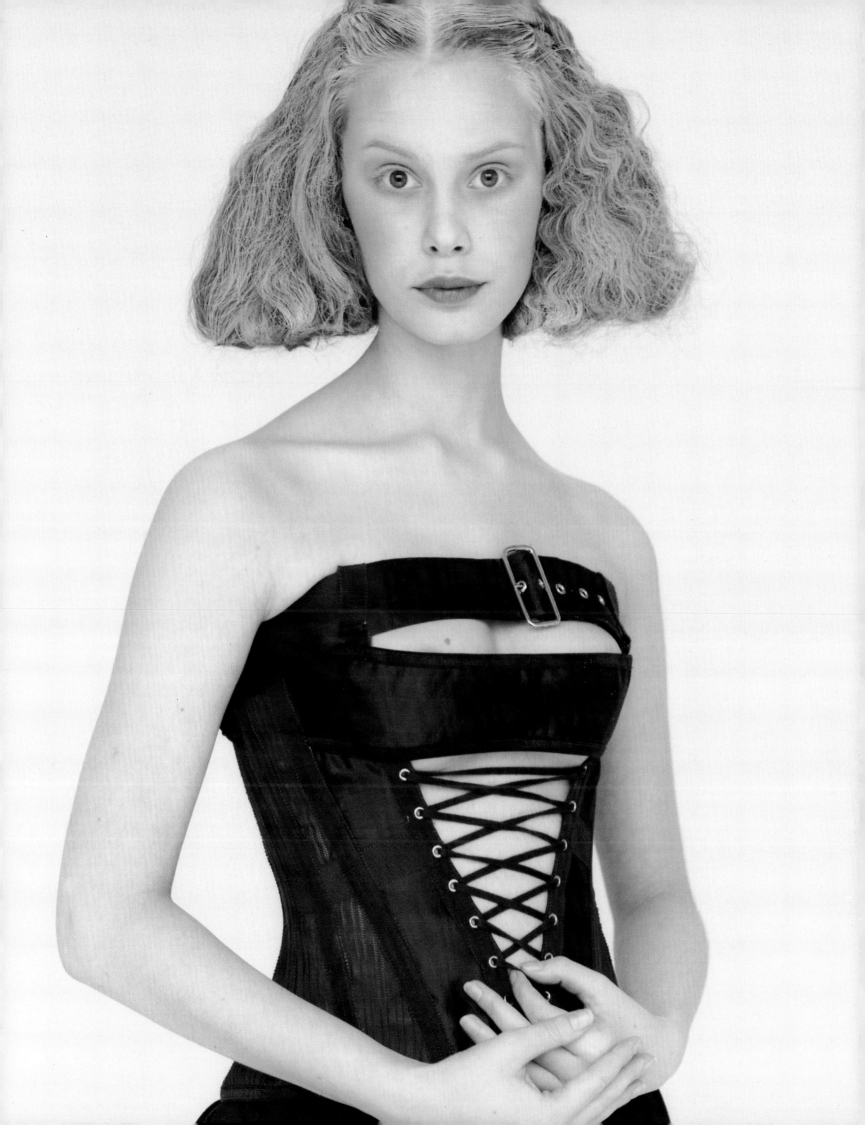

stagnation or crisis (the 1930s, the 1950s, and 1980s–90s). Others point to a shift from *little things* to *strapping girls* due to the combined forces not only of sport, better nutritional habits and more adequate hygiene, but also the Pill. *Slim back, big breasts*, so went the slogan.[7] Size 34B girls are being ousted by 36B, even C.[8] In 1995, the comedienne Valérie Lemercier was to put the equivalent French size (95C) into a song chronicling a girl's life mirrored in her vital statistics, summarizing, if elliptically, the whole history of woman's underwear since 1980.[9]

This was not the only way the bust was to be uplifted. Since the 1980s, plastic surgery was enhancing body shape: liposuction removed fat from the waist, stomach, and thighs, while silicone was injected into breasts. Gymnastic fashions succeeded one another: aerobics, body building, Stairmasters, and so on. Came the 1990s, a variety of briefs and tights—push-ups, light control, stomach flattening— more or less expensive prosthestic of body-shaping lingerie, took up the challenge to refashion the hip and buttock line. At certain runway fashion shows by Vivienne Westwood, for example, the return to underwear designed with the pretention of prosthetics for containment and support was refigured as a historically minded celebration of the improvers, bustles, and bum-rolls of the eighteenth and nineteenth centuries. *Hard glamour* musketeer John Galliano, for his part harked back to the 1950s since this was the "last period during which clothes were well and truly *constructed*." His models were supposed to "elevate femininity" and to "strike a chord with women who until now have been offered only unsexed, deconstructed garments"—in a barbed allusion to the Japanese designers Yohji Yamamoto and Rei Kawakubo (Comme des Garçons), *creators* for the *intelligensia* (two words to send shivers down the spine) who had achieved their notoriety as "deconstructors" of Western apparel at the beginning of the previous decade.[10]

The novelty store opened by Joseph Corre, son of Vivienne Westwood and Malcolm McLaren, in 1994 in Soho, London, was, with respect to the world of fashion lingerie, at the cutting edge of the tendency: "trashy" yet "sexy," as the weekly *Événement du jeudi* put it. In his shopfront-boudoir, a fantastical stage set halfway between a bordello and a wax museum worthy of Madame Tussaud's *tableau vivants*, "celluloid dummies in suggestive poses sport leathers, see-through or fake leopard-skin fabrics, and frilly bits and bobs." At the end of the 1950s, Star lingerie had promoted itself in advertising as the "secret agent" of feminine seductiveness, thus conforming to the stereotype of undercover missions, backrooms, and covert deals characteristic of the Cold War years. In the 1990s, Corre's boutique, called "Agent Provocateur," was in keeping with the now public face of this type of intimate "undercover" apparel that was no longer a simply private matter.

UNDIES ON TOP: FASHION DRAINS UNDERGARMENTS OF EROTIC CHARGE

One short-lived heroine of this restoration was the corset. It received the honors of the fashion runway, particularly as evening wear. As the most highly demonized piece of

Below:
Joseph Corre, the son of Vivienne Westwood and Malcolm McLaren, inside his exotic lingerie store, Agent Provocateur, London, 1998.

Facing page:
Half-bra and "panty-short" by Azzedine Alaïa, 1992. Such cotton garments can be worn easily as either underwear or outerwear.

Preceding pages:
The corset as outerwear. *Left*, a model by Thierry Mugler, 1998. *Right*, "anti-uplift" bra in taffeta and control fabric from Jean-Paul Gaultier's "Les rabbins chic" collection, Autumn–Winter 1993–94.

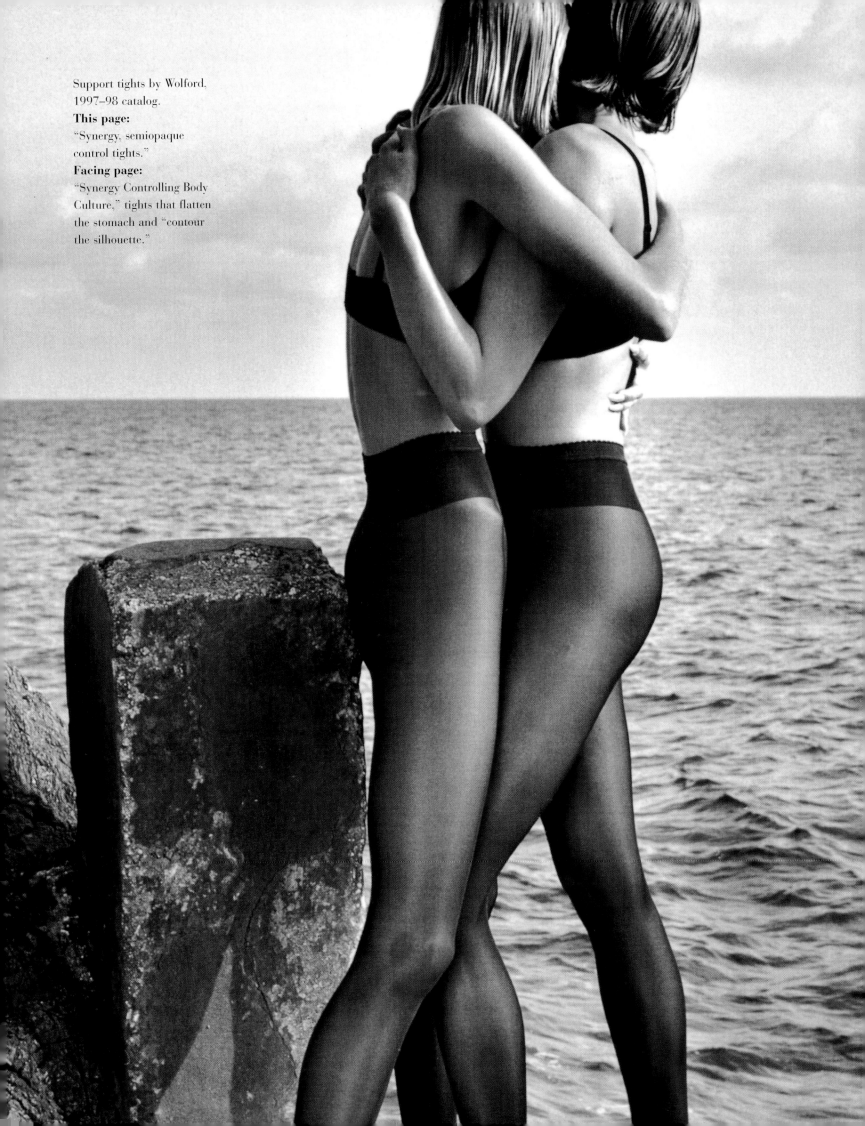

Support tights by Wolford,
1997–98 catalog.
This page:
"Synergy, semiopaque
control tights."
Facing page:
"Synergy Controlling Body
Culture," tights that flatten
the stomach and "contour
the silhouette."

Below:
Balconette, or push-up, bra with boxer shorts, Kookaï, 1997. In the 1990s, ready-to-wear labels annexed underwear as a new fashion vehicle.

Facing page:
Model Stella Tennant. "In England they call them *waifs*... like abandoned children," one could read in *Elle*, November 11, 1996. "A vacant stare, hollow hips, and emaciated arms.... With Kate Moss (5' 6", 103 lb.), Trish Goff (5' 7 1/2", 97 lb.) and Stella Tennant (6', 111 lb.), fashion has changed its statistics. After Claudia Schiffer..., make way for girls eaten up by pollution, drugs, and violence. Even Eva Herzigova, the full-figured Miss Wonderbra, has sacrificed her curves." This was a temporary phenomenon, as many observers commented in the same issue.

modern female dress, a fortress whose fall remained etched in the annals of women's liberation as a break for freedom or as a victory gained (the equivalent in sartorial terms of the right to vote), the corset was now readopted to encase a quite different femininity awash with sadomasochist and neopunk references. In 1990, Madonna undertook her Blonde Ambition World Tour decked out, by Jean-Paul Gaultier, in black fishnet stockings, zipped-up and belaced in a gold-colored corset with circular-stitch breast cones. Even more so than Gaultier—who had gleaned inspiration from the corset for dress designs as early as 1983—Thierry Mugler transformed the corset into the fetishistic highlight of his sexy and glamorous language, be it in varnished or plastic-coated leather, or in metalized cloth. From Christian Lacroix to Gianni Versace, from Alexander McQueen at Givenchy, to Stella McCartney *chez* Chloe, from Vivienne Westwood to Emanuel Ungaro, from Nina Ricci to Lolita Lempicka or Martine Sitbon—the corset was a fashion fad that reached its zenith in 1997. "We reckon we're Cléo de Mérode in our little boudoir, with the corset thrown in," the *Figaro* wrote on the subject of John Galliano's Dior collection.[12]

"Corset—pain or gain?" The press took up the cry. In December 1997, a journalist from *Elle* recounted how she had spent a *glamour* day with her waist reduced from her customary 30" to 23" without "passing out through suffocation." The method was able to "mold the body, without anorexia, without plastic surgery and without a Stairmaster." An English girl in her early thirties, Leonor, thus cut her waist measurement from 24" to 19". In New York the method was christened "BT"—"body-training"—while London knew it by the more sadomasochistic-sounding sobriquet "torso modification."[13] With the corset itself was reborn another long-forgotten personage, the corsetiere. One such was Poupie Cadolle, a guardian of a tradition of the support and deportment of the bust who ensured us that if now "tights have given women a tummy," they nonetheless do possess a "hollow at the waist that just begs to be shaped into a curve."[14]

As well as the classic type of corsetiere, two other figures resurfaced above the waters of fashion: the waist fetishist and the promoter of the corset as apparel. Mr. Pearl, a Britisher who himself wore a corset, is a prime example of the former. Rumor has it that he had a couple of ribs removed to get his waist down to that 18" that skeptical minds are not prepared to credit. The "strapped torso" in a black suit from Thierry Mugler's January 1997 collection equipped with a waist "of 19 inches, slimmer than Vivien Leigh's in *Gone with the Wind*," was his, *Le Monde* detailed—to an effort based on "micro-circumferences that have come to straighten out a fashion—or to ensure it support in uncertain times."[15] Hubert Barrère saw in the new fabric mixes (Tactel, Tencel, Lycra, spandex stretch) the potential for a "second skin corset," worn as outerwear.[16]

In the majority of fashion shows, the corset is indeed worn as a bustier, strapless top to a dress. As an undergarment it may have disappeared from view, but as a piece of clothing in its own right it made a comeback. It is yet another member of that family

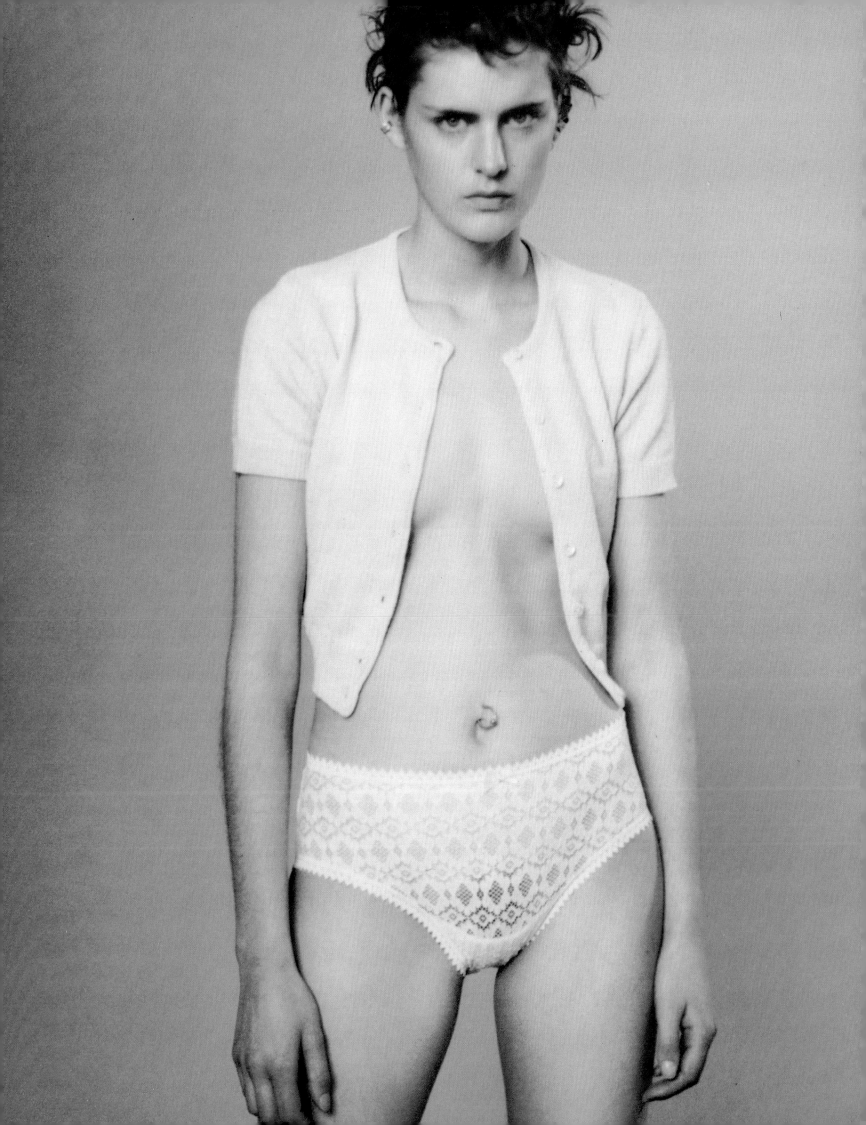

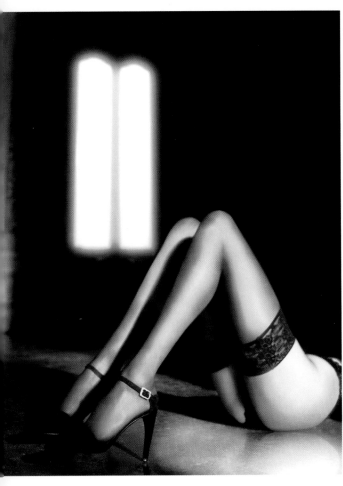

of extinct undergarments which, no longer worn as such and having therefore long been drained of their erotic charge, can undergo a personality change and be elevated to acceptability as part of the visible wardrobe without breaking taboos. Such were Renata's silk combination-dress in the 1970s, the little red-and-black checked bustier by Chantal Thomass in 1982, worn like a man's waistcoat with two welt pockets over a thin black polo shirt and under a gray suit.[17] If such undergarments can be worn "over," it can only be because they are no longer "undies."

Underwear worn over. The play on *over/under*—which had such an impact from the beginning of the 1980s—is contemporary with another cluster of events requiring more delicate handling and that resist easy interpretations. These events have to do with the representation of the female body together with its protective layers, screens and precious wrappings. What is the link, for instance, between this outer underwear and that other fashion for *anatomical* clothes? These garments bring to the surface an almost ultrasound scan of the printed, woven, and embroidered specter of an unclad female body—be it complete or limited to the breasts and pubic region—manufacturing an Eve in *trompe-l'oeil* in the same way as corsetry or its avatars sculpt her in relief.[18]

Provisional questions and stopgap answers for passing fads? A dose of *femininity* after all the *feminism*? Most probably. A backlash at a time when the sex-AIDS-death chain fills all with terror and hurriedly draws the curtain down on the mythical 1970s era of supposed sexual liberation? Most probably again. Perhaps this anatomical obsession with stating that a woman is a woman should also be seen as fashion's ambiguous response to yet another trauma much rehearsed by the media: artificial fertilization and surrogate reproduction. Next to the health, fashion, cosmetic, and plastic-surgery industries for which the female body now serves as raw material, there have appeared techniques of inspection, manipulation, management—in short, of annexation by medicine of an organic process over which, until now, women had exercised a monopoly: the manufacture of human life. Do not test-tube babies and surrogate mothers renting out a uterus, but also the new types of adoption (by homosexuals in particular) undermine a centuries-old representation of the female body as well as the symbols of descent and of maternal and parental identity? This one cannot assert unequivocally, but to ignore such developments as well as the metaphorical upheavals that arise from them is surely to deprive the recent history of lingerie and fashion of, if not of the glare of truth, then at least some kind of piecemeal enlightenment.[19]

Fashion recorded these real or imaginary tremors and embroidered over the scars. Its offerings are like the tiny bandages you tie around the sore finger of a child: they stem the blood, they console, amuse, and unpick the thread of each individual story

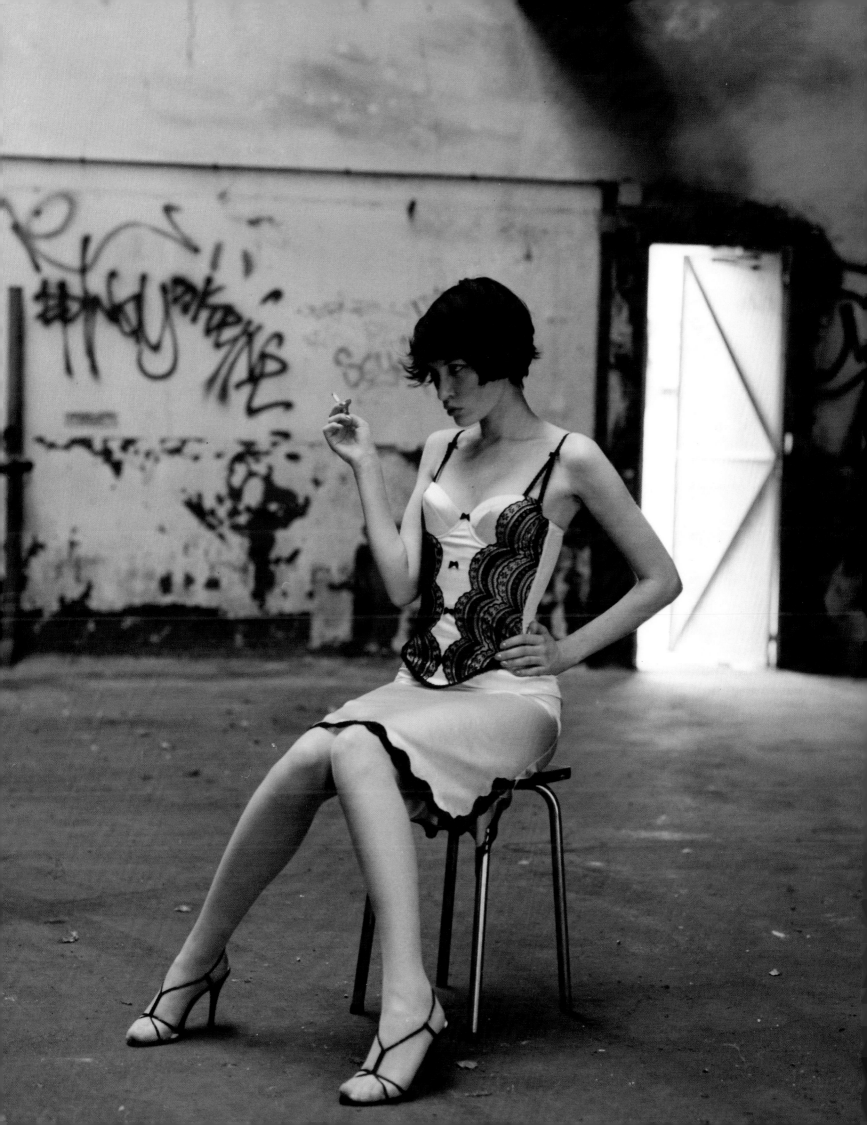

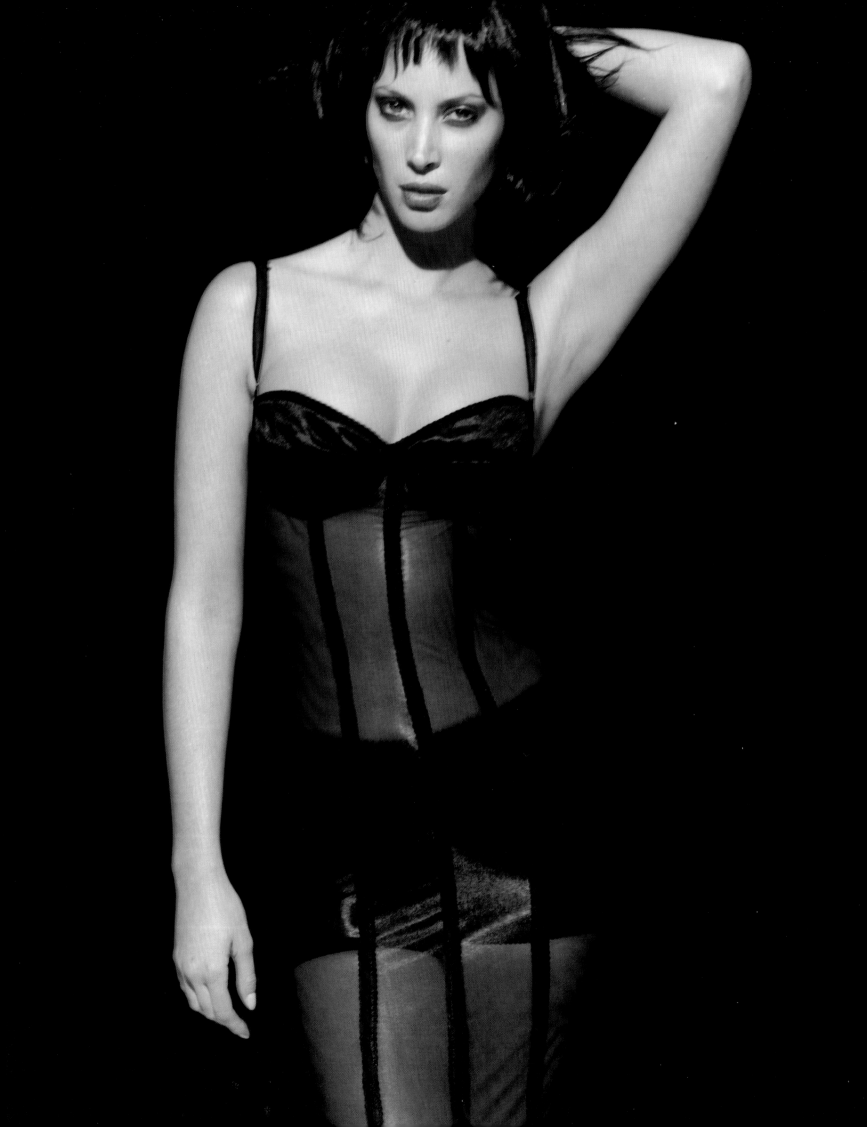

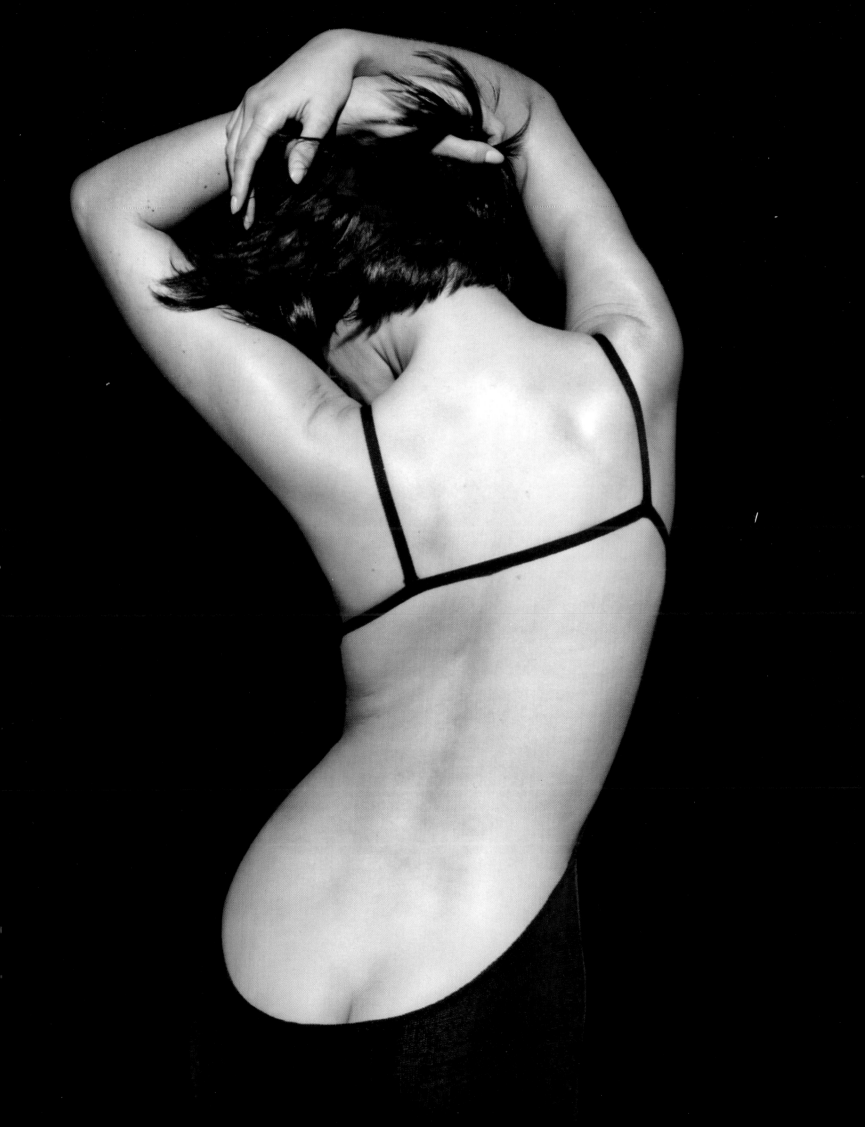

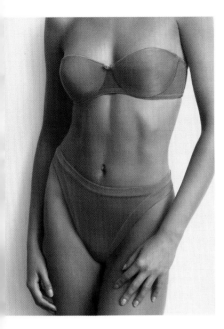

Above:
A "Mikonos" ensemble of
strapless bandeau bra and
high-thigh brief in Tactel.
Spring 1998. Tactel (a Du
Pont de Nemours registered
trademark) is a *microfiber*,
the end-of-century's
favorite material for *cosmetic* lingerie, where the
watchword is *soft*.
Facing page:
Model Laëtitia Casta in a
silk mousseline slip-dress
by Agnès B. and polyester
underpants by Alberta
Ferretti, 1997. "Miss, your
slip's showing." Gene Kelly
in 1966 remarked to
Françoise Dorléac in *The
Young Girls of Rochefort* by
Jacques Demy. At that
time, a slip or combination
should never show beneath
the hemline of the dress. In
the 1990s, the slip (often
with lace effects) is no
longer a piece of underclothing: it has become a
dress in itself.

the better to weave a collective history. Around the trend for reducing maternity to a series of biotech "sequences," 1990s fashion manufactured its parodic or dysfunctional "bandages." Let us keep two pictures in our mind's eye: the first arises from Jean-Paul Gaultier's spring–summer 1995 "Fin-de-Siècle" collection. Tradition has it that fashion parades end with the apotheosis of the wedding dress. On the final day of his show, Gaultier launched his heroine, Madonna, as a blond, skin-wrapped in a 1930s-inspired, see-through latex dress, a ruby-lipped saint-whore, laughing heartily in the midst of the photographers, pushing an old-style folding topped baby carriage, black in color with outsized wheels, at once the caricature and nostalgic love child of an improbably glam Immaculate Conception. "If it were a success, one might see in it a sort of *Critique of Pure Reason* of the artificial aids and other ploys that fashion, from padding to the Wonderbra, chooses to use and abuse," *Libération* observed. "As it is, it beggars embarrassment since one can sense a curious fantasy centered on a woman of the most monstrous ontology: a hunchbacked fairy godmother, an Elephant Woman dreamed up by an off-color David Lynch and *wrapped* by Christo on a bad day. Such hideously pregnant bellies are not to be recommended to any woman with child, in fact not to any women who are not in the habit of regarding their genetic code as a curse."[20]

NEW FIBERS FOR FEMININITY: TRANSPARENCY SKIN-DEEP

Less elaborately, the transmutation of innerwear into streetwear hailed the debut of lingerie on the fashion stage. The two domains were already swapping notes by the beginning of the 1980s,[21] but now lingerie espoused the logic, the rhythm, and the very language of fashion, even if any number of models went through the whole decade practically unaffected. After their eclipse in the 1970s, professional design salons turned into vast hypermarkets dealing in femininity and all its mysteries. Group shows and mini-catwalks jostled for space on the stands. Henceforth absorbed into conglomerates with global strategies, the big labels spirited away the most expensive and media-magnet supermodels, who, for their part, no longer found it demeaning to parade in well-known brands of underwear. Calvin Klein Underwear invited journalists and trade buyers to *meet with* Christy Turlington at the Paris International Lingerie Salon, Saturday, January 24, 1998, between 10:30 and 11:30.[22] In February 1998, as a foretaste of St. Valentine's Day, Victoria's Secret assembled a complete *Who's Who* of the modeling world to present its roaringly successful ensembles at the Plaza Hotel, New York: Karen Mulder in a naughty nightie, Heidi Klum in a décolleté bra, Naomi Campbell in fake leopard-skin briefs or else Laëtitia Casta in a string bikini brief beneath a black see-through bra baby-doll combination with embroidered golden flowerets. More modestly, in the spring–summer 1998 catalog for *La Redoute*, on a page entitled "Ophélie's Favorites," the singer-model Ophélie Winter was turned into a "glamorous ambassador for the comfortable Valclub line, for natural-looking women to bring out the beauty of their curves."

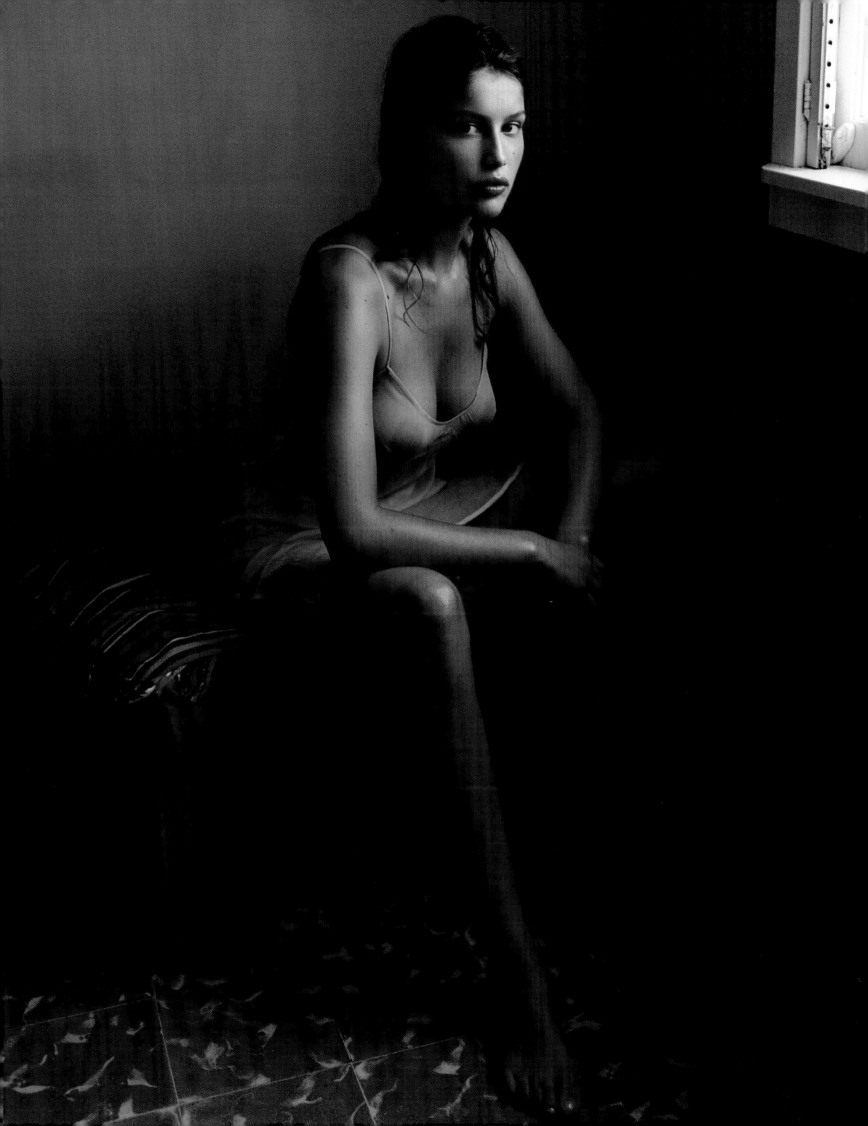

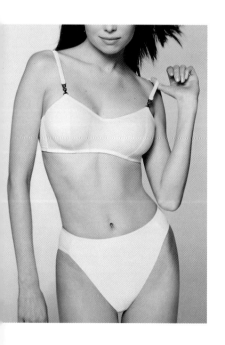

Back at marketing school, products, lines, and collections were being positioned into so many niches to meet detected needs, perceived desires, and fantasies on hold. The lingerie for adolescent girls and "young adults" was a prime example.[23] Evane Hanska, in *Les Amants foudroyés*, recounts how out-of-town schoolgirls of the 1970s were initiated into the mysteries of underwear, aided and abetted by their pretty little Petit Bateau panties, a prelude to their discovery of the string bikini brief. "Every self-respecting girl from the 'burbs has at one time or another worn these unassuming garments," she informs us. "Before going on to a nylon string bikini, the little girls from the housing projects squeezed their butts into pseudo-Petit Bateaus and set the Lolita-fanciers fantasizing. How many of those little marvels did I whip from supermarkets?"[24] In the mid-1990s—as a distant descendant of the 1960s wave with its *coordinates*—French teen lingerie comprised a very mixed bag for different girls: sporty, clean-cut girls within monogrammed Calvin Klein, Dim, Sloggi, or Fila, bra and shorts in black, white or mottled gray stretch fabric with a broad elasticated waistband; happy-go-lucky and colorful girls with a cotton Princesse Tam-Tam ensemble; delicate and dreamy girls in Cacharel, a sort of lace equivalent of the evanescent Anaïs-Anaïs, a world-famous perfume specifically targeted at adolescent girls and produced by the same company. Such rites-of-passage lingerie made inroads with a generation that was learning to live with its own femininity, hungry for all sorts of little treats, be they cute, coquettish, or simply brazen. According to a French study undertaken on the basis of 9,000 shopping baskets, spending on lingerie by 15- to 24-year olds between September 1995 and August 1996 reached 815 francs (out of an overall clothing budget of 4,450 francs), that is to say 34.3 percent more than the average outlay by French women generally.[25]

From tights with a garter belt look to garter belts and lace thongs, from see-through bustiers to tulle bras, the democratization of lingerie is inseparable from the recent changes wrought in fabrics. The age of nylon has been superceded by the Lycra generation. Registered by Du Pont de Nemours in 1958, the Lycra trademark made a mark on the story of textiles in the early 1960s and is the most widespread version of a synthetic elastic fiber, spandex. Stretchable up to seven times its length, and endowed with excellent elastic recovery when incorporated into a blend of other natural or synthetic materials, it contributes elasticity, flexibility, and comfort to all undergarments, from bras to tights. These qualities have turned it into the ideal vehicle for one of the more utopian sartorial dreams of the end of the twentieth century: the *second skin*. As a Du Pont de Nemours leaflet explains, "the simplest movements the human body executes such as bending the arm or the leg necessitate a skin elasticity in excess of 50 percent. However, cloths not containing Lycra cannot stretch more than 5 percent through natural extensibility or deformation. The appreciable difference between the skin's elasticity and that of traditional materials results in discomfort in wearing the garment and rapid loss of shape."[26]

Above:
Gossamer, microfiber bra
with no underwiring, the
"latest trend" in the
mail-order catalog *Une
Femme à Part*,
Summer–Autumn 1998.
**Facing and
preceding pages:**
Christy Turlington for
Calvin Klein underwear,
1996. An appropriate
symbol of the close bond
between fashion and lin-
gerie, top models such as
Christy were no longer
averse to posing for
underwear labels. Bras,
tops with bralike shoulder
straps, camisoles, cropped
T-shirts, for the most part
in cotton or microfiber:
this is minimalist lingerie
for the active life-style,
parading at once functional
simplicity and sports
hygiene, one of the essen-
tial trends of the second
half of the 1990s.

The origin point of this clothing utopia is *bodywear*. The rise and rise of the *body* (body garment)—originally a garment designed for dancers and gymnasts—began at the onset of the 1970s. Fads for aerobics, stretch, and body building propelled it into the fashion arena with the promise of a loose-limbed, slim-line body shape for a body that is its own master. In the mid-1980s, the body stocking or bodysuit became an undergarment in its own right, if not yet an all-purpose piece of clothing for a woman's wardrobe. As it was sometimes worn without underpants (as also is the case with tights), gynecologists complained about the fastening systems used for this updated leotard, be they buttons, snaps, or Velcro, sometimes a cause of irritation. The everyday life of body garment wearers was thus peppered with little mishaps in the crotch area, scratchy Velcro or a snap that popped open when it should not, leav- ing the garment prey to riding up and bunching in a disagreeable and unattractive manner.[27] The top part of a body, however, can replace an outerwear top as it is, but it also became available as an undershirt, a skintight sweater, a shirt or even, in the hands of a Jean-Paul Gaultier, a dinner jacket. Du Pont de Nemours uses the term *bodywear* to designate a hybrid wardrobe, based on Lycra and microfibers, that blurs the divide between daywear and dress-up wear in what the firm saw as one of the main trends of 1999.[28]

Among the innovative fabrics born in the wake of the vogue for "second skins" (with UV-blocking or thermoregulating properties, providing micromassage to improve the circulation, or antibacterial and scented encapsulation against the effects of sweat), the great event of 1990s lingerie was *microfiber*.[29] The strands, often sheerer than silk thread, are formed from countless polyester or polyamide filaments; the feel of the yarn, its finish, matte or shiny, depend on the internal structure of these filaments. After mastering elasticity, having harnessed luminosity, the third stage in the quest for lingerie's end-of-the-millennium Holy Grail was *softness*.

The constitution of a fabric is as much a sign of the times as any advertisement or cultural icon. If Lycra was the Ariadne's thread of body-shaping lingerie, microfiber serves the same purpose for *cosmetic* lingerie, for undergarments that vie with luxury skin creams in their "caress," in their "satin finish," in their emphasis on tactile over visual pleasure. Thanks to its *elasticity*, Lycra could see itself developing into a *sec- ond* skin; now microfiber has become a *first* skin, and, thanks to its peachy softness, is a fabric of almost intimate femininity, to be aimed at as an end in itself.

"After years of flounces and thrusting push-ups, boutiques are indulging in a dose of unadulterated minimalism," *Le Journal du Textile* wrote in 1998. "If one had only one product to chose, it would have to be invisible; if only one material, it would be microfiber. This is the current trend—comfortable, unseen, sober, even *basic* wear, hugging the body beneath the clothes. It's a move that began two years ago and has now exploded."[30]

At the cutting edge of this basic style one finds the *active* cotton underwear pro- moted above all by Calvin Klein: displaying a sporty, functionalist, almost hygienist straightforwardness, it first made its mark in the junior market. The decline of uplift

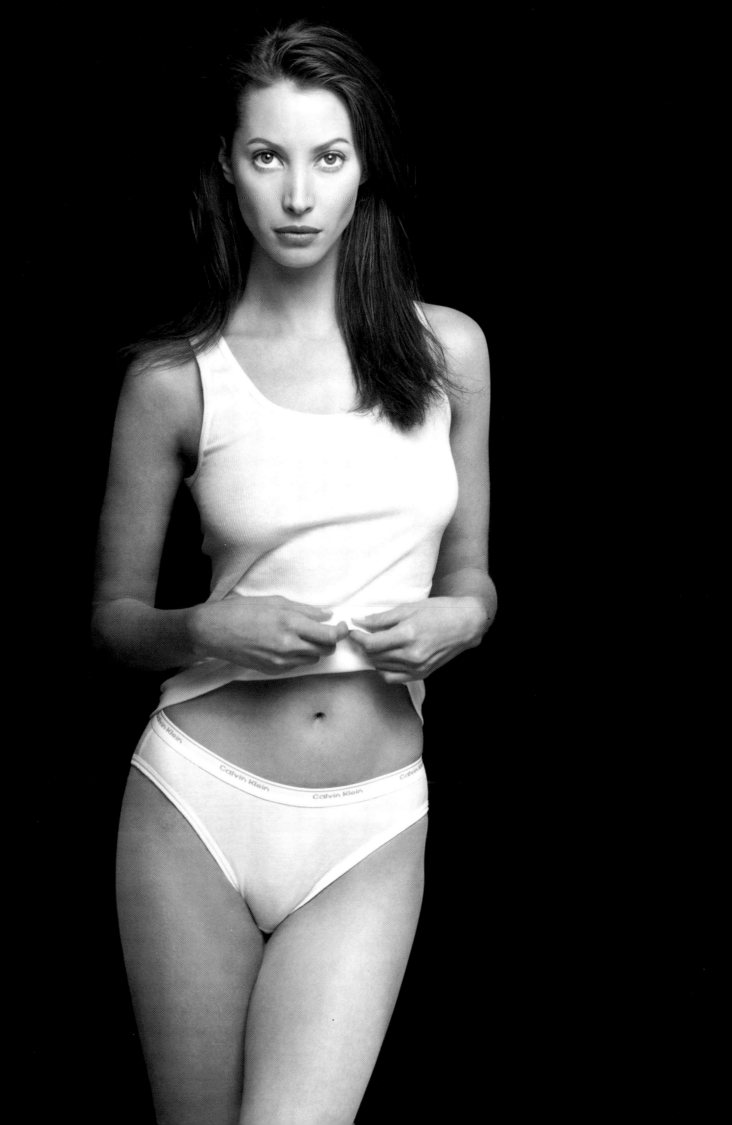

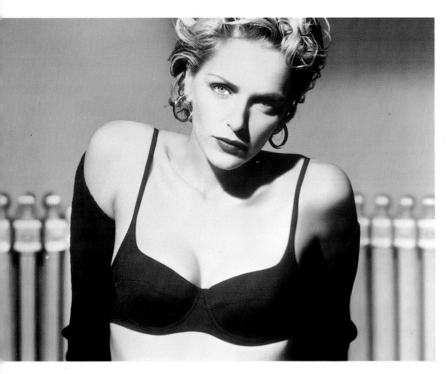

in bras since 1995 meanwhile promoted the return of molded cups. Their success, and that of Gossard's featherlight "Glossies," saw the end of the little tuck that used to give the bust a pointy tip. In the French *Redoute* catalog for autumn–winter 1998–1999, padded bras were now only marginally formed (*légèrement ampliformes*), when they were not simply ousted by styles at once seamless (a new buzzword) and flattening.

At the year 2000, while wild, young things are sprouting up to usurp supermodels of Claudia Schiffer's vintage, while fashion is all transparency, gossamer effects, and filmy overlays, all Prada or Jeremy Scott pleating that thinly veils androgynous bodies, lingerie keeps in the background, out of the limelight, with a marked tendency to "No Design."[31] This new invisibility is not the same as that of the *non-lingerie* of the 1970s. That disappearance had been loudly trumpeted in the name of woman, liberated of all taboos and free in her own body. Today lingerie is simply diaphanous: it cultivates its mystery, throwing a cloak over its own disappearance, as it were, like a fantasy double of the "Me-Skin"[32] whose bewildering tattoos, like lacework spreading over the skin, provide hints to the unanswered enigma of femininity.

Above:
"Sculpture" brassiere by La Perla.
Facing page:
Camisole and briefs.

APPENDIXES

TIMELINES

NOTES

BIBLIOGRAPHY

TIMELINE

LINGERIE

Beneath the crinolines,
pantaloons, or **drawers,**
become commonplace
for women

The **corset** encases the
female body in *armor*.
Fashion for **bustles**.

FASHION

Worth invents ***haute couture,***
his most prestigious customer
being Empress Eugénie.
Each costume
requires its own
panoply of accessories.

First **ladies' tailors.**
Having conquered the city,
white wedding gowns
now make headway
in the country.

CULTURE AND THE SPIRIT OF THE TIMES

1857: Gustave Flaubert's
novel ***Madame Bovary,***
in which *petit bourgeois*
Emma from Normandy
ruins herself trying
to become Parisian
fashionable.
The **cancan** is all the
rage in French dance halls.

In France, nondenominational
schooling is free and obligatory
for all. The earliest girls'
colleges and high schools.
Paris has a ball with **music
halls**, dancing girls, and
frou-frou skirts.

LINGERIE

1900: Suspender garters said to have been invented by Féréol Dedieu in 1876, henceforth replace the band garter. **Stockings** remain **black** as shown in Pierre Bonnard's nudes. Certain prostitutes use black sheets to bring out the white of their flesh.

1910: For a few years, for morningwear or sportswear, elasticated **belts** are worn in place of a corset. 1904: *soutien-gorge* (brassiere) enters French dictionaries. 1907: The "bra is an essential complement to the belt," writes Baronness d'Orchamps.[2] **Bandeau** and **flattener** brassieres appear. Rubberized springs replace corset boning.

1925: A "flapper's" underwear: flesh-colored silvered silk stockings, **flattener bra** to constrict the bust, loose **cami-knickers.** Disappearance of the petticoat and reintroduction of the band garter. Rayon, artificial silk.

1930:

Le Gant: name given by Warner to its elasticated Lastex girdle in the United States. Development of cup sizes for bras. **Closed-front drawers** replace prewar open-legged drawers.

FASHION

1900: Thonet chairs, Guimard's Paris Metro entranceways, the S-line: **curves** are in fashion. Paul Poiret joins Worth's in 1901. Couturiers send models dressed in their latest styles to the Bois de Boulogne and to the paddock at the races, both meccas for high fashion.

1910:

In 1909, **Mariano Fortuny** executes the first of his "Delphos" dresses with their legendary pleating. **Paul Poiret** ousts the corset in favor of waist cinchers under his Empire-line gowns.

1925: The new silhouette for women: **short hair** and freedom of movement. **Coco Chanel** borrows from male working attire for knits, jerseys, and "rough" materials.

1930: Charles James and the advent of American haute couture. Adrian dresses Hollywood's stars: Greta Garbo in Rouben Mamoulian's *Queen Christina* (1933).

CULTURE AND THE SPIRIT OF THE TIMES

1900: In England, and to a lesser extent in France, the **suffragettes** make their point. In France, the maximum legal working day is fixed at 11 hours for women and children. The **Eiffel Tower** is built for the 1899 Universal Exhibition: word has it that it "shows a woman's leg clad in net stockings and that the four pillars are the suspenders extending from the belt."[1]

1910: 1909: **Diaghilev** and the Ballets Russes in Paris—scandal but runaway success. The growth of the **silent cinema.** 1916: Lillian Gish in D. W. Griffith's *Intolerance.*

1925: Decorative Arts Exhibition in Paris. André Breton's first *Surrealist Manifesto* in 1924; psychoanalysis and Freudian ideas become widely known. **Jazz** is the music and the **Charleston** the dance of the age.

1930: Germany: **Marlene Dietrich** in *The Blue Angel*, wearing corset, black stockings, and garter belt. The Hayes Code (1934) in the United States censors Hollywood cinema by stipulating that a woman removing her stockings or having them removed by a man will on no account be shown on film.

	1935	1945	1955	1965
LINGERIE	**Renaissance of the bosom**. "A liar—like a bra," quips Louis-Ferdinand Céline. Mae West says to Marlene Dietrich, "You give 'em the bottom and I'll give 'em the top."[3] 1938: Nylon is invented. September 9, 1938: An advertisement for **tampons** (Tampax) in *Marie Claire*.	Marcel Rochas invents the **guêpière**, or wasp-waister corset. First **nylon stockings** appear in Europe. **Petticoat** renaissance.	**Seamless stockings** and stiletto heels enter the scene. The **foundation**, a simplified version of the full slip. 1959: Lycra is developed. Nightgowns: the **baby doll**, named for Caroll Baker in Elia Kazan's film of 1956.	**Panty-girdle**, or control panty: a new generation of girdles. Advent of **tights** meets with early success: opaque or brightly colored, they make classic light tones seem out-of-date. 1967: In Mike Nicholl's *The Graduate*, Dustin Hoffman, more used to the cotton panties of girls of his generation, soon loses his innocence to Mrs. Robinson and her disconcerting lingerie.
FASHION	**Long-line, bias-cut** dresses for a slim figure: **Madeleine Vionnet** creates a neoclassical silhouette. **Schiaparelli** juggles fantasy and surrealism.	1947: **Christian Dior** and the **New Look**. From now on: raised bust, wasp waist, and "Corolle" dresses.	**Coco Chanel** makes a comeback: *costumes* versus the New Look. Around 1958, in France, petticoats beneath checked "Vichy" skirts; the earliest blue jeans.	Advent of the **miniskirt** (Mary Quant, André Courrèges). Paco Rabanne's **metal dresses**. 1966: Yves Saint Laurent's **tuxes**.
CULTURE AND THE SPIRIT OF THE TIMES	1938: Classic French actress Arletty in *Hôtel du Nord*, directed by Marcel Carné. 1939: Vivien Leigh in Victor Fleming's *Gone with the Wind*. A French song of the time runs something like, "Old pairs of pyjamas/They're just for Pa/Titillating undies/They're just for Ma."	1949: Simone de Beauvoir's ***The Second Sex***, three years after Louis Réard's launch of a swimsuit christened the bikini for the Pacific atoll recently used for the first controlled **atomic bomb test** by the United States. Frenchwomen have the vote since 1944.	1956: Blonde bombshell **Brigitte Bardot** in Roger Vadim's *And God Created Woman*. **Elvis Presley** and **rock'n'roll**. The legs of **Marilyn Monroe** in Billy Wilder's *The Seven Year Itch* put the wind in America's sails.	The decade of the **baby boom**. The Beatles and the Rolling Stones. Twiggy, the skinny model. Carnaby Street, the hub of teenage fashion. Pop Art, Op Art, and the growth of pop-music culture. 1967: ***Blow Up*** by Michelangelo Antonioni. The contraceptive **Pill** legalized in France. **Woodstock**: three days of Peace and Love, and Music.

1972	1980	1990	1999...	
Underclothes are reduced to a strict minimum: **hipster briefs,** bras with preformed, transparent cups— or none at all. The **T-shirt** becomes universal as underwear and outerwear, while a man's shirt can be worn as a provocative nightdress.	After the **caraco** camisole in France and the string bikini brief, the bustier and garter belts. Vogue for **glamorous, sexy** lingerie. Lycra invades underwear generally. Lacey, clocked and fishnet tights. B**razilian briefs** and thongs. The **body garment** makes its mark mid-decade. First **stay-up stockings**. June 1989: *Life* devotes a cover to one hundred years of the brassiere.	**Body-sculpting** lingerie. 1994: Triumph of the **Wonderbra,** brand leader in uplift and cleavage-inducing bras. **Corsets** reappear on the catwalk. **Control** tights.	Lighter-than-air "**second-skin**" lingerie. Seamless bras, with invisible molded cups, almost transparent midriff band. Active sports underwear (Calvin Klein, Fila, Dim). Widespread use of **microfiber.**	LINGERIE
Trousers for women gain ground; the panty-girdle takes a final bow. **Unisex** and **retro** fashions. Fashion *créateurs* appear in Paris: Sonia Rykiel, Kenzo, etc. Parisian women fill their wardrobe from Vogue (a boutique on Rue Tronchet) and from the Prisunic department store.	**Shoulder-pads** for superwomen in suits. Boxer shorts, body stockings, close-fitting dresses. Azzedine Alaïa sculpts the female form. Yohji Yamamoto and Rei Kawakubo (Comme des Garçons): the Japanese hit Paris.	Haute couture has a new lease of life at the hands of Christian Lacroix, Jean-Paul Gaultier, and Thierry Mugler. An **international style** prevails: Donna Karan, Giorgio Armani. Every house markets its own perfume range.	See-through and tattoos: superpositions and **slip-dresses**. 1998: **high-heels** year, with the record going to Gucci for their *styletto*.	FASHION
1970: Women's Lib and abortion—women obtain increased rights. Vogue for "**erotic**" cinema (*Emmanuelle*, 1973) and X-rated films (porn, "skin flicks"). Ads for tampons and sanitary napkins. 1976: Punk arrives. 1977: *Saturday Night Fever*. Disco craze takes off on dance floors.	The Palace nightclub in Paris, Studio 54 in New York: the places to be seen. 1982: identification of HIV as the cause of AIDS. 1984: "Wombs to let" and **surrogate mothers.** Cult of the body and body building. High-tech. Jean-Paul Goude and Jean-Baptiste Mondino **image makers.** Madonna sings *Like a Virgin*. Michael Jackson undergoes face enhancement.	Vogue for **supermodels,** for liposuction, and silicon injection in the lips. 1996: Two Barbie dolls are sold on the planet every second. Quentin Tarentino's *Pulp Fiction*. **Rap**, **techno**, **raves,** and **Ecstasy**. 1997: The Spice Girl year, English "girl group" for the preteens.	A new generation of models following in the footsteps of Kate Moss (5' 7", 97 lbs.), discovered in 1992. James Cameron's *Titanic*: Kate Winslet shipwrecked in a see-through pink gown.	CULTURE AND THE SPIRIT OF THE TIMES

NOTES

PROLOGUE: THREE LINE OF INQUIRY

1. Eugénie Lemoine-Luccioni. *La Robe. Essai psychanalytique sur le vêtement* (Paris: Seuil, 1983). 13.
2. Adapted from Georges Bataille, *Eroticism*, trans. M. Dallwood (London: John Calder, 1962), 131–32.
3. Yvonne Verdier. *Façons de dire, façons de faire. La laveuse, la couturière, la cuisinière* (Paris: Gallimard, 1979). 180–90.
4. Odile Blanc. *Parades et Parures. L'invention du corps de mode à la fin du Moyen-Age* (Paris: Gallimard, 1997).

CHAPTER 1: TROUSSEAU AND UNDERWEAR: INVENTORY AND INVENTION

1. "Le grand siècle du linge" is the title of an article by Alain Corbin in *Ethnologie française*, n.s., 16, no. 3 (1986): 299–310, an issue devoted to underlinen and household linen.
2. Anne Kraatz. *Dentelles* (Paris: Adam Biro, 1988), 118.
3. The parallel between the trousseau and the intimate diary, or, more exactly, between "a peasant-girl embroidering her trousseau" and "a girl from the bourgeoisie keeping a private diary," is stressed by Alain Corbin in op. cit., p. 306.
4. On this *marking* of the trousseau in France, see Yvonne Verdier, op. cit., pp. 178–95, and the short introductory foreword.
5. Baroness Staffe, *Usages du monde* (Paris: Victor-Havard, 1890), 32, with the subtitle, "rules for living in modern society."
6. Jacques Laurent sees in the more general adoption of pantaloons a perfect illustration of the rule that states that, since the end of the eighteenth century, whatever is first worn by children is sooner or later worn by adults. *Le Nu rêtu et revêtu* (Paris: Gallimard, 1979), 125. On the success of this type of underclothing, see Philippe Perrot, *Fashioning the Bourgeoisie: A History of Clothing in the Nineteenth Century*, trans. R. Bienvenu (Princeton: Princeton University Press, 1994).
7. Edmond and Jules Goncourt. *Journal. Mémoires de la vie littéraire* [1851–96], vol. 1, (Paris: Robert Lafont, 1989), 1075 (May 30, 1864): At the dance at the Élysée-Montmartre, a woman dressed in high-heel ankle boots tapering like needles and a pair of flesh-colored silk stockings. Before the second figure, she bends down, stuffs her top in her drawers, then leaps forward, bows down low and, keeping her head at the height of her waist, holding her skirt high above her with both hands, stamps her feet in double-quick time, showing her legs up to the knees and her pantaloons right up to her honor.
8. Quoted by Romi. *Histoire pittoresque du pantalon féminin* (Paris: J. Grancher, 1979), 81. On La Goulue and the dance shows of the 1880s and 1890s, see Luce Abélès, "Toulouse-Lautrec: La baraque de la Goulue." *Cahiers Musée d'art et d'essai, Palais de Tokyo* (Paris: La Réunion des musées nationaux, 1984), 14; and Mariel Oberthür. *Montmartre en liesse 1880–1890* (Paris: Musée Carnavalet, 1994).
9. Armand Silvestre. *Les Dessous de la femme à travers les âges* (Paris: E. Bernard et Cie., 1902). 24.
10. *Hygiène de la grossesse*, quoted by Pierre Dufay. *Le Pantalon féminin. Un chapitre inédit de l'histoire du costume* (Paris: Charles Carrington, 1906). 224. When the drawers worn by a dancer are sewn closed, the corresponding fantasy has the material covering the crotch splitting asunder—a commonplace of the genre which provides ample scope for literary bravado. See, for example, Louis Legrand. *Cours de danse fin de siècle*, 1892: "In the matte whiteness of madapolam [cotton], a dark patch appeared. As small as a hundred *sous* coin, it went first past the audience's eyes without any unsettling effects, but, minute by minute, it became larger and more distinct. Soon, no doubt about it, a split had been breached in the all-important passion-killer, and precisely at the place where it was its paramount duty to remain intact.... The hole increased in size.... And now it measures a hand's span ... the teacher loses his temper: 'Tart! Slut! ... Ah! You've thrown on worn-out drawers to give us a quick glimpse of your c——! ... You guessed the journalist was coming today and you wanted to give him something to think about with your what's-it, eh!'" Quoted by Guy Ducret, *Corps et Graphies. Poétique de la danse et de la danseuse à la fin du XIX siècle* (Paris: Honoré Champion, 1996). 250–51.
11. On open-or closed-legged drawers before and after the First World War in France, see Jacques Mauvin. *Leurs pantalons, Comment elles les portent* (Paris: Jean Fort, 1923). 181ff., in the new edition revised and enlarged with a series of interviews of the 1912 publication. See especially Jill Fields. "The Production of Glamour: A Social History of Intimate Apparel, 1909–1952." PhD. Diss., University of Southern California, 1997, a work which we became aware of too late to use profitably in the present book, a situation we shall be sure to amend in any future edition. If one is unable to consult Jill Fields' thesis (it remains unpublished at this time), reference should be made to her article: "Three Sides to Every Story: The Material Culture of Intimate Apparel." *Dress* (1996).
12. Pierre Dufay op. cit., p. 162.
13. Harold Koda and Richard Martin, *Infra-Apparel* (New York: Metropolitan Museum of Art, New York, 1993), 62.
14. Baroness d'Orchamps. *Tous les secrets de la femme* (Paris: Bibliothèque des auteurs modernes, 1907). 78.
15. Émile Zola, *The Ladies' Paradise* [1883] (Berkeley: University of California Press, 1992), 363.
16. Émile Zola, op. cit.
17. Krafft-Ebing, *Psychopathia Sexualis*, 1886. Among the linenwear fetishists the celebrated German psychiatrist recorded, enthusiasts for women's handkerchiefs are numerous, one, for instance, being arrested just as he was trying to extract a handkerchief from a lady's pocket and add it to eighty or ninety counterparts he had already purloined in a similar fashion.
18. Gaëtan Gatian de Clérambault, *Passion érotique des étoffes chez la femme* [1908] (Paris: Les Empêcheurs de penser en rond, 1991), 41–48.
19. Quoted by Luce Abélès, op. cit. p. 11. On the industrialization of leisure pursuits and shows in Paris, see Julia Csergo. "Extension et mutation du loisir citadin. Paris XIX–début XX siècle," in Alain Corbin, *L'Avènement des loisirs. 1850–1960* (Paris: Aubier, 1995), 121–68. On the role of the gaze in mass culture at the Belle Époque, see Leo Charney and Vanessa Schwartz, eds., *Cinema and the Invention of Modern Life*, (Berkeley: University of California Press, 1995).
20. *Le Coucher d'Yvette*, quoted in Romi, op. cit., pp. 93–98. The other titles are *La Toilette de la Parisienne, Le Coucher de la mariée*, and *Le Déshabillé de la midinette*.
21. The expression is that of Countess Tramar in *Le Bréviaire de la femme Pratiques secrètes de la beauté* (8th edition, 1903), quoted by Philippe Perrot. op. cit., p. 261.
22. Pierre Dufay, op. cit., p. 162.

CHAPTER 2: THE HEALTHY BODY VERSUS THE CORSET

1. Jean Cocteau. *Portraits-Souvenirs: 1900–1914* [1935] (Paris: Grasset, 1954). 84.
2. On the transformations affecting corsetry, see Georges Vigarello, *Le Corps*

Facing page: *Waiting in the Chelsea Hotel.*
Following page: Warner Baxter choosing the female star for his film *Forty-Second Street* (1932).
Page 186: The main "protagonists" on the new glamour scene, as seen by Italian *Vogue*, in 1994.

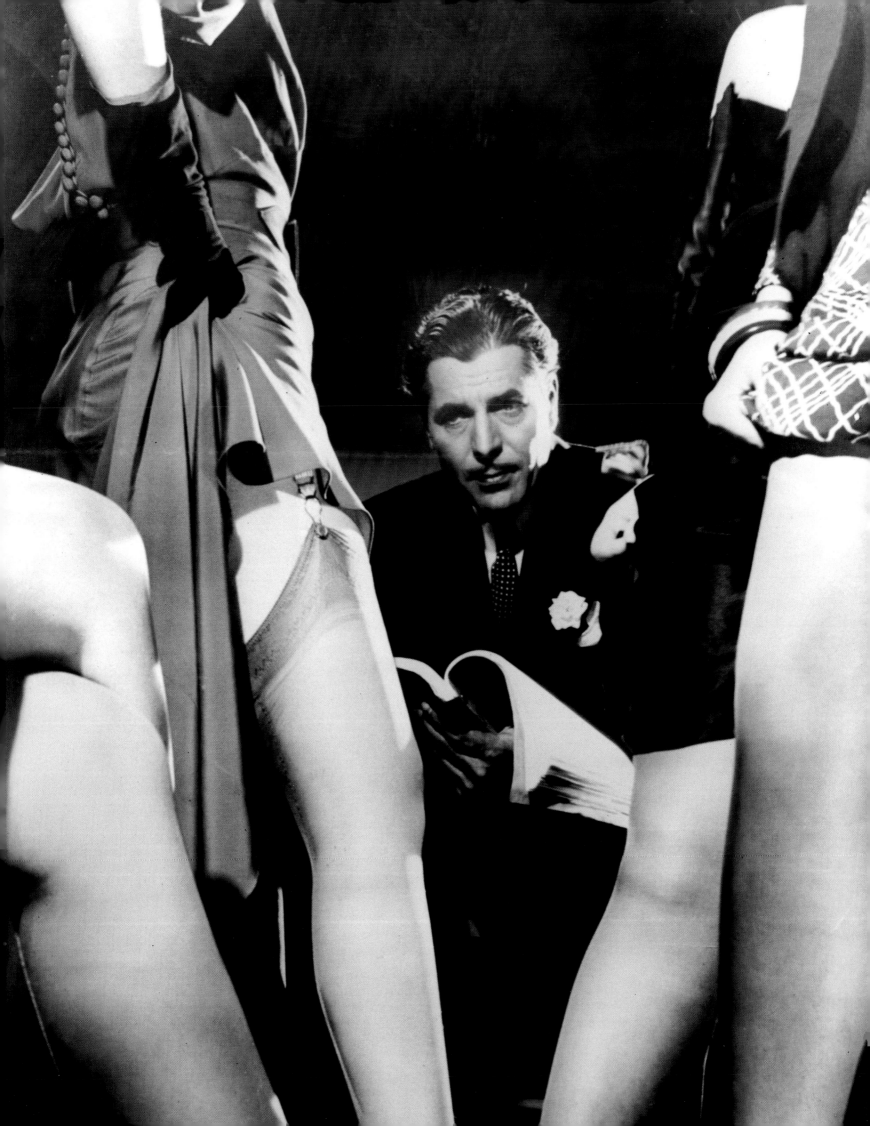

redressé (Paris: J.-P. Delarge, 1978). 130–31.

3. David Kunzle. "The Corset as Erotic Alchemy: From Rococo Galanterie to Montant's Physiologies," in *Woman as Sex Object: Studies in Erotic Art, 1730–1970*. Thomas B. Hess and Linda Nochlin. ed. (London: Allen Lane, 1973). 161.

4. Quoted by Philippe Perrot, *Fashioning the Bourgeoisie*, pp. 276–81.

5. Alison Gernsheim, *Victorian and Edwardian Fashion. A Photographic Survey* (New York, 1984), 56 (already published under the title, *Fashion and Beauty 1840–1914*, in 1963).

6. David Kunzle, op. cit., p. 109.

7. Emmanuel Bove, *Mes amis* [1924] (Paris: Émile-Paul Frères, 1929), 32.

8. On these dancers, see Marcelle Michel and Isabelle Ginot, *La danse au XX siècle* (Paris: Bordas, 1995), 81–93.

9. Jean-Jacques Rousseau, *Émile, or Education*, trans. A. Bloom (New York: Basic Books, 1979), 367.

10. J.-J. Rousseau, pp. 366–67.

11. An 1886 photograph shows May Morris dressed in a robe inspired by medieval models, worn without a corset: reproduced in Sarah Levitt, *Fashion in Photographs 1880–1900* (London: Batsford, 1991), 63. On hygienicists, rationalists, reformists and their various movements in Great Britain, see Stella Mary Newton, *Health, Art and Reason: Dress Reformers of the Nineteenth Century* (London: John Murray, 1974).

12. See Philippe Perrot, *Le travail des apparences ou les transformation du corps féminins XVIII–XIX siècle* (Paris: Le Seuil, 1984), 186–196.

13. Colette, "La culture physique et des femmes," *Le Matin*, December 18, 1913, in *Contes des mille et un matins* (Paris: Flammarion, 1970), 61–62.

14. Colette Willy, "Ma corsetière," *Paris-Journal*, July 12, 1910, in *Contes des mille et un matins*, p. 235.

15. According to Yvonne Deslandres, Madeleine Vionnet was already proposing body-hugging, bias-cut dresses that were so unacceptable that they were scarcely ever shown to customers," in *Paul Poiret 1879–1944* (Paris: Éditions du Regard, 1986), 99.

16. Paul Poiret, *My First Fifty Years*, trans. S. H. Guest (London, 1931), 72–73.

17. Y. Deslandres, op. cit., p. 99.

18. Palmer White, *Poiret* (London: Studio Vista, 1973).

19. quoted by Palmer White, op. cit.,p. 31.

20. The role of female doctors is underscored by Philippe Perrot, *Fashioning the Bourgeoisie*, pp. 244–45. Lady doctor Gaches-Sarraute was the author of two works: *L'Hygiène du corset*, published in 1896, and *Le Corset, étude physiologique et pratique*, published in 1900.

21. Colette Willy, op. cit.

CHAPTER 3: THE "GAMINE" IN THE AGE OF DEMOCRATIC LINGERIE

1. As described in Francis Carco, *Jésus-la-Caille* (Paris: Mercure de France, 1914).

2. According to Madeleine Delpierre, in *Secrets d'élégance, 1750–1950* (Paris: Musée de la Mode et du Costume, Palais Galliera 1978), 13.

3. *Le Corset de France et la lingerie*, April 1930, and Shazia Bouchet and Annette Handiquet, *Vingt-cing ans de lingerie ou la dentelle sans dessous-dessus* (Calais: Musée des Beaux-Arts et de la Dentelle, 1997), 72

4. Quoted by Colette, "En dessous," *Demain*, May 1, 1924, republished in Oeuvres, vol. 2, *Le Voyage egoïste* [1928]. (Paris: Gallimard, 1986). 1144. In *A Journey for Myself*, trans. D. LeVay (London: Peter Owen), 69.

5. Colette, ibid, p. 68. See Chapter 2.

6. Paul Louis de Giafferri (Giafar), *La Lingerie chez soi. Deux cents secrets de coupe, quatre cents croquis de lingerie et dessous élégants* (Paris: Fayard, n.d. [c. 1927]), 247.

7. *Mon Trousseau. Linge de corps et de maison. Manual général 1928–1929*, p. 9.

8. Ibid.

9. Ibid, p. 6.

10. P. L. de Giafferri, op. cit., p. 16.

11. Ibid.

12. Louis-Ferdinand Céline, *Journey to the End of the Night* [1932], trans. Ralph Manheim, (New York: New Directions 1983), 63.

13. On this phenomenon, see Agnès Fine and her analysis of the demise of the

trousseau in the 1970s in "A propos du trousseau: une culture féminine?" in *Une histoire des femmes est-elle possible?* under the general editorship of Michelle Perrot (Marseille: Rivages, 1984). 186.

14. P. L. de Giafferri, op. cit., p. 100.

15. *Mon Trousseau*, p. 2.

16. Agnès Fine, op. cit., p. 173.

17. G. de Clérambault, op. cit., p. 52. See Chapter 1.

18. *Mon Trousseau*, p. 3.

19. Ibid.

20. Léon-Paul Fargue. *Le Piéton de Paris* 1939 (Paris: Gallimard, 1982), 174.

21. P. White, op. cit., pp. 83–84. See Chapter 2.

22. Lucie Delarue-Mardrus, *Embellissez-vous!* (Paris: Éditions de France, 1926), 110–11.

23. Marny, *Les Bas à travers les âges*, followed by *Ce qu'il est bon ton d'acheter* (Paris: Marny, 33 Rue Tronchet, 1925), 28–54.

24. Lucie Delarue-Mardrus, op. cit., pp. 179 and 180.

25. Louis-Ferdinand Céline, *Death on Credit* (London: John Calder, 1966). 142.

26. André Breton, *Nadja*, trans. R. Howard (New York: Grove Press, 1960),

27. E. Bove, op. cit., p. 32. See Chapter 2.

28. Henri de Montherlant, *La Petite Infante de Castille* (Paris: Grasset, 1929), 602.

CHAPTER 4: PENELOPE 1930s STYLE: NOSTALGIA FOR THE FEMININE

1. Remarks by Jean Patou's close associate, quoted by Guillaume Garnier in *Paris-Couture Années Trente* (Paris: Musée de la Mode et du Costume, Palais Galliera, 1987), 9.

2. *Le Corset de France et la lingerie*, Nov. 1929. On evening dresses of the period, see Valérie Guillaume, "Les vagabondages de la mode du soir," in *Robes du soir* (Paris: Musée de la Mode et du Costume, Palais Galliera, 1990), 158.

3. Examples of the use of these metaphors are found in an excellent book by Bertrand Mary, *Les Pin Up ou la fragile indifférence. Essai sur la génèse d'une imagerie délaissée* (Paris: Fayard, 1983), 208 ff.

4. *Le Corset de France et la lingerie*, Dec. 1929.

5. *Marie Claire*, May 28, 1937.

6. *Le Corset de France et la lingerie*, Nov. 1928.

7. Arthur W. Pearce, *The Future Out of the Past: An Illustrated History of the Warner Brothers Company on Its 90th Anniversary, with the History of the Corporate Family, C. F. Hathaway, Puritan Sportswear and Warner Packaging* (Hartford: Warner Brothers Company, 1964), 39–43.

8. Maria Riva, *Marlene Dietrich by Her Daughter* (New York: Knopf, 1992), 219.

9. *Le Corset de France et la lingerie*, March 1928.

10. In the 1930s, numerous advertisements sang the praises of slimming girdles.

11. Alison Carter, *Underwear: The Fashion History* (London: Batsford, 1992). 82.

12. Ibid., and A.W. Pearce, op. cit., p. 41.

13. Remarks made by the writer Fernand Divoire quoted by Romi, op. cit., p. 139. See Chapter 1.

14. *La Belle Lingerie*, Winter 1938.

15. Ibid.

16. Emmanuel Berl, "La Mode 1932." *Les Nouvelles littéraires*, April 16, 1932. In *Lignes de chance* (Paris: Gallimard, 1934), 23–38.

17. *Mon Trousseau*, op. cit., p. 9. See Chapter 3.

18. On the price range of nightgowns at the end of the 1930s and on the ceremonies accompanying their purchase in the department stores of the time, see Lucien François, *Pimprenelle* (1939), reprinted in *Pimprenelle et sa fille* (Paris: SEMP, 1944), 89–93.

19. *La Belle Lingerie*, Winter 1937.

20. On this subject, see Francine Muel-Dreyfus, *Vichy et l'éternel féminin. Contribution à une sociologie politique de l'ordre des corps* (Paris: Seuil, 1996), and Dominique Veillon, *La Mode sous l'Occupation. Débrouillardise et coquetterie dans la France en guerre (1939–1945)* (Paris: Payot, 1990).

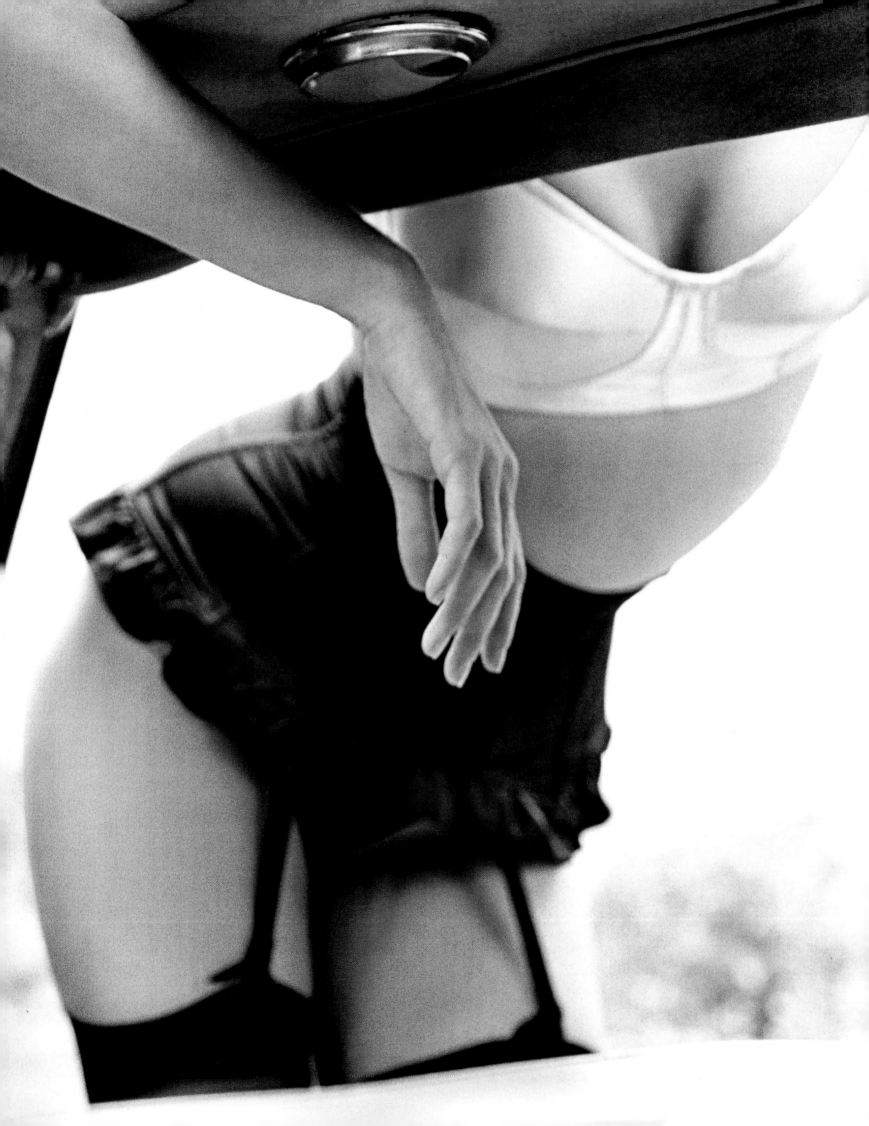

CHAPTER 5: 1947–1957: COLD YEARS—HOT UNDIES

1. In Michel Boisrond's 1959 film *Le Chemin des écoliers*, Françoise Arnoul played Yvette, one such coquette under the Occupation. In a famous scene, after clambering up on a table, she asks her lover and his pal, played by Alain Delon and Jean-Claude Brialy respectively, to do her legs, the friend finishing them off with a line for the seam.
2. On this whole period, see D. Veillon, op. cit. See Chapter 4.
3. Ibid., p. 70.
4. Lyse de Landroy, *La Couturière chez soi. Cours de coupe et couture en 12 volumes*. Vol. 6. *Les Tailleurs, la lingerie* (Paris/Geneva: Éditions G. Liechti/Les Éditions pratiques, 1952). 228–30.
5. L. François, op. cit., pp. 90-91. See Chapter 4.
6. D. Veillon, op. cit., p. 134.
7. *Les Dessous élégants*, June–July 1952.
8. Christina Probert, *Lingerie in Vogue since 1910* (New York: Condé Nast, 1981). 33.
9. *Dior by Dior*, trans. A. Fraser (Harmondsworth: Penguin, 1958), 21.
10. Ibid., p. 27.
11. Ibid., p. 46.
12. Ibid., p. 21.
13. On the pinups of the period, see Mary, op. cit. See Chapter 4.
14. Ibid., p. 326.
15. That the frontier between these two ideals could become hazy did not escape adversaries of the hourglass line, such as Madeleine de Rauch, a couturier who favored a more sober and sporty *chic* and who was delighted to see the regression (in predictions for the year 1955) of a fashion she judged "vulgar" (in *Les Dessous élégants*, Oct.–Nov. 1954). According to the same issue, couturiers were to "ban all curves" from their collections since they were "too sensual."
16. According to Jacqueline du Pasquier in *Le Guide de l'élégance* (Paris: Larousse, 1954). 16.
17. *Les Dessous élégants*, June–July–Aug. 1953 and July–Aug. 1954.
18. *Les Dessous élégants*, Oct.–Nov. 1953.
19. A. W. Pearce, op. cit., p. 47. See Chapter 4.
20. C. Probert, op. cit., p. 42.
21. D. Veillon, op. cit., p. 200, and A. Kraatz, op. cit., p. 176. See Chapter 1.
22. Pauline Réage, *Story of O*, trans. Sabine d'Estrée (New York: Grove Press, 1965), 139–140. On the relatively short life span of the wasp-waister, see M. Étienne, *Corset-gaine et soutien-gorge* (Paris: J.-B. Ballière & Fils, 1958). 174.
23. "In truth, it is this hollow that lies behind all my creations," Antonio de Castillo declared at Jeanne Lanvin's. "Yes, the pit of the stomach is like the touchstone of any youthful figure." *Les Dessous élégants*, April–May 1953.
24. J. du Pasquier, op. cit., p. 214.
25. Interview with Suzanne Chenoune, *née* Marchellier, Paris, April 21, 1998.
26. *Les Dessous élégants*, April–May 1953.
27. Albert Simonin, *Touchez pas au grisbi!* (Paris: Gallimard, 1953). 252.
28. Jacques Cellard and Alain Rey, *Dictionnaire du français non contemporain* (Paris: Hachette, 1981). 717.
29. *Les Dessous élégants*, April–May 1953.
30. Interview with Suzanne Chenoune, op. cit.
31. J. du Pasquier, op. cit., p. 216.
32. Marc de Saligny, *Précis des nouvelles usages* (Paris: Prisma, 1948). 99–100.
33. J. du Pasquier, op. cit., p. 216.
34. *Les Dessous élégants*, April–May 1953.
35. Jean Poirier, ed., "L'homme, l'objet, et la chose," in *Histoire des mœurs*, vol 1, *Les coordonnées de l'homme et la culture matérielle* (Paris: Gallimard, "La Pléiade" series), 947.
36. On the function of the prostitute in the economy of masculine and conjugal sexuality, see Alain Corbin, *Women for Hire: Prostitution and Sexuality in France after 1850*, trans. A. Sheridan (Cambridge, Mass.: Harvard Univerity Press, 1990), 186–214.
37. Armand Silvestre, op. cit., p. 24. See Chapter 1.

CHAPTER 6: LITTLE GIRLS AND LIBERATED WOMEN: PANTIES, BIKINI BRIEFS, AND TIGHTS

1. Jean-Jacques Schuhl, *Télex No. 1* (Paris: Gallimard, 1976). 22.
2. J.-J. Schuhl, *Rose poussière* (Paris: Gallimard, 1972). 84.
3. J.-J. Schuhl, *Télex No. 1*, op. cit., p. 54.
4. J.-J. Schuhl, *Rose poussière*, op. cit., p. 83.
5. On the modernization of France at this time, see Roland Barthes, *Mythologies* [1957] trans. A. Lavers (New York: Vintage, 1993). Also Kirstin Ross, *Fast Cars, Clean Bodies: Decolonization and the Reordering of French Culture* (Cambridge, Mass.: M.I.T. Press, 1997), who quotes Alain Robbe-Grillet.
6. Ibid., p. 83–84.
7. *L'Express*, April 16, 1964.
8. Ibid.
9. Ibid.
10. Ibid.
11. Benoîte and Flora Groult, *Il était deux fois* (Paris: Livre de Poche, 1971). 233.
12. Interview with Christine Martin, Paris, February 25, 1998.
13. Louis Simon, *Dim* (Paris: Chêne, 1985), unpaginated. On Dim tights, see Giorgio Agamben, *La communauté qui vient. Théorie de la singularité quelconque*, trans. from Italian by Marilène Raiola [1990] (Paris: Le Seuil, 1990). 50–55.
14. "Le maniérisme d'un monde sans manières," interview with Jean Baudrillard, *Le Nouvel Observateur*, February 18, 1983.
15. Figures quoted by Catherine Ormen, *Les Sous-Vêtements féminins, 1968–1972*, an unpublished study realized under the auspices of the Musée des Arts et Traditions populaires (École du Patrimonie), December 1, 1987.
16. Pascal Lainé, *The Web of Lace*, trans. George Crowther (London: Abelard, 1976). 59.
17. On the history of the term *unisex* and its significance, see Olivier Burgelin and Marie-Thérèse Basse, "L'unisexe. Perspectives diachroniques," publ. in "Parure, pudeur, étiquette," *Communications* 46, ed. Olivier Burgelin and Philippe Perrot (Paris: Le Seuil, 1987). 279–304.
18. *Le Torchon brûle*, 5, Paris, 1973.
19. Figures cited by C. Ormen, who emphasizes the discrepancy between behavior and opinion, and mentions the results of a survey undertaken in 1970 interviewing a sample of 1,230 for the benefit of the French National Federation of Corsetry Industries, according to which 84 percent of women asked stated that they wore a bra "all of the time." In conclusion, the author of the report stresses that "young women, contrary to what is commonly held, remain attached to the bra. In fact, it is up to manufacturers to provide models they would like to wear." Ormen also mentions the "equally extraordinary results" of another poll (commissioned by the same federation in December), this time on wearing girdles: 55 percent of women declared that "they wore a girdle, step-in girdle, panty-girdle, or panties, all of the time," and 48 percent said they wore tights with such underwear: op. cit., p. 10 and note 22, pp.15–16.
20. A. Carter, op. cit., p. 133. See Chapter 4.
21. Interview with Chantal Thomass, February 2, 1998.
22. G. Agamben, op. cit., p. 51.
23. Chantal Chawaf, *Le Soleil et la terre* [1977] (Paris: Livre de Poche, 1979). 90–91.

CHAPTER 7: TEMPTATIONS FOR A NEW EVE

1. It is worth noting that Just Jaeckin shot commercials for Dim.
2. Alain Roger, "Vulva, Vultus, Phallus," *Parure, pudeur, étiquette*, op. cit., p. 189. See Chapter 6.
3. *The Illustrated Report of the Commission on Obscenity and Pornography* (San Diego: Greenleaf Classics, 1970). Richard Nixon rejected its findings on the pretext that the authors had detected no danger to morality in the proliferation of pornography: ibid., p. 17.
4. Alphonse Boudard, *Les Enfants de chœur* (Paris: Flammarion, 1982). 197–98.
5. Interview with Chantal Thomass, op. cit. See Chapter 6.
6. Ibid.

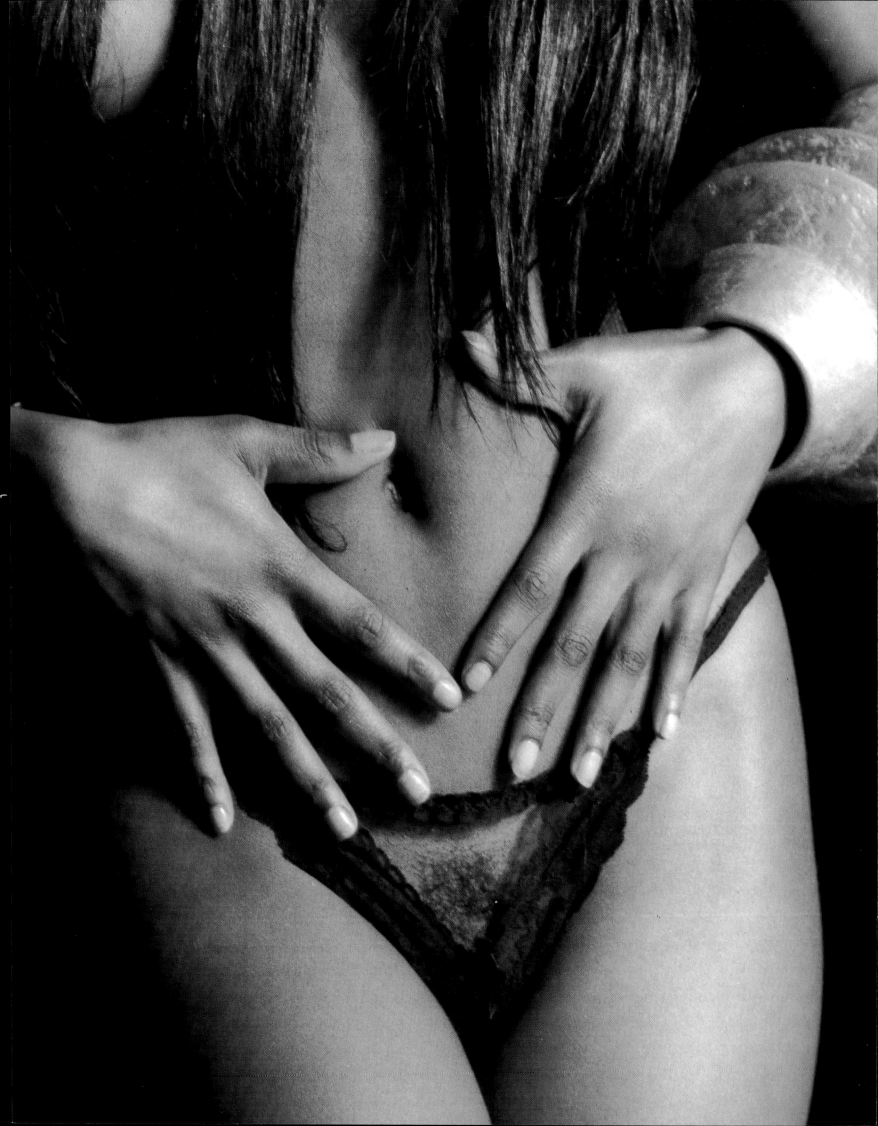

7. On this period, see particularly Alain Pacadis, *Un jeune homme chic* (Paris: Le Sagittaire, 1978); Brice Couturier, *Une scène-jeunesse* (Paris: Autrement, 1983), and, for fashion, Marylène Delbourg-Delphis, *Le Chic et le Look. Histoire de la mode féminine et des moeurs de 1850 à nos jours* (Paris: Hachette, 1981), 233 ff.

8. Evane Hanska, *J'arrête pas de t'aimer* (Paris: Balland, 1981), 150.

9. Laurence Benaïm, *L'Année de la mode, 1987–1988* (Paris: La Manufacture, 1988), 124–35.

10. "Le maniérisme d'un monde sans manières," interview with Jean Baudrillard, *Le Nouvel Observateur*, op. cit. On the miniskirt, see Chapter 6. On Georges Bataille's analyses, see the concise exposé and the passage quoted in our Prologue above.

11. The extracts from *F. Magazine* and *Marie Claire* come from K. Dekhli. "Civilité et monde moderne," *La Chose sexuelle, Nouvelle Revue de psychanalyse* 29 (1983), quoted by Gérard Vincent, "Le corps et l'énigme sexuelle," *Histoire de la vie privée*, ed. Philippe Ariès and Georges Duby, vol. 5 (Paris: Seuil, 1987), 367–69.

12. Marie Bertherat and Martin de Halleux, *100 ans de lingerie* (Paris: Atlas, 1996), 103.

13. Susan Faludi, *Backlash: The Undeclared War Against American Women* (New York: Crown, 1991), 170.

14. Farid Chenoune, "Comment ils les appelent," an unpublished article based on findings from a modest survey undertaken by the author in 1985 using a miniscule sample of twenty or so interviewees, its conclusions being necessarily intuitive.

15. M. Bertherat and M. de Halleux, op. cit., p. 107.

16. Jean Vautrin, *Bloody Mary* (Paris: Mazzarine, 1979), 196–97.

17. Definition taken from an eighteenth-century fashion journal, quoted in *Modes et Révolutions. 1750–1804* (Paris: Musée de la Mode et du Costume, Palais Galliera, 1989), 226.

CHAPTER 8: SLIM BACK, BIG BREASTS—THE 1990s

1. On these second-generation black and white adolescents, see Nathalie Gathié, "Leçons de drague black." *Libération*, April 15, 1994.

2. See particularly B. and F. Groult, op. cit., p. 243. See Chapter 6.

3. Alphonse Boudard, *La Cerise* (Paris: Plon, 1963), 178.

4. On the figurative use of the term *airbags*, see for instance an interview with the singer-model Ophélie Winter in *Elle*, May 13, 1996: *"Elle*: The nickname *double airbag*, which did the rounds offstage at M6, that didn't upset you?" / "O.W.: No, that was the only thing that stuck in people's minds at the time."

5. Anne Boulay, "Les dessous trichent." *Libération*, Nov. 23, 1994.

6. Ibid.

7. *The Shape of Things to Come*, brochure on the breast and feminine curves generally (Paris: ESMOD-Section Lingerie, ISEM and C. concepts, n. d. [c. March 1998]), unpaginated. See also Vincent Ostria, "La mode au fil(m) du temps)," in *Art et Mode, Attirance et divergence. Art Press*, special no. 18 (1997), 53–57.

8. Interview with Henri Barrère, Paris, February 12, 1998.

9. For those acquainted with French, it is worth citing what is a fun song:
80CT

Les soirées plateau télé/ Dans mon grand tee-shirt Mickey
J'étais encore un bébé
85G
Pas très envie d'en parler/ Les Treets cachés sous mes draps
C'était vraiment l'âge ingrat
90A
Fait frémir la femme en moi/ Les caleçons donnaient le la
C'était les années Lycra....
95C
Plus la peine de s'effacer/Ma croissance est terminée
Pour moi tout peut commencer
C'est l'année des bonnets C
Des toujours et des je t'aime/Et moi j'écoute Boney M.

10. *L'Officiel de le couture*, July 1995. "The fifteen-year dictatorship of Japanese designers has made it seem humiliating to please others: *sexy* and *pretty* had become synonymous with stupidity. My women can be clever; they just don't need to look as though they are." said Véronique Leroy (a young

stylist and former assistant of Jean-Paul Gaultier) whose women displayed "B-film" coquettishness in skintight mock-leopard or vinyl python. "She's no call-girl for all that; she plays with cliché but she's never its victim," Leroy contended (*Libération*, March 17, 1997).

11. Alexandre Kaprisky, "La lingerie dans tous ses états. Fétichistes contre modernistes," *L'Évènement du jeudi*. Jan. 29–Feb. 4, 1998.

12. Dominique Savidan, "Barok attitude," *Le Figaro*, Oct. 17, 1997.

13. *Elle*, Dec. 15, 1997. The French women's weekly was inspired by an article in the London *Sunday Times*, which was quoted at length. In France, *Elle* managed to unearth "a gorgeous, wasp-waisted student, aged twenty-six, nobody's fool." Karine, who wears a corset, being careful "to keep a layer of cotton wool between her skin and the garment to avoid irritation," and who feels, "strong, mistress over her own body, free! ... And it has nothing to do with any kind of feminism," she added. "On the contrary, I am rather more a member of the old school, a boy should open doors for me."

14. Interview with Poupie Cadolle, Paris, January 12 and 15, 1998.

15. Laurence Benaïm, "Alexander McQueen chez Givenchy, John Galliano chez Dior," *Le Monde*, Jan. 26–27, 1997.

16. Interview with Hubert Barrère, op. cit.

17. Wasp-waisted bodice worn as outerwear reproduced in *Le Jardin des modes* (Oct. 1982), 25.

18. On anatomical clothing, see the numerous examples analyzed by Olivier Saillard, "La mode au corps," in *L'Art au corps. Le corps exposé de Man Ray à nos jours* (Marseille: Musées de Marseille, Réunion des musées nationaux, 1996), 374–91.

19. On the question of the connections between the biological, the symbolic, and the social, see David Le Breton, *Anthropologie du corps et modernité* [1990] (Paris: PUF, 1995), particularly pp. 241–44; and, above all, Françoise Héritier, *Masculin/Féminin. La pensée de la différence* (Paris: Odile Jacob, 1996).

20. Anne Boulay and Gérard Lefort, "Défilés du prêt-à-porter printemps–été 1997. Issey Miyake, signes du plaisir," *Libération*, Oct. 10, 1996.

21. The notion that designers might give new life to the world of lingerie was already gaining ground as early as the early 1970s. In 1971, for instance, the group "Dentelle de Calais" published a series of sketches by former model Emmanuelle Khan, who was about to start off on a career as a prêt-à-porter stylist. On this, see S. Boucher and A. Haudiquet, op. cit., pp. 18–21 (see Chapter 3), as well as L. Benaïm, *L'Année de la mode 1987–1988*, op. cit., pp. 134–35.

22. Invitation card, Calvin Klein Underwear, January 1998.

23. *La Lingerie pour femmes de quinze ans et plus*, study undertaken by the Centre textile de conjoncture et d'observation économiques, Clichy-sur-Seine, 1997.

24. Evane Hanska, *Les Amants foundroyés* (Paris: Mazarine, 1984), 162–63.

25. *La Lingerie pour femmes de quinze ans et plus*, op. cit.

26. "Lycra dans le prêt-à-porter féminin," leaflet produced and published by Du Pont de Nemours, n.d. (c. 1996).

27. Interview with C. Martin, op. cit.

28. *Bodywear, Fabric-Color: Styling Trends*, '99, leaflet produced and published by Du Pont de Nemours, 1998.

29. Dominique Cuvillier, *Fibres et matières intelligentes. Le guide des nouveaux textiles qui vont changer la mode* (Paris: Carlin, 1998).

30. Odile Mopin, "Fréquentation tonique au Salon de la lingerie." *Journal du Textile* (Feb. 16, 1998).

31. Ibid.

32. On the notion of the "Me-Skin" ("*moi-peau*"), see Didier Anzieu, *Le Moi-Peau*. (Paris: Dunod, 1985) as well as the whole collection of *Ritologiques* brought out by Jean-Thierry Maetens from 1978 (Paris: Aubier).

TIMELINES

1. Guy Goffette, *Elle, par bonheur, et toujours nue* (Paris: Gallimard, 1998), 86.

2. Baronness d'Orchamps, op. cit., p. 86. See Chapter 1.

3. Maria Riva, op. cit. 143. See Chapter 4.

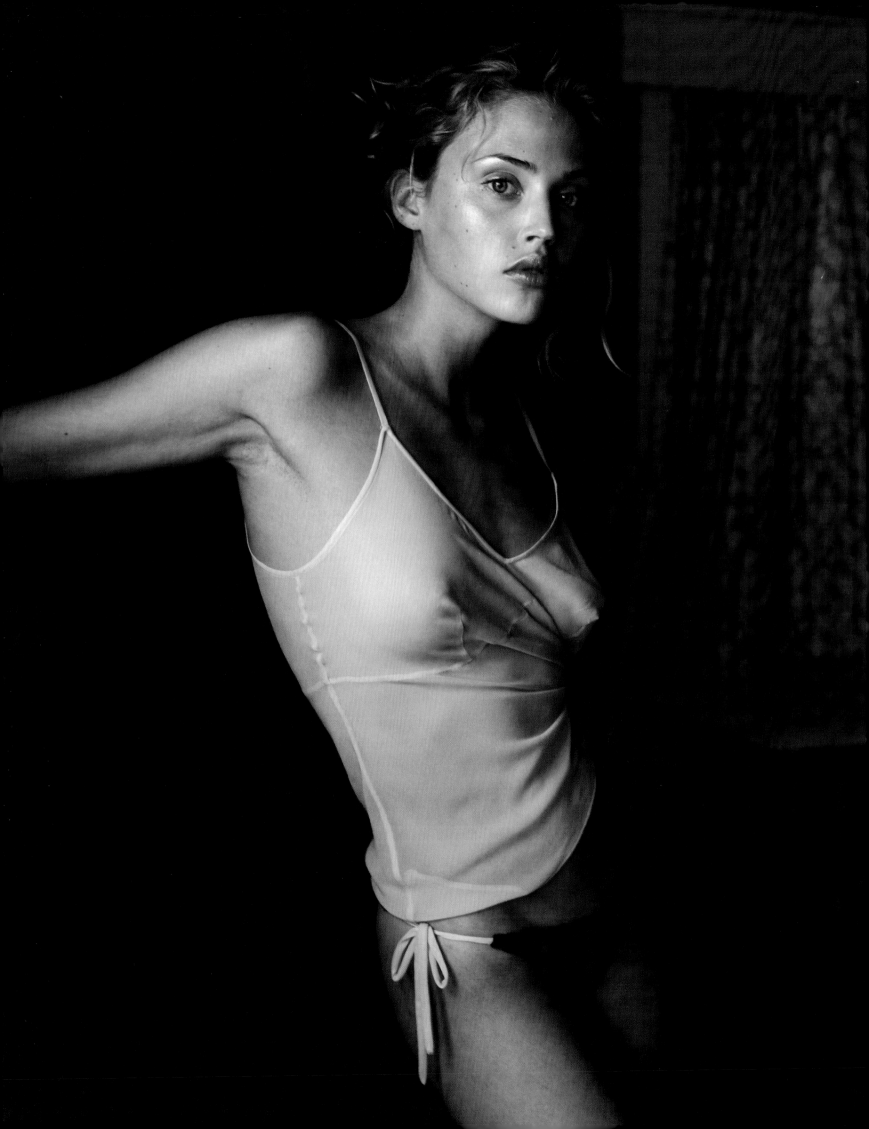

BIBLIOGRAPHY

With a few exceptions, the following bibliography lists books pertaining to underwear, lingerie, and corsetry. In the main they have already been mentioned in the notes.

C'era una volta il corredo da sposa. Burano: Museo del Merletto: Consorzio Merletti di Burano, 1987.

La Distribution de la lingerie. Quelle redistribution des cartes? (Xerfi, study undertaken by Emmanuelle Planes, in collaboration with Karine Billotet). Paris, 1996.

"Linge de corps et linge de maison." *Ethnologie française* (special number, general editors, Daniel Roche and Michel Vernet), n. s. 16, no. 3 (1986).

La Lingerie. Paris: Precepta (Conseil et analyses stratégiques), 1990.

Les Politiques marketing des marques de lingerie de jour. Paris: Precepta (Observatoire stratégies marketing), 1992.

The Underwear Story. New York: The Galleries at the Fashion Institute of Technology, Shirley Goodman Resource Center, 1982.

Amir, Gisèle. "Intimité corporelle et discours publicitaire." In *Le Gouvernement du Corps,* edited by Georges Vigarello. *Communications,* no. 56. Paris: Le Seuil, 1993.

Baclawski, Karen. *The Guide to Historic Costume.* London: Batsford, 1995.

Bertherat, Marie, and Martin de Halifax. *100 ans de lingerie.* Paris: Atlas, 1996.

Bologne, Jean-Claude. *Histoire de la pudeur.* Paris: Orban, 1986.

Borel, France. *Le vêtement incarné. Les métamorphoses du corps.* Paris: Calmann-Lévy, 1992.

Boucher, Shazia, and Annette Haudiquet. *Vingt-cinq ans de lingerie ou la dentelle sans dessus-dessous* (exh. cat.). Calais: Musée des Beaux-Arts et de la Dentelle, 1997.

Bouvier, Jeanne. *La Lingerie et les Lingères.* Paris: Gaston Doin, 1928.

Brooks, Rosetta. "Sighs and Whispers in Bloomingdales: A Review of a Bloomingdale Mail-Order Catalogue for their Lingerie Department." In *Zoot Suits and Second-hand Dresses: An Anthology of Fashion and Music,* edited by Angela McRobbie. London: Macmillan, 1989.

Butin, Dr. F. *Considérations hygiéniques sur le corset.* Paris, 1900.

Caldwell, Doreen. *All Was Revealed: Ladies' Underwear, 1907–80.* London: A. Barker, 1980.

Carter, Alison. *Underwear: The Fashion History.* London: Batsford, 1992.

Claude-Salvy. *Histoire des bas d'hier et d'aujourd'hui.* n.p. n.d.

Crawford, M. D. C., and Elizabeth Crawford. *History of Lingerie in Pictures.* New York: Fairchild, 1952.

Cunnington, C. Willett, and Phillis Cunnington. *The History of Underclothes.* London: Faber & Faber. [1951] 1981.

Delamare, Béatrice. *Comment je fais ma lingerie.* Paris: Éditions de la "Mode du Jour," 1946.

Delpierre, Madeleine. *Secrets d'élégance, 1750–1950.* Paris: Musée de la Mode et du Costume, Palais Galliera, 1978.

Dufay, Pierre. *Le Pantalon féminin. Un chapitre inédit de l'histoire du costume.* Paris: Charles Carrington, 1906.

Étienne, M. *Corset-gaine et soutien-gorge.* Paris: J.-B. Ballière, 1958.

Ewing, Elizabeth. *Fashion in Underwear.* London: Batsford, 1971.

———. *A History of Twentieth-Century Fashion.* London: Batsford, 1974.

———. *Dress and Undress: a History of Women's Underwear.* London: Batsford, 1978.

Fields, Jill, "The Production of Glamour: A Social History of Intimate Apparel, 1909–1952." Ph.D. diss., University of Southern California, 1997.

———. "Three Sides to Every Story: The Material Culture of Intimate Apparel." *Dress, The Annual Journal of the Costume Society of America* 23 (1996): 75-81.

Fine, Agnès. "A propos du trousseau: une culture féminine?" *Une histoire des femmes est-elle possible?* edited by Michelle Perrot. Marseille: Rivages, 1984.

Fontanele, Béatrice. *Corsets et soutiens-gorge. L'épopée du sein de l'Antiquité à nos jours.* Paris: La Martinière, 1992.

Garsauilt, F. A. *Art de la Lingerie.* Paris: L.-F. Delatour, 1771.

Giafferri (Gaifar), Paul Louis de. *La Lingerie chez soi. Deux cents secrets de coupe, quatre cents cro-*

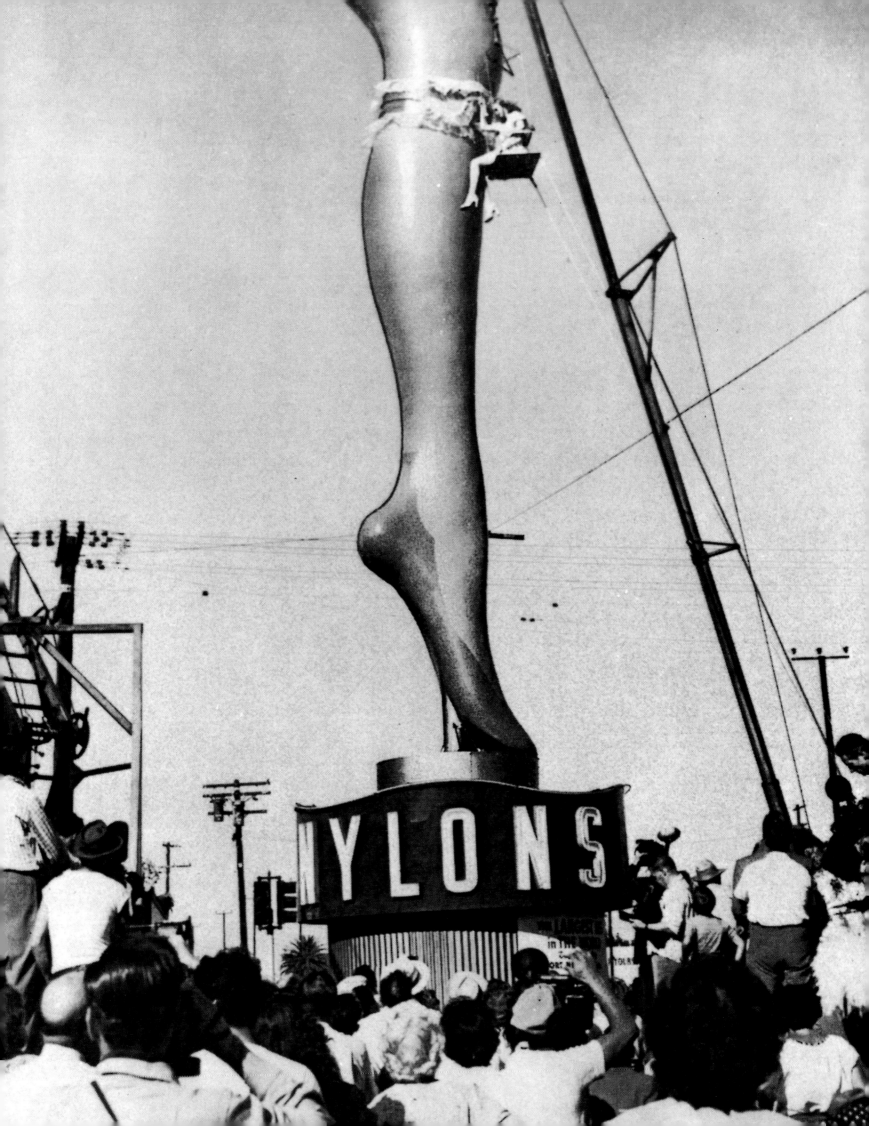

quis de lingerie et dessous élégants. Paris: Fayard, n.d. [c. 1927].

Grand-Carteret, John. La Femme en culotte. Paris: Côté Femmes [1899], 1993.

Grasse, Marie-Christine. Coup de soleil et bikinis. Grasse: Musée international de la parfumerie, 1997.

Hawthorne, Rosemary. Oh! Knickers! London: Bachman & Turner, 1985.

———. Knickers—An Intimate Appraisal. London: Souvenir, 1991.

Kaufmann, Jean-Claude. La Trame conjugale, Analyse du couple par son linge. Paris: Nathan, 1992.

Kidd, K. Laura, and Farrell-Beck, Jane, "Menstrual Products Patented in the United States, 1854–1921." Dress, The Annual Journal of the Costume Society of America 24 (1997).

Krantz, Anne. Dentelles. Paris: Adam Biro, 1988.

Kunzle, David. "The Corset as Erotic Alchemy: From Rococo Galanterie to Montaut's Physiologies." In Woman as Sex Object, Studies in Erotic Art, 1730-1970, edited by Thomas B. Hess and Linda Nochlin. London: Allen Lane, [1972] 1973.

Kunzle, David. Fashion and Fetishism: A Social History of the Corset, Tight-Lacing and Other Forms of Body-Sculpture in the West. Towota, N.J.: Rowman & Littlefield, 1982.

Landroy, Lyse de. La Couturière

chez soi. Cours de coupe et couture en 12 volumes. Vol. 6. Les Tailleurs, la lingerie. Paris/Geneva: Éditions G. Liechti/Les Éditions pratiques, 1952.

Laurent, Jacques. Le Nu vêtu et revêtu. Paris: Gallimard, 1979.

Le Fustec, Marie-Madeleine. Matières premières utilisées en lingerie. Paris: Eyrolles, 1944.

Lelieur, Anne-Claude. Rayon Lingerie. Un siècle de publicité (exh. cat.). Paris: Forney, 1992.

Léoty, Ernest. Le Corset à travers les âges. Paris: Ollendorf, 1893.

Libron, Ferdinand, and Henri Clouzot. Le Corset dans l'art et les mœurs du XIIIe au XXe siècle. Paris: Ollendorf, 1932.

Lombardi, Paolo, and Marie-Rosa Schiffino. L'Éloge du bas. Paris, 1989.

Mary, Bertrand. Les Pin Up ou la fragile indifférence. Essai sur la génèse d'une imagerie délaissée. Paris: Fayard, 1983.

Marny. Les Bas à travers les âges, followed by Ce qu'il est bon ton d'acheter. Paris: Marny, 33 Rue Tronchet, 1925.

Martin, Richard, and Harold Koda. Infra-Apparel. New York: Metropolitan Museum of Art, 1993.

Martin-Fugier, Anne. "La douceur du nid. Les arts de la femme à la Belle Époque." Urbi 5 (1982).

Mauvin, Jacques. Leurs pantalons. Comment elles les portent. Paris: Jean Fort [1912], 1923.

Néret, Gilles. Les Dessous de la pub. Paris: Robert Laffont, 1986.

O'Followell, Dr. Le Corset. Histoire, médecine, hygiène. Paris: Maloine, 1908.

Page, Christopher. Foundations of Fashion—The Symington Collection: Corsetry from 1856 to the Present Day. Leicestershire Museums Publications, no. 25, 1981.

Paillochet, Claire. Sans dessus dessous. Paris: Love me tender, 1983.

Pearce, Arthur W. The Future Out of the Past: An Illustrated History of the Warner Brothers Company on its 90th anniversary, with the History of the Corporate Family, C. F. Hathaway, Puritan Sportswear and Warner Packaging. Hartford: Warner Brothers Company, 1964.

Philippe, Perrot. Fashioning the Bourgeoisie: A History of Clothing in the Nineteenth Century, translated by R. Bienvenu. Princeton: Princeton University Press, 1994.

———. Le Travail des apparences, ou les transformations du corps féminin, XVIIIe–XIXe siècle. Paris: Le Seuil, 1984.

Probert, Christina. Lingerie in Vogue since 1910. New York: Condé Nast, 1981.

Rachline, Michel. L'Art de la lingerie. Paris: Etam/Orban, 1988.

Romi. Histoire pittoresque du pantalon féminin. Paris: J. Grancher, 1979.

Ross, Kirstin. Fast cars, clean bodies: Decolonization and the Reordering of French Culture. Cambridge, Mass.: M.I.T. Press, 1975.

Saint-Laurent, Cécil. Histoire imprévue des dessous féminins. Paris: Herscher, 1986.

Silvestre, Armand. Les Dessous de la femme à travers les âges. Paris: E. Bernard, 1902.

Simon, Louis. Dim. Paris: Le Chêne, 1985.

Sztajn, Lili. Histoire du porte-jarretelles. Paris: La Sirène, 1992.

Verdier, Yvonne. Façons de dire, façons de faire. La laveuse, la couturière, la cuisinière. Paris: Gallimard, 1979.

Vigarello, Georges. Le Corps redressé. Paris: J.-P. Delarge, 1978.

———. Concepts of Cleanliness. Cambridge, England: Cambridge University Press, 1988.

Warner, Deborah Jean. "Fashion, Emancipation, Reform and the Rational Undergarment." In Dress, vol. 4. New York, 1978.

Waugh, Norah. Corsets and Crinolines. London: Batsford [1954], 1970.

Main specialist and trade journals consulted:

Albums du Jardin des modes
La Belle Lingerie
Le Corset de France et la lingerie
Créations Lingerie
Les Dessous élégants
Journal de la lingerie
Lingerie et linge de France
Lingerie parisienne
Mode Dessous international
Mon aiguille
Revue de la lingerie

Facing page: United States, 1940s.
Preceding page: Lingerie. Elle, 1998.
Page 188: String bikini brief, 1995.

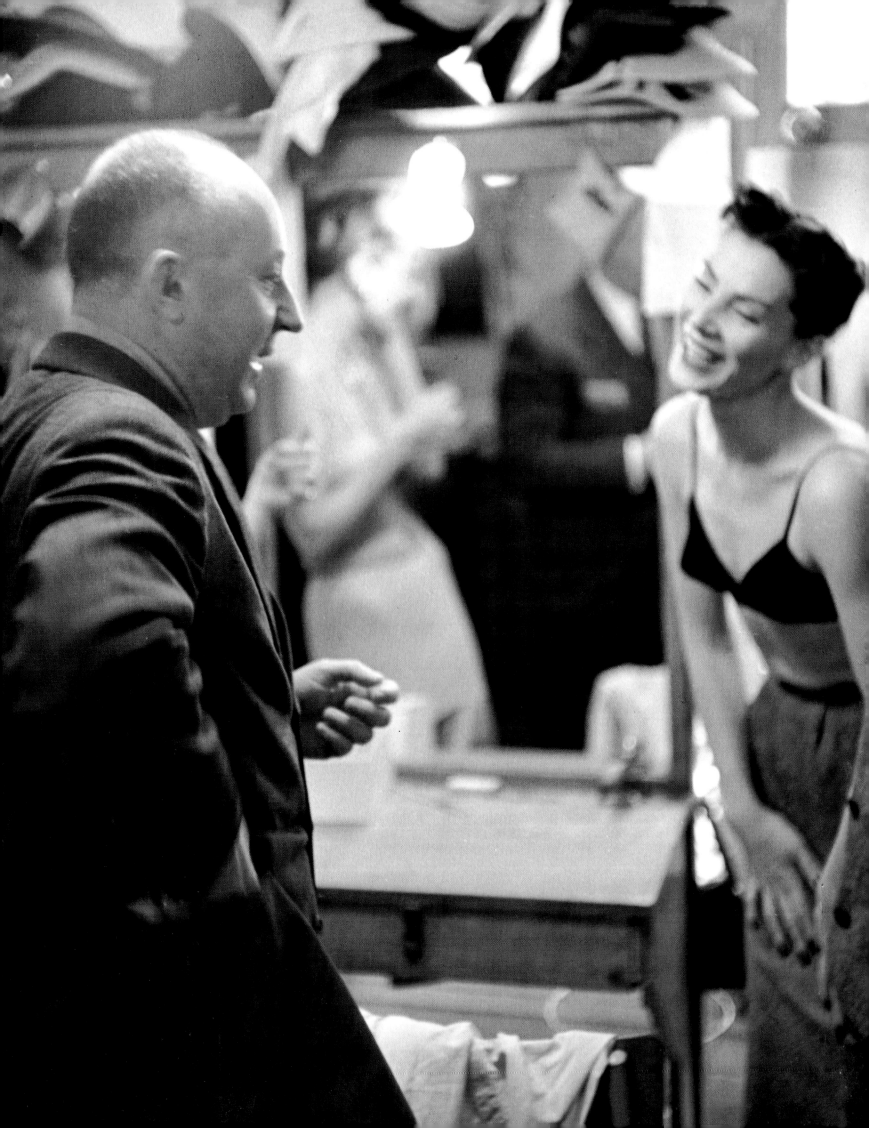

PHOTOGRAPH CREDITS

Facing page: Christian Dior and the model Lucky. 1947.
Following page: Corset. 1947.
Page 198: Novelty wear shop. England. 1950.
Page 200: Chantelle Lingerie. 1998.

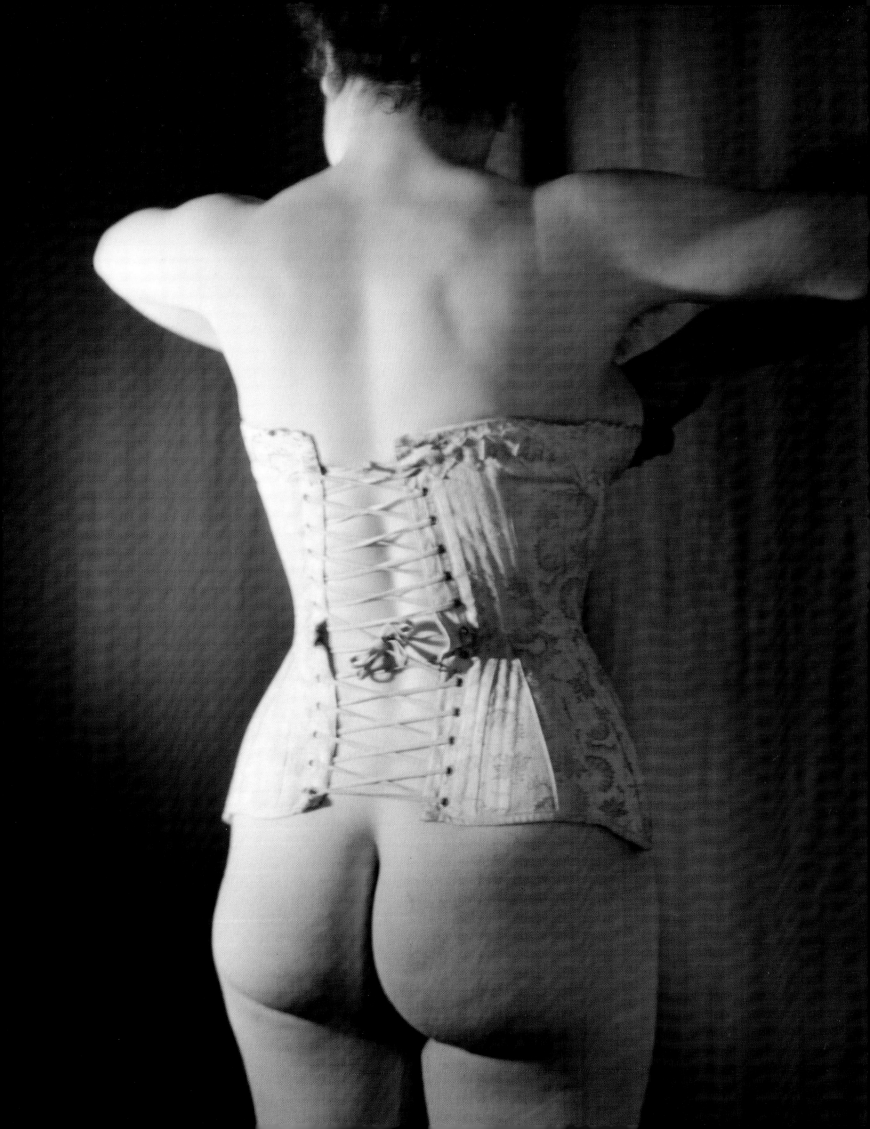

ACKNOWLEDGEMENTS

The author would like to thank the following individuals who at one time or another have provided him with assistance, information, or both: Marlène Aouat, Catherine Aygalinc, Marie-Odile Bouillon, Dominique Cuvillier, Jacques Damade, Nicole Foucher, Véronique Pataut, Daniel Percheron, Dominique Quessada, Bruno Remaury, Suzanne Tise, Bernadette Villars, and Éric Walbecq, as well as Martine and Prosper Assouline, Laurence Stasi, Julie David, and Stéphanie Libérati at Éditions Assouline.

Thanks too are due to Valérie Lemercier for allowing us to reproduce a passage from her song 95C, to Éditions Melody Nelson for extracts from Les Dessous chics by Serge Gainsbourg, to Campbell Cornelly and Warner Chappell Music France for a verse from Claude Nougaro's Don Juan, and finally to Collins P.O.L. for the the text entitled The Chest of Drawers, from Marguerite Duras's Practicalities, trans. B. Bray (London: Collins, 1990), 121–22.

The publisher would like to take this opportunity to thank Mademoiselle Catherine Deneuve.

Gratitude is also due to all those who made this book possible, especially: Agence C.C.P., Agence Vu, Azzedine Alaïa, Barbro Andersson, Martine d'Astier, (Association des amis de Jacques-Henri Lartigue), Lillian Bassman, Viviane Beauvillain (Chantal Thomass), Renata Benichou (Renata), Marie-Christine Biebuyck (Magnum Photo), Véronique Biguand (B.I.F.I.), Bruno Bisang, Sandrine Bizzaro (Michele Filomeno), Christine Blanc (Vannina Vesperini), Angela de Bona, Mélanie Boswell (La Perla), Annie Bredin-Benezy (Aubade), Samuel Bourdin, Poupie Cadolle (Sarl Alice Cadolle), Sylvie Cantelli, Laëtitia Casta, Cat's Documentaliste, Alix de Chabot (Calvin Klein), Jean-Loup Charmet,

Sirot-Angel Collection, Juliette Coste, Stéphanie Courtel (Agence Mafia), Gwénaëlle Dautricourt (Marie Claire), Patrick Demarchelier, Dim, Cécile Dubost (B.I.F.I.), Elle, Margit Erb, Mary Evans, Explorer, Sylvie Flaure, Don Freeman, Thierry Freiberg (Sygma), Marina Fröhling (Museum Ludwig, Cologne) Dominique Gabel-Litny (Une Femme à Part), Galleries Lafayette, Gamma, Bernard Garret (A.K.G.), Catherine Gosselet (Publicis Conseil), Jean-Paul Goude, René Gruau, Michèle Guérin (Du Pont de Nemours), Laziz Hamani, Véronique Hascöet (Antinéa), Emmanuelle Haugel, Anne Herme (Roger-Viollet), Marc Hispard, Annick Huet (Centre d'information Lejaby), Françoise Huguier, Hulton-Deutsch, Dominique Issermann, Agnès Jacquet, Sandrine Kaïm (Marie Claire), Karen (Art & Commerce), Kharbine-Tapabor, Christian Kettiger, Peter Knapp, Kobal Collection, Christophe Kutner, Sybille de Laforcade (Nine Ricci), Alexandra Lejeune, J.-A. Lelorrain (Sarl Alice Cadolle), Sabine Lévin, Peter Lindbergh, Ruth Malka-Viellet (Karin), Marie Claire Copyright, Steven Meisel, Jean-Baptiste Mondino, Emmanuelle Montet (U.F.A.C.), Hervé Mouriacoux (A.K.G.), Roswitha Neu-Kock (Museum Ludwig, Cologne), Helmut Newton, Sylvie Nissen, Marino Parisotto, Vincent Peter (Madison), Sylvie Pitoiset (Ville de Paris/Bibliothèque Forney), Marc Pussemier (Trademarc), Gilles Raison (Princesse Tam-Tam), Fanny Remadier (Chantelle), Rapho, Réunion des Musées Nationaux, Maison Rochas, Hélène Rossignol (Michele Filomeno), Marie-Françoise Rouy (Wolford), Paolo Roversi, Lothar Schmid, Ferdinando Scianna, Scoop, David Seidner, Catherine Seignouret (Keystone), Philippa Serlin, Jeanloup Sieff, Calypso de Sigaldi, Sipa Press, Sabine Spruyt, Stella Tennant, Catherine Terk (Archive Photos), Chantal Thomass, J. Walter Thompson (Lejaby), Top, Barbara Tubaro (T.D.R.), Christy Turlington, Claude Vittiglio (Association Française pour la Diffusion du Patrimoine Photographique), Estella Warren, Tina and Suzan Winfield (Une Femme à Part), Patricia Zevi (La Perla).

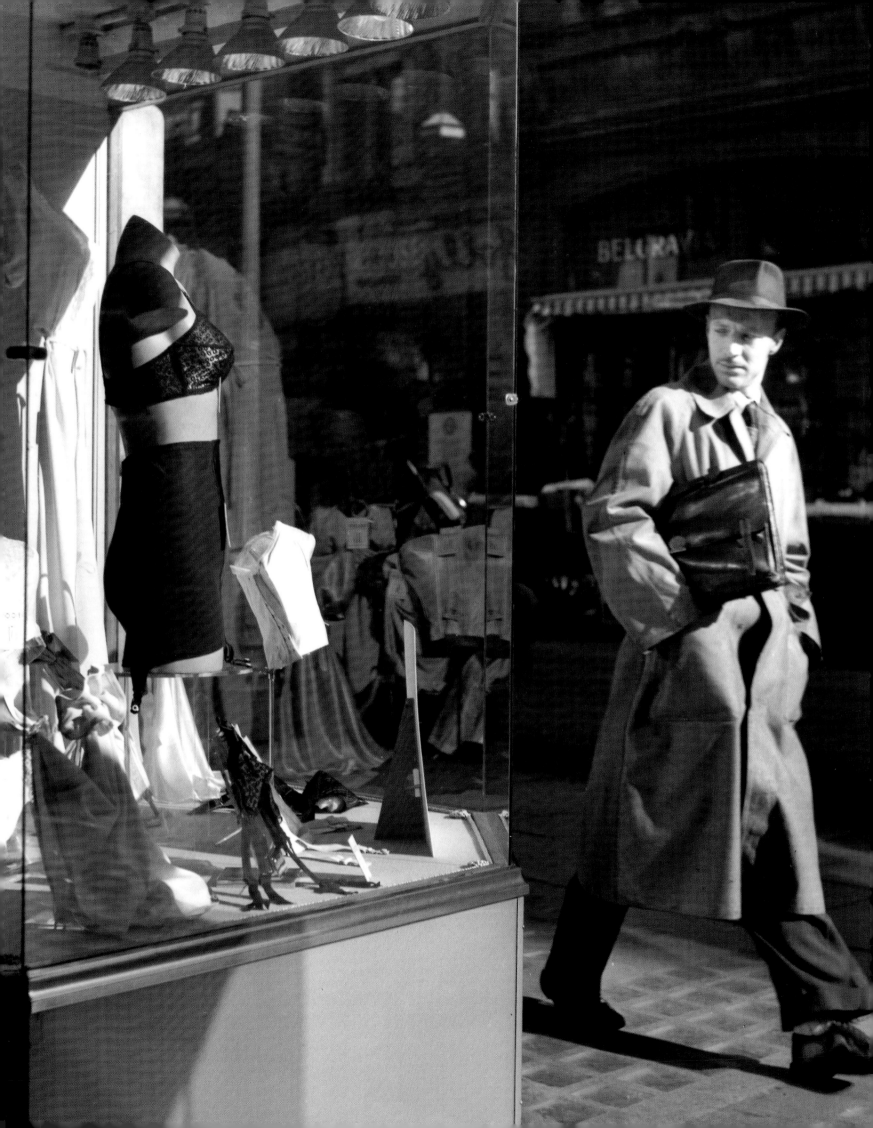

First published in the United States of America
in 1999 by
RIZZOLI INTERNATIONAL PUBLICATIONS, INC.
300 Park Avenue South, New York, NY 10010

Copyright 1998 Editions Assouline
26-28, rue Danielle Casanova,
75002 Paris, France

ISBN: 0-8478-2204-4
LC 99-74736

Designer: Isabelle Ducat

Printed and bound in Italy

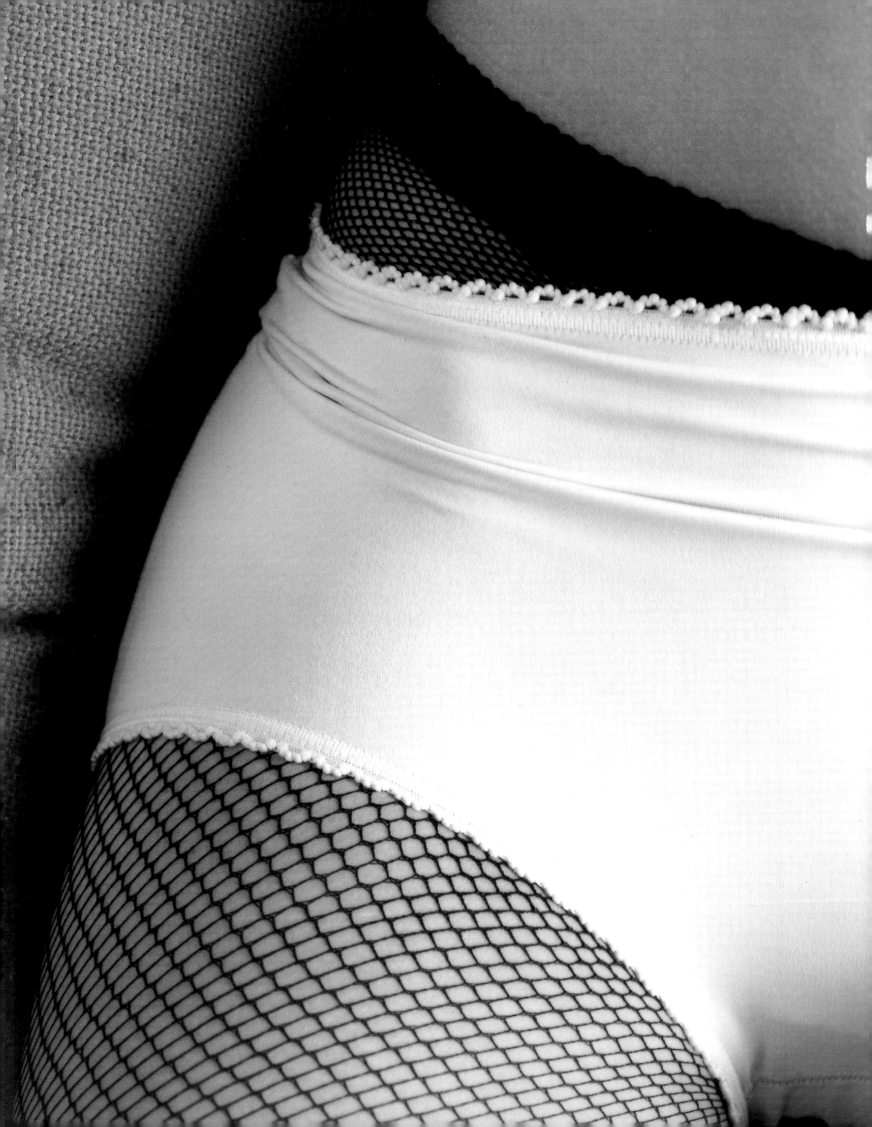